W9-AEP-743

DEMCO

Decoys and Disruptions

OCTOBER Books

George Baker, Yve-Alain Bois, Benjamin H. D. Buchloh, Catherine de Zegher, Leah
Dickerman, Hal Foster, Denis Hollier, Rosalind Krauss, Annette Michelson, Mignon
Nixon, and Malcolm Turvey, editors

Broodthaers, edited by Benjamin H. D. Buchloh

AIDS: Cultural Analysis/Cultural Activism, edited by Douglas Crimp

Against Architecture: The Writings of Georges Bataille, by Denis Hollier

Painting as Model, by Yve-Alain Bois

The Destruction of Tilted Arc: Documents, edited by Clara Weyergraf-Serra and
Martha Buskirk

Techniques of the Observer: On Vision and Modernity in the Nineteenth Century, by
Jonathan Crary

Looking Awry: An Introduction to Jacques Lacan through Popular Culture, by Slavoj Žižek

Cinema, Censorship, and the State: The Writings of Nagisa Oshima, by Nagisa Oshima

The Optical Unconscious, by Rosalind E. Krauss

Gesture and Speech, by André Leroi-Gourhan

Compulsive Beauty, by Hal Foster

Continuous Project Altered Daily: The Writings of Robert Morris, by Robert Morris

Read My Desire: Lacan against the Historicists, by Joan Copjec

Fast Cars, Clean Bodies: Decolonization and the Reordering of French Culture, by Kristin Ross

Kant after Duchamp, by Thierry de Duve

The Duchamp Effect, edited by Martha Buskirk and Mignon Nixon

The Return of the Real: The Avant-Garde at the End of the Century, by Hal Foster

for Joshua and Sari

Decoys and Disruptions

Selected Writings, 1975–2001

Martha Rosler

An OCTOBER Book

The MIT Press
Cambridge, Massachusetts
London, England

in association with International Center of Photography
New York, New York

This book was set in Bembo by Graphic Composition, Inc., and was printed and bound in the United States of America.

Library of Congress Cataloging-in-Publication Data

Rosler, Martha.
Decoys and disruptions : selected writings, 1975–2001 / Martha Rosler.
 p. cm.
"An October book."
Includes index.
ISBN 0-262-18231-9 (alk. paper)
1. Photography—Philosophy. 2. Photography—Social aspects. I. Title.

TR185.R67 2004
770′.1—dc22

 2003066827

CONTENTS

This book represents several currents in my writing over the past few decades. It is a selection—it is not comprehensive. The aim is to suggest a range of concerns centering not only on image production, exhibition, and reception—in art, photography, and video—but also on the circumstances that condition them, as well as historiographic trends after the fact. Rather than theorizing art as consisting of static, knowable objects or events, I have sought to understand it as a set of coded possibilities that are—only and always—instituted within a specific set of social circumstances.

Henri Lefebvre, quoting Hegel, notes that "the familiar is not necessarily the known." It was feminism that underlined for me that it is life on the ground, in its quotidian, thoroughly familiar details, that makes up life as lived and understood but that bears a deeper scrutiny. I have often, in my work, invoked the image of the decoy, a lure that attracts attention by posing as something immediately—reassuringly, attractively—known. The disclosure of the decoy's otherness unsettles certainty and disrupts expectations. I retain the hope that in some small measure my work can help us "see through" the commonsensical notion regarding things as they are: that this is how they must be. This is the first step toward change of any magnitude.

Collective transformation requires communication. This obvious necessity has fueled my interest in the production and reception of images intended, at the most basic level, to advance truth claims. More pertinently, I am interested in work meant to make social contradictions visible in order to energize a response, whether humanitarian (for want of a better word), "post-humanitarian," or more patently and immediately political. Several articles in this collection address questions of documentary. Documentary practices have evolved over the past century, adapting to changes in the public mood, advancing sophistication, information glut, and the increasingly easy computer-driven mutability of images. I look at these matters in articles from the mid-1970s through the present.

I have spent the past few decades observing, and writing about, the workings of the systems and subsystems of the "art world," including its systems of production, exhibition, sales, and publicity, following the early lead of Hans Haacke. At the same time, the virulent "culture wars" instituted by right-wing elites have prompted me, along with many others, to think about censorship and have led to a spate of lectures and articles. Some of these articles have found their way into this volume. I have included here only a couple of my writings on particular artists and photographers, and only when the work provided me with an entree to certain central questions. Thus, I look at some of the work of Lee Friedlander, whom I dub the exemplary modern—that is, modernist—street photographer of the Vietnam decade. I have also included a newspaper review of a book of war photographs of Susan Meiselas, a vital and widely seen, sympathetic representation of revolution in the fraught atmosphere of the early 1980s. Although feminism provides a central frame of reference for me, rather than including my discussions of specific work by other women here, I have included something of an overview instead. Other areas that occupy a great deal of my attention are not represented at all, for they could not achieve critical mass in this book. The social "production of space" and the built environment (especially housing and transportation in advanced industrial societies) have captured my passionate interest and have continued to provoke a number of projects and

interventions, but a more complete treatment will have to wait for another occasion—as will, perhaps, a collection of the nondiscursive writing that has formed a central element of my work as an artist.

The works published here span from the late 1970s to the turn of the twenty-first century. Most, but not all, of these essays have been previously published; one or two have heretofore existed only in lecture form. My hope is that the chronology provides evidence of development and adaptation, both in personal terms and in view of the march of history. On the whole it did not seem wise, or even possible, to correct or revise most of the published texts, except to snip out one or two remarks that no longer speak to public matters and make other, mostly minor adjustments. In a couple of cases I restored a text edited for journalistic publication to its earlier state, and in another instance I restored a title. Long ago I decided—spurred, I think, by a remark of Brecht's—that a necessary expediency might justify importing elements from one text wholesale into another, if that would serve the desired purpose in writing in the first place. I have often borrowed from my own writings without apology, and I have repeated central themes, as readers will discover, for articles addressing disparate audiences.

This book has been shaped and brought into being by many people, all of whom deserve my deepest thanks. It is hardly possible to call up a complete list of names, but I will mention a few here. First I would like to thank Roger Conover, art and architecture editor at the MIT Press; he has proved himself to be both patient and supportive, as well as critically engaged, during the period—over a decade—in which this book's final manuscript was imminently to appear. I further thank Matthew Abbate and the staff at the MIT Press for their invaluable editorial and production assistance. I gratefully acknowledge the editorial assistance of Catherine de Zegher, editor of October Books and Director of the Drawing Center in New York; Brian Wallis, Chief Curator at the International Center of Photography (ICP) in New York; and Kristen Lubben, Assistant Curator at the ICP. De Zegher and Wallis—both experienced editors and dear friends—devoted time and effort to

reviewing a plethora of articles and talks and assisting in making an appropriate selection. Over the past two years, Kristen Lubben, with dedication and sharp insight, as well as plain hard work, took charge as we tended to the details of making a manuscript out of disparate articles. She helped form the manuscript and saw it through to its final stages. I thank Alexander Alberro for his friendly and timely advice. I gratefully acknowledge the initiative of Richard Bolton as far back as 1987 to work with me in developing a book of essays, a plan whose failure is traceable entirely to me.

At the ICP there was the further labor of interns: Elisheva Lambert, whose intelligent enthusiasm provided an important ignition spark; and Karen Hellman, Nora Ausfeld, Telah Quemere, Louise Skidmore, and Annie Bourneuf, who furthered that work and helped bring it to fruition. I thank the Rutgers University Faculty Council for a research grant at an early stage of manuscript preparation. At Rutgers, also, I am grateful for the assistance of Beryle Chandler at the Center for the Critical Analysis of Contemporary Culture, during my tenure there as a fellow in 1993–94.

Assisting me on various phases of manuscript preparation also were Leigh Kane in the late 1980s and Dona Ann McAdams in the early 1990s; at that stage Anne Holcomb provided valuable editorial intervention. In the manuscript's second wind, a big boost was provided by the organizationally sublime and intelligent Kerry Tribe, working with Melissa Cliver and Mariola Alvarez. All these women, most of them also artists and photographers— with a few art historians among them—provided warmth and support as well as their considerable abilities. And here I offer the necessary disclaimer that all errors are, unfortunately, my own.

I would also like to thank the artists, including photographers, whose names appear in the text. This is no idle gesture, for it is artists and their work that have helped me engage with the world, understand it, and try to take part in the necessary efforts to change it.

I

Situated in Context

For an Art against the Mythology
of Everyday Life

1. Where do ideas come from? All the myths of everyday life stitched together form a seamless envelope of ideology, the false account of the workings of the world. The interests served by ideology are not human interests properly defined; rather, ideology serves society by shoring up its particular form of social organization. Ideology in class society serves the interests of the class that dominates. In our society, that ideology is held up as the only possible set of attitudes and beliefs, and we are all more or less impelled to adopt them, and to identify ourselves as members of the "middle class," a mystified category based on vague and shifting criteria, including income levels, social status, and identification, that substitutes for an image of the dominant class and its real foundations of social power.

This essay was originally published in *LAICA Journal* (Journal of the Los Angeles Institute of Contemporary Art; June-July 1979). It is based on "To Argue for a Video of Representation, to Argue for a Video against the Mythology of Everyday Life," written to accompany the exhibition *New American Film Makers: Martha Rosler,* at the Whitney Museum of American Art, New York, in 1977, and distributed to the audience as a pamphlet. That statement was published in Alexander Alberro and Blake Stimson, eds., *Conceptual Art: A Critical Anthology* (Cambridge, Mass.: MIT Press, 1999).

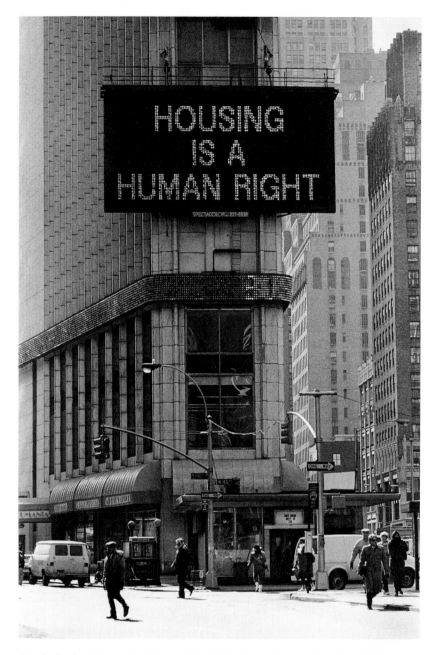

Martha Rosler, *Housing Is a Human Right,* 1989. Times Square, New York. Still from short Spectacolor animation sponsored by the Public Art Fund in its series *Messages to the Public.*

Historically, the advance of industrial capitalism has eradicated craft skills among working people and *economically productive* activity within the family and thus lessened our chances to gain a sense of accomplishment and worth in our work. More and more we are directed to seek satisfaction instead in "private life," which has been redefined in terms of purchase and consumption and which is supposed to represent, as the antithesis to the workaday world, all the things missing from work. As the opportunities for personal control diminish for all but a relative few, self-confidence, trust, and pleasure conceived in straightforward terms are poisoned. In their place, advertising, the handmaiden of industry, promises personal power and fulfillment through consumption, and we are increasingly beguiled by an accordion-like set of mediations, in the form of commodities, between ourselves and the natural and social world.

Our mode of economic organization, in which people seem less important than the things they produce, prompts us to stand reality on its head by granting the aura of life to things and draining it from people: *We personify objects and objectify persons.* This fetishism of commodities, as Marx termed it, is not a universal mental habit; it has its origins in a productive system in which we are split off from our own productive capacities, our ability to make or to do things, which is transformed into a commodity itself, the abstract leveler "labor power," which is saleable to the boss for wages. We experience this condition as alienation from ourselves as well as from others. We best comprehend ourselves as social entities in looking at pictures of ourselves, assuming the voyeur's role with respect to our own images; we best know ourselves from within in looking through the viewfinder at other people and things.

Those who aspire to move upward socially are led to develop superfluous skills—gourmet cooking, small-boat navigation—whose real cultural significance is extravagant, well-rationalized consumerism and the cultivation of the self. These skills, in seeking legitimation, mimic skills once necessary to life; skills which, moreover, were tied to a form of social organization that we think of as less alienated and more familial than our own. Things—in this case, skills—that once were useful and productive are now reseen through the

haze of commodification, and we are sold back what we imagine as our ancestral heritage. People's legitimate desire for meaningful, creative work and for self-determination is thus forced into a conformingly reactionary mode of expression.

At the same time, women, trapped in an economically unproductive and often unsatisfying activity or relegated to low-paying, low-status jobs on top of home and family maintenance, see entrance into the job and skill marketplace as an emancipation from economic dependency and as a chance to gain a social identity now mostly denied us. Yet many of us can see that moving from slavery to indentured status, so to speak—to "wage slavery" or more privileged types of paying work—is only a partial advance. And arrayed against us now are not just an escalating right-wing reaction against our demands for equality with men and deceitful attacks on our bodily self-determination but also the marketing of new commodifications of our lives, resting on the language of liberation. While we achieve greater acceptance in the job market, we seem to slip back toward object status, accepting without complaint the new ways in which we remain defined by *how we look* and by the style in which we *perform* our lives. Meanwhile, merchandisers strive to extend an obligatory narcissism to men. New expressions of sexuality play upon pretend transferences of power from men to women and the symbolic acting out of rebellion and punishment. Again the desire for self-determination is drowned in a shower of substitutions and repressions.

2. How does one address these banally profound issues of everyday life, thereby revealing the public and political in the personal? It seems reasonable to me to use forms that suggest and refer to mass-cultural forms without simply mimicking them. Television, for example, is, in its most familiar form, one of the primary conduits of ideology, through its programs and commercials alike. One of the basic forms of mass culture, including television and movies, is the narrative. Narrative can be a homey, manageable form of address, but its very virtue, the suggestion of subjectivity and lived experience, is also its danger. The rootedness in an I, the most seductive encoding of *convincingness,* suggests an absolute inability to transcend the individual con-

sciousness. And consciousness is the domain of ideology, so that the logic of at least the first-person narrative is that there is no appeal from ideology, no *metacritical* level. Given the pervasive relativism of our society, according to which only the personal is truly knowable and in which all opinions are equally valid outside the realm of science, the first-person narrative suggests the unretrievability of objective human and social truth. At most, one or another version of the dominant ideology is reinforced.

Yet this inability to speak truth is the failure not so much of narrative as of the naturalism that is taken as narrative's central feature. Break the bonds of that naturalism and the problem vanishes. One can provide a critical dimension and invoke matters of truth by referring explicitly to the ideological confusions that naturalism can only falsify through omission. A character who speaks in contradictions or who fails to manage the socially necessary sequence of behaviors can eloquently index the unresolvable social contradictions—starvation in the midst of plenty, gourmetism as a form of imperialism, rampant inflation and impoverishment alongside bounding corporate profits—that underlie ideological confusion, and make them stand out clearly.

3. In dealing with issues of personal life in my own work, in particular how people's thoughts and interests can be related to their social positions, I use a variety of different forms, most of which are borrowed from common culture, forms such as written postcards, letters, conversations, banquets, garage sales, and television programs of various forms, including human-interest interviews and cooking demonstrations. Using these forms provides an element of familiarity and also signals my interest in real-world concerns, as well as giving me the chance to take on those cultural forms, to interrogate them, so to speak, about their meaning within society. In video, for example, I see the opportunity to do work that falls into a natural dialectic with TV itself. A woman in a bare-bones kitchen demonstrating some hand tools and replacing their domesticated "meaning" with a lexicon of rage and frustration is an antipodean Julia Child. A woman in a red-and-blue Chinese coat, demonstrating a wok in a dining room and trying to speak with the absurd

voice of the corporation, is a failed Mrs. Pat Boone or a low-budget appliance ad. An anachronistically young couple, sitting cramped and earnest in their well-appointed living room, attempting to present a coherent account of starvation, are any respectably middle-class couple visited by misfortune and subjected to an interview.

4. In choosing representational strategies, I have avoided the naturalism that I mentioned earlier as being that which locks narrative into an almost inevitably uncritical relation to culture. Rather, I aim for the distancing effect that breaks the emotional identification with character and situation that naturalism implies, substituting for it, when it is effective, an emotional recognition coupled with a critical, intellectual understanding of the *systematic meaning* of the work, its meaning in relation to common issues. In video I tend to seek this effect with a wrenched pacing and bent space; an immovable shot or, conversely, the obvious movement or the unexpected edit, pointing to the mediating agencies of photography and speech; long shots rather than close-ups, to deny psychological intensity; contradictory utterances; humor and burlesque; and, in acting, flattened affect, histrionics, theatricality, or staginess. In written texts I also use humor and satire, and I may move a character through impossible development or have her display contradictory thoughts and behavior or, conversely, an unlikely transcendent clarity. In photography I pass up single-image revelations and often join photos with text.

5. There is another critical issue to consider: the choosing or seeking of an audience. I feel that the art world does not suffice, and I try to make my work accessible to as many people outside the art audience as I can effectively reach. Cultural products can never bring about substantive changes in society, yet they are indispensable to any movement that is working to bring about such changes. The clarification of vision is a first step toward reasonably and humanely changing the world.

LOOKERS, BUYERS, DEALERS, AND MAKERS:
THOUGHTS ON AUDIENCE

PRELUDE

The purpose of this article is to encircle rather than to define the question of audience. It is discursive rather than strictly theoretical. The analytic entity "audience" is meaningful only in relation to the rest of the art system of which it is a part, and as part of the society to which it belongs. This is not to say that the question of audience must disappear in a welter of other considerations, but rather that there are certain relationships that must be scrutinized if anything interesting is to be learned.

Photography has made what seems to be its final Sisyphean push up the hill into the high-art world, and therefore the photography audience must be

———————————

This essay was originally published in *Exposure* (Spring 1979). It was republished in Brian Wallis, ed., *Art after Modernism: Rethinking Representation* (New York and Boston: New Museum and David R. Godine, 1984). A somewhat different version appeared as "The System of the Postmodern in the Decade of the Seventies," in Joseph N. Newland, ed., *The Idea of the Post-Modern: Who Is Teaching It?* (Seattle: Henry Art Gallery, 1981), pp. 25–51.

Martha Rosler, man taking a photograph at a museum in Salzburg, Austria, 1983.
Original photograph is in color.

considered in terms of its changing relation to the art world system that has engulfed it. The most important distinctions among members of the art audience are those of social class, the weightiest determinant of one's relation to culture. In the mediating role played by the market in the relationship between artist and audience, the network of class relations similarly determines the relation between those who merely visit cultural artifacts and those who are in a position to buy them.

Historical determinants of the artist's present position in the art system include the loss of direct patronage with the decline of the European aristocracy and artists' resulting entry into free-market status. One ideological consequence of modernity was romanticism and its outgrowths, which are a major source of current attitudes about the artist's proper response to the public. Unconcern with audience has become a necessary feature of art producers' professed attitudes and a central element of the ruling ideology of Western art set out by its critical discourse. If producers attempt to change their relationship to people outside the given "art world," they must become more precise in assessing what art can do and what they want their art to do. This is particularly central to overtly political art.

After wrestling with these questions, artists must still figure out how to reach an audience. Here a discussion of art world institutions is appropriate. As photography enters the high-art world of shows, sales, and criticism, people involved in its production, publication, and distribution must struggle with its changed cultural meaning.

In writing this article I have avoided assuming a close knowledge of the material on the part of readers; I hope impatience won't turn the more knowledgeable ones away.

SOME FEATURES OF THE AUDIENCE

It seems appropriate to begin a discussion of "audience" by taking note of the fact that there is anything to discuss. There are societies, after all, in which

the social positioning of (what we call) art is not in question. But segmentation is apparent in the culture of late capitalism, where the myths and realities of social life can be seen to diverge and where there is an unacknowledged struggle between social classes over who determines "truth." In our society the contradictions between the claims made for art and the actualities of its production and distribution are abundantly clear. While cultural myth actively claims that art is a human universal—transcending its historical moment and the other conditions of its making, and above all the class of its makers and patrons—and that it is the highest expression of spiritual and metaphysical truth, high art is patently exclusionary in its appeal, culturally relative in its concerns, and indissolubly wedded to big money and "upper-class" life in general. (See tables 1, 2, 3 on the following pages.)

A mere statistical survey of high-culture consumership will delineate the audience and outline its income level, types of occupation, and attitudes toward the ownership of "culture," serving quite nicely to show how limited the audience really is to definable segments of the educated bourgeoisie,[1] and a minimally sophisticated opinion poll will suggest how excluded and intimidated lower-class people feel.[2] There are, however, no *explanations* in the brute facts of income and class; only a theory of culture can account for the composition of the audience. Further, there is a subjective, ideologically determined element in the very meaning of the idea of art that is essential to people's relations to the various forms of art in their culture. The truth is that, like all forms of connoisseurship, the social value of high art depends *absolutely* on the existence of a distinction between a high culture and a low culture.[3] Although it is part of the logic of domination that ideological accounts of the meaning of high culture proclaim it as the self-evident, the natural, the only real culture of civilized persons, its distinctive features are distinguishable only against the backdrop of the rest of culture. What is obscured is the *acquired* nature of the attitudes necessary for partaking in that culture, the *complexity* of the conditions under which one may acquire them, and the *restrictedness* of access to the means for doing so.

Table 1. National Endowment Budget, 1978 and 1979[1]

Category	1978	1979	Change[2]
Architecture	$4,018,268	$3,718,000	−8%
Dance	6,939,231	7,783,700	+11
Exhibition arts	7,201,210	8,005,000	+11
Folk arts	1,532,428	2,376,500	+36
Literature	3,772,800	4,000,070	+6
Media arts	8,077,281	8,412,400	+4
Museum aid	11,501,155	11,377,000	−2
Music	14,642,364	12,570,000	−15[3]
Opera	4,074,320	4,774,000	+15
Theater	6,577,686	7,098,300	+8
Visual arts	4,884,750	4,533,000	−8
Education	5,074,172	5,559,000	+9
Federal-state partnership	18,946,060	22,678,500	+17
Intergovernmental activities	—	1,250,000	
Special projects	2,973,002	3,369,000	+12

Source: Adapted from "NEA to Ask $200M for FY 1980 . . . ," *Art Workers News* (New York, January 1979): 1.11

1. Data furnished by the National Endowment for the Arts, Office of the Northeast Regional Coordinator. The columns do not add up to the total figures supplied; presumably, administrative costs account for the difference.

2. 1979 showed a 20 percent increase over 1978—from $121 million to $149.6 million—and about a 60 percent increase over 1977's budget of $94 million.

3. Drop reflects money taken out of Music category to establish Opera-Music/Theater category.

Note: The *Art Workers News* article clarified that the NEA was expected to request between $180 and $200 million; the latter figure, if accepted, would mean a 34 percent increase over the 1979 budget of $149.6 million. "A spokesman . . . said that the Endowment expects at least a modest increase . . . though declined to speculate on the chances of receiving the full amount requested." The Carter administration had earlier asked government agencies to limit increases to 7 percent. (The 1979 budget increase of 20 percent over 1978 was 1 percent *below* that proposed by Carter.)

Note the sizes of music, media, and museum allocations and the grants to states, and compare the relatively small amount available in total to all visual arts producers and critics. Symphony, opera, and dance lobbies are reputedly very powerful.

———

It can be meaningfully claimed that virtually the entire society is part of the art audience, but in making that claim we should be aware of what we are saying. The widest audience is made up of onlookers—people *outside* the group generally meant by the term "audience." They know of high culture mostly through rumor and report. The vast majority of people in the traditional working class are in this group, as are people in most office, technical, and service jobs; they were probably taught the "value" of high art in school and retain a certain churchly feeling[4] about art but have little real relation to it. Yet their knowledge of the bare lineaments of high culture plays a part in underlining the seeming naturalness of class distinctions—that is, in maintaining capitalist social order—for the transcendental loftiness that is attributed

Table 2. Museum Attendance and Educational Attainment[1]

Educational Level Attained	Percentage of Each Category Who Visit Museums			
	Greece	Poland	France	Holland
Less than primary	0.02	0.12	0.15	—
Primary education	0.30	1.50	0.45	0.50
Secondary education	10.5	10.4	10	20
Post-secondary education	11.5	11.7	12.5	17.3

Source: Adapted from John Berger et al., *Ways of Seeing* (London and Harmondsworth: BBC and Penguin, 1972), p. 24; data originally drawn from Pierre Bordieu and Alain Darbel, *L'Amour de l'art* (Paris: Editions de Minuit, 1969), appendix 5, table 4.

1. The data, drawn from European surveys conducted over 10 years ago, can only be suggestive with respect to the United States, but it seems clear that having completed a secondary education (a higher level of education in the societies studied than in the United States) predisposes a person to attend art museums. Taking the opposite tack—querying art audiences about educational background—Hans Haacke polled visitors to the John Weber Gallery in Manhattan's SoHo (art district) in 1972. Of about 820 people responding, 80 percent were in or had graduated from college (84 percent of artists, 77 percent of others with a professional art interest, and 73 percent of those without such interest). Of 4,547 replies to Haacke's query at the Milwaukee Art Center in 1971, 39 percent of people with a professional interest in art and 59 percent of those without were in or had graduated from college. See Hans Haacke, *Framing and Being Framed* (Halifax and New York: Press of the Nova Scotia College of Art and Design and New York University Press, 1975).

―――

Table 3. Occupation and Attitudes to the Museum[1]

Of the places listed below, which does a museum remind you of most?	Manual Workers	Skilled and White Collar Workers	Professional and Upper Managerial
Church	66%	45%	30.2%
Library	9	34	28
Lecture hall	—	4	28
Department store or entrance hall in public building	—	7	2
Church and library	9	2	4.5
Church and lecture hall	4	2	—
Library and lecture hall	—	—	2
None of these	4	2	19.5
No reply	8	4	9
	100 (n = 53)	100 (n = 98)	100 (n = 99)

Source: Adapted from John Berger et al., *Ways of Seeing* (London and Harmondsworth: BBC and Penguin, 1972), p. 24; data originally drawn from Pierre Bourdieu and Alain Darbel, *L'Amour de l'art* (Paris: Editions de Minuit, 1969), appendix 4, table 8.

1. Presumably in France. The occupational categories given do not reflect clear-cut class divisions, to my way of thinking, except that "manual worker" clearly represents the traditional working class.

When Hans Haacke polled visitors to the John Weber Gallery in SoHo (see table 2 for a complete reference) in 1973, he asked about their *parents'* estimated "socioeconomic background" (offering a vague set of categories having more relation to income than social class). Of the 1,324 replies, 3 percent chose "poverty," 18 percent, "lower middle income," 34 percent, "upper middle income," 4 percent "wealthy," 11 percent gave no answer. (65 percent reported their own 1972 gross income as under $10,000.) In the 1973 poll and in one Haacke carried out in the same circumstances in 1972 (858 replies), the following responses were obtained with respect to occupation (46 percent reported an annual gross income under $10,000):

Artists	30%
Professional, technical, and kindred workers (including art professionals other than dealers)	28
Managers, officials, proprietors (including dealers)	4
Clerical workers	<1
Salesworkers	0
Craftsmen and foremen	1
Operatives	<1
Housewives	3
Students	19
Others	2
None	1
No answer	6

to art artifacts seems attached as well to those who "understand" and own them, the *actual* audience. It helps keep people in their place to know that they intrinsically do not qualify to participate in high culture.

As to who does own high culture: Everyone knows who they are, those men in white ties and tuxes, those women in floor-length furs, the Rockefellers, the Whitneys, the Kennedys, Russian ballet dancers, the international jet set, the Beautiful People, the men who run the world of high finance, government, and giant corporations, and their wives and daughters. They are very good at sniffing the wind, and every time a cultural practice is developed that tries to outrun them and their ability to turn everything into money, they manage to buy it out sooner or later and turn it into investments. In their own cultural arena they are, by definition, unbeatable.

Between the people who own and define the meaning of art as high culture and those who are intimidated by it are those who actively cultivate an "appreciation" of art as evidence of elevated sensibilities. The new "professional and managerial class," sometimes called the new petite bourgeoisie, is marked by strong consciousness of its advantages vis-à-vis the wage-enslaved working class and is just as strongly marked by its aspirations toward the cultural privileges of its class superiors, the big bourgeoisie. Although the dimensions of independence that once characterized this class position have been dramatically reduced, the professional and managerial class is still inclined to count its blessings when it compares itself with the working class, and it clings to its cultural pretensions as proof of its unfetteredness in relation to the workaday world.

The Market as Mediator between Artist and Audience

It is useful to make a further distinction among members of the actual audience for high culture—that between the audience simple and the market, a smallish subset of that audience. Such a distinction was of little meaning in Western societies when patronage relations existed between the dominant classes and artists, for then buyers closely controlled art production; there was

Martha Rosler, opening reception for the exhibition *Helmut Newton: Work,* at the International Center of Photography, New York, 2001. Original photograph is in color.

Martha Rosler, reception for the Art Historians Association held among the Elgin Marbles at the British Museum, London, 1989. Original photograph is in color.

no other audience for secular works until late in the eighteenth century. But artists developed a rhetoric of productive emancipation as patronage declined and they entered into a condition approximating the competitive free market—of which I say more below. Once again, ideological accounts tend to obscure the contours of both audience and market, suggesting that everyone equipped with the right inclinations may choose to belong to either or both. The meaning of art (roughly, its "use value") is held to transcend or even contradict its material existence, and discussions of the economics of art (its exchange relations) are confined to professional seminars and business journals (and there is a formulaic ending for such discussions that is meant to rescue them from philistinism: Taste is the ultimate judge, buy only what you *like*). The actual effects of the market have thus been made mysterious. But we can trace some of the parameters.

Certainly the very rich collectors (including corporate ones) are still the constant substructural support of the art world. Big collectors, now including photo collectors, aside from keeping the cash flowing, have a great deal of leverage with museum and gallery directors and curators and often are trustees or board members of museums and granting agencies. They also donate (or sell) contemporary works to museums, securing windfall tax savings and driving up the financial value of their other holdings by the same artists. In photography, what is now cast in relief is the collectors' ability to engineer the historiography of the medium to suit their financial advantage. These are clear-cut influences of market on audience at large.

There are, however, many people below the high bourgeoisie who buy art for decoration, entertainment, and status—and very much because of art's investment value. Their influence is not formative, yet they constitute a vital layer of the market. This market segment is far more subject to the fluctuations in capitalist economies than is big money, though both are affected by boom-and-bust cycles.

As capitalist economies experience downward swings, changes occur in buying patterns that bring about specifiable changes in what the audience at large gets to see. For example, dealers have lately supported (by means of

Martha Rosler, Chairman of the Board of Trustees Ronald Lauder and his wife, Evelyn, at a reception at the Museum of Modern Art, New York, 1999. Original photograph is in color.

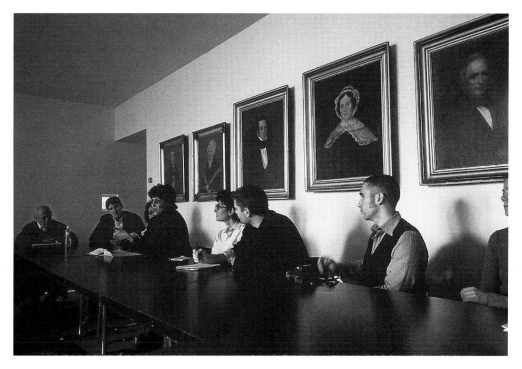

Martha Rosler, meeting at The Cooper Union, New York, between the trustees of the New Museum of Contemporary Art, New York, and prominent architects presenting proposals for a new building, 2001. Original photograph is in color.

shows and even artists' salaries) certain types of trendy art, including performance, which sell little or not at all but which get reviewed because of their art world currency and which therefore enhance the dealer's reputation for patronage and knowledgeability. Bread and butter comes from backroom sales of, say, American impressionist paintings. When money is tight, the volume of investment declines and investors fall back further on market-tested items, usually historical material. This, as well as the general fiscal inflation, may cause dealers to decrease support to nonsellers. But when economic conditions are uncertain over a longer term and investors worry about economic and governmental stability—as now—many investors, including institutions with millions of dollars to invest, put their money in art. Small investors avoid the stock market and savings accounts and buy "collectibles" or "tangibles."[5] Tangibles encompass gems, gold (notoriously, the South African *krugerrand*), real estate, old luggage, and objets d'art: vases, antiques, classy craft items such as silver and ceramics, and old art by dead artists—lately including "vintage" photo prints. People unconcerned with art discourse can be comfortable with such work, especially when, thanks to the effects of the big collectors, brand-name paintings and sculpture seem far too pricey. Thus, the level of safe, purely investment, buying may rise dramatically while patronage buying diminishes.[6] With the falling dollar, investors from other countries find tried-and-true U.S. art and collectibles to be good buys, thus also enlarging the market for those items—and skewing it toward their particular favorites, such as photo-realist painting. (At the same time, countries such as Britain that are in worse financial shape are experiencing an outflow of old master paintings to high bidders from everywhere else.)

As dealers concentrate on work that sells and show less of the less saleable, museums and noncommercial galleries also show it less. Artists then make less of it, though the newer sorts of institutional funding—teaching jobs and government grants—keep a reduced amount of nonselling work in production and circulation, at least in the short run. The balance begins to tip toward ideologically safe work. At any time, the nonbuying audience (except for other artists) seems to have a negligible effect on what kind of contem-

porary art gets supported and produced and therefore on what it gets to see. Popular response no doubt has somewhat more effect on the planning for cultural-artifact museum shows, such as the very heavily promoted King Tut exhibition at New York's Metropolitan Museum of Art,[7] providing a convenient reference for moves that granting agencies and corporate sponsors make toward these apparently populist and often wildly popular projects and away from exhibits of contemporary work.

ART WORLD ATTITUDES

So far I've talked about the actual audience as relatively homogeneous and as beyond the artist's power to determine. But artists may want to reach a different audience from the usual high-culture-consuming public or different audiences at different times. The idea of discriminating among publics is rare in art conversation (though hardly so in marketing), with historical underpinnings. A certain lack of concern with audience took hold with the romantic movement in early-nineteenth-century Europe, a disconnection that was linked to the loss of secure patronage from the declining aristocracy and the State. Production clearly predominated, and marketing was treated as a necessary accommodation to vulgar reality.

The new conception of the artist was of someone whose production cannot rationally be directed toward any particular audience. In one version the artist is a visionary whose springs of creativity, such as Genius and Inspiration (or, in mid-twentieth-century America, internal psychic forces), lie beyond his conscious control and whose audience is "himself."[8] Alternatively, the artist is a kind of scientist, motivated to perform "investigations," "explorations," or "experiments" to discover objective facts or capabilities of, variously, art, taste, perception, the medium itself, and so on, for presentation to similarly invested peers.

A revolt against the canons of high-art production of the earlier, aristocratic order helped clear the way for artists to choose their subjects and styles more freely. But artists, as a class now petit bourgeois, "naturally" tended

toward a range of subjects and treatments that was more in tune with the outlook of the new bourgeois audience-market than with that of any other class. Yet artists' marginality in that class, and their new estrangement from government elites, contributed to a struggle against the wholesale adoption of the bourgeois worldview and against the increasing commodification of culture. Although the new mythology of art denied the centrality of the market, questions of showing and sales remained of great importance, even if successive waves of artists tried to answer them with rejection. The language of liberation began to be heard at just the historical moment in which all social relations were on the verge of domination by market relations. The various bohemian-avant-gardist trends in nineteenth- and twentieth-century art have constituted a series of rejections and repatriations with respect to bourgeois culture, a series united by their initial contempt for the market and the bourgeois audience at large. The art movements of the late nineteenth and early twentieth centuries often were part of a larger oppositional culture (and sometimes related to more direct political practice). That was true of a number of versions of "modernism," as most postcubist art came to be called. Yet, for the most restricted versions of formalist modernism, such as that propounded by the American critic Clement Greenberg at midcentury, there can be no recoverable relation between the work of art and its context other than that composed of similar objects within the aesthetic tradition and the answering faculty of taste.

In the United States, the dominant high-art discourse from, say, the 1940s on has distorted the history of all forms of oppositional culture, whether explicitly part of a revolutionary project or not, into one grand form-conscious trend, with a relentless blindness to the formative influences of larger society and, thus, of the audience. Artists with working-class audiences or who otherwise showed solidarity with revolutionary and proletarian struggles (or, indeed, their opposites, those who produced for the flourishing academic or "bourgeois realist" market) are neutralized in this history. At most, it conceded that (passing over the strident thirties in America, against which this history constitutes a reaction) art and politics were fruitfully linked only in

revolutionary France and the Soviet Union, and then but briefly, in the transient, euphorically anarchic moment of liberation.

The proscription against a clear-eyed interest in the audience is part of an elaborated discourse on the nature of art that was developed in the period of consolidation of industrial capitalism. Resting on the philosophy of Immanuel Kant, the eighteenth-century German idealist philosopher, modernism has built its house on the base of "artistic freedom" from the audience-market and used as its architect the faculty of taste. "Taste" is the construct Kant used (in *The Critique of Judgment*) regarding human responses, including appetite and sexual desire, morality, and religious sentiments. In the Kantian tradition, the aesthetic has no object or effect other than the satisfaction of taste, and all other concerns are excluded as contaminants. For the present topic, the signal issue is the impossibility of a sense of responsibility to any audience, a ban that was related to the romantic figure of the artist as utterly alone, perhaps a rebel, unassimilable within bourgeois social order, and, finally, uncomfortable in his own existence. In the folklore of advanced capitalism this figure lies behind the unsympathetic mass-culture view of the average artist as a kook and a misfit, or at best a lucky (because financially successful) fraud, reinforcing the confinement of a positive relation to high art to the socially elite, specialized audience.

The protocols of taste involve a curious attitude toward judgment; judgment becomes a kind of noncalculated, innate response to the work, almost a resonance with it. Normal standards of judgment about the *meaning* of what one sees before one's eyes are negated, and in particular the referential ties between the work and the world—especially the social world—are broken. The signal system itself becomes the proper subject of conversation. Mass audiences know that there is a restricted body of knowledge that must be used to interpret the codes of art at the same time that they recognize their outsider status. One is left confronting a void of permissible responses out of which the exit line is often an apologetic and self-derogating "I don't know anything about art, but I know what I [don't] like." For the art world audience,

———

the *knowledge* that informs their taste recedes into unimportance compared with the compliment to their inborn "sensibilities" (taste) that an appreciation of high art offers.

Modernist American critics with the power to define a discourse and an art practice, such as Clement Greenberg, posited an opposition between bourgeois high culture and a more widely comprehensible culture as that between avant-garde and kitsch, and imagined avant-gardism to be magically revolutionary through a liberation of imagination without any need to change social structures; others, like Harold Rosenberg, derided the value of art informed by "community criticism," instead favoring idiosyncrasy and *un*willed art; and scores and hundreds of critical hacks have emulated, embellished, and popularized these dogmas.[9] Informing this critical line was a militant anti-Stalinist reaction against the thirties' art world progressivism.

The Concerns of Art

How might artists and other cultural workers abrogate the gospel of genius, isolation, and formalist concerns? Once we even think to pose the question of how to construct an audience, we are confronted by questions that intervene.[10] We must, for example, ask ourselves what the point of our art is (despite the injunction against posing this question). For instance: to entertain, amuse, divert, confuse, defuse, inculcate, educate, edify, mystify, beautify, satisfy, tickle the sensibilities, alienate, make strange, terrorize, socialize. Some of these are incidental to other art world purposes, such as turning a profit, getting grants, or making a reputation.

All art, from the crassest mass-media production to the most esoteric art world practice, has a political existence, or, more accurately, an ideological existence. It either challenges or supports (tacitly perhaps) the dominant myths a culture calls Truth. There was a dry period in the United States, from about the Second World War through the McCarthy period to the midsixties, during which the art world slammed shut to even mildly socially invested work.[11] But after the cultural heresies of the sixties, the neutralist

cultural monolith began to crumble, and art with a conscious political orientation could enter the breach. Theories of culture (as opposed to simple ideologies and journalistic promotion) that began to gain currency in that period have proved useful to the development of an informed art practice.

Following a taxonomy of politicized art developed during the brief period of Soviet cultural experimentation, we may categorize art according to its intentions: to agitate about immediate issues, such as particular strikes, health hazards, tenants' struggles; to propagandize about more general questions, such as personal liberties, institutionalized violence against women, right-wing insurgency; or broad theoretical education, such as the social significance of economic events, the strategies of cultural forms. The words "agitation" and "propaganda" evoke a familiar negative response in us. They call up pictures of clenched-fist posters, yet it should go without saying that only crude works of agitation and propaganda are crude, and only those that offend our ideological precepts are dismissed out of hand. Propagandistic and agitational works from earlier periods are often recuperated; photography provides unending examples in the wholesale legitimation of past photographic practice. State-propagandist enterprises theoretically should strike us as most objectionable but in reality may be the most easily recuperated; it is those propagandizing against the State that are the least acceptable. The gigantic State-propagandist Farm Security Administration corpus, or to choose a less momentous but more recent example, the courthouse survey (in which a coordinated group of documentarians photographed historically significant courthouses), are readily recovered for art—usually in dismembered form, *auteur* by *auteur.*

The theoretical, which is most similar to the art-theoretical modernist project, has the greatest snob appeal and is most easily assimilable into high culture. It is notoriously prone to turn back on itself and vanish into form-conscious academicism. Yet there are fundamental theoretical issues that deserve airing before a mass audience; even to demonstrate how ideology is rooted in social relations is to advance a theory of culture.

The audiences for each type of work depend not on the category but on the content, including the form. The "audience," then, is a shifting entity whose composition depends not only on who is out there but on whom you want to reach with a particular type of work, and why. There is a generalized passivity in artists' relation to their audiences, however, built into the structure of the art world.

Art World Institutions and Supports

The "art world" (revealing term!) includes the producers of high art, a segment of its regular consumers and supporters, the institutions that bring the consumers and work together, including specialized publications and physical spaces, and the people who run them. Since the art world is fundamentally a set of relations, it also encompasses all the transactions, personal and social, between the sets of participants. The gallery system remains basic to the art world. The conception of the gallery is tailored to the still pervasively modernist view of high art: The gallery is a space apart from any concern other than Art, just as art's only rightful milieu is Art. The gallery is a secular temple of Art, just as the art within it is the secular replacement for religion. The invisible motto above the gallery door reads, "Abandon worldly concerns (except if you're buying), ye who enter here." The paradigm is one in which work is made apart from an audience and in which a space is then secured, at the sufferance of an intermediary, where the audience may "visit" the work (and where the few may appropriate it physically). This sequential network paradigm of artist/artwork/gallery/audience severs any sense of responsibility or commitment to an audience, and political artists must seriously question whether it isn't against their interest to perpetuate it.

A main arena for art discourse, the art journals—they are actually trade magazines—have played the utterly vital role of unifying information (and therefore have helped nail the coffin lid shut on true "regionalism," which could not persist in the face of internationalized communication and marketing). Both the front and the back of the book—both feature articles and

reviews—are essential. In the early seventies the major attention given to photography by *Artforum*, the paramount journal, forged a mighty link in the chain tying photography to the art world. The relations between journals and galleries are close and too often covertly financial. I will pass lightly over the fact that the field of art criticism and reviewing is peppered with puff pieces written by people enjoying close relationships with dealers, a fact too well known to be belabored, and a practice that may be more widespread in Europe than in America. But journals patently live on their advertising—gallery advertising. The "new" *Artforum* of 1975 to 1976, which lionized photography and began a hesitant but injudiciously trumpeted foray into cultural criticism, was slammed by the art world powers-that-be (who literally seemed to fear a Marxian takeover of the editorial policy), and was immediately faced with the danger of destruction by the withdrawal of gallery advertising. Dealers felt that reviews, which are what bring the buyers, were becoming sparse and sloppy and that in any case the journal was jeopardizing its imperiously aesthetic vantage point. Exeunt the editors.

In addition to commercial galleries there are other places where art is exhibited. There are the museums, of course, but such institutions as large corporations, schools, and even some unions run noncommercial galleries as well. These galleries typically play only a small part in those organizations; their reasons for existing are ideological—to satisfy public-relations goals. Large corporations avoid controversial work, wanting to appear as patrons of Art-in-general, not as promoters of this or that trend. They want to brand the work rather than have it brand them. This is not patronage but sales and hype.[12] The audience that corporate galleries attract is much like the general gallery-going public, though it may include the more marginal members. The ticket of entry remains some previous inculcation in the social import of high art.

State and municipally funded art museums play an intermediate role. Having a democratic mandate, they cater to the broadest audiences they can safely attract but have special slots for each level of culture. In the disquiet of the sixties, many museums opened token "community-oriented" galleries to

show melanges of local work, mass culture, ethnic heritage, and folk-art remnants. But the *Harlem on My Mind* fiasco of Thomas P. F. Hoving's tenure at the Metropolitan Museum of Art in New York demonstrates what trouble high-culture denizens can cause themselves when they attempt large-scale interpretations of "minority" culture.[13]

Museums of modern and contemporary art address a more restricted audience than municipal ones. New York's Museum of Modern Art, a project of the Rockefeller family and the Kremlin of modernism, is the prototype in terms of its architecture, its ideology, and the social group it addresses.[14] Its domination extends to contemporary photography and its putative antecedents as well, thanks to the efforts of John Szarkowski, curator of photography.

Museums and noncommercial galleries are under the Damoclean sword of censorship in the form of dismissal of curators and directors or withheld financial support from powerful donors or board members with conservative tastes.[15] As I suggested earlier, the cultural climate for the showing of "advanced" work (thus, likely to be of low market value) darkens in times of economic constriction. As museums are generally conceded to be in some trouble, many have even opened boutiques selling copies and cultural artifacts within their walls; these thriving businesses create rips in the seamless ideology of museology and have upset many art world observers. The December 6, 1976, issue of *Newsweek* reported that "*New York Times* art critic Hilton Kramer has accused them of destroying the 'sacred hush' that should pervade museums by distracting patrons with 'counterfeit materials.'"[16] The advancing bureaucratization in its corporate-sponsorship form is ominous, for here audience taste may have its strongest negative influence. Corporate sponsors want their names to reach the widest museum-going audience and, as in their own galleries, wish to support only sure winners, art that poses the least challenge to entrenched points of view. Corporations sponsor exhibitions of securely commodified art and that which is most acceptable to mass culture.[17]

Perhaps only the few union-run and community spaces, especially those of and for "minority" communities, regularly draw audiences that are solidly

Martha Rosler, gift shop at the Los Angeles County Museum of Art, 1989. Original photograph is in color.

working class. In many cases the art shown is art made within the community (which, of course, is also true of the art world community), and the work has some chance of being topical or even polemical. Of all gallery situations it may be here that radical, oppositional work has the best likelihood of realization. Although junior-college and library galleries may also take chances, most are more likely to show work that reveals a missionary intention to bring a warmed-over high art down to the viewers.

In general the gallery system helps keep art directed toward the making of products, toward individual authorship, toward a consistency of medium and style, and toward a generalized content. In the art world of the mid-sixties, there was a wholesale rejection of the tiny but hegemonic New York gallery system.[18] Some artists attempted to contradict the commodity status of art by making work that seemed unsaleable or that was multiply reproducible; some began doing "performance" art. But in the succeeding years, the scores of new commercial galleries that opened, and the older ones that reoriented themselves (later opening outposts in SoHo, and so on) to cash in on the boom in the art market, provided potent reminders of how closely art has remained tied to commodity production.

Efforts to bypass the gallery system included the formation of militantly insurgent artists' cooperative galleries, especially by women; the increasing use of electronic and print media, which could be distributed by artists themselves at little cost; and the creation of "alternative spaces" for showing work. The formation of cooperatives was born of feminists' resolve to reach audiences both outside and within the art world, despite the exclusion of most women from established institutions, as evidenced by the minuscule percentage of women in exhibitions. More fundamentally, they meant to shake the profoundly male-suprematist orthodoxies of the art world. Cooperatives avoid the domination of an intermediary but often require a prohibitive amount of time and money; and some are simply alternate routes to glory—and the same old audience. As for electronic and print media, they can be quite expensive and are also now well along in the process of commodification; of course, their potential for doing something different isn't exhausted.

So-called alternative spaces embodied a reaction against curatorial hierarchies, often a certain contempt for the glamorous upper reaches of the audience and, outside New York, sometimes a rejection of New York's domination. Begun as a democratized way of circulating work and ideas among a smaller rather than a larger audience (producers rather than shoppers or browsers—they are sometimes called "artists' spaces"), they pose no inherent challenge to art world ideologies, and some have already undergone a fair degree of institutionalization, having latterly been adapted to provide a funnel for government grant money. Those run by artists tend to have a more-or-less explicit anarchic philosophy but, contradictorily, often rely on state funding. They often serve as a testing ground for dealers and generate publicity that may lead to sales. They have been manipulated, by clever dealers and others playing on the issue of artistic freedom, into showing work too controversial for a more mainstream gallery. But again, fiscal conservatism is taking its toll on alternative spaces (a few of which are known to have run through astounding sums with small results), and many venues may become less brave as they also become less numerous and hungrier.

THE ASSIMILATION OF PHOTOGRAPHY

The late sixties and early seventies were the high period of the insurgency efforts I just described, which were fueled by a largely antiwar, antiracist, and feminist energy. That was also the moment in which photography entered the art world. Conceptual and pop artists who wanted to avoid the deadening preciousness and finish of high art and who were moving toward a narrative literalism brought photography and video into the galleries; for pop artists, photography was a form of quotation from mass culture, no more intrinsically respectable than comic books. Conceptual artists, moving away from "object making," also were attracted by the anonymity and negative valuation attached to these media. But, never far behind, dealers learned to capitalize on the unsellable, at that moment by adopting and reifying "documentation," which relies most heavily on photography and written material.

In the early seventies the lack of an established new style, the escalating prices of traditional art objects, the end of the stranglehold of the modernist critics, and the consequent weakening of the commercial galleries in the face of wider economic crisis helped direct attention toward photography as an art form and as a less exalted commodity. On a more basic level of society we can look to the restructuring of culture in this period of advanced capitalism into a more homogeneous version of "the society of the spectacle,"[19] a process accelerated by the increasing importance of electronic media (in which all traditional art is represented rather than seen) and the consequent devaluation of craft skills, along with the collapsing of all forms and understandings of high social status into celebrityhood, or "stardom." Dominant cultural forms are increasingly able to absorb instances of oppositional culture after a brief moment and convert them into mere stylistic mannerisms, thus recuperating them for the market and the celebration of the what-is. In the enterprise of celebrity promotion—of increasing importance in the art world from the time of the abstract expressionists onward and now central to the social meaning of art—the role of photography is fundamental.

It is possible that the meaning structure of art has been undergoing reorganization while the market merely faltered briefly and then regained its stride. The late seventies may turn out to have been a revanchist period in which the controlling interests within the audience and market elites regrouped to reestablish the stratification of the audience and its objects, thereby reasserting, for example, the preeminence of painting as standard-bearer and tangible investment. In any case, photography's position is neither threatened nor threatening but rather rationalized within the system.

Whatever its causes, the rapid assimilation of photography into high art has taken place within a continuing series of changes in the place of photography within our broader culture as well as in the meaning assigned to photography as a force within art. The intermingled histories of photography and painting, formerly disavowed, is now paraded by both sides, though more so by photography people. The following chance quotation from a review re-

veals the occasional absurdity of using these media to validate each other without acknowledging conditioning factors outside the oeuvre of particular producers: "For all his critical sobriety, [Walker Evans] was one of the fathers of pop art. . . . Evans' famous print of a small-town photographic studio . . . looks forward to Andy Warhol's hundreds of Campbell soup cans, each painted in its little niche on the canvas."[20] As photography has moved closer in and farther out and then back again to the charmed circle of high art, it has replicated the ideology and many of the gambits of the more established arts. In the current phase of art world acceptance, the "history of photography" (old prints, called "vintage" prints) is doing better than contemporary work, a fact that seems unarguably market-determined. Photography is selling well and getting regular critical attention (and therefore attention from the art audience); art world interest still tends to be confined to dead photographers, to a few unassailably established living ones, and to those closest to conceptual art.[21] There is little interest, indeed, in the photographic discourse that was craft-oriented or a pale version of abstract expressionism, and a new discourse is being developed that can be better assimilated to art world discourse. Photo critics are retiring in disgust, outclassed by New York art critics working hard to create, borrowing from opposite European schools of literary or cultural criticism, what often amounts to a mystified language of commentary and analysis in which to couch increasingly esoteric accounts of the supposed essential elements of photography.

For most of the art world the acceptance of photography seems tied to a vision of it as conforming to the modernism now moribund in the other arts. That is not accidental; it was necessary to the process of its legitimation that photography pick up the torch of formalism and distantiation from real-world concerns. Photography had to reconfigure its own high culture/low culture split: a central matter for photography, which has penetrated daily life and informed our sense of culture as no form of visual representation has before. Photographers are very conscious of Szarkowski's controlling influence, as regnant photo czar, in determining whose career shall be advanced and what gets said about contemporary work. Aside from his responsibility for

the course of the careers of Arbus, Winogrand, and Friedlander, Szarkowski has chagrined many interested observers by his recent elevation of William Eggleston from virtually nowhere, successfully cornering color photography before mass-media photographers like Ernst Haas or postcard artists like Eliot Porter might be slipped into the top spot. The specifics of his influence on discourse affect the most fundamental relations between the work, the photographer, and the world. They include an insistence on the private nature of photographic meaning (its ineffable mysteriousness) and on the disjuncture between the photo itself and the occasion for its making—well-worn art world commonplaces. It can be argued that these elements of an older art world discourse still dominate most photographic production and sales promotion while the new art-critical enterprise is restricted to art journals and anti-Szarkowskian production.

Concomitantly with the elaboration of the received doctrines of photography, the picture of the quintessentially modern (art) photographer as a marginally socialized person has firmed its outlines. It stands in contradistinction to the conception of photojournalists and documentarians as hard-bitten, still artisanal and rational, and to that of fashion photographers as sycophantic (except the few with good publicity).

I can recapture my astonishment at Dorothea Lange, in an interview filmed very near her death, describing a forgotten wartime photo she had rediscovered when preparing her retrospective at MoMA (held in 1966). Szarkowski hovers nearby throughout the film. We see the photo, showing many men and women filling the frame, frozen in the artificial ranks provided by a broad but unseen staircase; they are dressed as industrial workers and they seem to be going off shift. Lange interprets the photo for us, not in terms of the unity of those people in a common purpose (war production); rather she says that each was looking off into a private internal world. There was a terrible appropriateness in this: For someone who had just survived the fifties, the period of the deepest artistic passivity and withdrawal into a phantasmic universe, so to rethink the meaning of her project was to stand it on its head, converting a tight, utilitarian identification into a grossly atomized individ-

ualism. There was no gun at Lange's head; the role of cultural commissar has been diffused among the multivoiced propagandizers, Szarkowski among them. In a fundamental way Lange's account reproduces the changed account of the documentary enterprise itself, from an outward-looking, reportorial, partisan, and collective one to a symbolically expressive, oppositional, and solitary one. We may take Robert Frank's practice to mark this transition from metonymy to metaphor.

Artistic solipsism has now advanced farther than the Lange narrative suggests, yet the incident represents a turning, within the course of development of a single artist, away from social engagement into the psychological interior. The art photographer has taken on some of the baggage of the familiar romantic artist—in this case one bound to the use of apparatuses to mediate between self and world—whose ultimate reference is simply that self. More and more clearly, the subject of art has become the self, subjectivity; and what this has meant for photography is that photography heading for the galleries must be reseen in terms of its revelatory character not in relation to its iconic subject but in relation to its "real" subject, the producer.

Levels of Audience and Market for Photography

For most of the art audience and especially for buyers who want investment that will appreciate in value, the *certainty* attaching to elevated sentiments, to the Kantian rhetoric of removal and formal values, to the denial of the relevance of subject and context, offers the reassuring familiarity of a discourse that sounds like art-ten-years-ago, dishing up again the ruling ideas of painting from the late forties through the sixties. Many photographers produce for this market, and young ones are trained to do so, learning as quickly as young professionals in any field what the road is to success.

So photography penetrated the high-art audience in its moment of hesitation and raised its sights above its previous audience of other, often amateur, photographers. The older, hobby-oriented photo magazines may still concentrate on craft: printing papers, films, lenses, exposure times; but

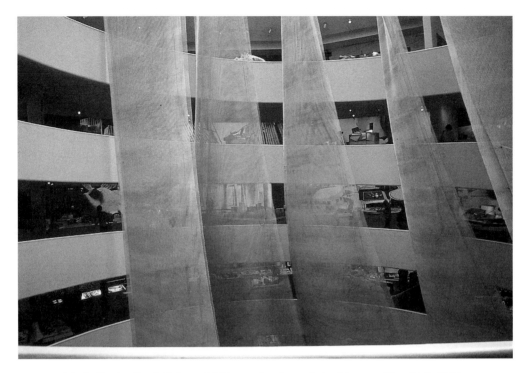

Martha Rosler, Frank Gehry exhibition at the Guggenheim Museum, New York, 2001.
Original photograph is in color.

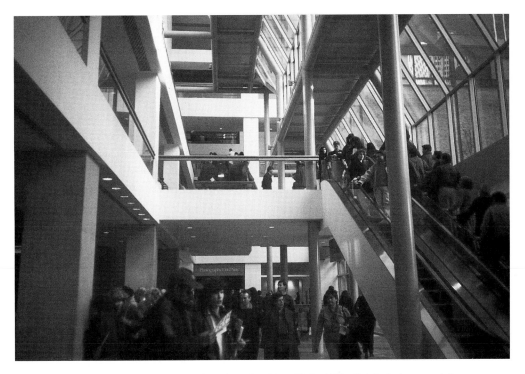

Martha Rosler, the Museum of Modern Art, New York, 1990. Original photograph is in color.

elsewhere the new semiological discourse appears. The new photo journals are being constructed on the model of art journals and the newer, cheaper newspaper-format publications. A great urge for respectability emanates from their very typefaces and layouts. Nevertheless, the smallness and newness of the field is betrayed by the existence of an academic journal calling itself simply *The History of Photography*.

In the realm of production, a theory-inspired approach referred to as structuralism, a latter-day minimalist modernism borrowed from small film-making, appears in art-photo galleries, whereas it could never have entered the photo galleries of an earlier epoch; it has not made it into the controlling commercial dealerships such as New York's Light or Marlborough galleries. It is usually art audiences and hip fringes of the photo audience—mostly interested professionals, including curators and critics—that are the audience and potential market for such work.

While art photography was divorcing its old audience and romancing a classier one, the industry was increasing its pursuit of the amateurs.[22] Reports of the new status of photography are disseminated in versions appropriate to ever-widening circles of the audience. The value of the categories of photographic practice, from high art to advertising to family commemorative, is raised, and all the corresponding markets swell in response. Photo exhibitions and art world attention to photography sell camera and darkroom equipment like painting shows never sold brushes and paint. What accident can there be in the fact that the Museum of Modern Art started promoting color photography just when the industry started pushing home color darkroom equipment in a big way? One can imagine the bonanza of one-dimensionality in store for us if photo corporations like Kodak can sponsor prestigious exhibitions of auratic prints from photographic history that will not only serve as terrific public relations but also lead to an immediate leap in corporate profits. Perhaps Eastman House can have itself declared a national shrine as well.

A new intelligentsia of photography is currently developing in university programs. They will be equipped to dispense the correct cultural line on the meaning of the events being used to mark the march of photography and

to shape the received utterances about current work. There is a mutual legit-imation at work: People are engaged in codifying a body of knowledge, the study of which will lead to the status-conferring professional credentialing of persons who will be empowered to grant, by their public utterances and other forms of publicity, a legitimacy to that reified cultural entity "the history of photography" and to specific works within it. As the enterprise of art history (itself codified precisely to validate works for collectors) has amply proven, the effect of this legitimation on the market is direct and immediate.[23]

The pantheon of past greats will surely continue to be enlarged with new "discoveries," to forestall the exhaustion of the stock of vintage prints. Photographers will attend parties at which they can meet art and occasionally photo critics, may read a few art journals, and will learn to control public statements about their work. One may be sure also that the firmer the hold photography gains in the art world, the more regular will be the attack on photography's truth-telling ability and on its instrumentality. Already there is little distinction between Winogrand, Arbus, and Avedon in their relation to a truth above the street. Further, a belief in the truth value of photography will be ever more explicitly assigned to the uncultured, the naive, and the philis-tine and will serve to define them out of the audience of art photography.

I confess to looking at the transformation of photography with a mix-ture of amusement, frustration, and awe. I have no sentimental longings for the clubby days before the surge of the market swept the photo world away;[24] but I am pained to see the mass-hypnotic behavior of those who thought they lived in a comfortable backwater but now find themselves at the portals of discovery with only a halting knowledge of the language of utopia. I won't forget the theory-terror exhibited at the last meeting of the Society for Pho-tographic Education (my first), or people's fear of offending anyone at all, on the chance that a job, a show, or a critical notice might walk away from them; I both understand and don't understand the pull of fame as it roars near. Artists have had a longer time to learn the game.[25]

There is a sense in which photography, the most reifying of represen-tational forms, verbal or visual, is a sitting duck for the big guns of art. Even

in the earlier moments of photography's gallery life, the craft orientation was pervasive; the tradition of single fine prints in white overmats merely replicated the presentational style of paintings and graphics. In Stieglitz's universe, art had to be a *propter hoc* motive, not a belated discovery in work originally meant for use. The conversion of photographs that once did "work" into noninstrumental expression marked the next great leap into art. In the historical moment of its utterance, as I tried to show earlier, this insistence on the uselessness of art was meant as a cry of the producers' liberation from the object relations of their product. In an ironic reversal, the denial that the meaning of photographs rests on their rootedness in the stream of social life preserves the photograph at the level of object, a mere item of value hanging on a wall.

It requires quite a lot of audience training to transform the relation between a viewer and a photograph to one primarily of mysteriousness, though the gallery dislocation helps. The dual questions of art's instrumentality and of its truth are particularly naked in relation to photography, which can be seen every day outside the gallery in the act of answering to a utilitarian purpose, in assertions of truth from legal cases to advertising to news reports to home album. This cultural disjunction, made possible by commodity fetishism, accounts for the desperation with which young photographers snatch at the vulgarism that only lies are art and that the truth of photography must therefore be that it is all artful lies, constructions outside the understanding of the common mind. There is an exquisiteness to this hermeneutic, a quiet ecstasy that accompanies the purported lift in understanding that sees beyond the world of appearances through the agency of mere light, magical light, in a leaden culture gone unidimensionally object-bound. But the art world's sleight of hand consists in substituting another mystificatory veil of "meaninglessness" for the naive one of transparency.

Let us now imagine a relation between viewer and photographic project in which the producer actively shares a community with the audience in a different way from the community she or he shares with other producers. I will not make an argument here for a practice that comes far closer to this

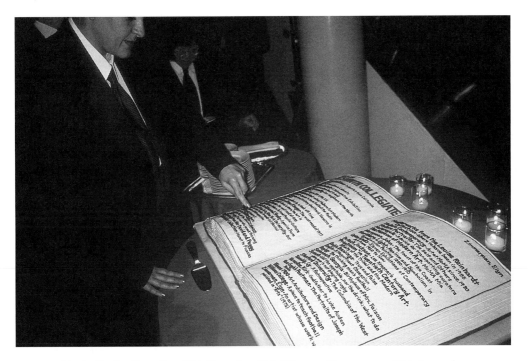

Martha Rosler, farewell to Kirk Varnedoe, Chief Curator, Department of Painting and Sculpture, the Museum of Modern Art, New York, 2001. Original photograph is in color.

understanding of art and its place in the world.[26] As a polar situation, we can imagine the disappearance of the idea of audience, along with, perhaps, the ubiquitous standard of the single producer. In the real world we can maintain the movement toward this pole as a tendency. Imagine the implication of the audience in the *formation* of work: It is just this implication of community that is profoundly embedded in the meaning of art. Its present lack of disconnectedness is more polemical than real, and it has left producers at the mercy of everyone but their wider—nonpurchasing—audience. It was art historian Arnold Hauser's observation that the doctrine of art's uselessness was the result of the fear of the upper classes after the French Revolution that they would lose control of art.

The lie of official culture is that socially invested art is sullied, deficient in its conception, deformed in its gestation, brutalized by the conditions of its birth, and abused in its lifetime. To rescue ourselves from this damaging fiction surely requires a new emancipation from market relations, and it demands a rethinking of all the facets of the production of art within culture. The leveling effect of money, of commodity relations, so that all photographs are equal regardless of what they depict and in which standards of quality are external to iconographic statement and intent, cannot go unchallenged:

> To supply a productive apparatus without trying . . . to change it is a highly disputable activity even when the material supplied appears to be of a revolutionary nature. For we are confronted with the fact . . . that the bourgeois apparatus of production and publication is capable of assimilating, indeed, of propagating, an astonishing amount of revolutionary themes without ever seriously putting into question its own continued existence or that of the class which owns it.[27]

To make this argument is not to call for artists to change masters but to effect a break with preceding practice in a strong and meaningful way. We are in a period in which oppositional practice is regaining strength and taking on

international aspects. We must inventively expand our control over production and showing, and we must simultaneously widen our opportunities to work with and for people outside the audiences for high art, not as annunciatory angels bearing the way of thought of the *haute monde,* but to rupture the false boundaries between ways of thinking about art and ways of actively changing the world.

NOTES

1. Hans Haacke's surveys at various locations indicate that the audience for contemporary work seems to be made up of a very high percentage of people who are occupationally involved in art—museum and gallery professionals, artists, art teachers, art students, critics, and art historians. See Haacke, *Framing and Being Framed* (Halifax: Press of the Nova Scotia College of Art and Design, 1975).

2. Pierre Bourdieu and Alain Darbel, *L'Amour de l'art: Les musées d'art européens et leur public* (Paris: Editions de Minuit, 1969).

3. There is a dynamic between high and low culture, as well, in which elements within each represent either incorporations or rejections of corresponding elements within the other, though that does not affect the argument here.

4. Bourdieu and Darbel, *L'Amour de l'art,* p. 18.

5. For this army of small collectors, the project of the late Nelson Rockefeller to produce up-market imitations held out the promise of limited-edition, classy-looking art objects with the tantalizing combination of imaginary and real ownership: imaginary company with the very rich, the hint of solid investment bound to rise in value. See note 16.

6. To underline this point: Investment in art has been discussed increasingly often in business magazines and other periodicals addressing people with money, especially in light of the stock market's "October massacre" devaluation of 1978. In "The Art Market: Investors Beware," in the *Atlantic Monthly* for January 1979, Deborah Trustman addresses the market's incredible boom: "Art is big business. Sotheby Parke Bernet, the international

auction house . . . announced sales [in America] of $112 million for . . . 1977–78, an increase of $32 million over the previous year More Americans have become wary of inflation and have begun putting more capital into works of art." She quotes a vice-president of Sotheby's in New York who cited a market survey showing that "the young professionals, the high-salaried lawyers and business executives" make up a large segment of the newer buyers.

7. *The Treasures of King Tutankhamun,* the gold-heavy mid-1970s traveling exhibition of loot from the tomb of the 18th Dynasty pharaoh (the tomb famously opened by English archaeologist Howard Carter and others in 1922), was the original blockbuster exhibition, the art show to which the term was first applied. Drawing crowds of unprecedented size and composition to New York's Metropolitan Museum of Art and to its numerous subsequent venues, it set the standard for museum attendance, and perhaps for populist hype, to the dismay of many.

8. "Herself" was very rare.

9. From a randomly selected book and page: ". . . critics and historians are tempted to blame the [unsatisfactory] situation on the dominance of collectors' or tastemakers' whims. Yet while these factors can have considerable effect on momentary prices and popularity, they have never had much effect on the real artist. Rembrandt and Cezanne are famous for their disdain of social pressures . . . sculptor David Hare has remarked, 'It is a classical complaint that the artist is forced into certain actions by society. The artist need not be so forced, unless it is his desire to be so for motives outside art." In John P. Sedgwick Jr., *Discovering Modern Art: The Intelligent Layman's Guide to Painting, from Impressionism to Pop* (New York: Random House, 1966), p. 199.

10. There are always plenty of people who have their markets well staked out. It remains to be seen who the *pompier* photographers will be, beyond the predictable sexual panderers like David Hamilton and Helmut Newton.

11. The simplest expedient was the forgoing of representation in favor of abstraction. "The art of Ben Shahn or Leonard Baskin may have a quicker and easier appeal, but in time it seems to have less 'content'—that is, less meaningful experience—than the paint-

ings of Mark Rothko or Clyfford Still, which at first glance might look almost empty." (Sedgwick, *Discovering Modern Art,* p. 196.)

12. The invention of minimal art in the sixties proved fortunate; having no generally intelligible meaning and looking remarkably like nothing other than stray bits of modular architecture, it has sold very well to big companies as appropriate decoration for corporate offices and lobbies, which reflect the same Bauhaus-derived sensibilities. It seems there must be appropriately lofty photographs to serve where smaller work is desired—weak-kneed surrealism, say, might be the right choice.

13. In January 1969, the Metropolitan Museum opened what was likely the first major exhibition in the United States to chronicle the cultural richness of Harlem in the twentieth century up until that point. With its huge photo blowups and projections but no original works of art on the order of paintings or sculpture, it managed to evoke storms of rage from several powerful constituencies. African American artists picketed to protest their exclusion and the fact that the show was organized without significant assistance from the black community. In fact, at this time of rising tensions between New York's African American and Jewish communities, the main organizer was a Jewish man, Allon Schoener—but that did not save the institution from the rage of the Jewish community (whose militant right wing also picketed), incensed over what it perceived to be anti-Jewish slights in the preface to the catalogue. That the remarks, according to Schoener, were unattributed quotations from Nathan Glazer and Daniel Patrick Moynihan's famous study of immigration, *Beyond the Melting Pot,* mollified no one; the *New York Times* and Mayor John Lindsay denounced the catalogue, which was belatedly withdrawn (but reissued almost thirty years later). Paintings elsewhere in the museum were vandalized, and the show—which featured photography in an early instance of visual culture—became the signal instance of incautiously speaking for others.

14. On the ideological role of the modern-day museum, see Carol Duncan and Alan Wallach, "Ritual and Ideology at the Museum," in *Proceedings of the Caucus for Marxism and Art* (Los Angeles, January 1978). For a more extensive treatment by the same authors, see Duncan and Wallach's "Museum of Modern Art as Late Capitalist Ritual: An Iconographic Analysis," *Marxist Perspectives* 1, no. 4 (Winter 1978): 28–51 [and Carol Duncan, *Civilizing Rituals* (London: Routledge, 1995)].

15. On a panel about funding at the 1979 meeting of the College Art Association held in Washington, D.C., some of the human meaning of art emerged. On the panel were a representative of Exxon, Robert Kingsley (now dead), needled by Hans Haacke in his work *On Social Grease* for calling art a "social lubricant" necessary for the maintenance of business executives in big cities; someone from the Rockefeller Foundation; someone from the National Endowment for the Arts (NEA); someone from a state granting agency; and a gallery director at a huge California state university. The Exxon and Rockefeller men suavely offered facts, figures, and descriptions of their expanding underwriting of art. The woman from NEA was positive but cautious; the federal art budget wasn't running much ahead of inflation. The audience shared her pleasure over the fact that President Carter's budgetary stringency hadn't affected the arts, and everyone refrained from mentioning what *did* feel that ax: social services and aid to cities. But the gallery director acidly sketched a picture of slashes in state and local art budgets, of canceled shows, of museum and gallery closings, of abrupt firings. The session encapsulated the working of the fiscal crisis, in which federal control may be consolidated at the expense of state and local control and in which the public sector—with municipalities like New York and Cleveland experiencing the crisis most acutely—must cede a wide range of funding, services, and jobs to the private sector. For a powerful analysis of the more general relationship between the state and the private sector in advanced capitalist society, see James O'Connor, *The Fiscal Crisis of the State* (New York: St. Martin's Press, 1973).

16. Think of the uproar over the "traitorous" project of simulacrum production that *Newsweek* headlined as "Rocky's Art Clones" (October 16, 1978). *Fortune* had it as their cover story, captioning the cover photo "Nelson Rockefeller, Salesman" (October 23, 1978).

17. The largest corporate sponsors include giant conglomerates and multinationals, among them Xerox, Mobil, Exxon, Rothmans, and Philip Morris, for whom patronage is part of a campaign to counter negative publicity (over the social cost of their products or industrial practices) by constructing a corporate "personality," replacing a threatening facelessness with a human image. Philip Morris has also used art to create a culturally valorized workplace to "motivate" and pacify workers. I will dwell on this awhile, because it represents in concrete form the instrumental relation that corporations have to art, here not merely for "image building" but also in attempting to manage productivity and workers' satisfaction.

———

In 1974, when massive corporate financial incursions into art had become a subject of talk, a pair of articles by Marylin Bender appeared side by side in the Sunday *New York Times* (October 20, 1974): "Business Aids the Arts . . . and Itself" and "Blending Automation and Aesthetics." The first ties the rise of corporate spending to the severe effects of the bearish market on the portfolios of arts foundations and museums during a period of rapidly rising profits in certain industries. The second describes Philip Morris's new plant in Richmond, Virginia, designed around pop art. It provides, among other lessons, a textbook example of how a shift in audiences immediately destroys irony. The loss of the art world frame (which had occurred long before 1974, with the reincorporation of postmodern, pop imagery in its new, validated form back into mass culture) meant an airlessness between the visual artifact and its representation, a collapse that destroyed the whispered critique of mass culture apprehended by high-art audiences and replaced it with adulatory monumentalization. Oversize graphics as art were, at the Philip Morris plant—"the world's biggest and most highly automated cigarette factory"—strategically placed to contradict the utilitarian character of the jobs done within; to drown out symbolically workers' alienation and its psychological manifestations; to argue the existence of a shared cultural unity between owners, managers, and workers; and to slap a veneer of civilized decor over material issues of health and safety, wage demands, and the desire for self-determination. Bender writes, "The plant represents a striving for maximum aesthetic return to help attain such mundane business objectives as increasing productivity and edging out competitors in a tight labor market."

To quote Robert W. Sarnoff, collector of contemporary art, vice chairman of the Business Committee for the Arts, council member of the Cooper-Hewitt Museum, formerly a trustee of the Whitney Museum of American Art and currently of the John F. Kennedy Library Corporation, as well as former chairman of the board and past chief executive officer of both NBC and RCA, who has numbered among his positions directorships of the New York Stock Exchange, the American Home Products Corporation, the Planning Research Foundation, the American Arbitration Association, and the Roper Public Service Opinion Research Center, and executive positions at Cowles Publications, and directorships of Manufacturers Hanover Trust, Random House, Banquet Foods, and Hertz; who is a board member of the Institute of Judicial Administration and of several colleges and universities, including Harvard and UCLA; and who has many other business and cultural affiliations, speaking in Toronto in an interview broadcast in March 1979: "The history of Western civilization is that business has been patron and sponsor of

the arts. What's happening in our country is that it's a new phenomenon. Business is *beginning* to be a major support of the arts, particularly over the past decade, and it's taking the place of the individual patron, because, frankly, of size and cost." The force of pop-as-art-form is summarized in the fifteen-story "pop obelisk" (designed by Ivan Chermayeff of Chermayeff & Geismar Associates) converting the plant's merely artily designed sign covered with corporate trademarks into a cultural monument. Art's role here is to add its implacable authority to that of the corporation.

18. The rejection was of art's commodity status and its consequent vulnerability to market domination far more than of the ideology of art as a specialized entity within culture. Formalism moved away from the stress on composition and transcendence symbolized by Bauhaus aesthetics in favor of the formalism of the Duchampian art-as-idea. There was little overt politicization of the idea of art, nor was much attention paid to the role of art within class society. And except for a sector of the organized feminists, few artists really went after audiences with less art education. Finally, the fact that the formation of true *work collectives* or collaborations was hardly ever seriously considered reveals much about the retention of auteurship.

It can be argued that the turn away from commodity production was an inevitable further move into the "twentieth century," since handicrafts had long been superseded in the culture at large by industrial objects and images whose existence and power were unrelated to their saleability as artifacts and depended, rather, on their existence as texts, bodies of signifiers. Thus pop appears as a continuation of artists' preoccupation with the processes of signification.

19. See Guy Debord, *Society of the Spectacle,* rev. English trans. (Detroit: Black & Red, 1977) [reprinted, ed. Donald Nicholson-Smith (New York: Zone Books, 1994)]; and Walter Benjamin, "The Work of Art in the Age of Mechanical Reproduction," in *Illuminations,* ed. Hannah Arendt, trans. Harry Zohn (New York: Schocken Books, 1969).

20. Alfred Frankenstein, *San Francisco Examiner & Chronicle Sunday World* magazine, January 21, 1979, p. 56.

21. There are a few celebrity fashion photographers recognized for their aspirations to an art practice.

22. "For a wild week in December *photokina* packed a dozen halls in Cologne While commerce reigned supreme in the football-field-sized halls, the aesthetic side of the medium was revealed across the Rhine with photography exhibitions at the city's art museum and at other galleries. The growth of *photokina,* from sleepy trade show to big-time world's fair, reflects the surge in popularity of photography itself. Today photography is a boundless industry with millions of dollars in annual sales Indeed, it is hard to imagine a more insatiable buying public than that existing in today's photographic marketplace." In John von Hartz, "*Photokina:* World's Fair of Photography," "Marketplace" section of Pan Am/Intercontinental Hotel's *Clipper Magazine,* January 1979. Art and commerce are here seen to march in step.

23. Dealers and buyers look up artists and works, past and present, to see what if anything has been said about them, for example. A tiny further example of the day-to-day relations within a system: At the recent College Art Association meeting (see note 15), there was a scholarly session called "Atget and Today," two of whose participants were Szarkowski and Alan Trachtenberg, a respected social historian with an interest in turn-of-the-century photography. At the back of the hall a young woman handed out discreetly printed cards announcing "EUGENE ATGET, An exhibition of vintage prints, Reception in honor of the delegates [*sic*] to the College Art Association . . . , Lunn Gallery/ Graphics International Ltd.," with address.

24. For precisely this lament, see Shelley Rice, "New York: What Price Glory" (*Afterimage,* January 1978), from which this excerpt is drawn: "It's intimidating to walk into an opening where everyone is over 60 and wearing mink and photographers are justified in feeling co-opted. From this point on, the creative individuals are only the grist for the economic mills. Collectors and potential collectors are now the star of the show."

25. This would be the place to point to the outrageous sexism and white-skin privilege of the photo establishment, despite the large number of women involved in photography and the far greater number of nonwhites than we ever get to know about professionally. There is also the further problem that the tokenistic partial incorporation of some of women's photography into art world photography is used to obscure both the question of *oppositional* practice and the dismal inattention to minority-culture photography. That is, a superficial acceptance of some basic feminist demands is used to divert attention from

the retrograde practices that prevail. But in these matters photography seems about equal to art; again, the art world has had the time to construct a better defended façade.

26. Instead, I refer you to Allan Sekula's "Dismantling Modernism, Reinventing Documentary (Notes on the Politics of Representation)," *Massachusetts Review* 19, no. 4 (Winter 1978): 859–83 [reprinted in *Photography Against the Grain* (Halifax: Press of the Nova Scotia College of Art and Design, 1984)], which defines an oppositional practice emerging from a conscious break with the late-modernist paradigm.

27. Walter Benjamin, "The Author as Producer," in *Understanding Brecht,* trans. Anna Bostock (London: New Left Books, 1973), pp. 93–94.

———

VIDEO: SHEDDING THE UTOPIAN MOMENT

What we have come to know as "video art" experienced a utopian moment in its early period of development, encouraged by the events of the 1960s. Dissatisfaction with the conduct of social life, including a questioning of its ultimate aims, had inevitable effects on intellectual and artistic pursuits. Communications and systems theories of art making, based partly on the visionary theories of Marshall McLuhan and Buckminster Fuller, as well as on the structuralism of Claude Lévi-Strauss—to mention only a few representative figures—displaced the expressive models of art that had held sway in

This essay was originally delivered as a talk, "Shedding the Utopian Moment: The Museumization of Video," at the conference "Vidéo '84" (Université de Québec à Montréal), and published in René Payant, ed., *Vidéo* (Montréal: Artexte, 1986). It also appeared in *Block* (London), no. 11 (1985–86). It was republished in Doug Hall and Sally Jo Fifer, eds., *Reading Video* (Millerton, N.Y.: Aperture, 1991); excerpted in the *Next Five Minutes Zapbook* (Amsterdam: Paradiso Amsterdam, 1992); republished (edited) in Kristine Stiles and Peter Selz, eds., *Theories and Documents in Contemporary Art* (Berkeley: University of California Press, 1995); republished in Jon Bird, ed., *The BLOCK Reader in Visual Culture* (London: Routledge, 1996); and translated in Nathalie Magnan, ed., *Vidéo: Guide de l' étudiant en art* (Paris: École Nationale Supérieure des Beaux-Arts, 1997).

the West since the early postwar period. Artists looked to a new shaping and interventionist self-image (if not a shamanistic-magical or kabbalistic one), seeking yet another route to power for art, in counterpoint—whether discordant or harmonious—to the shaping power of the mass media over Western culture.

Regardless of the intentions (which were heterogeneous) of artists who turned to television technologies, especially the portable equipment introduced into North America in the late 1960s, these artists' use of the media necessarily occurred in relation to the parent technology: broadcast television and the structures of celebrity it locked into place. Many of these early users saw themselves as carrying out an act of profound social criticism, criticism specifically directed at the domination of groups and individuals epitomized by the world of television and perhaps all of mainstream Western industrial and technological culture. This act of criticism was carried out itself through a technological medium, one whose potential for interactive and multisided communication ironically appeared boundless. Artists were responding not only to the positioning of the mass audience but also to the particular silencing or muting of *artists* as producers of living culture in the face of the vast mass-media industries: the culture industry versus the consciousness industry.

As a reflection of this second, perhaps more immediate motivation, the early uses of portable video technology represented a critique of the institutions of art in Western culture, regarded as another structure of domination. Thus, video posed a challenge to the sites of art production in society, to the forms and "channels" of delivery, and to the passivity of reception built into them. Not only a systemic but also a utopian critique was implicit in video's early use, for the effort was not to enter the system but to transform every aspect of it and—legacy of the revolutionary avant-garde project—to redefine the system out of existence by merging art with social life and making audience and producer interchangeable.

The attempt to use the premier vernacular and popular medium had several streams. The surrealist-inspired or -influenced effort meant to develop a new poetry from this everyday "language" of television, to insert aesthetic

pleasure into a mass form, and to provide the utopic glimpse afforded by "liberated" sensibilities. This was meant not merely as a hedonic-aesthetic respite from instrumental reality but as a liberatory maneuver. Another stream was more interested in information than in poetry, less interested in spiritual transcendence but equally or more interested in social transformation. Its political dimension was arguably more collective, less visionary, in its effort to open up a space in which the voices of the voiceless might be articulated.

That the first of these streams rested on the sensibility and positioning of the individual meant, of course, that the possibilities for the use of video as a theater of the self, as a narcissistic and self-referential medium, constantly presented themselves. And, indeed, the positioning of the individual and the world of the private over and against the public space of the mass is constantly in question in modern culture. Yet this emphasis on the experience and sensibilities of the individual, and therefore upon expression as emblematic of personal freedom and thus as an end in itself, provided an opening for the assimilation of video—as "video art"—into existing art world structures.

Museums and galleries—the institutionalized art-delivery structures—have continued to try to tame video, ignoring or excising the elements of implicit critique. As with earlier modern movements, video art has had to position itself in relation to "the machine"—to the apparatuses of technological society, in this case, electronic broadcasting. Yet the "museumization" of video has meant the consistent neglect by art world writers and supporters of the relation between "video art" and broadcasting, in favor of a concentration on a distinctly modernist concern with the "essentials of the medium." This paper, in Part I, attempts to trace some basic threads of artists' reactions to nascent technological society and marketplace values in the nineteenth century, using photography as the main example. The discussion invokes the dialectic of science and technology, on one side, and myth and magic, on the other. In considering the strategies of early-twentieth-century avant-gardes with respect to the now well-entrenched technological-consumerist society, it asks the question: movement toward liberation or toward accommodation? Part II considers historiography and the interests of

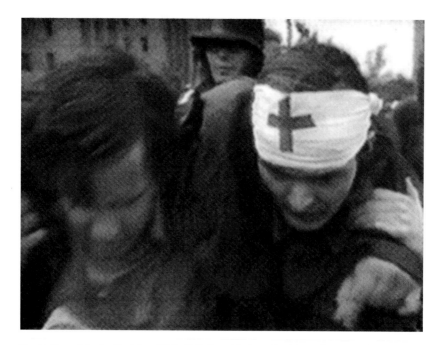

David Cort, *Mayday Realtime,* 1971. Still from black-and-white videotape of a demonstration against the Vietnam War in Washington, D.C., on May Day, 1971. Cort was present as both demonstrator and documentarian. Cort was a founding member of New York's Videofreex collective, which envisioned portable video equipment as providing an alternative to the monolith of network television.

the sponsoring institutions, with video history in mind. Part III considers the role of myth in relation to technology, with a look at the shaping effects of the postwar U.S. avant-garde and the writings of Marshall McLuhan on the formation and reception of "video art" practices.

Part I: Prehistory

Video is new, a practice that depends on technologies of reproduction late on the scene. Still, video art has been, is being, forced into patterns laid down in the nineteenth century. In that century, science and the machine—that is, technology—began to appear as a means to the education of the new classes as well as to the rationalization of industrial and agricultural production, which had given impetus to their development. Although the engineering wonders of the age were proudly displayed in great exhibitions and fairs for all to admire, the consensus on the shaping effects that these forces, and their attendant values, had on society was by no means clear. Commentators of both Left and Right looked on the centrality of the machine as signaling the decline of cultural values in the West. Industrialization, technology's master, seemed to many to rend the social fabric, destroying rural life and traditional values of social cohesiveness and hard work that had heretofore given life meaning.

Central to the growing hegemony of the newly ascendant middle classes, bearers of materialist values and beneficiaries of these new social dislocations, were the media of communication—not excluding those physical means, such as the railroads, that welded communities together with bands of steel and inescapably added to the repertoire of perceptual effects. Although the new mass press aided communication among classes and factions vying for social power, its overweening function was the continuous propagation of bourgeois ideology among members of the still-developing middle classes and, beyond them, to the rest of society. And it was this ideology that accorded science a central position. "Science," as sociologist Alvin Gouldner has noted, "became the prestigious and focally visible paradigm of the new

mode of discourse."[1] One need hardly add that this focus on science and technology incorporated the implicit goals of conquest, mastery, and instrumentalism responsible for the degradation of work and the destruction of community.

The new technologies of reproduction, from the early nineteenth century on, were not segregated for the use or consumption of ruling elites but soon became embedded in cultural life. Perhaps the most public examples are the growth of the mass press, as previously noted, and the invention of photography, both before midcentury. The birth of the press in the previous century has been identified with the tremendous expansion of the public sphere, frequented by the cultured, including the cultured bourgeois tradesman alongside the literate aristocrat. The growth of the mass press coincided with the pressure for broader democratic participation, to include the uncultured and unpropertied as well. The erosion of forms of traditional authority, which had rested with the aristocracy, helped bring the previous ruling ideologies into crisis.

Conflict over cultural values and the machine stemmed, then, from the aristocracy and from the newly proletarianized "masses" as well as from traditional craftspeople, tradespeople, and artists. Artists' revolts against the technologization and commodification of "culture" and its ghettoization as a private preserve of the ebullient middle classes took place in the context of the artists' own immersion in the same "free-market system" that characterized those classes. Thus, technological pessimism characterized diverse social sectors, for a variety of reasons. In England, the home of the industrial revolution, both cultural conservatives, such as John Ruskin, and political progressives, such as his former student William Morris, sought to find a synthesis of modern conditions and earlier social values. It may not be stretching a point too far to remark that the centrality of instrumental reason over intellectual (and spiritual) life is what motivated the search of these figures and others for countervailing values. The romantic movement, in both its backward-looking and forward-looking aspects, incorporates this perspective.

The world is too much with us; late and soon,
Getting and spending, we lay waste our powers;
Little we see in Nature that is ours . . .
—William Wordsworth[2]

To some, the political struggles of the day, the growth of turbulent metropo-
lises housing the ever-burgeoning working classes, and the attendant de-
pletion of rural life were the worst aspects of nineteenth-century society. To
others, like Morris, the worst aspect was the situation of those new classes,
their immiseration of material and cultural life, and its deleterious effect on
all of society, which he came to see as a matter of political power. Techno-
logical pessimism and an attempt to create a new "humanist" antitechnolog-
ical culture marked the efforts of these latter critics.

The American history of responses to technology differs from the
English, if only at first. Initially mistrustful of technology, American thinkers
by midcentury looked to technological innovation to improve the labor
process and develop American industry while safeguarding the moral devel-
opment of women and children. The American transcendentalist poet and
writer Ralph Waldo Emerson was initially one of the optimists, but, fearing
technology's potential to deaden rather than illumine sensibilities, he had
turned pessimist by the 1860s.

Despite the doubts, stresses, and strains, there was, of course, no turn-
ing back. In European as in American cultural circles, even those most sus-
picious of technological optimism and machine-age values incorporated a
response to, and often some acceptance of, science and the technologies of
mass reproduction in their work. The impressionist painters, for example,
placed optical theories drawn from scientific and technical endeavors (such as
the weaving of tapestries) at the center of their work, while keeping photog-
raphy at bay by emphasizing color. They also turned away from the visible
traces of industrialism on the landscape, in a nostalgic pastoralism. Photogra-
phy itself quickly forced the other visual (and poetic!) practices to take ac-
count of it, but strove in its aesthetic practices to ape the traditional arts.

As Richard Rudisill has demonstrated, in America inexpensive visual images, which precipitated a collecting mania even before the invention of daguerreotypy, went straight to the heart of American culture as soon as the processes of reproduction became available.[3] Rudisill notes that Emerson had referred to himself as a great eyeball looking out during his moments of greatest *in*sight. As John Kasson observes, Emerson was "most concerned with the possibilities of the imagination in a democracy" and "devoted himself not so much to politics directly as to 'the politics of vision.' . . . For Emerson, political democracy was incomplete unless it led to full human freedom in a state of illuminated consciousness and perception."[4] The identification of the closely observed details of the external object world with the contents of interiority, landscape with inscape, and with the ethical and intellectual demands of democratic participation, provided a motif for American cultural metaphysics that we retain.

Just before photography appeared, the popularity of American art with Americans reached a zenith with the art clubs, in which ordinary people, through subscription or lottery, received American artworks, most of which were carefully described in the popular press. The decline of these clubs coincided with the rise of the new photo technologies, which rested far closer to the heart of private life than did paintings and graphics. Artists took note.

It is worth noting that the person who introduced photography to America was Samuel F. B. Morse—not only a painter but also the inventor of the telegraph; Morse received the photographic processes from Daguerre himself. While they chatted in Morse's Paris lodgings, Daguerre's diorama theater, based on the protofilmic illusions of backdrops, scrims, and variable lighting, burned to the ground. This is the stuff of myth. Despite their conjuncture in Morse's person, the technologies of sound and image reproduction did not come together for close to one hundred years.

The subsequent history of Western high culture included efforts to adapt to, subsume, and resist the new technologies. Although artists had had a history of alliance with science since the Enlightenment (and despite their market positioning via-à-vis the middle classes, as previously described), even

such technologically invested artists as the impressionists, and even photographers, were likely to challenge the authority of scientists, often by stressing magic, poetry, incommensurability. (The lament over demystification and the loss of a "pagan creed outworn" fills out Wordsworth's sonnet, cited above.)

The powers of imagination were at the center of artists' claim to a new authority of their own, based on command of interiority and sensation or perception, notwithstanding the fact that the formulation of those powers might be based on the methods and discoveries of the rival, science. Sectors of late-nineteenth-century art practice, then, stressed occultist, primitivist, sexist, and other irrationalist sources of knowledge and authority, spiritual insights often based not on sight per se but on interpretation and synesthesia, and on a rejection of "feminine" Nature. The dialectic of these impulses is the familiar one of modern culture, as Nietzsche suggested.

John Fekete, in *The Critical Twilight,* has called symbolism, whose genesis occurred during this period, "aesthetics in crisis, protesting hysterically against commodity pressures."[5] Fekete refers to its attempt to shut out all of history and the social world as "the sheer despair of total frustration and impotence."[6] Wordsworth's lament about "getting and spending" was transformed by fin-de-siècle artists into aesthetic inversion and mysticism. Fekete notes, significantly, the transformation from the formalism of Rimbaud's insistence on "disordering of all the senses" to more modern versions of formalized aestheticism, which "make a fetish of language and [embrace] its principles of order," promoting "the unity characteristic of the contemporary ideologies of order."[7] Including social order.

The capitulation to modernity is associated with cubism, which identified rationalized sight with inhuman culture. We should note that rejecting realism, as cubism did, allowed painting to continue to compete with photography, partly by including in a visual art analogies to the rest of the sensorium, and partly by opposing simultaneity to the photographic presentation of the moment. The sensorium and its relation to form remained at the center of artists' attention. Futurism's apologia for the least salutary shocks of modernity and urbanism featured a disjointed simultaneity that abolished

time and space, history and tradition. Its perceptual effects were composed into a formal whole in which figure and ground were indistinguishable and ideological meaning suppressed. Although futurism handled modernity through abstraction and condensation, Picasso's cubism incorporated African and other "primitive" (premodern) imagery as a technique of transgression and interruption, signifying, one may speculate, incommensurability and mystery lost to modernity—a break in bourgeois rationality. Both cubism and futurism rejected photographic space (but not, it seems, photographic tropes, such as overlaid temporal sequencing or multiperspectival views).

So far I have cast photography in the role of rational and rationalizing handmaiden of bourgeois technological domination. There is another side to it. By the turn of the twentieth century, photography was well established as a rational and representational form, not only within private life and public spectacles of every type, but implicated in official and unofficial technologies of social control: police photography, anthropometry, urban documentation, and time-and-motion study, for example. Photographs were commodities available to the millions by the millions, and they could easily produce their own. But, as previously noted, aesthetic practice in photography was interested in the model provided by the other arts. European aesthetic photography after the middle of the nineteenth century was associated both with the self-image of the intellectual and social elite (through the work of Julia Margaret Cameron, for example) and with an appreciation of fairly up-to-date painterly realism or pictorialism, though in coolly distanced form (P. H. Emerson).

The first important art-photographic movement in the United States, Alfred Stieglitz's Photo-Secession Group, was modeled after the European fin-de-siècle secession movements, with which Stieglitz had had some first-hand experience. Stieglitz melded symbolist notions with the aestheticized pictorial realism of his mentor, Emerson. The sensory simultaneity of symbolist synesthesia appealed to this former engineering student, who also revealed his enthusiasm for the mechanical reproduction of sound offered by the wireless and the player piano.[8]

The photographic example provides an insight into the choices and silences of aestheticism with respect to technology. In addition to the use of a

camera—a still-confusing mechanical intrusion—this new art photography depended for its influence on the latest technologies of mass reproduction. In Stieglitz's publication *Camera Work,* which helped create a nationwide, or worldwide, art-photography canon, current and historical photographs appeared as gravures and halftones, the products of processes only recently developed for the mass press. Thus, an art apparently hostile and antithetical to mass culture, preserving craft values and arguing against "labor consciousness," in fact depended on its technologies: a seeming paradox worth keeping in mind. The camera and print technologies were perceived as neutral, tool-like machines to be subsumed under the superior understandings of an aesthetic elite. The aesthetic sensibility was an alchemical crucible that effected a magical transformation.

Still, by 1916, Stieglitz had so thoroughly acceded to the photographic modernism of Paul Strand that he devoted the last two issues of the moribund *Camera Work,* specially resurrected for this purpose, to his work. After Strand, the camera apparatus and its "properties" prevailed, displacing the negative-to-print handiwork at the center of art-photographic practice. For Strand and others, the camera was an instrument of conscious seeing that allowed for a politicized "cut" into, say, urban microcosms, peasant counterexamples, and the structures of nature. Photography was, for them, mediation *toward,* not away from, social meaning. For others, of course, photographic modernism meant a new abstract formalism or, through the rapid growth of product photography, a corporate symbolism of commodities.

Thus, photographic modernism accepted science and rationality but also allowed for an updated symbolism of the object in a commodified world, a transformation that advertising made into its credo. Whereas photographic pictorialism had suggested a predictable alliance of aestheticism and elitism as a noble bulwark against the monetary measure of the marketplace and sold proletarian labor, formalist modernism united the high arts with the mass culture of modern entertainment forms and commodity culture. Modernism, in Kantian fashion, favored the material artwork while remaining vague (or ambivalent) about the meaning it was supposed to produce. Formalist ideologies were furthered by such Bauhaus figures as László Moholy-Nagy,

who propagated a scientific vocabulary of research and development, thera-
peutic pedagogy, and experimentation. In art and architecture, formalist
modernism promised a healthier, more efficient and adaptive—and libera-
tory—way of life, for all classes. The possibly revolutionary intent, to pave
the way for democratic participation, could quickly turn into accommoda-
tion to new, technocratic elites.

It has been observed that postwar American modernism, despite its
strict separation of the arts from each other as well as from the social world,
and with its fetishization of materials, nevertheless institutionalized the
avant-garde. To discover what this represents for our concerns, we must look
at the aims of the classic twentieth-century European avant-garde move-
ments, dada and surrealism, which appeared in the 1920s and 1930s, when
modern technological society was already firmly established. The use of, or
transgression against, the media of communication and reproduction was on
their agenda, for the avant-garde saw art institutions as integrated into op-
pressive society but as ideally positioned nonetheless to effect revolutionary
social change; this was a reworking of the symbolist effort to disorder the
senses, perhaps, but with new political intentions. The aim of dada and sur-
realism was to destroy art as an institution by merging it with everyday life,
transforming it and rupturing the now well-established technological ratio-
nalism of mass society and its capacity for manufacturing consent to wage
enslavement and rationalized mass killing. Peter Bürger has described the
activity of the avant-garde as the self-criticism of art as an institution, turn-
ing against both "the distribution apparatus on which the work of art de-
pends, and the status of art in bourgeois society as defined by the concept of
autonomy."[9] Thus, Duchamp's readymades, which, through their validation
of despised objects by the agency of the artist's signature, exposed the real op-
erations of the art-distribution apparatus. Bürger writes: "the intention of the
avant-gardists may be defined as the attempt to direct toward the practical the
aesthetic experience (which rebels against the praxis of life) that Aestheticism
developed. What most strongly conflicts with the means-end rationality of
bourgeois society is to become life's organizing principle."[10]

The disruptive efforts of expressionism, dada, and surrealism were intended to transgress not just against the art world but also against conventional social reality and thereby to become an instrument of liberation. As Bürger suggests, the avant-garde intended on the one hand to replace individualized production with a more collectivized and anonymous practice and on the other to get away from the individualized address and restricted reception of art. But, as Bürger concludes, the avant-garde movements failed. Instead of destroying the art world, they were taken into an art world that swelled to encompass them, and their techniques of shock and transgression were absorbed as the production of refreshing new effects. "Non-art" became "ART-Art," to use the terms set in opposition by Allan Kaprow in the early 1970s. Kaprow—himself a representative postwar U.S. avant-gardist, student of John Cage—had helped devise a temporarily unassimilable form, the "happening," a decade or so earlier. Kaprow wrote, in "The Education of the Un-Artist, Part I,"

> At this stage of consciousness, the sociology of culture emerges as an in-group "dumb show." Its sole audience is a roster of the creative and performing professions, watching itself, as if in a mirror, enact a struggle between self-appointed priests and a cadre of equally self-appointed commandos, jokers, gutter-snipers, and triple agents who seem to be attempting to destroy the priests' church. But everyone knows how it all ends: in church, of course.[11]

As Kaprow plainly realized, the projected destruction of art as a separate sphere was accomplished, if anywhere, in the marketplace, which meant a thwarting of avant-gardist desires. But nothing succeeds like failure, and in this case failure meant that the avant-garde became the academy of the postwar world. The postwar American scene presented a picture of ebullient hegemony over the Western art world. Stability and order seemed to have been successfully erected on an art of alienation and isolation. High culture

appeared to have conquered the negative influences of both politics and mass culture by rigorously excluding—or digesting and transforming—both through a now thoroughly familiar radical aestheticism. Art discourse continued to draw upon the dialectic of scientific experimentation on technique and magical transformation through aestheticism and primitivism, veering toward an avant-garde of technical expertise.

This hegemonic condition lasted about as long as "the American century" it seemed to accompany—that is, until the new decade of the 1960s. The rapid growth of television and the cybernetic technologies, which had gotten a big boost from the war and American militarization, precipitated a crisis. Television had no difficulty building on the structure and format of radio, with pictures added. Radio had established itself in a manner like that of the mass press and photography in the previous century and had played a vital role in disseminating the new ideologies of consumerism, Americanism, and statism. Like photography, radio depended on action at a distance, but with the added fact of temporal simultaneity. It appeared to be a gift, free as air. The only direct sale came through hardware—which took on the fanciful forms of furniture, sky-scraping architecture, cathedrals, and the hearth, the mantelpiece, and the piano, all in one, with echoes of the steamship. Bought time appeared as free time, and absence appeared as presence. Radio had the legitimacy of science (and nature) and the fascination of magic.

Television was able to incorporate into this array all the accommodations of photography and film, though in degraded form with respect to image quality. As with advertising, the all-important text was held together with images of the object world, plus the spectacle of the State and the chaos of the street, as well as voyeuristic intrusions into the private lives of the high and the low, the celebrity and the anonymous. Television was like an animated mass magazine and more. As commentators from Dwight Macdonald, Gunther Anders, and Marshall McLuhan to Guy Debord and Jean Baudrillard have observed, the totalizing, ever-whirling and spinning microcosm of television supplanted the more ambiguous experience of the world.

———

Warhol's pop was a multifaceted and intricate "confession" of powerles[s]
accomplished through productions, entourages, modes of product[ion]
poses, that mimicked, degraded, fetishized, and "misconstrued,"
fashion, the slick, seamless productions of corporate mass cul[ture]
those of the technologies of reproduction. The slave's ironi[c]
tion between art and technology was to retain the older,
of oil paint and silkscreen, but to use them to copy or
of the photographic mass media. The apotheosi[s]
transmutation into the servant of mass culture

As Kaprow wrote about the social c[ontext]
he termed it, of the period:

it is hard not to assert as ma[ny]
that the LM [Lunar Mod[ule]
contemporary sculptu[re]
that the broadcast
Spacecraft Cen[ter]
temporary p
that, wit[h]
breaks
co

of mass culture through an em[p]
of patriarchy, high-culture aura, and autonomy. It was mass cultur[e]
State, after all, that had made abstract expressionism a "success," made it a *prod-*
uct bearing the stamp "Made in the USA" much like any other product.

sness,

on, and

n slavelike

ure, especially

take on the rela-

craft-oriented media

reorder the reified icons

of the avant-garde was its

Aura had passed to the copy.

ntext and "art consciousness," as

ters of fact:

ule] mooncraft is patently superior to all

ral efforts;

verbal exchange between Houston's Manned

er and Apollo 11 astronauts was better than con-

oetry;

its sound distortions, beeps, static, and communication

, such exchanges also surpassed the electronic music of the

cert halls;

that certain remote control video tapes of the lives of ghetto fam-
ilies recorded (with their permission) by anthropologists, are more
fascinating than the celebrated slice-of-life underground films;

that not a few of those brightly lit, plastic and stainless-steel gas
stations of, say, Las Vegas, are the most extraordinary architecture
to date;

that the random, trancelike movements of shoppers in a super-
market are richer than anything done in the modern dance;

that the lint under beds and the debris of industrial dumps are
more engaging than the recent rash of exhibitions of scattered
waste matter;

that the vapor trails left by rocket tests—motionless, rainbow col-
ored, sky-filling scribbles—are unequaled by artists exploring
gaseous mediums;
that the Southeast Asian theater of war in Viet Nam, or the trial
of the "Chicago Eight," while indefensible, is better than any play,
that . . . etc., etc., . . . non-art is more art than ART-art.[14]

Apprehending the collapses of public and private spaces, Kaprow, too, rep-
resenting the aesthetic consciousness, could only bow before the power
of science, technology, the State, and the ephemera of modern urban-
suburbanism, especially as orchestrated through television. The "antihege-
monic" 1960s also brought a different relation to issues of power and
freedom, more populist than avant-gardist, more political than aestheticist.
Students rebelled against the construction of what émigré philosopher Her-
bert Marcuse termed one-dimensional culture and its mass subject, while the
politically excluded struggled against the conditions and groups enforcing
their powerlessness. The iron grip of science and technology became a focus
of agitation, particularly in relation to militarism and the threat of total war.
The twin critique of technological and political domination helped beget
a communitarian, utopic, populist, irrationalist, anti-urban, anti-industrial,
anti-elitist, anti-intellectual, antimilitarist, communitarian counterculture,
centered on youth. Hedonic, progressive, rationalist, antisexist, antiracist,
anti-imperialist, and ecological strains also appeared. The severe stress on the
reigning ideologies also put models of high culture in doubt, not least among
its own younger practitioners.

Artists looked to science, social science, and cultural theory—any-
where but to dealers, critics, or aesthetic theories—for leads. New forms
attacked head-on the commodity status of art. "Objecthood" was an issue
not only because art objects were commodities but because they seemed
insignificant and inert next to the electronic and mass-produced offerings of
the mass media.

Part II: History

At last, video. This is well-worked territory. In fact, video's past is the ground not so much of history as of myth. We could all recite together like a litany the "facts" underlying the development of video art. Some look to the substantive use of a television set or sets in altered or damaged form in art settings in the late 1950s or early 1960s. Others prefer the sudden availability of the Sony Portapak in the mid-1960s or the push supplied by Rockefeller capital to artists' in their use of this new scaled-down technology. But the consensus appears to be that there is a history of video to be written—and soon. I would like to consider the nature of such histories, and their possible significance for us.

Historical accounts are intent on establishing the legitimacy of a claim to public history. Such a history would follow a pattern of a quasi-interpretive account of a broad trend activated by significant occurrences, which, on the one side, are brought about by powerful figures and, on the other side, determine or affect what follows. Video's history is not to be a *social* history but an *art* history, one related to, but separate from, that of the other forms of art. Video, in addition, wants to be a major, not a minor, art.

Why histories now? Is it just time, or are the guardians of video reading the graffiti on the gallery wall, which proclaim the death or demotion of photographic media? (Like those of color photos, video's keeping, archival, qualities seem dismal, and the two are liable to vanish together without a trace.) If video loses credibility, it might collapse as a curated field. Or perhaps the growth of home video and music television has made the construction of a codified chain of *art*-video causation and influence interesting and imperative.

Some fear that if histories are written by others, important issues and events will be left out. Others realize the importance of a history in keeping money flowing in. The naturalization of video in mass culture puts the pressure on to produce a history of art video, or video art, that belongs in the art world and that was authored by people with definable styles and intentions, all recognizable in relation to the principles of construction of the other modern art histories.

Sometimes this effort to follow a pattern might appear rather silly. For example, one well-placed U.S. curator made the following remarks in the far-away days of 1974:

> The idea of the video screen as a window is . . . opposite from the truth in the use of video by the best people. Video in the hands of Bruce Nauman, or in the hands of Richard Serra, is opaque as opposed to transparent. It's an extension of a conceptual idea in art. It enables the audience—again on a very subliminal and intuitive level—to return to painting, to look at painting again, in a renewed way.
>
> . . . In the future, most of us who have been watching video with any amount of attentiveness are going to be able to recognize the hand of the artists in the use of the camera. It's possible to know a Van Gogh as not a fake . . . by a certain kind of brush-stroking; very soon we're going to know the difference between Diane Graham [*sic*] and Bruce Nauman and Vito Acconci because of the way the camera is held or not held. Style in video, that kind of personal marking, is going to become an issue. And it's going to subsume information theory with old-fashioned esthetic concepts.[15]

Ouch! It is not Jane Livingston's fault that in 1974 video editing had not yet imposed itself as the style marker she thought would be the analogue of the "brush-stroking" maneuver. As absurd as such remarks may now sound, she was surely right about the role of "old-fashioned esthetic concepts," for aestheticism has been busily at work trying to reclaim video from "information" ever since. It is the self-imposed mission of the art world to tie video into its boundaries and cut out more than passing reference to film, photography, and broadcast television, as the art world's competition, and to quash questions of reception, praxis, and meaning in favor of the ordinary questions of originality and "touch."

Historiography is not only an ordering and selecting process, it is also a process of simplification. Walter Hines Page, editor of the turn-of-the-century magazine *The World's Work,* liked to tell writers that "the creation of the world has been told in a single paragraph."[16] Video histories are not now produced by or for scholars but for potential funders, for the museum-going public, and for others professionally involved in the field, as well as to form the basis for collections and shows. The history of video becomes a pop history, a pantheon, a chronicle. Most important, the history becomes an *integrationist* rather than a transgressive one. And the names populating the slots for the early years are likely to be those of artists known for earlier work not in video or those of people who remained in the system, producing museumable work over a period of years or at the present. And, of course, they are likely to be New Yorkers, not Detroiters, or even Angelenos or San Franciscans, not to mention San Diegans. Some histories do recognize the contribution of Europeans—perhaps mostly those histories produced in Europe—or Canadians or even Japanese, always assuming they have entered the Western art world. Finally, the genres of production are likely to fit those of film and sculpture. Codification belies open-endedness and experimentation, creating reified forms where they were not, perhaps, intended. This even happens when the intent of the history is to preserve the record of open-endedness. And so forth.

Thus, museumization—which some might point to as the best hope of video at present for it to retain its relative autonomy from the marketplace—contains and minimizes the *social negativity* that was the matrix for the early uses of video.

PART III: MYTH

At the head of virtually every video history is the name Nam June Paik. Martha Gever, in her definitive article on his career upon the occasion of his unprecedented exhibition at New York's Whitney Museum of American Art, referred to Paik's "coronation."[17] I prefer the word "sanctification"; for

Paik, it would appear, was born to absolve video of sin. The myths of Paik suggest that he had laid all the groundwork, touched every base, in freeing *video* from the domination of corporate TV, and *video* can now go on to other things. Paik also frees video history from boring complexity but allows for a less ordered present. By putting the prophet at the front, we need not squabble over doctrine now, nor anoint another towering figure, since the video-art industry still needs lots and lots of new and different production.

The myth of Paik begins with his sudden enlightenment in Germany—the site of technical superiority—through John Cage, the archetypal modernist avant-gardist, at a meeting in 1958. Gever relates that Paik later wrote to Cage in 1972, "I think that my past 14 years is nothing but an extension of one memorable evening at Darmstadt '58." Paik came to America around 1960, affiliated, more or less, with the Fluxus movement. Fluxus was a typical avant-garde in its desire to deflate art institutions; its use of mixed media, urban detritus, and language; the pursuit of pretension-puncturing fun; its de-emphasis of authorship, preciousness, and domination. Paik participated in some events and, we are told, showed his first tape at a Fluxus event. Again showing us the rest of the way, this time to funding, Paik supposedly made this tape with some of the first portable equipment to reach U.S. shores, equipment he bought with a grant from the John D. Rockefeller III Fund. According to the myth, the tape was of the pope (!).

The elements of the myth thus include an Eastern visitor from a country ravaged by war (our war) who was inoculated by the leading U.S. avant-garde master while in technology heaven (Germany); who, once in the States, repeatedly violated the central shrine, TV, and then went to face the representative of God on earth, capturing his image to bring to the avant-garde; and who then went out to pull together the two ends of the American cultural spectrum by symbolically incorporating the consciousness industry into the methods and ideas of the cultural apparatus—always with foundation, government, museum, broadcast, and other institutional support.

And—oh yes!—he is a man. The hero stands up for masculine mastery and bows to patriarchy, if only in representation. The thread of his work

includes the fetishization of a female body as an instrument that plays itself, and the complementary thread of homage to other famous male artist-magicians or seers (quintessentially, Cage).

The mythic figure Paik has done all the bad and disrespectful things to television that the art world's collective imaginary might wish to do. He has mutilated, defiled, and fetishized the TV set, reduplicated it, symbolically defecated on it by filling it with dirt, confronted its time-boundedness and thoughtlessness by putting it in proximity with eternal Mind in the form of the Buddha, in proximity with natural time by growing plants in it, and in proximity with architecture and interior design by making it an element of furniture, and finally turned its signal into colorful and musical noise.

Paik's interference with TV's inviolability, its air of nonmateriality, overwhelmed its single-minded instrumentality with an antic "creativity." Paik imported TV into art world culture, identifying it as an element of daily life susceptible to symbolic, anti-aesthetic aestheticism, what Allan Kaprow called "anti-art art."

Gever discusses the hypnotic effects of his museum installations—effects that formalize the TV signal and replicate viewer passivity, replacing messages of the State and the marketplace with aestheticized entertainment. In some installations the viewer is required to lie flat. Paik neither analyzed TV messages and effects, nor provided a counterdiscourse based on rational exchange, nor made the technology available to others. He gave us an upscale symphony of the most pervasive cultural entity of everyday life, without giving us any conceptual or other means of coming to grips with it in anything other than a symbolically displaced form. Paik's playful poetry pins the person in place.

The *figure* of Paik in these mythic histories combines the now-familiar antinomies, magic and science, that help reinforce and perpetuate rather than effectively challenge the dominant social discourse. Why is this important? The historical avant-garde, as we have seen, harbors a deep ambivalence toward the social effects of science and technology; surrealism and dada attempted to counter and destroy the institutionalization of art in machine

society, to merge it with everyday life and transform both through liberation of the senses, unfreezing the power of dissent and revolt. Although this attempt certainly failed, subsequent avant-gardes, including those that begin to use or address television technology, have had similar aims.

Herbert Marcuse spelled this out back in 1937 in his essay "The Affirmative Character of Culture."[18] Marcuse traces the use of culture by dominant elites to divert people's attention from collective struggles to change human life and toward individualized effort to cultivate the soul like a garden, with the reward being pie in the sky by and by—or, more contemporaneously, "personal growth." Succinctly put, Marcuse shows the idea of culture in the West to be the defusing of social activity and the enforcement of passive, individualized acceptance. In the Western tradition, form was identified as the means actually to affect an audience.

I would like to take a brief look at a sector of the U.S. avant-garde and the attempt to contain the damage perceived to have been wrought on the cultural apparatuses by the mass media. Consider the notable influence of John Cage and the Black Mountaineers, which has deeply marked all the arts. Cage and company taught a quietist attention to the vernacular of everyday life, an attention to perception and sensibility that was inclusive rather than exclusive but that made a radical closure when it came to divining the causes of what entered the perceptual field. This outlook bears some resemblance to American turn-of-the-century antimodernism, such as the U.S. version of the arts-and-crafts movement, which stressed the therapeutic and spiritual importance of aesthetic experience.[19]

Cage's mid-1950s version was marked by Eastern-derived mysticism— in Cage's case, the antirational, anticausative Zen Buddhism, which relied on sudden epiphany to provide instantaneous transcendence, or transport from the stubbornly mundane to the Sublime. Such an experience could be prepared for through the creation of a sensory ground, to be met with a meditative receptiveness, but could not be translated into symbolic discourse. Cagean tactics relied on avant-garde shock, operating counter to received procedures or outside the bounds of a normative closure, like playing the

strings of the piano rather than the keys or concentrating on the tuning be-
fore a concert—or making a TV set into a musical instrument. As Kaprow
complained, this idea was so powerful that soon he could observe that "non-
art is more art than ART-art." Meaning that this supposedly challenging
counterartistic practice, this anti-aesthetic, this noninstitutionizable form of
"perceptual consciousness," was quickly and oppressively institutionalized,
gobbled up by the ravenous institutions of official art (Art).

Many of the early users of video had similar strategies and similar out-
looks. A number (Paik among them) have referred to the use of video as being
against television. It was a counterpractice, making gestures and inroads
against Big Brother. They decried the idea of making art—Douglas Davis
called *video art* "that loathsome term." The scientistic modernist term *ex-
perimentation* was to be understood in the context of the 1960s as an angry
and political response. For others, the currency of theories of information in
the art world and in cultural criticism made it vitally necessary to rethink the
video apparatus as a means for the multiple transmission of useful, socially
empowering information rather than the individualized reception of disem-
powering ideology or subideology.

Enter McLuhan. McLuhan began with a decided bias in favor of tradi-
tional literacy—reading—but shifted his approval to television. With a
peremptory aphoristic style, McLuhan simplified history to a succession of
technological First Causes. Many artists liked this approach because it was
simple, and because it was formal. They loved the phrase "The medium is the
message" and loved McLuhan's identification of the artist as "the antenna of
the race." McLuhan offered the counterculture the imaginary power of over-
coming through understanding. Communitarians, both countercultural and
leftist, were taken with another epithet, "the global village," and with the val-
orization of preliterate culture. The idea of simultaneity and a return to an
Eden of sensory immediacy gave hippies and critics of the alienated and re-
pressed one-dimensionality of industrial society a rosy psychedelic wet dream.

John Fekete notes that McLuhan opposed mythic and analogic struc-
tures of consciousness—made attractive also through the writings of Claude

TVTV, *Four More Years,* 1972. Still from black-and-white videotape of the Republican National Convention in Miami that renominated Richard Nixon for president of the United States. The collective TVTV, or Top Value Television, used their press passes to gain access to the convention floor, the press corps, the Nixonettes, and the antiwar demonstrators outside. *Four More Years* represents an effort to ironize political spectacle and the media that present it and to demonstrate the banal but deadly human choices behind both the political process and mediation.

Lévi-Strauss—to logic and dialectic, a move that Fekete says "opens the door to the displacement of attention from immanent connections (whether social, political, economic or cultural) to transcendent unities formed outside human control."[20] Fekete then rightly quotes Roland Barthes on myth (here slightly abbreviated):

> *Myth is depoliticized speech.* One must naturally understand *political* in its deeper meaning, as describing the whole of human relations in their real, social structure, in their power of making the world. . . . Myth does not deny things, on the contrary, its function is to talk about them; simply, it purifies them, it makes them innocent, it gives them a natural and eternal justification, it gives them a clarity which is not that of an explanation but that of a statement of fact. . . . In passing from history to nature, myth acts economically: it abolishes the complexity of human acts, it gives them the simplicity of essence, it does away with all dialectics, with any going back beyond what is immediately visible, it organizes a world which is without contradictions because it is without depth, a world wide open and wallowing in the evident, it establishes a blissful clarity: things appear to mean something by themselves![21]

This is the modern artist's dream! McLuhan granted artists a shaman's role, with visionary, mythopoeic powers. McLuhan wrote that art's function is "to make tangible and to subject to scrutiny the nameless psychic dimensions of new experience" and noted that, as much as science, art is "a laboratory means of investigation." He called art "an early warning system" and "radar feedback" meant not to enable us to change but rather to maintain an even course. (Note the consciously military talk.) Art assists our accommodation to the effects of a technology whose very appearance in world history creates it as a force above the humans who brought it into being. The mythic power that McLuhan conferred on artists appeared to provide their impotent fan-

tasies of conquering or neutralizing the mass media with a route to fulfill-
ment. In accepting this vision—accepting rather than analyzing or dissect-
ing their power, accepting that their effects were due to physiology and
biology rather than to social forces—artists could apply an old and familiar
formula in new and exciting ways. The formalist avant-garde would once
again be seen to transcend and transform the phenomena of everyday life and
culture, in service to the human community.

Artists, like other people, take what they need from the discourse
around them and make of it what they will. McLuhanism, like other aesthetic
theories, offered artists a chance to shine in the reflected glory of the prepo-
tent media and—they might hope—to profit from their power over others,
which stemmed from formalized mimesis. At the same time, however, the
theories and catchphrases of McLuhanism inspired many progressive and crit-
ical producers to develop new ways to work with media and many of them to
seek ways to disseminate their work outside mainstream institutions as well.

SOME CONCLUSIONS

Some new histories of video have taken up this formalized approach and have
portrayed artists in the act of objectifying their element, as though tinkering
could provide a way out of the power relations structured into the apparatus.
Reinforcing the formalist approach has brought them, perhaps unintention-
ally, to confirm the power of these media over everyday life, as McLuhan had
done. In separating out something called video art from the other ways that
people, including artists, are attempting to work with video technologies,
they have tacitly accepted the idea that the transformations of art are formal,
cognitive, and perceptual. This promotes a mystified relation to the question
of how the means of production are structured, organized, legitimated, and
controlled, for the domestic market and the international one as well.

Video, it has been noted, is an art in which it is harder than usual to
make money. Museums and granting agencies may protect video from the
marketplace, as I remarked earlier, but they exact a stiff price. Arts that are

Cara DeVito, *Ama l'uomo tuo (Always Love Your Man),* 1975. Still from black–and–white videotape documentary based on conversations DeVito conducted with her immigrant grandmother Adeline LeJudas.

marginally saleable command poor critical support apparatuses, and video is not an exception. Video reviewing has so far been sparse and lackluster in major publications. This leaves the theorizing to people with other vested interests. Without a more nuanced critical underpinning, museumization must involve the truncation of both practice and discourse to fit the pattern most familiar and most palatable to notoriously conservative museum boards and funders. Even when institutions actually show work that transcends this narrow compass, what they say about it is cut to fit that pattern.

Video histories, as I've suggested, rely on *encompassable* symbolic transgressions of the institutions of both television and the museum, formalist rearrangements of what are uncritically called the "capabilities" of the medium, as though these were God-given, a technocratic scientism that replaces considerations of human use and social reception with highly abstracted discussions of time, space, cybernetic circuitry, and physiology. This is a vocabulary straight out of old-fashioned formalist modernism, largely discredited elsewhere.

Museumization has heightened the importance of installations that make video into sculpture, painting, or still life, because installations can live only in museums—which display a modern high-tech expansiveness in their acceptance of mountains of obedient and glamorous hardware. (This reassures the artists, the curators, the museums and galleries and thus potential collectors). Curatorial frameworks—like the influential video festivals—also differentiate genres within media, so that video has been fit into old, familiar categories based on film genres: documentary, personal, travelogue, abstract-formal, image-processed—and now those horrors, dance and landscape (and perhaps music) video. These categories provide a hierarchy of preferences; only the brave curator will show documentary regularly. Interactive systems, a regular transgressive form of the early 1970s, are utilized far less often now.

Perhaps the most prominent consequence of museumization is the "professionalization" of the field, with its inevitable normalization of what are called "production values." These are a set of stylistic changes rung on the

givens of commercial broadcast television, at best the objective correlatives of the electronic universe. Nothing could better suit the consciousness industry than to have artists playing about its edges, embroidering its forms and quite literally developing new strategies for ads and graphics. The trouble is, high production values require huge expenditures on production and post-production. The costs of computerized video editing surpass those of (personal) film editing by factors of ten.

Some of the most earnest producers of art videotapes expect that condensation of the formal effects of this kindly technology will expose the manipulative intent of television. The history of the avant-gardes and their failure to make inroads into the power of either art institutions or the advancing technologies through these means suggests that these efforts cannot succeed.

Alvin Gouldner describes the relation between art and the media as follows:

> Both the cultural apparatus and the consciousness industry parallel the schismatic character of the modern consciousness: its highly unstable mixture of cultural pessimism and technological optimism. The cultural apparatus is more likely to be the bearer of the "bad news" concerning—for example—ecological crisis, political corruption, class bias; while the consciousness industry becomes the purveyors of hope, the professional lookers-on-the-bright-side. The very political impotence and isolation of the cadres of the cultural apparatus grounds their pessimism in their own everyday life, while the technicians of the consciousness industry are surrounded by and have use of the most powerful, advanced, and expensive communications hardware, which is the everyday grounding of their own technological optimism.[22]

We may infer from this that American video artists' romance with super high-tech production is a matter of production envy. It would be a pity if the institutionalization of video art gave unwarranted impetus to artists' de-

sires to conquer their pessimism by decking themselves out in these power-ful and positivist technologies.[23]

On the other hand, as the examination of the Paik myth suggests, it would be equally mistaken to think that the best path of transgression is the destruction of the TV as a material object, the deflection of its signal, or other acts of the holy fool. The power of television relies on its ability to corner the market on messages: interesting messages, boring messages, endlessly repeat-ing images. Surely we can offer an array of more socially invested and pro-ductive counterpractices, ones making a virtue of their person-centeredness and origination with particular persons—rather than from industries or in-stitutions. These, of course, will have to live more outside museums than in them. But it would be foolish to yield the territory of the museum, the eas-iest place to reach other producers and to challenge the social impotence im-posed by art's central institutions. Obviously the issue at hand as always is who controls the means of communication in the modern world and what are to be the forms of discourse countenanced and created.[24]

NOTES

1. Alvin W. Gouldner, *The Dialectic of Ideology and Technology: The Origins, Grammar, and Future of Ideology* (New York: Seabury Press, 1976; New York: Oxford University Press, 1982), p. 7.

2. William Wordsworth, "The World Is Too Much with Us" (1806), published in *Complete Poetical Works of William Wordsworth* (London: Macmillan, 1888). Wordsworth's son-net traces a failure of poetic imagination to the aggressive materialism of modernity.

3. Richard Rudisill, *Mirror Image: The Influence of the Daguerreotype on American Society* (Albuquerque: University of New Mexico Press, 1971).

4. John F. Kasson, *Civilizing the Machine: Technology and Republican Values in America, 1776–1900* (Harmondsworth: Penguin, 1976).

5. John Fekete, *The Critical Twilight: Explorations in the Ideology of Anglo-American Literary Theory from Eliot to McLuhan* (London: Routledge & Kegan Paul, 1977), pp. 15–16.

6. Ibid.

7. Ibid.

8. In *Camera Work,* cited by Sally Stein in "Experiments with the Mechanical Palette: Common and Cultivated Responses to an Early Form of Color Photography" (unpublished paper, 1985), Stieglitz wrote: "on the Kaiser Wilhelm II, I experienced the marvelous sensation within the space of an hour of Marconi-graphing from mid-ocean; of listening to the Welte-Mignon piano which reproduces automatically and perfectly the playing of any pianist . . . ; and of looking at those unbelieveable color photographs! How easily we learn to live our former visions!" Cited by permission.

9. Peter Bürger, *Theory of the Avant-Garde,* trans. Michael Shaw (Minneapolis: University of Minnesota Press, 1984), p. 22.

10. Ibid., p. 34.

11. Allan Kaprow, "The Education of the Un-Artist, Part I," *ArtNews* (February 1971), p. 20.

12. Herbert J. Gans, "The Politics of Culture in America," in Denis McQuail, ed., *Sociology of Mass Communications* (London: Penguin, 1972), p. 378, cited in Gouldner, *The Dialectic of Ideology and Technology,* p. 173.

13. See Max Kozloff, "American Painting during the Cold War," *Artforum* (May 1973), on abstract expressionism as the emblematic U.S. artistic product, and Eva Cockcroft's subsequent rereading of the situation, "Abstract Expressionism: Weapon of the Cold War," *Artforum* (June 1974). See also Serge Guilbaut, *How New York Stole the Idea of Modern Art: Abstract Expressionism, Freedom, and the Cold War* (Chicago: University of Chicago Press, 1983).

14. Kaprow, "Education of the Un-Artist," p. 18.

15. Jane Livingston, "Panel Remarks," in Douglas Davis and Allison Simmons, eds., *The New Television: A Public/Private Art* (Cambridge, Mass.: MIT Press, 1977), p. 86. This book was based on the conference "Open Circuits" held in January 1974 in association with New York's Museum of Modern Art.

16. Christopher P. Wilson, "The Rhetoric of Consumption: Mass Market Magazines and the Demise of the Gentle Reader, 1880–1920," in Richard W. Fox and T. J. Jackson Lears, eds., *The Culture of Consumption* (New York: Pantheon, 1983), p. 47.

17. Martha Gever, "Pomp and Circumstances: The Coronation of Nam June Paik," *Afterimage* 10, no. 3 (October 1982): 12–16.

18. Marcuse's essay first appeared in *Zeitschrift für Sozialforschung* 6 (1937). Reprinted in English translation in Herbert Marcuse, *Negations* (Boston: Beacon Press, 1968), pp. 88–133.

19. See T. J. Jackson Lears, *No Place of Grace: Anti-Modernism and the Transformation of American Culture, 1880–1920* (New York: Pantheon, 1981).

20. Fekete, *The Critical Twilight,* p. 178.

21. Roland Barthes, "Myth Today," in *Mythologies* (New York: Hill and Wang, 1972), p. 143.

22. Gouldner, *Dialectic of Ideology and Technology,* pp. 174–175.

23. See Lucinda Furlong, "Getting High-Tech: The 'New' Television," *The Independent* (March 1985), pp. 14–16; see also Martha Rosler, "'Video Art,' Its Audience, Its Public," *The Independent* (December 1987), pp. 14–17.

24. [The present article, based on the lay of the land in the mid-1980s, was perhaps correct in its general observations about the institutionalization of video, but it could not foresee the particular way in which video would be valorized in the commercial art world by the late nineties or the technological developments that would incorporate video into the mainstream film industry and allow video to adopt the mantle of film.]

II

Strategies of Production

The Figure of the Artist,
the Figure of the Woman

From where they stood in the postwar world, it looked like a new beginning—to start over in everything, including art. The turbulence of the previous half-century was relegated to (mere) history—it was what had led, after all, to the unthinkable debacle. A new global balance, called "The American Century" by *Time* magazine, was under way: But the United States, the most modern, most recent industrial power, would exercise its hegemony through business rather than direct force. The West was united as a patriotic patriarchy: Male quest and male heroism in a militarized society had saved the day, allowing a democratic reconstitution of the West as a space friendly to the private peace of the gender-bipolar nuclear family, as against the earlier possibility of a society split by class war.

The postwar art world placed the artist at the center of its discourse. The figure of the artist as romantic hero reappeared full-blown. Its central organizing features were isolation and genius—a "genius" denotes a responsive distiller of experience and sensation whose talent lies in his ability to master

This essay was presented as a lecture at the conference "Die Andere Avant Garde," held at the Brucknerhaus, Linz, Austria, in 1983.

and transform ideas and substances through an innate imaginative faculty into a new tangible entity that acts powerfully on an aesthetically receptive faculty in the viewer (and critic). Women, by virtue of their earthliness and closeness to Nature, their involvement with natural birth, were foreclosed from Genius, for, of course, flesh and spirit do not mix. In the United States this implicitly male shaping power was inflected by features drawn from the various myths of maleness and productive labor: the cowboy, the patriarch, man of action, working man, hard drinker, and fighter. The isolation of the Hegelian Great Man of history melded with the isolation of the frontiersman and cowboy. As to his product, the work of art, whose existence was taken for granted, its ultimate reference point (or audience) was the artist himself, even at the risk of a wider failure. As June Wayne pointed out a decade later, in combating the American figure of the pansy artist, American artists had to play the self-sufficient supermale role with extra intensity.[1]

Assumptions about the work of art centered on its ability to reach toward the "Sublime," to transcend and contradict the negative and antihuman conditions of everyday life. The work of art represented a utopic bounded rectangle of hope in a hopeless world or (in a different view) the place of symbolic struggle between the artist-subject and intractable materiality. The synthetic space of the work of art, the locus of the struggle of subjectivity to transcend material conditions of unfreedom, provided as well a place for the viewer to experience the atemporal movement of transcendence. The abstract quality of these confrontations was a consequence of their necessary detachment from concrete situations.

Harold Rosenberg, a critic, and Robert Motherwell, an artist, wrote in the first number of *Possibilities* (1947–48), a journal under their editorship:

> Naturally the deadly political situation exerts an enormous pressure. . . .
>
> Political commitment in our times means logically—no art, no literature. A great many people, however, find it possible to hang around in the space between art and political action. If one

is to continue to paint or write as the political trap seems to close upon him he must perhaps have the extremist faith in sheer possibility. In his extremism he shows that he has recognized how drastic the political presence is.[2]

In this comparison of the politically committed person with the artist, there is no contest: The political is the "drastic," "deadly," "catastrophic," whereas art is the province of "faith" and "sheer possibility." This is the language of existentialism, whose central construct was *possibility;* existentialism was meant to replace the prewar Marxism in Western intellectual culture.

Motherwell wrote, in "The Modern Painter's World," published in *Dyn* (1944):

> It is because reality has a historical character that we feel the need for new art . . . the crisis is the modern artist's rejection, almost *in toto,* of the values of the bourgeois world. Modern art is related to the problem of the modern individual's freedom. For this reason the history of modern art tends at certain moments to become the history of modern freedom. It is here that there is a genuine rapport between the artist and the working class. At the same time, modern artists have not a social, but an individualist experience of freedom. . . . The modern artist's social history is that of a spiritual being in a property-loving worldthe artist's problem is *with what to identify himself.* The middle class is decaying, and as a conscious entity the working class does not exist. Hence the tendency of modern painters is to paint for each other.[3]

The deeply antipolitical and allegorical character of this new art was supported by a (Kant-derived) emphasis on the universalistic nature of the aesthetic and its inability to stray into any other domain, whether politics, religion, morality, literature, or appetite.

———

Ideologically, the postwar world was locked into a totalizing duality—in West and East, the State all but announced itself as a projection of Self against the diabolical Other, whether the Soviet world of Iron Curtain impenetrability or the aggressive U.S. imperialists. In the domestic sphere the big subject was "materialism"—the encroachment of the new mass culture on every previously untouched corner of daily life and its invasion of the self through the commandeering of the instincts. This was the longed-for prosperity of peace, but its character made intellectuals, like Motherwell, decry mass culture alongside the bureaucratic State and its global menace. In the West the engineering of personal desire and political consent shadowed all of social life with the twin specters of Eros and Thanatos, sex and the Bomb.

In the West, also, the predicament of the postwar world was theorized on male terms, as a failure of autonomy of a powerful and controlling (masterful, patriarchal) self, a sense of impaired potency. This failure of the personal was related to the evident rout from the private (family) sphere of patriarchal power in favor of the overarching and impersonal power of the corporations and the State. Yet if blame was assigned for the depotentiation of the male, typically it was women who were held guilty. Women were identified with domesticity and domestication—pacification—yet they themselves would not be pacified. The extinguishing of any expectation of proletarian revolution (still alluded to by Motherwell)—the virtual (cultural) embourgeoisement of the working class and the humiliation of those who failed to negotiate this class migration—contributed to the perceived decline of maleness, especially in the eyes of intellectuals and artists.

By the early 1960s, U.S. hegemony over the economically booming West was firm. The center of the art market shifted from Paris to New York. A tired abstract expressionism lost its hold on the art world. With it went the understanding of the *oppositional* nature and role of art and artist as enunciated by Motherwell. Abstract expressionism, which had depended on an image of stripped-down production, of a chosen poverty in a giant-size arena that insisted on its public rather than *owned* (commodity) status, had conquered the art world, achieved high commodity status, and even entered

92

Jackson Pollock in *Life* magazine, August 8, 1949.

mass culture via the media—all contradictory to its axiomatic foundations. Its oppositions to "society" and State were no longer interesting in the new Technicolor world, nor was it convincing in its new context of acceptance, fame, and financial reward.

Its mainstream successor, pop art, began once in England in the early fifties, once in New York in the late fifties. Mass culture, the rejection of which was so decisive for abstract expressionism, was pop's point of departure. In rejecting the rejectionism of abstract expressionism, jettisoning its values of separation and difference, metaphor and transcendence, pop artists had asked the same questions about the relations between art and meaning, artist and society—Motherwell's *with what to identify*—and concluded that the answers had to be radically new. Pop's great break followed from its perception of the qualitatively different array of social factors that dictated its new answers to the questions about opposition and resistance, about audience, about media, about individual versus society, maleness and mastery, "spiritual freedom in a property-loving world." The subject behind the work could no longer be the alienated male subject struggling to hold onto civilization's highest spiritual values through a sense of personal power, dignity, and autonomy. Even the hope of transcendence had to be relinquished, since God was dead: no more existential choices—the very coherence and character of the subject in the modern world was in grave doubt. If, in the era of consolidating capitalism, the struggle had been to situate oneself in relation to society and to others—the problem of radical individualism as it confronted a hostile social order, a hostile array of radical Others, and a hostile universal order of time and space—by the 1960s, the ground of struggle had become that self. The problem now was to hold together its internal elements, to locate the sources of personal identity in and against a society unified under the "authorial rule of the commodity." The vantage point outside the self, which is vital to comprehend the self's unity, was gone.

Pop evidences no alarm or opposition to everyday life. It shows the domestic(ated) world not as the private domicile—heretofore but no longer ruled by an actual Father (or Mother)—but as the world of the everyday,

which appears as the whole world, an airless terrain with neither "inside" nor "outside." The reconstitution of the work of art as a discourse of images banished affect and consigned the unconscious to muteness; the unconscious became the unrepresentable in a society that attempted to replace it with behaviorist reflexes conditioned toward ownership. Similarly, the problematic realm of Nature now made its rare appearance as Chaos—the unruly domain of Others and the inarticulable residues of the inner life. Against abstract expressionism's existential "possibility" the pop work paraded the impossibility of "authentic" subjectivity, the impossibility of seeing art as the locus of resistance to the dehumanization of the human subject identified by Marx and Lukács as the concomitant of the humanization of the commodity.

Against the figure of the abstract expressionist artist as "resistance fighter," the pop artist represented the quiet capitulation of the ordinary inarticulate modern subject—Beckett's, not Kafka's—the robotic Mass Man. Where the abstract expressionist played his part straight, the pop artist played his as camp. Against the abstract expressionist bohemian, the pop artist was a dandy who, surveying his immediate historical circumstances, understood the end of the artist as genius invested with the responsibility for taking serious, calculated risks.

Far from staying in the elevated museum-gallery world, pop referred always to the mass media. It teasingly skewed and inverted the paradigms of art production, its subjects, sites, allegiances, and models. The new paradigm was above all systemic: a communication model, with appropriately impersonal "sender," "channel," "message," and "receiver." For the first time, at least since the war, the viewer was acknowledged—but not flattered. The industrialization of the art system, strenuously excluded from most previous accounts of art-in-society, brought a weak picture of the viewer that mirrored that of the artist. Pop positioned itself in ambiguous relation to sources of power. Against the advancing social orderliness, it resorted to the marginal disorderliness of irony. Wielding the simulacra of phallocratic corporate power, pop artists (like the diminutive, neuterlike Wizard of Oz) symbolically pursued their only hope of securing some of that male power themselves. As to the magical

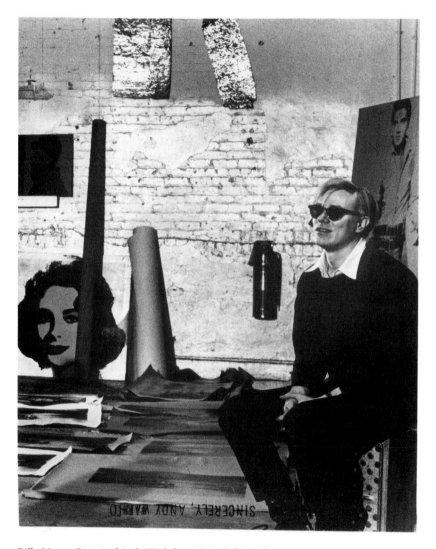

Billy Name, *Portrait of Andy Warhol,* c. 1964. Gelatin silver print.

image-objects, many are those of the female. The lost object, the phallus, may be signified by the image of woman, often in situations reminiscent of the drama of castration, or threatening, as images of the phallic mother may seem to be. The ambiguity of gender as power in pop reflects the ambiguity of possession: in gaining commodities, who has mastered what?

Pop's appropriation of the commodity image thus takes on a ritualistic character that amounts to a strategic retreat. One may see its literal quotation, relocation, and reordering as the only option of the weak or—not so differently—as an ambiguous maneuver that highlights the *question* of will and control played out in the image arena. Is *selecting* (pop's basic, "Duchampian," move) an act of aesthetic power or a sign of mere acceptance—like shopping? If reproducing images changes them—in Warhol's work, through coarsening and slippage; in Lichtenstein's, through rigid formalization and industrialization by application of principles of commercial design—what is conveyed? The ambiguity is whether the artist has positioned himself as the *speaker* or the *spoken* of these "languages" of domination. If the spoken, is the refusal ("inability") to reproduce precisely the imagery of commodified pleasure and machined threat the last residue of *humanness*?

In sum, pop presupposed the socially integrated character of subjectivity and its contents, and the public, corporately authored character of private life. The conclusion was the obsolescence of a culture divided into "high" and "low" and the disappearance of history as a human horizon—for the spasms of desire know nothing beyond the next moment. In this, even intellectuals are complicit, though divided—on no "mission," representing no class, and internally compelled both toward and away from mass culture.

Pop points to a series of oppositions arrayed around the perception of crucial absences or *lacks:* Most important is the absence of a historically transcendent subject and therefore of a human nature, a "species being," and the absence of an answering culture of resistance. If it is not an essence that (as in expressionism) cries out against domination, if a truth beyond culture cannot be discerned, then it depends on conscious discrimination to decide meaning—it depends on idiosyncratic taste and a now devalued rationalism. Thus,

Roy Lichtenstein, *I Know How You Must Feel, Brad!*, 1963. Pencil and touche on paper.

pop was rationalist/antiexpressionist, cool and nonpartisan; it was literalist/antitranscendent/antimetaphoric; impersonal and chosen rather than authored; bounded rather than open-ended; sociological rather than metaphysical; synchronic rather than diachronic. In its relation to signification (coincidentally agreeing with Walter Benjamin's earlier description of the death of the aura), pop was radically anti-original (or antihumanist) both in the sense of rejecting originality or creativity—constrained selves cannot create—and in the sense of rejecting the idea of singular truth and authenticity.

As to subjectivity, the true subject in the image empire is neither the maker nor the consumer of images, the "private person," but the spectral person, the person-as-image, that is, the celebrity. As Warhol developed this point, the artist recognizes the centrality of celebrity as the new reference point for identity—which is thus increasingly replaced by role. The phallic order and the Father's Law are supplanted by an array of male and female heroes whose biography is dwarfed by their images, which they do not control. Yet pop artists, with the exception of Warhol, and unlike other sixties artists, were not the media figures one might have expected. It was, appropriately, the image and the style that got top billing. American pop artists tended to be biographyless, one might say characterless. The homosexuality of a number of the leading figures, which might have suggested so much about the work, registered zero for the mass media.

Where is the woman in this account of postwar art? Was pop androgynous? Degendered? If *lack* was a central construct, why didn't women articulate their absence or domination? In fact, there was no space for women in pop. Its main tasks required a silencing of women that was related to its ambiguous theater of mastery through the transcoding and rearrangement of magical images, many of them images of women. The replacement of artistic *touch* by deauthored affectless production signaled more than deadening, superficiality, and detachment; the replacement of subjectivity-as-emotion and suffering (abstract expressionism, existential angst) with rationalism, or identity-in-cognition, meant an end to the problem of having a feminine intuitive softness at the core of art. There was no room for the voicing of a

different, "truly" female, subjectivity, although pop rejected the mastering maleness of abstract expressionism and toyed with the femaleness of surrender. In other sixties art, it is clearer that the new rationalism was viewed as a male mastery, as in "earth art," minimalism, and conceptualism.

In pop, the female appears as sign, deconstructed and reconstructed as a series of fascinating fields of view, each with its own fetishized allure. The figure of the woman was assimilated both to the desire attached to the publicized commodity form and to the figure of the home—even there, where she *should have* yielded to the male subject's desire, she functioned instead as a sign of the prepotency of social demands. In both locales she is the masquerade of faceless capital whose origin is in the boardroom but which is projected into the home, in a maneuver that every modern man knows about but forgets in the moment of surrender—which itself is an assumption of the female role. Yet, *as sign,* the female is indeed conquered in pop, as she was in expressionism.

If pop contains a critique, it depends on the viewer to perceive it, and many could not. Instead, many—especially the newly prosperous postwar generation—saw affirmation and confirmation in its bright accessibility and fun. If pop contains a critique, it is not of any particular historical event, such as a particular war, but of a civilization. It is a critique that depends on embrace. Critique, like women's voice, is absent, appears as absence. The resurgence of feminism in the late sixties arose partly from the same materially superabundant, spiritually vacant bourgeois life that gave rise to pop, and partly from the opposition, the progressive movements which reclaimed the public as the arena of dissent and activism. Feminism of the period, like pop, articulated the social character of the self and of private life. Unlike pop, feminism—and feminist art—insisted on the importance of gender as an absolute social ordering principle and also on the *politics* of domination in all of social life, whether personal or public.

Women artists renounced the "feminine" passivity of pop and understood the importance of the renarrativization of art. The figure of the artist was problematized to allow a space for women. The "woman artist" (like the

woman writer, the black artist, the black writer) had won limited acceptance in a grudgingly given space in modernism; thus, because of the allegorical subject in abstract expressionism, women could be accepted as quasi-men. To name this as tokenism and to show it as based on exclusion required, of course, the force of a mass movement. Already established women artists (like token participants everywhere) tended to reject feminism. They had developed within a different discourse and would have had to disclaim its rules of excellence. In *Art and Sexual Politics,* edited by Thomas Hess and Betsy Baker, artists Elaine de Kooning and Rosalyn Drexler replied to Linda Nochlin's famous essay "Why Have There Been No Great Women Artists?" with venomous rejection. Nochlin's own answer was sociological: Women were historically kept from the training needed to become great, and their contributions were in any event undervalued because of their gender. Elaine de Kooning replied: "To be put in any category not defined by one's work is to be falsified." Drexler: "No one thinks collectively unless they are involved with propaganda." De Kooning: "I think the status quo in the arts *is* fine as it is—in this country, at least, women have exactly the same chance as men do. . . . There are no obstacles in the way of a woman becoming a painter or a sculptor, other than the usual obstacles that any artist has to face."[4]

Clearly, to make these attitudes unacceptable, their explanations insufficient, required a mass movement. From its basis in that movement, feminism brought into the art world new but firm discourses, rituals, procedures, and goals, many adapted directly from the black, student, and antiwar movements, but others developed within its own distinctive discourse, notably the consciousness-raising group.

Like the liberation movements, feminism made a political and moral critique of domination, as well as of the accompanying ideology that blamed the dominated for *lacking* the right characteristics and having the wrong ones. Part of the project of feminism was the redefinition of subjectivity as socially produced rather than as "natural," a task pop art also shared. But feminists made it their business to show "weakness," "lack," and exclusion not only as imposed but also as remediable. Women suggested not only that the

"feminine"—far from being unimportant, irrelevant, or disqualifying—existed as a positive and powerful force but also that it still remained to be discovered. The feminine, it was implied, might have been deformed by the historical domination of women, but its subterranean expression in "women's culture," when sympathetically excavated and evaluated, would provide both an inspiration and a guide. Contrary to the posture of surrender assumed by pop, art world feminists demanded not just a space for women's voices but substantive social change.

The figure of the artist most bitterly attacked by art world women was the mass myth of the artist/seer/He-Man, which had last been applied unquestioningly to abstract expressionism. Although it hardly operated in New York pop, it continued to do so in California, where pop artists like Billy Al Bengston traded heavily on their images as hard-drinking, skirt-chasing motorcyclists.

California was also the locale of the first organized and institutionally housed feminist art-educational program, begun with Judy Chicago's classes at California State University, Fresno. Soon after, Chicago and Miriam Schapiro set up the Feminist Art Program at the recently established, Disney-funded California Institute of the Arts (Cal Arts), in Valencia, outside Los Angeles. The fact of the program's existence was very important to American women artists everywhere. A few years later, differences over the possibility of having a truly feminist program in an "establishment" institution led to the program's dissolution and to the formation, by Chicago and others (but not Schapiro), of the Woman's Building, in a low-income Los Angeles neighborhood. The Woman's Building was an "alternative" institution, like many, such as the "free universities," formed on the periphery of educational and cultural institutions in that era in Europe and the U.S., with the understood foundations of collective investigation and empowerment and of self-expression, self-management, and self-help. The Building attempted, in many respects successfully, to provide women with supportive social and learning situations, with places to gather, with access to materials and printing facilities, with entertainment, and so on. Its teaching and organizing

functions went well beyond the classes it provided in the Feminist Studio Workshop and other programs.

The West Coast feminist artist practice is interesting particularly because it attended to audience creation and artist reproduction. The creation of a space discontinuous with capitalism and patriarchy, with an agenda of transformation and self-transformation, helped give it its strength. It is significant that Chicago and Schapiro had come to maturity during the abstract expressionist (Schapiro) and pop (Chicago) eras and had not adapted particularly well to the art system's demands—or at least had not been granted much "success."

The Feminist Art Program and the Woman's Building were "cultural feminist" in orientation. This approach involved an investigation of what women's (art) work might be as it developed in a context that was sometimes called "free space": Women would populate the entire system of production and reception and, further, the works produced could be taken as an utterance that may have originated from one or more particular women but was meant, nonetheless, as a contribution to an open-ended collective project— that of building women's culture, and perhaps more. This shared discourse was seen as conscious and direct, as opposed to what was thought of as the covert, distorted, and denied one of disguised male art and architecture. The nonhierarchical model of art production and of the artwork itself challenged the mastery of both the work and the artist in high modernism, as I have suggested pop was also doing, but in a very different way—for feminists, especially cultural feminists, believed they were developing an alternative that would transform society, whereas pop artists had neither the program nor the wish to promote change. (There were other male artists, of course, who did have a vision of social change.)

The implicit challenge to authorship embedded in the critiques put forward by the Feminist Art Program and the Woman's Building led to the production of communal work by some of the students but not by the teachers; individualism was the hardest to relinquish of the demands of the art

Faith Wilding, *Waiting*. Performance monologue at Womanhouse, Los Angeles, 1972. Womanhouse was the temporary transformation of an uninhabited Los Angeles house into the site of multiple installations by the faculty and students of the Feminist Art Program at Cal Arts.

Nancy Buchanan, *Rock 'n' Roll Piece,* 1974. In this performance at the Gerard John Hayes Gallery in Los Angeles, Nancy Buchanan, backed by the band Blue Cheer, performed a song she had composed from Union Oil Company's annual report to its shareholders. Using her own blood, drawn on stage, Buchanan signed over to raffle winners shares of the company's stock that she had inherited.

world. Judy Chicago has pointed out that her *Dinner Party,* which required vast contributions from many people, was not a collaborative work.

Schapiro and Chicago were unfriendly to socialist analyses and socialist feminism, though a number of younger faculty and students at the Woman's Building became interested in socialist versions of feminism and included class alongside gender in their analyses of oppression. The Building also made a number of rapprochements with the poor Mexican residents of their neighborhood, with modest success. Versions of goddess worship and mysticism, although perhaps as uninteresting to Chicago and Schapiro as economic analysis, were tolerated far more easily in West Coast feminism and were more easily assimilated into the theories of women's culture, since they suggested a less immediately threatening, less unfamiliar hermeneutic source of powerful imagery. Following the model of the Woman's Building, but often more politically involved with poor women, women in other cities set up Women's Buildings, although none with the timeliness or art world impact of the first.

The suggestions of essentialism and mysticism on the part of the California women upset many East Coast feminist artists, who were far less willing to accept the idea of a female essence that could be traced in style and form. (There was a fuss over the "central vaginal imagery" thesis, which in any case may have originated with the decidedly East Coast Lucy Lippard, at that time the best-known feminist art critic in America.) But the majority of the women who identified with, participated in, or supported the women artists' movement accepted the goals of participation, of some kind of communalism—although usually outside the act of art making itself—of political progressivism and egalitarianism, of acceptance of difference, of critique of domination, and of optimism and productivity. Other, nonteaching alternative institutions were established, such as the Women's Interart Center in New York City. Following a time-honored artists' option, women also established cooperative galleries, such as New York's A.I.R. Other so-called alternative spaces were also formed. These may or may not have been intended as steppingstones into the high-art world. In any case, they provided a context for theoretical work that, in other disciplines, including art history, was

Judy Chicago, *The Dinner Party,* 1979. Mixed-media installation featuring ceramic portrait plates commemorating historical female figures and a ceramic tile floor naming others. (Work was in production from 1974 to 1979; first exhibited 1979.)

occurring in and around the academy. Feminist art journals and newsletters were begun, and some feminist art criticism appeared for a time in established journals. Women exposed, picketed, and protested the exclusion and under-representation of women in major museum collections and shows, with significant effect.

Some of the differences between the east and west coasts may be instructive.[5] The West Coast women tended more toward the formation of communities, creating their new discourse and working toward instituting their ideas within the context of those communities. In New York, with its larger network of people and the allure of the preeminent art institutions, activities were often directed outward. Consensus seemed to be based on political actions and statements rather than on collective adjustments of theory, study, and art making, although study groups were an important element. But intellectual considerations were broader, and there were more competing theories, and East Coast women were unlikely to seize on a few simple tenets such as the "vaginal imagery" thesis. On both coasts, however, many lesbian artists were interested in separatism and therefore in the formation and theorization of a strong women's culture, in which goddess imagery was often central. On the West Coast, collective works were more likely to be tried. On the East Coast, individualism in the studio, as required by the New York "scene," was virtually a given, and the search for the springs of creativity in presocial, mythic forms was pursued by few—but notably by Lippard. Formal boundary-breaking, the use of mass media, theatricality, simultaneity of metaphoric and direct speech, and multiplicity of elements characterized West Coast performance art, which was the main new form pioneered there and which was the perfect form for the emergence of women's voices.

Feminist reinterpretation of the most stringently formal mainstream art, combined with an assault on ideology and practice, was a further step in the process under way in pop of carrying high art into the wider cultural arena. The appearance of the female voice in the discourses of high art as something other than *lack* shattered, temporarily, the univocality of style. So did the struggle against commodity form and against dealer control of art

world entry—but this process helped put the high-art world into even closer accord with the entertainment model of art, which was first centrally acknowledged by pop in the person of Andy Warhol.

The women's movement, because it had a political analysis and agenda, stressed the *continuity* of mass culture and high culture with respect to the representation of women. Blasting the images of (non-Warholian) pop for their male chauvinism went hand in hand with attacking such images at their original sources in the mass media, especially advertising. Further (see John Berger, especially his widely read *Ways of Seeing,* published by Penguin in 1977 and based on his lecture series on the BBC), such images in advertising could be seen as a continuation of the representation of the female throughout the history of Western painting.

The analyses of systematic exclusions from the art world of types of work based on African American and leftist critiques was enlarged by women's critiques and made effective in that women succeeded in legitimating their claims to enter the art world on their own terms—as women, making "women's art," not degendered art—whereas no racial or ethnic minority had succeeded in doing so. Nevertheless, the feminist agenda—the allowance of difference and of explicit analysis within the work, attention to institutional exclusions and the reworking of the terms of participation in art—allowed for the *possibility* of a more open and inclusive cultural apparatus. The success of the political and cultural strategies of the sixties depended on the generalized demand for social justice and participation. Government agencies, public institutions, and schools adapted accordingly, and the art world seemed more permeable than ever to new ideas and multiple practices. But this phase of "postmodernism," premised simply on rejecting the aesthetic closure of modernism, was transitory. Although many women artists, and many art world institutions, developed through the seventies with the adjusted model of the art system, conservative and specifically antidemocratic forces were building their strength during the period of economic contraction. Many younger women began to regard feminism as passé, as having achieved its goals.

The conservative sweep of the eighties immediately began dismantling the political and cultural changes of the sixties and seventies, and sectors of the art world quickly seized the initiative. Enterprising dealers saw the right moment for the repositioning of blue-chip commodities at the top of the market. In no time at all, painting and sculpture were repositioned at the top of the art world hierarchy of sales and attention. Not just any painting and sculpture—a mythic, irrationalist, and highly misogynistic neo-expressionism appeared that confirmed the triumphantly resurgent misogyny and elitism of the high rollers. Lest anyone miss the point that progressivism and difference have been ridden out of town on a rail, one of the leading New York dealers, the tiny, ultrafeminine, and expensively ornamental Mary Boone, has recently explained to *People* magazine[6] that women are simply not as expressive as men and that although she'd take on a good woman anytime, curators would have none of it.

Before feminism, women could make it in the art world only through "superprofessionalism": by seeming tough and "masculine"—one of the boys. Now the point is that expressiveness is being reclaimed as the softer side of male-only artists; the "eighties man" is unafraid to display his feminine side, obviating any need for women to do it. It seems that big expression, like haute cuisine, requires the banishing of women from the kitchen, although it was woman, *as* woman, who returned subjectivity and expression as an attribute of the figure of the artist.

Nothing is more central to the movement of economic, cultural, and private reaction than the reassertion of principles of inequality and domination, the reconstitution of the Law of the Father (even when mediated by "the figure of a woman," Margaret Thatcher or even Mary Boone): Yet true patriarchy is broken, as pop understood, and cannot be restored; and the current heroic male artist-figures from both continents, Europe and America, are only shams, suffering nostalgia twice removed.

Young women artists, who seemed to regard feminism's main tasks as having been accomplished by the mid-seventies, are in no position to appre-

ciate the repeat nature of these moves or to figure out what to do. Economic contractions send people rushing to the center, and New York is currently full not only of rich Europeans taking advantage of a weak dollar but of artists from all over the United States, each trying to succeed no matter what it takes. Ferocious competition rather than communalism is the rule, and it is hard enough for a woman to have her work shown without trying to seem as though she is conveying a message from the sixties.

There may be few women's shows now, but there are many feminist artists of all ages. The academicization of feminist criticism and its development as a psychoanalytic approach to culture and subjectivity, particularly in France, provides legitimacy—although, as the always sympathetic critic Lawrence Alloway recently pointed out, hardly anyone writes feminist criticism anymore.[7] Women of the sixties (and seventies) generation continue to meet, and to work from a feminist viewpoint. Some women artists have been identified with critical, often feminist, though not perhaps otherwise political art—art that points its finger at patriarchal culture discourse itself and its tendency to swallow up the powerless, especially women, and silence them. Interestingly, such work, in New York, at least, is aimed right inside the *commercial* gallery, the last place it would have sought a decade ago. We should probably take this to mean that the "alternative space" is moribund, yet the past few years in New York have seen the formation of many small galleries and collectives—Colab, PADD, Group Material, Fashion Moda, for example—by young artists, male and female, often with some aspect of social negativity and punk-flavored criticality to their work. Among these artists, many of the women are feminists, though operating outside feminist communities. Most of the new galleries are meant to provide entry to the big galleries, though they might conceivably reach critical mass, becoming a scene in their own right, especially within the brash East Village landscape. But, sadly, it seems safe to predict that, as in the past, the distinctive presence of women will disappear without concerted effort on women's part to redefine their wider goals and resume militant activities.

———

Notes

1. June Wayne, "The Male Artist as a Stereotypical Female," *Art Journal* 32 (Summer 1973): 414–16. Also published as "The Male Artist as a Stereotypical Female, or Picasso as Scarlett O'Hara to Joseph Hirshhorn's Rhett Butler," *Artnews* (December 1973), pp. 41–44.

2. Robert Motherwell and Harold Rosenberg, preface to *Possibilities* 1 (Winter 1947– 48): 1.

3. Robert Motherwell, "The Modern Painter's World," *Dyn* 1, no. 6 (November 1944): 9–14.

4. Elaine de Kooning and Rosalyn Drexler, "Dialogue," in Thomas B. Hess and Elizabeth C. Baker, eds., *Art and Sexual Politics: Women's Liberation, Women Artists, and Art History* (New York: Macmillan, 1971), pp. 57–59.

5. I lived in the West for most of the period 1968–1980, with occasional returns to New York City for stays of varying lengths, and my firsthand experience with feminism, including art world feminism, was incomparably greater in that period with West Coast than with East Coast varieties. Feminist art on the West Coast was centered in Los Angeles, however, whereas I lived in and near San Diego until 1978, when I moved north to San Francisco and then further north to Vancouver, B.C., before returning to my native New York late in 1980.

6. Issue dated April 12, 1982.

7. Lawrence Alloway, a British critic and the inventor of the term pop art, was always sympathetic to feminism and other art world insurgencies and was married to the portrait painter Sylvia Sleigh, a feminist.

LEE FRIEDLANDER, AN EXEMPLARY
MODERN PHOTOGRAPHER

I

Lee Friedlander's photos are in a sense exemplary. Their cool, gentle disdain places them at a crossing point between photography and high art, where meaning can be made to shift and vanish before our eyes. In 1967, when the Museum of Modern Art showed photos by Diane Arbus, Garry Winogrand, and Friedlander, the exhibit was called *New Documents;* at the recent MoMA exhibit of fifty of Friedlander's photos, curator John Szarkowski termed the photos "false documents." Szarkowski's rhetoric about Friedlander has undergone the corresponding shift from asserting that the work represents a kind of device for improving our vision of the commonplace to asserting that it represents the outcome of personal "hedonism" while stemming nonetheless

This essay was originally published under the title "Lee Friedlander's Guarded Strategies" in *Artforum* 13, no. 8 (April 1975). It was republished in Peninah Petruck, ed., *The Camera Viewed,* vol. 2 (New York: Dutton, 1979); in Joann Prosyniuk, ed., *Modern Arts Criticism* (Detroit: Gale Research Press, 1991); and in Diana Emery Hulick with Joseph Marshall, eds., *Photography 1900 to the Present* (Englewood Cliffs, N.J.: Prentice-Hall, 1997).

from "an uncompromisingly aesthetic commitment." The overriding assertion now is that Friedlander's concern is both "disinterested" and "artistic," and the corollary disclaimer is about instrumentality. That is, the work is firmly claimed as part of an art tradition and distinguished from the documentary photography of the thirties and earlier, which was meant to "change the world."

Quite a few of the photos in the recent show had appeared either in Friedlander's book *Self Portrait* or in the joint *Work from the Same House,* which coupled Friedlander's photos with hairy, somewhat pudendal etchings by his friend Jim Dine. The ones exhibited at the Modern were those closest to elegance, geometry, cleanness, and high-quality camerawork, and, among the humorous photos, those displaying pure-minded irony and wit untainted by lowness or sexuality, which the book done with Dine had plenty of. All the rawest photos, in both subject and handling, were absent.

Friedlander's work provides some of the first and best examples of what has become a widespread approach to photography. It was part of the general reorientation of the sixties within American art. Within photography his work violated the dominant formal canons not by inattention but by systematic negation. High-art photography had had a tradition of being directed, by and large, toward some universal message. It had aimed to signify a transcendental statement through subtraction or rationalized arrangement of elements within the photographed space, dramatic lighting, expressive intensity of glance or gesture, exotic or culturally loaded subjects, and so on. If Friedlander uses these devices, it is only to subvert them, to expose their arbitrariness. But in shifting the direction of art photography, Friedlander has not rejected a transcendental aim—nor has he specifically embraced one. Instead his attention is on the continuum whose poles are formalist photography at one end and transparent, or information-carrying, photography at the other. Imagine a mapping system for photographic messages: The continuum formal versus transparent is perpendicular to the continuum transcendent versus literal. (A photo of a fiery helicopter crash in combat, for example, is "transparent" and literal when it functions to document the particular crash; it is moved toward

the formal if the style of the photograph or the oeuvre of the photographer becomes an issue, but it may still be a literal document. It is moved toward the transcendent range of meaning if it is taken as embodying a statement about, say, human inhumanity, heroism, or the tragedy of war, and into the formal-transcendent range if its efficacy as a bearer of this message is held to lie with its formal rather than strictly denotative features.) Without insisting on this device, we can observe that even if an artist locates his work near the formal end of the one continuum, his messages, no matter how common-place or "vernacular," are still free to wander anywhere along the other, from literalness to transcendence.

In moving toward vernacular photo images, photography has had to confront some of the issues behind realism, such as whether a photograph is in any sense a document and, if so, what kind. Is it "about" what it shows con-cretely, metaphorically, representatively, allegorically? Does it refer to a mo-ment alone? If so, how long a moment? Does it reveal only that moment, or does it indicate past and future as well? Or is a photo a record of sensibility, or is it most specifically about photography itself? These are metacritical questions about the range of messages a photo can convey as well as about how it signals what it signals. These questions are both contentual and for-mal, and they are all at issue in Friedlander's work.

The meaning of a photographed instant is pivotal, though the problem is not flamboyantly explored. Among the reasons why it is unwise to com-pare Friedlander's photos to "snapshots," the most telling may be that they are not commemorations of a moment; once you have seen more than one, his critical concerns clearly emerge. His conscious presence assaults the notion of transparency, breaking our experience of the moment photographed while at the same time alluding to it. Whereas the photos display the look and the subjects of literal and transparent photography, Friedlander's use of these commonplace features shifts their meaning to another plane.

In commenting on E. J. Bellocq's straightforward photos of New Or-leans prostitutes[1]—photos that had come into Friedlander's possession and

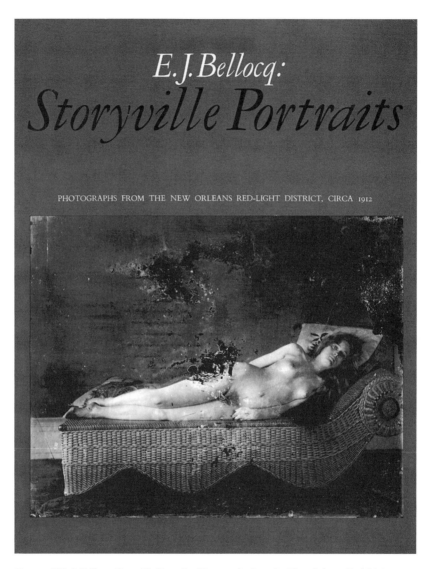

Cover of *E. J. Bellocq: Storyville Portraits, Photographs from the New Orleans Red-Light District, circa 1912* (New York: Museum of Modern Art, 1970). The photos were reproduced from prints made by Lee Friedlander.

been carefully reprinted by him—Friedlander calls Bellocq an "ultraclean realist."[2] He continues: "I think in photography that's even more artistic than making [everything] romantic and fuzzy."[3] Friedlander uses the word "magic" to describe the camera's ability to render things "in astonishing detail," as he phrased it elsewhere. In Friedlander's framing discussion of Bellocq, and in Szarkowski's of Friedlander, the literalist image is somehow transformed into art-magic, but it seems that the only acceptable topic of discussion is the image—only the image is subject to control. Photography is something you do; magic is an ineffable something that happens. Friedlander has remarked that "the pleasures of good photographs are the pleasures of good photographs, whatever the particulars of their makeup."[4]

The locus of desired readings is, then, formalist modernism, where the art endeavor explores the specific boundaries and capabilities of the medium, and the iconography, while privately meaningful, is wholly subordinate. Whatever meaning resides in Friedlander's photographs—and it is more than the image management at the Modern has let show—this set of claims allows Friedlander, and the hundreds of young photographers following the same lines, to put forward playfulness and the making of pseudo-propositions as their strategy while identifying some set of formal maneuvers as the essential meaning of their work. The transiency or mysteriousness of the relations in their photos suggest the privatization of the photographic act. The result is an idiosyncratic aestheticization of formerly public and instrumental moves.

Yet the ambiguity of presenting a set of familiar images while simultaneously denying both their exoteric, outward reference and their commonly understood symbolic meaning is problematic in such work, as in pop art in general. Friedlander shares with pop the habit of converting instrumental uses of a medium into formal and metacritical ones, using the techniques and images of naive photography where pop might use those of graphic design. "Composition," control of pictorial elements, isn't really enough to distinguish work that quotes naive imagery from what is being quoted, especially in photography, where the format and the framing of art and non-art are basically the same (in painting and sculpture there is usually at least a medium

or a scale change). What is required in such work is aggressively conscious, critical intelligence (as opposed to sensibility or expressiveness), signaled by aesthetic distancing.

Friedlander's presentation is exhaustive yet cool, the effect markedly distanced. The voraciousness of a view that yields, in good focus and wide tonal range, every detail in what passes for a perfectly ordinary scene, the often kitschy subject handled in a low-key way, the complete absence of glamour, and the little jokes: these put intelligence and humor where sentiment or anger might have been. Distancing is everywhere evident in the palimpsests of shadow, reflection, and solidity, in the fully detailed small-town-scapes empty of incident, in the juxtapositions and the carefully composed spatial compressions and sliced reflections that are significant only in a photo. Art making here entails a removal from temporal events, even though the act of recording requires a physical presence, often duly noted. Friedlander records himself passing through in a car, standing with eye to camera, and so on, in widely separated locations, always a nonparticipant.

Control is evidenced by Friedlander's hard-headed, patiently systematic formal moves. Most of the issues of painterly composition within a rectangular format turn up in his photos. There are echoes of analytical cubism in the deconstruction, crenellation, fragmentation, and other deformations of space and image, and in the look of collage—the (apparent) joining of disparate elements and image fragments—as well as in the attitude toward stylistics, and even in the homeyness of the subjects. When Friedlander breaks the rules of "good" photography, his doing so amounts to an insistence on photography as photography.

This insistence violates a broader set of pictorial conventions. Take the compression of foreground and background fairly common in Friedlander's photos. As he accomplishes it, this spatial compression violates the tacit rule that a representational photo should suggest space as we perceive it in the world and that any deformations should be easily decodable. Friedlander's deformations rarely result from the optics of lenses, which we have learned to cope with. Rather, he arrays the pictorial elements so that they may connect

as conceptual units, against our learned habit of decoding the flat image into rationalized space. More importantly, spatial compression is a possibility peculiarly inherent to photography, where such junctures can happen accidentally. Friedlander characteristically locates the issue in the domain of control, which he equates with insisted-on consciousness. Once you accept that photography need not rest on the history of painting (where, before the heavy influx of photographic influence, at least, there had been no concept of chance imagery, only accident, or better or worse decisions about intentional juxtaposition), you can accept as the outcome of conscious and artistic control photos that have the look of utter accident. Friedlander's work may make us think of naive photos that incorporate unwanted elements until we inspect a body of his work, when his habitual choice becomes evident, and chance and accident can be seen to diverge.

Chance imagery figures in Friedlander's wider strategy of juxtaposition and collage. Collaging in Friedlander's photos, no matter how it is accomplished, once again points out the nature of photography, its impartial mapping of light-dependent images at a single instant in time. All types of visual phenomena have essentially the same "weight" in a photo, formally speaking—but conceptually that is obviously not true. Friedlander's collages involve not just spatially disjunct imagery but a conceptually based welding of elements of different time scales into a unitary image. Friedlander tends to go for the dryly humorous juncture, as in *Knoxville, Tennessee, 1971,* a rather typical naturalistic collage: a perky little cloud seems to sit like cartoon ice cream atop the back side of a leaning Yield sign whose shadow angles down the unremarkable street. The sign is a long-term, weighty, manufactured element; the shadow is a natural, regularly recurring light-produced image that moves only gradually; and the cloud is a natural, randomly appearing visual element not as substantial as the sign but much more so than the shadow. Clouds, shadows, and signs feature fairly often in Friedlander's iconography, along with clumsy statues and telephone poles, as types of signifiers marked for duration, solidity, provenance, and iconicity. Reflections and mirror images, like shadows, also appear often, and all are, in a sense, proto-photographs.

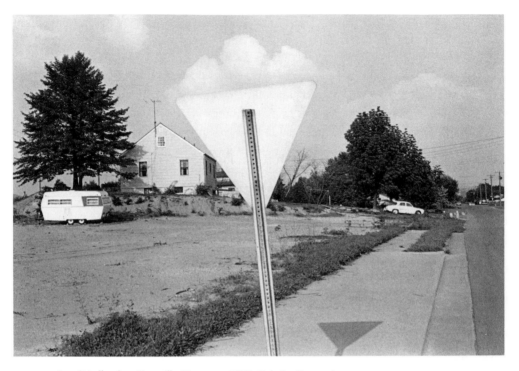

Lee Friedlander, *Knoxville, Tennessee, 1971.* Gelatin silver print.

All raise questions about the immediacy and the validity of the photographic document.

Friedlander's reflection photos tend to be less casually humorous than some of his naturalistic ones. Window reflections, a subset of light-dependent chance images, produce superimposed collaging that is often so strong it is Hofmannesque in effect. The substrate of the reflection is a manufactured surface, usually a commercial one. Images of people are cut by or paired with other images, often without any possibility of their consent. The high number of partial inclusions in these photos makes it difficult to determine exactly what is depicted—do we see, for example, a person's reflection on a storefront window (is it the photographer's or someone else's?) or a person standing inside? Images of signs, of material objects, of natural phenomena, and of shadows—as well as of photos—are as conceptually dominant as straightforward images of people. We grow confused. In a regionally marked photo, *Los Angeles, 1965,* photo cutouts of two implacably smiling TV stars, conspicuously taped onto a storefront window, are the only clear elements against ripply reflections of palms, clouds, and cars. It is only the simulacra of people that we see without obstruction—and that we must, on some level, respond to as though they were photos of people, unmediated.

A photo of a mirror image, like one of a photo, provides no superimposition and so is like a direct photo of the thing mirrored. The importance of the instant is subordinate to the cognitive tension about what is seen and which side of the camera it is on. In some photos, large car-mirror reflections disrupt the unity of the image, turning the photos into diptychs or triptychs. Whether they form part of the ostensible subject, modify it, or subvert it, these images box in the space and provide a "fourth wall." Such closure is accomplished in other photos by an obstructing foreground element. Like the oblivious passerby who ruins a snapshot, these elements obtrude between camera and ostensible subject. The fronted barrier provides a cognitive, not a formal, tension—like the annoyance you feel when your theater seat is behind a pole or your view out the car window is blocked by a passing truck. Friedlander's own image, shadow, or reflection, famously in virtually every

Lee Friedlander, *Los Angeles, 1965*. Gelatin silver print.

photo in *Self Portrait,* is another closing element. It is not a stand-in for our presence in the real-world moment referred to by the photo but an appropriation of it.

Friedlander's almost algorithmic variation of stylistic elements is echoed by both his conceptual repertoire and his formal one, though the expressionist-introspectionist part of the range is underrepresented or betrayed. Some photos are falsely lame apings of genre, like the regional stereotype (the parking lot at the Lone Star Cafe, El Paso, composed into a pyramid with a pickup truck seemingly on display with the cafe sign on its roof and with cacti, gravel, and a neon star against the sky); individual or group portraiture (a flash-lit photo of potted flowers or, not in the show, a grinning group of firemen quickly posed class-portrait-style before a smoking ruin); nature photography (pathetic, scraggly flowerbeds or trees); or architectural tableaux.

Portraiture is extensively undercut; people are opaque. We are mostly kept at arm's length or further. The closer shots at the Modern were party photos, in which several people press together across the picture plane or form a shallow concavity. They seem to be ordinary youngish middle-class urban or suburban people—the kind of people who look at photos. Their expressions, although sometimes bizarrely distorted, say more about the effects of flash lighting than about personality or emotion, except the most conventionalized kind. The close-up is a form suggesting psychological encounter, and Friedlander uses it to negate its possibilities. People shown interacting with things often look unwittingly funny, or peculiarly theatrical, bringing a suggestion of seriousness to the irony of their situation. This is perhaps clearest in the photos with statues.

In *Connecticut, 1973,* a statue of a soldier, rifle at the ready, crouches on a tall pedestal in a small clump of greenery bordering a street of stores. Two women, one pushing a child in a carriage, have just passed it. The child, a small image at the right, is looking back. We are separated from the horizontal tableau by an almost-centered telephone-pole shaft and a street sign. This photo contains images of the immovable and noniconic (the pole), the iconic immovable looking movable (the statue), the fleeting human (the

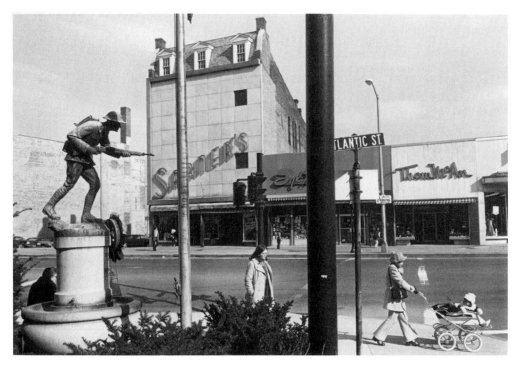

Lee Friedlander, *Connecticut, 1973.* Gelatin silver print.

walking women and the child), and the stationary human (women seated at the statue's base). Can we extract any transcendent message? If so, it is not about war but may be about human durations—perceived durations relative to those of icons. The humanly produced statue has a potential "life span" far longer than that of any person and exists in a different time frame; everyone in these photos ignores the statue, which remains fixed against a changing backdrop of temporal events. And the time frame of the photo is that of the statue, not that of the people. Or suppose this photo is more centrally about interaction. Its dominant vectorial geometry seems to tie the gazes of statue and infant, but no interaction occurs. The child's back is to its mother, hers is toward the woman behind, and the other women in the foreground look off at right angles.

The possibility of such heavy metaphysics, despite the picture's ordinariness, at first seems rather remote. The viewer must make some observations and decisions before considering it. The facticity of the image is not in doubt; unquestionably the elements were present in the real world and the photo was not set up like a Michaels, a Meatyard, or a Uelsmann photo. But it was set up like a Cartier-Bresson, in which the architecture required the presence of a human figure falling within a range of specifications in order to elicit the desired internal comparison between figure and ground. That is, Friedlander presumably positioned himself in the right spot and waited for someone to appear. And, of course, the irony is only in the photo—it is the photographer, with his prevision of a flat representation, who can present the people as transient self-absorbed entities enclosed in a humanly created space that has gotten away from its creators. The viewer recognizes that the statue's impingement is unreal; its iconicity fools us into considering that it might be implicated, whereas we know it is no more so than the street sign or the telephone pole. The viewer can decide that the photo conveys something truer than the commonplace apprehension of reality, putting the photo within the bounds of surrealism. The viewer is unlikely to accept the as-if proposition that the statue is invested with more than the surface appearance of the real and can in fact interact with the people. (The backward-glancing child is

tantalizing; is he a Wordsworthian creature trailing memories of immortal-
ity, that is, of transcendent nontemporality, or is he, impossibly, conscious of
the statue's false menace? Is he not yet fully human and paradoxically not yet
fully unconscious? Or is he just glancing back at the woman we assume to
be his mother?)

The viewer accepts the simile that the statue looks as if it were engag-
ing with the passersby only on the level of aestheticized experience, or story-
telling. We do not imagine that the photo is a literal document, about this
particular spot in Connecticut or the figures in a townscape who appear in it.
We assume the photo is synecdochic, intended to convey, if anything, some-
thing about people in general, or about some class of people, or about some
class of images, or most attenuatedly, about some class of images of images.
The particular conjoinedness of images can be taken as a witticism rather
than as a serious assertion about the real world. Interpretation, if it occurs,
is a private task of the viewer's. Grossness or fineness of interpretation is a
covert issue in Friedlander's work, just as grossness or fineness of looking is
an overt one. It is likely that Friedlander doesn't care to decide at what level
his photos are to be read. He presents tokens of the type that might be called
"significant pseudo-junctures"; his images function like the mention rather
than the use of a word—noninstrumentally. Ultimately we are unjustified in
associating the statue with the people just because their images share the same
frame. This metamessage applies as well to photos of people with people; that
is fairly clear in the party photos, for example, where you can't tell who is as-
sociated with whom, except for the one in which a man is kissing a woman's
neck, and what does that signify at a party, anyway?

We can't know from a single image what relation the people in it have
to one another, let alone whether they communicate or what they did before
or after shutter release; the photos rely on our presuppositions to bias them
toward a reading. The general lack of such personal markers as foreignness,
poverty, age, and disability allows Friedlander an unbounded irresponsibility
toward the people he photographs. His refusal to play psychologizing voyeur
by suggesting that a photo can reveal some inner or essential truth about an

individual or a stereotyped Other is gratifying. But it is part of the larger re-
fusal according to which photographic propositions have truth value only
with respect to photos, not to what is photographed. Even this refusal is un-
stated. Friedlander has laid vigorous claim to control over his camerawork but
has omitted any active claim to control over reading. His work can be taken
by casual viewers as value-free sociology and, because of his denial of photo-
graphic transparency, as artful construction for photography buffs.

II

Friedlander's work has antecedents in the small-camera photography and
street photography of such people as Eugène Atget and Walker Evans, to men-
tion only two, but both Atget and Evans appear serious where Friedlander
may seem clever, light, or even sophomoric. Atget and Evans photographed
people of various classes, in their work roles and out. They cannot be accused
of making their subjects the butt of jokes, whereas Friedlander does so almost
always, though not the savagely involved ones of Arbus or Robert Frank. For
both Atget and Evans, photography's ability to convey hard information was
not much in doubt.

 In Evans's *American Photographs*[5] there is a deadpan photo, a Friedlander
precursor, of a similarly deadpan statue of a doughboy on a personless street
in a Pennsylvania town.[6] Evans follows it with a Vicksburg statue of an un-
mounted Confederate officer and his horse, a monument to heroism in de-
feat;[7] Evans's framing of the image and its isolation against the sky exaggerate
the transcendental histrionic gesture enough to kill it by overstatement. Next
in the book are some pretty unappealing portraits of men and boys wearing
uniforms. The sequence narrows down the range of meanings of the photos
to the subject of war and violence and how they are represented in the world.
Evans, like Friedlander, is not psychologistic, but his photos are seated much
more firmly in their social context; even his captions are more informative:
Coal Dock Worker, 1932 and *Birmingham Steel Mill and Workers' Houses, 1936*
are more than the bare bones of place and year.[8] Evans, too, used collage,

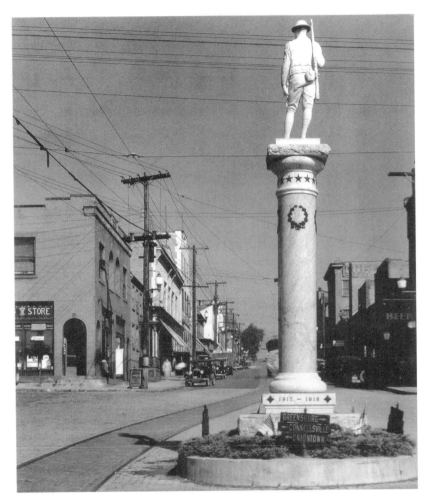

Walker Evans, *Main Street of a Pennsylvania Town*, 1935. Gelatin silver print.

Walker Evans, *Battlefield Monument, Vicksburg, Mississippi,* 1936. Gelatin silver print.

including in a photo both "positive" and "negative" cultural elements: heroic statues and clean streets meeting up with prosaic power lines, icons denoting beauty or sleek commercial messages embedded in degraded human environments, people in rags lying in front of stores. Like Evans's collages, Friedlander's may preserve the impression of simple recording and mass-produced iconography at the same time as exquisite awareness of both formal niceties and telling juxtapositions. But Friedlander's collages, hung on chance and ephemera, are not consciously invested with social meaning and may or may not aspire to universal import. What for Evans occurs in the world occurs for Friedlander in the mind and in the camera. The emerging cultural icons that in Evans's photos represent the directed message of the haves imposed on the have-nots are solidified and naturalized in Friedlander's. The have-nots have disappeared.

In Friedlander's books, Friedlander comes across as a have-not himself—significantly, though, one psychosocially rather than socioeconomically defined—a solitary guy who slipped around with a camera in a crazy-clockwork world, fantasizing with mock voyeurism about sleazily sexual targets while never forgetting the meaning of a photo. More recently, as in the latest exhibition at the Modern, selected by Szarkowski, Friedlander has shown us a sanitized, if unglamorous, uniformly middle-class world. His human presence has been submerged under his professionalism, and nothing is serious but the photographic surface—he is approaching the status of classic in his genre. Minute detail in these photos does not add up to a definitive grasp of a situation or event; it would be an ironically false presumption to suppose we can infer from the photo something important about the part of the world depicted in it. Yet making connections is an ineradicable human habit, and the metamessage of framing is that a significant incident is portrayed within. Looking at his photos, we are in the same situation as Little Red Riding Hood when she saw dear old Grandma but noticed some wolflike features and became confused. Our pleasant little visit has some suggestion of a more significant encounter, but we don't have enough information to check. The level of import of Friedlander's work is open to question and can be read anywhere from photo funnies to metaphysical dismay.

Notes

1. Bellocq was a local New Orleans commercial photographer working around 1912, a primitive in a sense, whose work was basically unknown until Friedlander came across it after Bellocq's death. Bellocq seems to have photographed the women as friends, with aspirations neither to art nor to profit. A book of the photos, reprinted by Friedlander in a style he tried to match as closely as he could to Bellocq's own, was published as *Storyville Portraits* in 1970 by the Museum of Modern Art. Most of the remarks quoted here were drawn from the book's introduction, a peculiar jigsaw puzzle of conversational remarks ascribed to various persons and recorded at various times and places, all finally selected, edited, and arranged by John Szarkowski into an imaginary "conversation."

2. Lee Friedlander and John Szarkowski, *E. J. Bellocq: Storyville Portraits, Photographs from the New Orleans Red-Light District, circa 1912* (New York: Museum of Modern Art, 1970), p. 11.

3. Ibid.

4. His words appear as part of a collection, mostly of photographers' work with short accompanying remarks, which has almost nothing to do with snapshots and represents another step in the attempt by Minor White and others to assimilate all photographs to their particular quasi-mystical version of photographic history. Lee Friedlander, quoted in "The Snapshot," ed. Jonathan Green, *Aperture* 19, no. 1 (1974): 113.

5. Walker Evans, *American Photographs* (New York: East River Press, 1938).

6. *Main Street of a Pennsylvania Town,* 1935, in *American Photographs,* p. 61.

7. *Battlefield Monument, Vicksburg, Mississippi,* 1936, ibid., p. 63.

8. Ibid., pp. 71, 128. The latter is captioned *Steel Mill and Workers' Houses, Birmingham, Alabama, [March] 1936* in *Walker Evans, Photographs for the Farm Security Administration, 1935–1938* (New York: Da Capo, 1973), a catalogue of the prints then available through the Library of Congress.

———

Notes on Quotes

Quotation, often as collage, threads through twentieth-century art and literature fugally entwined with the countertheme of "originality." In quotation the relation of quoter to quote, and to its source, is not open and shut. Quoting allows for a separation between quoter and quotation that calls attention to expression as garment and invites judgment of its cut. Or, conversely, it holds out a seamless cloak of univocal authoritativeness for citers to hide behind. Although there is nothing unprejudiced about any representation, in the modern era attempts at a necessarily false "objectivity" in relation to meaning have periodically been made—whether in art, as in the German Neue Sachlichkeit (New Objectivity), or in journalism, United States style.

These notes began as a section of an essay in the book *Martha Rosler, 3 Works* (Halifax: Press of the Nova Scotia College of Art and Design, 1981), entitled "I cannot say, I can only repeat (a note on quotes and quoting)." The material was first published in expanded form in *Wedge,* no. 2 (Fall 1982). It was republished in *Open Letter* (Toronto) (Summer-Fall 1983), special issue, "Essays on Performance and Cultural Politicization," ed. Bruce Barber. It was also republished as an addendum to "In, around, and afterthoughts (on documentary photography)" in Richard Bolton, ed., *The Contest of Meaning: Critical Histories of Photography* (Cambridge, Mass.: MIT Press, 1990).

Photography, dressed as science, has eased the path of this feigned innocence, for only photography might be taken as directly impressed by, literally formed by, its source.

Because of the power and pervasiveness of the social myth of photographic literalism, there has been a great deal of energy devoted to the demolition of that myth of directness. At various times the aim has been to invest the image with marks of authorship. Lately, the idea has been to expose the social—that is, the ideological—thrust of the myth, its not-accidental character.

Quotation has mediation as its essence, if not its primary concern, and any claims for objectivity or accuracy are made in relation to representations of representations, not representations of truth. The effect of this has tended to be a closure at the level of representation, which substantially leaves aside the investigation of power relations and their agencies.

But beyond the all-too-possible reductive-formalist or academic closure, in its straining of the relation between meaning and utterance, quotation can be understood as confessional, betraying an anxiety about meaning in the face of the living world, a faltered confidence in straightforward expression. At its least noble it is the skewering of the romantic consciousness on the reflexive realization of the impossibility of interpretational adequacy followed by a withdrawal into a paranoiac pout. Pointing to the existence of a received system of meaning, a defining practice, quotation can reveal the thoroughly social nature of our lives. In a society in which personal relations are characterized by fragmentation while the trend of history is toward reorganization into a new, oppressive totality in which ideological controls may be decisive, quotation's immanent self-consciousness about the avenues of ideological legitimation—those of the State and its dominating class and culture—or, more weakly, about routes of commercial utterance, can accomplish the simple but incessantly necessary act of making the normal strange, the invisible an object of scrutiny, the trivial a measure of social life. In its seeming parasitism, quotation represents a refusal of socially integrated, therefore complicit, *creativity*.

———

In this aspect, quotation is alienated sensibility. At certain historical junctures, quotation allows a *defeat* of alienation (alienation as psychological state, not as a structural disconnection of human beings and their labor power, as described by Karl Marx and Georg Lukács), an asserted reconnection with obscured traditions. Yet the revelation of an unknown or disused past tradition emphasizes a rupture with the present and the immediate past, a revolutionary break in the supposed stream of history. The writing of history is always controlled by the dominant class, which selects and interprets events according to its own successes and which sees history's goal, its *telos*, as the triumph of that class. This use of quotation—that is, the appropriation of elements from the dustbin of official historiography—is intended to destroy the credibility of those reigning historical accounts in favor of the point of view of that history's designated losers. The homage of quotation is capable of signaling not self-effacement but rather a strengthening or consolidating resolve. Thus, for feminists in the past decade, the resuscitation of a great variety of earlier works in all cultural fields was accompanied by energetic new production. The interpretation of the meaning and social origins and rootedness of those forms helped undermine the modernist tenet of the separateness of the aesthetic from the rest of human life, and an analysis of the oppressiveness of the seemingly unmotivated forms of high culture was companion to this work. The new historiographic championing of forgotten or disparaged works served as emblem of the *countering* nature of the new approach. That is, it served as an anti-orthodoxy announcing the necessity of the constant reinterpretation of the origin and meaning of cultural forms and as a specifically anti-authoritarian move.

Not incidentally, this reworking of older forms makes plain the essential interpenetration of "form" and "content." Yet bourgeois culture surrounds its opposition and, after initial rejection, assimilates new forms, first as a parallel track and then as an incorporated, perhaps minor, strand of the mainstream. In assimilating the old forms now refurbished, the ideological myths of the conditions of cultural production and the character of its creators are reimposed and substituted for the unassimilable sections of the

newly rewritten histories that rejected or denied the bourgeois paradigms of cultural production. Today, we are witnessing the latter part of this process, in which critical and divergent elements in art are accepted, but at the expense of the challenge to the paradigm of production or even, increasingly, at the expense of the challenge to institutionalized art world power. Most particularly, there seems to be little challenge remaining to conventional notions of success.

In general, it is through irony that quotation gains its critical force. One speaks with two voices, establishing a kind of triangulation—(the source of) the quotation is placed *here,* the quoter over *here,* and the hearer/spectator *there*—and, by inflection, one saps the authority of the quote. Irony, however, is not universally accessible, for the audience must *know* enough to recognize what is at stake.

Irony certainly functions within the wider culture, but at present it seems to do so differently from the way it does in high art, where it is still pursued by those following from the pop tradition. In the pop era, quotation represented a two-faced literalism: a retying of connections to a social life beyond artistic expression that nevertheless offered a final refuge in formalism with a newly assimilated imagery. (This process has also affected some feminist quotation of styles extricated from their historically extinguished moment—it has served as a transfusion mechanism, a source of borrowings, and the same myths of individualized production have reappeared.) Pop also returned consciousness and presentness to art and artists (and intensified a tug-of-war with critics).

In the United States, the direction of pop's quotational irony was so faintly inscribed (and so often denied) as to offer the public at large the sense of monumentalized approbation of the banal commercial commodity, that is, of its form, without *critique*—except possibly a critique of *execrable taste* . . . or, inversely, its exultant acceptance (a version of the romantic pout). As "art," pop may have given the public a pain (it wasn't transcendent or beautiful) or a thrill (it acknowledged their taste for the decorative), but as a source of new

merchandise, the cheap commercial "spin-offs," it was just plain fun, slightly outrageous in its brashness. Liking it was not just a way of worshipping Moloch; it was a way to fly in the face of boringness while placing oneself under the up-to-date signs of cultural power: corporate symbology.

In society at large, irony is sporadic and cathartic.[1] It permits an outlet for relatively unexamined and sometimes only superficially understood feelings of resentment and exclusion. In high culture, the pervasive irony toward cultural production is well understood as connected to a developed critique of social structure or of the conditions of human existence. What seems culpable from the vantage point of high culture may appear whimsical, clever, or cute from the perspective of mass culture; seeing cultural elements as implicating all culture is very different from seeing them as randomly produced, isolated entities.

With quotation, as with photography, meaning is heavily weighted by the frame. Simply introducing something where it has been excluded— mass-culture imagery in an elite-culture setting (pop) or photographs of the unphotographed poor or of subcultures—can be a radical opener, until familiarity dissipates the shock and closure is again made, with the disruptive elements now inside. Quotes, like photos, float loose from their framing discourses, are absorbed into the embracing matrix of affirmative culture (see Marcuse on this and on repressive tolerance). The irony of pop quotation, which hardly allowed for even the sustained moral indignation that photos of the poor conceivably might, was short, for not only was no coherently critical framework provided for pop, but even partial attempts at devising such a framework were refused by its critics and artists. And it is even easier to admire designs from the graphic lexicon or decorations from mosque mosaics or incidental Chinese illustrations than a photo of some poor victim somewhere, no matter how familiar it has become and no matter how rich the narrative you have managed to invest it with (though in time the human content of the former photo of protest will likely raise its esteem above high-art quotation of any mass-culture detritus).

Pop's irony is now nearly exhausted, but quotation is still used by artists to give form to irony and critique. "So hard to do anything original any more" betrays the dilemma of avant-garde sentiment at a time when a true avant-garde is absent and may be structurally impossible. In considering the recent critical practice in photography, we have to differentiate art world photography from "photo world" photography. In the latter, a situational irony, external to the work, now exists as it has not before: Previously, aestheticizing photographic practice, like art, was high-minded, but the past twenty years' history in the art world has made that position too stodgy. Photographers, particularly those with art school educations, search for new looks as the omnivorous commodification of photography makes photos into art-historical material. Photos quote painting, drawing, conceptual art diagrams, advertising, or other photos, generally as a tactic of upward mobility, embracing the authority of the source and avoiding *socially* critical practice. (Even documentary photography is marked by fragmentation, subjectivization, and the distortion of images stemming from surrealism and its offshoot advertising strategies.) There is little irony intended in relation to the sources of such work (or should I say little received?): This is quotation from (or for) the aesthetically minded Right, which naturally prefers aesthetics to politics in art.

As capitalism-in-depression attempts to refurbish itself and to reimpose a business-is-king ideology that stresses competition along with rank and privilege, a predictable restructuring of the art world is under way.[2] Painting and sculpture, shepherded by dealers and surrounded by suitably adulatory critical effusions, are the preeminent art-world commodities of the era of reaction. In considering the popularization of quotational ("neo-") expressionist art now, much needs to be said about its relation to economic and ideological warfare, but that is beyond my concern here. Most of the quotational expressionism is lavish in its homages, though to some extent a loose Freudianized iconography has replaced mythological elements traditionally presented or tricked up as street figures. This newer work, the intensely capitalized and promoted production of Italian, German, and some American

artists, ferociously attempts a return to "transcendent" art, with at best a weak and convoluted irony toward its own historical meaning. Expressionism's return, even apart from the meaning of the imagery, cannot be greeted with a consideration of the search for authenticity integral to its first debut. In relation to society, Lukács has provided an illuminating analysis of expressionism (in literature) in his essay of 1934, "Expressionism: Its Significance and Decline." In confronting a class-divided society in intense conflict, expressionists see only the wrenching sorrows imposed on the individual by "civilization." There is no need to take sides, only to wash one's hands of the whole thing.

> As an opposition from a confused anarchistic and bohemian standpoint, expressionism was naturally more or less vigorously directed against the political right. And many expressionists and other writers who stood close to them only took up a more or less explicit left-wing position in politics. . . . But however honest the subjective intention behind this may well have been in many cases, the abstract distortion of the basic questions, and especially the abstract "anti-middle-classness," was a tendency that, precisely because it separated the critique of middle-classness from both the economic understanding of the capitalist system and from adhesion to the liberation struggle of the proletariat, could easily collapse into its opposite extreme: into a critique of "middle-classness" from the right, the same demagogic critique of capitalism to which fascism later owed at least part of its mass basis.[3]

There is, nonetheless, a much-needed practice of critical photography and text currently in the art world. It is getting feverish attention from the sectors of the critical establishment unwilling to swim with the tide of reaction. It effects a critical engagement with the images of mass culture, visual and verbal, and with those of photography (and art) as a practice. It is quotational ("appropriational") and ironic. But let me explore some problems with this

crucial work, which, despite its aggressive and sometimes globalized claims, seems at times timid in relation to its own material.

Appropriation and analysis are at issue in critique. The difference between them must be appreciated. Appropriation sharply depends on context to provide the critical movement—generally, as I've remarked, through irony. Appropriative strategies do not in principle exclude either analysis or synthesis (but the ones currently receiving the most attention tend to do so). But replicating oppressive forms, whether by quoting them directly or through the fashioning of simulacra, may replicate oppressiveness. Further, the works at issue imply a totalizing or systemic critique. Implicating a whole system is logically unsatisfactory; if an assertion encompasses an entire universe, there is no vantage point outside from which to make or understand the critique. Thus, I will argue that using the language of advertising or melodrama or a simulated series of "cultural unconscious" utterances in fact leaves their systems uncriticized and reproduces their power-seeking and anxiety-provoking gambits far too well. The work, in its stringency, is didactic in relation to other art production. Just as it locates itself logically above other art, the critical discourse needed to support it is put in the same relation to it.

Irrationalism, companion of reaction, is furthered by withdrawal from direct social analysis. Rationalism implies and fosters certitude, and doubt and ambiguity deepen social distress, as I've already noted.[4] Simulacra of ideological discourses without analysis, whether in images (say, of women) or verbal stereotypes, offer no foothold within the work but instead throw up a treacherous and contradictory dream world that encourages projection and myth. In his essay on expressionism, Lukács quotes Karl Pinthus, whom he calls "one of the leading expressionist theorists":

> We felt ever more clearly the impossibility of a humanity that had made itself completely dependent on its own creation, on its science, technology, statistics, trade and industry, on an ossified social order, and bourgeois and conventional customs. This recognition meant the beginning of a struggle against both the epoch and

its reality. We began to resolve the surrounding reality into the unreality it is, to penetrate through the phenomena to the essence, and to surround and demolish the enemy by assault on the mind. We sought first of all to distance ourselves from our environment by ironic superiority, by grotesquely jumbling its phenomena, *floating easily through the viscous labyrinth . . . , or rising into the visionary with the cynicism of the music-hall.*[5]

Later in the essay Lukács remarks that "this 'essence' is . . . presented by the expressionist as the poetic reality. . . . He does this in poetry . . . by gathering together as a literary form his own inability to arrange and master the objective reality in thought, making this into the chaos of the world itself and simultaneously the sovereign act of the writer."[6]

In work based on advertising, the critique is of domination congealed into photographic images (not necessarily from ads) and language, and the presentation draws on magazine, billboard, and other display techniques. As in advertising, the relation of text to image is generally ironic: contradictory, perhaps, or revelatory. Yet there is no *particular* critique of these forms as concretized oppression, instrumentalities of selling. Advertising is dirtied by backwash from other critical elements in the work; although the forms are shown as constrained, they are not deeply criticized, for they carry a new, critical message. Works using television gambits suffer from the same problems. Each locates clear instances of oppressive imagery, generally of the kind that targets women or sensationalizes violence, and each repeats oppressive formal strategies of the chosen industry (advertising, television) such as authoritative phrasing and type design or rapid editing, organized into an up-to-date format. As some of these artists have developed their oeuvres, the work has come to seem locked in fascination to its own material.

The ambivalence toward the appropriated material is evident in the form's being pressed into service of a new authoritativeness, a new mastery. This ambivalence contributes to the formalist cast of the work, for the polish may seem more powerful than the criticism. For those without a preexistent

critical relation to the material, the work might be a slicked-up version of the original, a new commodity. In fact, some of this work has proved quite sale-able, easy to show, easy to write about, easy to sell. Epigrammatic and rhyth-mic, the work's effect is to tend to foreclose thought rather than to stimulate it, to replace criticism and analysis with sloganeering. No one, neither critic nor viewer, has to do the hard work of understanding the social relations al-luded to in the work.

The flat refusal of "new production" (which mistakenly assumes that reproduction is no production) of some quotational artists is deeply roman-tic in continuing to identify creativity as the *essence* of art. This jettisons, for example, a more open-ended idea of art as stemming from and returning to lived relations. The cry of the isolated producer, the spectator of social life, represents a choice behind which lies a profound stasis. The work is immo-bile while critics do their work on it, "Nature" to their "Culture," female to their male (more on this later). What does it mean to reproduce well-known photos or photos of well-known art works directly? Explanations have been inventive: removing the works from their rarefied niches and making them more widely accessible (from a respectable curator); claiming them as part of our cultural unconscious (a recent *New York Times* article); exposing the com-modity status of all art in the age of mechanical reproduction (European-influenced critics); protesting the glut of existing imagery (a friend). Each explanation remains in its own domain of meanings. (Few have remarked on the way in which this work challenges the "ownership" of the image.)

What alternative vision is suggested by such work? We are not offered the space within the work to understand how things might be different. We can imagine only a respite outside social life—the alternative is merely Edenic or utopian. There *is* no social life—no personal relations, no groups, classes, nationalities; there is no production other than the production of im-ages, the fascination of the age. Yet a critique of ideology necessitates some materialistic grounding if it is to rise above the theological or metaphysical.

Some of the problems with the new quotational work make sense, as I've suggested, in the light of our current historical situation. The force be-

hind its irony is not derived from a process of politicization, although it claims a politics. Consider the irony of political movements. Consider the cartoons, plays, and songs, for example, of past movements, many of which have entered official histories cut from their contexts of political ferment. The irony and parody of oppressive social institutions and their representatives contained in these works are resilient with anger and forward motion, a resolve toward change that seems convinced of the direction of history. Most of this work stems from working-class movements, with bourgeois and petit bourgeois allies such as intellectuals and artists. But the lack of a coherent oppositional movement now in the United States leaves artists with the easy institutional alliance that they (we), along with intellectuals and other "cultural workers," form with the controlling classes.

The critical art I have been discussing tends toward traditional modernism in its reliance (with some exceptions) on art world institutions, in the form of galleries, museums, and critics. A hybrid practice, it combines the obsessiveness of (abstract) expressionism with the stringency of conceptualism (or, more properly, minimalism). Compared with the multiply inventive, directorial, and entrepreneurial activity of Andy Warhol's pop or the self-confidently shaping intelligences of conceptual art, much of this work seems ready-made for the critic. Most of the sympathetic critics concern themselves only with art that has already found its location in commercial art galleries and museums, so that the process of legitimation is presupposed to exclude either a wider practice, a non–New York (or non-European) practice, or one that neglects or refuses commitment to the showing and selling institutions of high culture. The conservatism (and laziness) of this restricted critical practice is confirmed in its methods of intensively "working" a few artists, usually single-move artists, most of whom provide relatively passive subjects of critical attention; the artist-critic symbiosis of high modernism is reborn.

Some of the opposition to bourgeois cultural hegemony has taken on the Althusserian direction of "theoretical praxis," which claims as revolutionary the theoretical work that bares the structures of capitalist domination in the field of ideology. (Lukács stresses the theory orientation of expressionists.)

However, this work remains within the relations of production of its own cultural field. For critics and other sympathetic producers, this functionally modernist closure reinforces their own sense of opposition to dominant bourgeois culture without raising difficult questions about their relation to political movements (although Althusser was a member of the French Communist Party even through its Stalinist period). Critics and the artists they write about engage in mutual confirmation that questions of civilization and culture must be dealt with within the universe of meaning circumscribed by the internationalized art world, mutual confirmation of the impossibility of engaging with political questions that challenge rather than simply *highlight* power relations in society. The oppressiveness of social institutions and social relations is overstated in the art I am considering, leaving no room for oppositional human agency—a charge that has been made against Althusser's work as well. Amid deepening uncertainty, criticism has retreated further from an engaged stance. The still-emergent criticism deriving from the work of Jacques Derrida tends to deny any possibility of unambiguous political stands (though recently Derrida himself, pressured to respond, expressed his belief in the need for social transformation), along with a denial of authorship that may paradoxically help in dusting off the view of the artist as a passively creating, socially disconnected figure.

The return to the trappings of genius (or, less histrionically, the lone producer) fits interestingly with questions of feminism. It is not at all accidental that most of the artists at issue are women (and I count myself among them). Women are more likely than men to be critical of existing power relations, since they have less of the power. But particularly in the highly conscious intellectual community, where feminism is still taken seriously, femaleness tends now to be the token for all markers of difference; appreciation of the work of women whose subject is oppression exhausts consideration of all oppressions. This arraying of oppressions mirrors that in the rest of society, which divides and conquers. The difference is that, in the art world, race and class (for example) can be left out. This is not to say that for the art world the rest of society is obliterated. If New York is sometimes Culture to the rest

of society's Nature, the world of artists and intellectuals is also sometimes Culture while the rest of culture, either as corporate mass culture or as popular or street culture, is Nature. Nature, of course, provides setting and raw material.

Working-class and minority life and culture recede as an issue in the championing of the female oppressed (no need to cast blame). Single-move art needs strong support systems, as I've said. This support can be literally patronizing: Svengali and Trilby is too extreme a model for this relationship, but inevitably there are elements of performer and manager here. The dominance of critical discourse over the artist's expressive utterances is a guilt-denying dominance, for it is carried out in the logical superiority of meta-language over language. If the woman artist, asserting herself (and all of us?) to be a prisoner of phallocentric language, refuses to try to speak, her refusal, coupled with her continuing to seek, through ordinary art world channels, the validation of critics, curators, and buyers, confirms the image of woman as bound and impotent. The ornithological interest of some critics in the song of the caged bird fits the pattern set by previous doomed actresses and singers. One critic tempered his praise of each woman he discussed with a sobering assessment of the "weaknesses" of her approach, a strategy he has never applied to men.

Some of the new quotational work exists in relation to "the street." "The street" suggests metropolitan locales with deeply divided class structure and conflict, and perhaps where the impoverished and excluded are also ethnically different. Operating in New York's closed and self-reinforcing art world but often living among its dispossessed populations, artists may identify with their neighbors but aspire to art world success. Coming to New York is regarded as a dangerous rite of passage through which only the strong pass victorious. However deeply felt in matters of daily life, this situation becomes a fantasy drama in the matter of making art. The street and its culture become both a source of style and a theatrical setting for an art still aimed at

high-culture audiences and the intermediary subcultures of young producers and supporters.

This dilemma of identification is not easily solved and is exacerbated by the location of art sites in impoverished neighborhoods, for the facts of social power and privilege can hardly be wished away. We have seen the bludgeoning of human sentiments and the truncation of social life, whose continuing vitality testifies to human resiliency under terrible conditions—conditions that activists and social critics point to as evidence of the destructiveness of capitalism—transformed into exciting sources of artistic experiment and imagery, cut off from the context of oppression and need. An encounter through which art audiences are left to imagine that the poor or the desperate are happy where they are, God bless 'em, is as supportive of the status quo as art that leaves them out.[7]

Quotation is a larger practice than I have considered here. Although some of both types, critical and mystificatory, is done by both men and women, it is evident that neo-expressionism, at least, is now (and has been) a male strategy, part of whose burden is the painful loss of individual mastery for all but a few men (and part of whose social use is "backlash"). Concomitantly, most of the socially critical, largely photographic work is made in response to the oppressive power of unauthored ideological domination as expressed in imagery of the female and logically, therefore, is done by women. Because women, in aiming for self-determination and success, have had to downplay their "expressiveness," this work is stringent and tough. Vacating the field of expression left that territory open for men to rush into and stake their claims as neo-expressionists and otherwise (and left room for the important New York gallerist Mary Boone to remark entrepreneurially that men are more expressive than women and simultaneously to claim, in *People* magazine for April 12, 1982, "I'll always take a great woman artist, but the museum hierarchies won't accept them").

The enfeeblement of feminism in society makes the continuation of feminist art essential. But if women artists fit too easily into the institutional

patterns of the art world, it seems plausible that feminist art will be just a competing style of the sixties and seventies and will be outdated by fashion. Repeating the images of woman bound in the frame will, like pop, soon be seen as *confirmation* by the "postfeminist" society. We need to find a way to maintain not just a critical but a countering practice, as I mentioned at the start of these notes. Quite possibly it will be developed by those who have forged the critical practice I have considered here or by others much like them, as well as by men who refuse the kinds of rewards now offered by an art world more and more tied to the interests of those bent on control over society.

NOTES

1. [In hindsight, we can see that irony was on its way to becoming a widespread cultural trope, as a means of coping with the information—and advertising—glut.]

2. See Martha Rosler, "Lookers, Buyers, Dealers, and Makers: Thoughts on Audience," reprinted in this volume.

3. Georg Lukács, "Expressionism: Its Significance and Decline," first published in *Internationale Literatur I* (1934), pp. 153–73; translated in Lukács, *Essays on Realism,* ed. Rodney Livingstone, trans. David Fernbach (Cambridge, Mass.: MIT Press, 1981), p. 87. Lukács is responding to the *return* of expressionism in the thirties and discussing its rise in the late teens.

4. The Central Intelligence Agency is well aware of the usefully destabilizing effect of the bizarre stories that promise chaos or catastrophe, shaking common sense or social mores. In Chile, for example, in preparation for the coup of 1973, it reportedly spread rumors and planted news items about such horrors as foreigners eating cats. Similar techniques were used in Jamaica—along with, it has been said, a murder campaign in Kingston—before the progressive Manley regime was voted out of office. This well-worn propaganda technique also serves such publications as the *New York Post,* for fascination and dependency also increase sales.

5. Preface to the anthology *Menschheitsdämmerung* (Berlin, 1920), p. x, quoted in Lukács, "Expressionism," in *Essays on Realism,* p. 88. (Emphasis added by Lukács.) Although I certainly cannot accept Lukács's championing of realism as the only socially conscious and critical art, I find his analysis of expressionism to be powerfully apt, in describing not only reactionary neo-expressionist work but also the genuinely critical work as well.

6. Ibid., p. 105.

7. See Edit de Ak's review of John Ahearn's work in *Artforum* (November 1982).

III

PHOTOGRAPHY AS IMAGE AND TRACE

In, around, and afterthoughts
(on documentary photography)

Jacob Riis, *Hell on Earth,* 1903. Riis commented: "One night, when I went through one of the worst dives I ever knew, my camera caught and held this scene. . . .When I look upon that unhappy girl's face, I think that the Grace of God can reach that 'lost woman' in her sins; but what about the man who made profit upon the slum that gave her up to the street?" From "The Peril and Pressure of the Home," in Alexander Alland, Sr., ed., *Jacob Riis, Photographer and Citizen* (Millerton, N.Y.: Aperture, 1974).

Lewis Hine, *Spinner in New England,* 1913. Gelatin silver print.

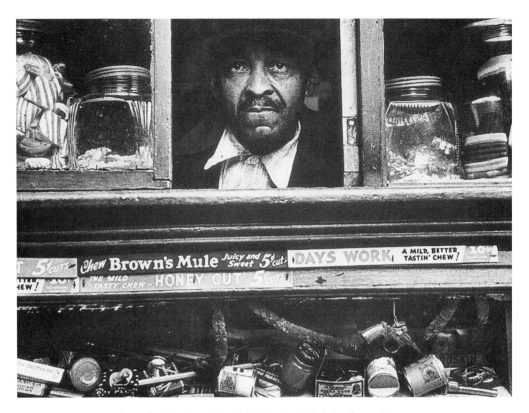

Morris Engel, *Harlem Merchant, New York City,* 1937. Gelatin silver print.

Ellen Grounds, age 22, a "pit broo wench" (pit-brow worker) at Pearson and Knowles's Pits, Wigan, with Arthur Munby beside her "to show how nearly she approached me in size." *Carte-de-visite* by Robert Little (or Mrs. Little), Wigan, September 11, 1873.

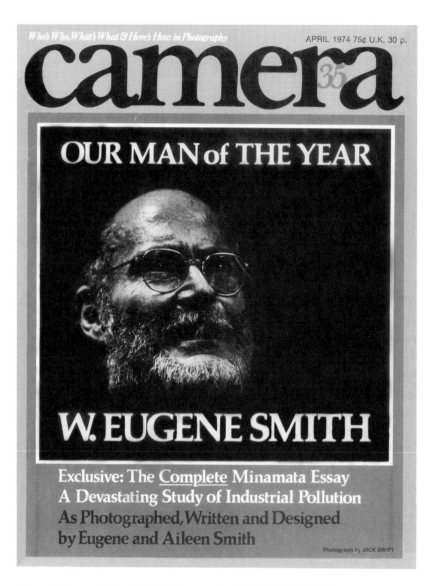

Cover of *Camera 35* (April 1974). Photograph of Smith by Dick Swift.

Another adventure in one of the 87 lands where Canadian Club is "The Best In The House"®.

"We thought we were in a peaceful village until we realized we were being stalked by the primitive Mudmen of New Guinea."

1 "Anna and I always wanted to visit a tribe of Mudmen to see one of their Sing-Sing ceremonies," George Malynicz tells us. "Our guide, Peter Barter, refused to tell us exactly what the ceremony entailed, just to heighten the suspense a little. But we got more than we bargained for. We followed the Asaro River into the New Guinea interior to a village where it was rumored there might be a Sing-Sing. Sure enough, there were only women and children in the huts. Peter said the men must be in the jungle preparing for the ceremony, and went to look for them. Anna and I waited near the village.

2 "Suddenly a lone warrior appeared out of the brush and moved slowly toward us. My first reaction was to grab Anna and run. But then I realized that we were being stalked by at least thirty warriors from all sides. They approached us silently, carrying spears, in a kind of menacing slow-motion dance. When I was certain we were done for, I spotted Peter taking pictures of the whole incredible thing. The Mudmen are highly unpredictable, and even Peter became concerned.

3 "Peter shouted to the Mudmen to stop stalking us and joined us to talk with them in pidgin English. We found out that the stalking Sing-Sing 'dance' was a re-enactment of a legendary tribal battle which their ancestors won by frightening off their enemies. Looking at the Mudmen we could understand how

4 "Back in Goroka our hotel terrace was a welcome sight, and we couldn't stop talking about our adventure with the Mudmen. Even more welcome was the sight of Canadian Club." Smooth as the wind. Mellow as sunshine. Friendly as laughter. It's the whisky that's light enough for women yet bold enough for men. The whisky that's "The Best In The House"® in 87 lands.

Canadian Club
Imported in bottle from Canada

Canadian Club whiskey advertisement, 1971.

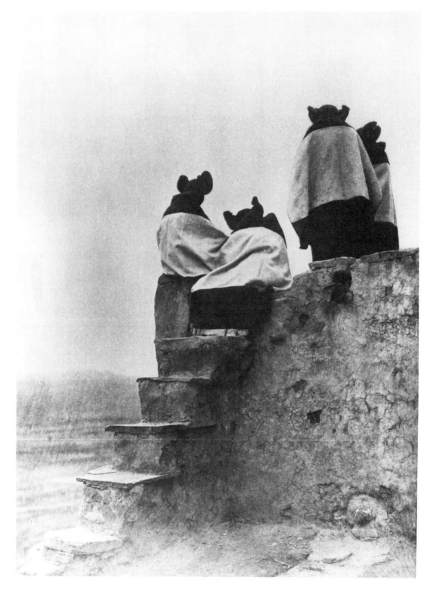

Edward Curtis, *Hopi Girls,* c. 1900. Original is gold toned.

Robert Flaherty, c. 1914. Woman identified as "Allegoo (Shining Water), Sikoslingmuit Eskimo Woman, Southern Baffin Lands," but she may be a woman named Kanaju Aeojiealia. Published in March 1915 in a Toronto newspaper with the caption "Our little lady of the snows . . . makes a most engaging picture."

No posing in this 16 mm. shot by Rev. L. E. Tullar of Jos Nigeria, British West Africa.

A Mexican bazaar, unaware of the presence of Dr. A. J. Atkinson of Glencoe, Illinois.

Even in this extreme close-up, the subject appears unconscious of the camera.

Why always head-on shots? Dr. Atkinson occasionally lets 'em walk out of the picture.

Mr. Rodman C. Pell of San Francisco encourages his Tahitians to "be themselves."

Mr. Ripley W. Bugbee of Pitman, N. J., kept a respectful distance for this cathedral shot.

More interested in the other outrigger than in Mr. Pell—and a better shot because of it.

But he moved in closer for this unsuspected glimpse of a Mexican wash day.

From *How to Make Good Movies* (Rochester, N.Y.: Eastman Kodak Company, n.d.).

160

Adam Clark Vroman, *Hopi Towns: The Man with a Hoe,* 1902. Gelatin silver print.

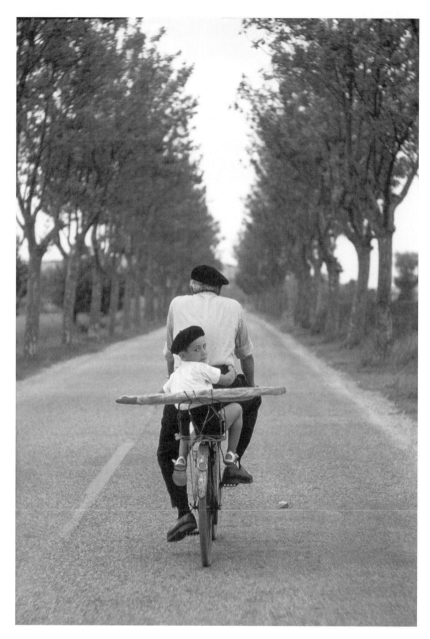

Elliott Erwitt, *Boy with grandfather returning from baker, Provence,* on an assignment for the French Office of Tourism in the 1950s. Original photograph is in color.

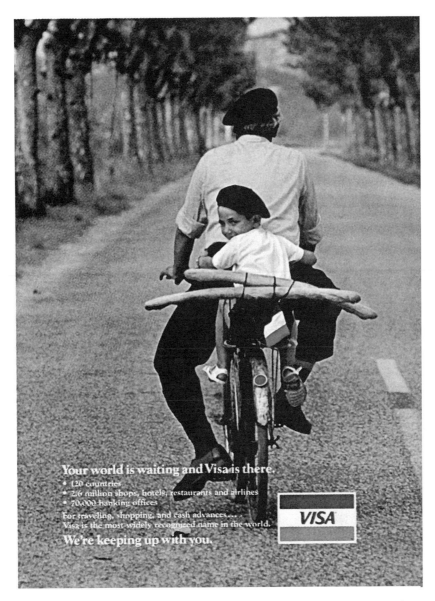

Elliott Erwitt, credit card advertisement. Original is in color. For the ad campaign, this scene was also restaged, twenty years after Erwitt made these stills, by the producer of a (moving) television commercial.

A colonial variant in the Sunday *New York Times* travel section for November 22, 1981, captioned "Riding home with a French loaf at Capesterre on Basse-Terre." Basse-Terre is part of Guadeloupe in the French West Indies. Frank J. Prial's accompanying article, "A Francophile's Guadeloupe," avers that despite U.S. tourism, "thank heaven, every-thing has remained absolutely French, or at least French-Caribbean."

David Burnett, contact sheet showing prisoners detained at the stadium, Santiago, Chile, September 1973. From *American Photographer,* December 1979.

David Burnett, *Detained Prisoners,* September 1973. From *American Photographer,*
December 1979.

Recorder of an Era

Early in 1979, American Photographer mounted as impressive portfolio of Dorothea Lange. Accompanied by text illustrating Lange's rise to notoriety as one of the foremost documentary photographers of her time, the "Migrant Mother" sequence is considered perhaps the most effective icon of the 1930s. It accomplishes the prime purpose of government photography: to provoke action. Lange, under assignment from the Farm Security Administration (FSA), took these photographs in March 1936 as she drove by a destitute peapickers camp in Nipomo, California. Lange approaches from 40 feet, finally focusing on the mother's face.

Dorothea Lange, *Migrant Mother* series, March 1936. As reproduced in a promotional sheet for *American Photographer*, late 1970s. The famous photo, usually captioned *Migrant Mother, Nipomo, California, 1936,* is on facing page.

Associated Press (photographer unknown), Florence Thompson in her trailer home
with a framed copy of her photo and the book *In This Proud Land.* From the *Los Angeles
Times,* November 18, 1978.

Scott Osborne, *Allie Mae (Burroughs) Moore,* 1979. Allie Mae Moore in her trailer home. From *American Photographer,* September 1979.

Walker Evans's photograph of Allie Mae Fields Burroughs (left) appears, captionless, in Agee and Evans's *Let Us Now Praise Famous Men* (Boston: Houghton Mifflin, 1941); in that work she is pseudonymously called Annie Mae Woods Gudger. The second photo (right) was published in Evans's *American Photographs* (New York: Museum of Modern Art, 1938), captioned *Alabama Tenant Farmer's Wife, 1936*. The photograph also appears in *Documentary Photography* (New York: Time-Life, 1972), captioned *Tenant Farmer's Wife, Hale County, Alabama, 1936;* in *Walker Evans: Photographs for the Farm Security Administration* (New York: Da Capo Press, 1973), captioned *Allie Mae Burroughs, Wife of a Cotton Sharecropper, Hale County, Alabama, Summer 1936* (LC-UCSF342-8139A); and in *Walker Evans, First and Last* (New York: Harper and Row, 1978), captioned *Allie Mae Burroughs, Hale County, Alabama, 1936.* These photos are two of four of Allie Mae Burroughs clearly taken at the same time. They appear together in *Walker Evans at Work* (New York: Harper and Row, 1982), where all are said to be from 8 × 10 negatives, which require some time to change the piece of film in the camera. I know of no references to the existence or more than one *Allie Mae* with different expressions (the second photo is the most neutral of the four). Many writers depend on their being just one, the preceding photo. For example, Scott Osborne, in "A Walker Evans Heroine Remembers," *American Photographer* (September 1979), quotes Agee as calling the image "a fraction of a second's exposure to the integrity of truth." But working photographers regularly make several exposures and choose just one; the grounds for choice may have little to do with a version of the "decisive moment" doctrine.

———

Layout from *Modern Photography,* July 1980. The top photo is the cover of the Diane Arbus monograph published by Aperture in 1972, featuring *Identical Twins, Roselle, N.J., 1967.* The bottom photo is *Arbus Twins Revisited,* by Don Lokuta, 1979.

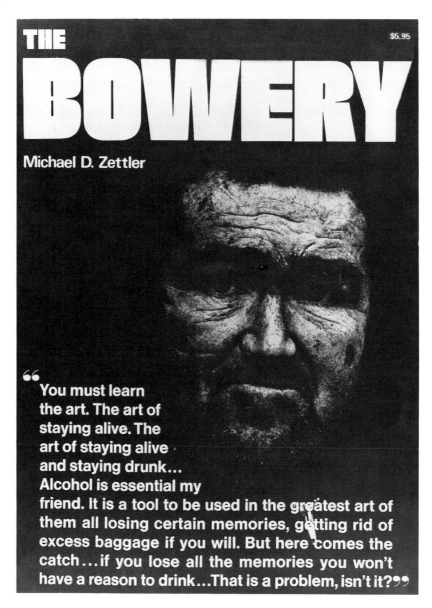

Cover of Michael D. Zettler's book *The Bowery* (New York and London: Drake Publishers, 1975).

I

The Bowery, in New York, is an archetypal skid row. It has been much pho-
tographed, in works veering between outraged moral sensitivity and sheer
slumming spectacle. Why is the Bowery so magnetic to documentarians? It
is no longer possible to evoke the camouflaging impulses to "help" drunks
and down-and-outers or "expose" their dangerous existence.

　　How can we deal with documentary photography itself as a photo-
graphic practice? What remains of it? We must begin with it as a historical

This essay was originally published in *Martha Rosler:3 Works* (Halifax: Press of the Nova
Scotia College of Art and Design, 1981). It was republished in Richard Bolton, ed., *The
Contest of Meaning: Critical Histories of Photography* (Cambridge, Mass.: MIT Press, 1990),
and in Liz Wells, ed., *Photography: A Critical Reader* (London:Routledge, 2000). It has been
translated into several languages, including as "I, omkring og ettertanker (om doku-
menterende fotografi)," *UKS-Forum for Samtidskunst* (Oslo) 1–2 (1979); and as "Drinnen,
drumherum und nachträgliche Gedanken (zur Dokumentarfotografie)," in Sabine Breit-
wieser and Catherine de Zegher, eds., *Martha Rosler, Positionen in der Lebenswelt* (Vienna
and Cologne: Generali Foundation and Walther König, 1999).

phenomenon, a practice with a past. Documentary photography[1] has come to represent the social conscience of liberal sensibility presented in visual imagery (though its roots are somewhat more diverse and include the "artless" control motives of police record keeping and surveillance). Photo documentary as a public genre had its moment in the ideological climate of developing State liberalism and the attendant reform movements of the early-twentieth-century Progressive Era in the United States and withered along with the New Deal consensus some time after the Second World War. Documentary, with its original muckraking associations, preceded the myth of journalistic objectivity and was partly strangled by it. We can reconstruct a past for documentary within which photographs of the Bowery might have been part of the aggressive insistence on the tangible reality of generalized poverty and despair—of enforced social marginality and finally outright social uselessness. An insistence, further, that the ordered world of business-as-usual take account of that reality behind those images newly seen, a reality newly elevated into consideration simply by *being photographed* and thus exemplified and made concrete.

In *The Making of an American,* Jacob Riis wrote:

> We used to go in the small hours of the morning to the worst tenements . . . and the sights I saw there gripped my heart until I felt that I must tell of them, or burst, or turn anarchist, or something. . . . I wrote, but it seemed to make no impression. One morning, scanning my newspaper at the breakfast table, I put it down with an outcry that startled my wife, sitting opposite. There it was, the thing I had been looking for all those years. A four-line dispatch from somewhere in Germany, if I remember right, had it all. A way had been discovered, it ran, to take pictures by flashlight. The darkest corner might be photographed that way.[2]

In contrast to the pure sensationalism of much of the journalistic attention to working-class, immigrant, and slum life, the meliorism of Riis, Lewis Hine, and others involved in social-work propagandizing argued, through the presentation of images combined with other forms of discourse, for the rectification of wrongs. It did not perceive those wrongs as fundamental to the social system that tolerated them—the assumption that they were tolerated rather than *bred* marks a basic fallacy of social work. Reformers like Riis and Margaret Sanger[3] strongly appealed to the worry that the ravages of poverty—crime, immorality, prostitution, disease, radicalism—would threaten the health and security of polite society as well as to sympathy for the poor, and their appeals were often meant to awaken the self-interest of the privileged. The notion of charity fiercely argued for far outweighs any call for self-help. Charity is an argument for the preservation of wealth, and reformist documentary (like the appeal for free and compulsory education) represented an argument within a class about the need to give a little in order to mollify the dangerous classes below, an argument embedded in a matrix of Christian ethics.

Documentary photography has been much more comfortable in the company of moralism than wedded to a rhetoric or program of revolutionary politics. Even the bulk of work of the U.S. version of the (Workers') Film and Photo League[4] of the Depression era shared in the muted rhetoric of the popular front. Yet the force of documentary surely derives in part from the fact that the images might be more decisively unsettling than the arguments enveloping them. Arguments for reform—threatening to the social order as they might seem to the unconvinced—must have come as a relief from the potential arguments embedded in the images: With the manifold possibilities for radical demands that photos of poverty and degradation suggest, any coherent argument for reform is ultimately both polite and negotiable. Odious, perhaps, but manageable; it is, after all, social *discourse*. As such, these arguments were surrounded and institutionalized into the very structures of government; the newly created institutions, however, began to prove their inadequacy— even to their own limited purpose—almost as soon as they were erected.

II

Let us consider the Bowery again, the site of victim photography in which the victims, insofar as they are now victims of the camera—that is, of the photographer—are often docile, whether through mental confusion or because they are just lying there, unconscious. (But if you should show up before they are sufficiently distracted by drink, you are likely to be met with hostility, for the men on the Bowery are not particularly interested in immortality and stardom, and they've had plenty of experience with the Nikon set.) Especially now, the meaning of all such work, past and present, has changed: The liberal New Deal State has been dismantled piece by piece. The War on Poverty has been called off. Utopia has been abandoned, and liberalism itself has been deserted. Its vision of moral idealism spurring general social concern has been replaced with a mean-minded Spencerian sociobiology that suggests, among other things, that the poor may be poor through lack of merit (read Harvard's Richard Herrnstein as well as, of course, between Milton Friedman's lines).[5] There is as yet no organized national Left, only a Right. There is not even drunkenness, only "substance abuse"—a problem of bureaucratic management. The exposé, the compassion and outrage, of documentary fueled by the dedication to reform has shaded over into combinations of exoticism, tourism, voyeurism, psychologism and metaphysics, trophy hunting—and careerism.

Yet documentary still exists, still functions socially in one way or another. Liberalism may have been routed, but its cultural expressions still survive. This mainstream documentary has achieved legitimacy and has a decidedly ritualistic character. It begins in glossy magazines and books, occasionally in newspapers, and becomes more expensive as it moves into art galleries and museums. The liberal documentary assuages any stirrings of conscience in its viewers the way scratching relieves an itch and simultaneously reassures them about their relative wealth and social position; especially the latter, now that even the veneer of social concern has dropped away from the upwardly mobile and comfortable social sectors. Yet this reminder

carries the germ of an inescapable anxiety about the future. It is both flattery and warning (as it always has been). Documentary is a little like horror movies, putting a face on fear and transforming threat into fantasy, into imagery. One can handle imagery by leaving it behind. *(It is them, not us.)* One may even, as a private person, support causes.

Documentary, as we know it, carries (old) information about a group of powerless people to another group addressed as socially powerful. In the set piece of liberal television documentary, Edward R. Murrow's *Harvest of Shame,* broadcast the day after Thanksgiving in 1960, Murrow closes with an appeal to the viewers (then a more restricted part of the population than at present) to *write their congressmen* to help the migrant farm workers, whose pathetic, helpless, dispirited victimhood had been amply demonstrated for an hour—not least by the documentary's aggressively probing style of interview, its "higher purpose" notwithstanding—because *these people* can do nothing for themselves. But which political battles have been fought and won by someone for someone else? Luckily, César Chávez was not watching television but rather, throughout that era, was patiently organizing farm workers to fight for themselves. This difference is reflected in the documentaries made by and for the Farm Workers' Organizing Committee (later the United Farm Workers of America, AFL-CIO), such works as *Sí, Se Puede* (Yes, We Can) and *Decision at Delano;* not radical works, perhaps, but militant works.

In the liberal documentary, poverty and oppression are almost invariably equated with misfortunes caused by natural disasters: Causality is vague, blame is not assigned, fate cannot be overcome. Liberal documentary blames neither the victims nor their willful oppressors—unless they happen to be under the influence of our own global enemy, World Communism. Like photos of children in pleas for donations to international charity organizations, liberal documentary implores us to look in the face of deprivation and to weep (and maybe to send money, if it is to some faraway place where the innocence of childhood poverty does not set off in us the train of thought that begins with denial and ends with "welfare cheat").

Even in the fading of liberal sentiments one recognizes that it is impolite or dangerous to stare in person, as Diane Arbus knew when she arranged

179

her satisfyingly immobilized imagery as a surrogate for *the real thing,* the real freak show. With the appropriate object to view, one no longer feels obligated to suffer empathy. As sixties' radical chic has given way to eighties' pugnacious self-interest, one displays one's toughness in enduring a visual assault without a flinch, in jeering, or in cheering. Beyond the spectacle of families in poverty (where starveling infants and despairing adults give the lie to any imagined hint of freedom and become merely the currently tedious poor), the way seems open for a subtle imputation of pathetic-heroic choice to victims-turned-freaks, of the seizing of fate in straitened circumstances. The boringly sociological becomes the excitingly mythological/psychological. On this territory a more or less overt sexualization of the photographic image is accomplished, pointing, perhaps, to the wellspring of identification that may be the source of this particular fascination.[6]

III

It is easy to understand why what has ceased to be news becomes testimonial to the bearer of the news. Documentary testifies, finally, to the bravery or (dare we name it?) the manipulativeness and savvy of the photographer, who entered a situation of physical danger, social restrictedness, human decay, or combinations of these and saved us the trouble. Or who, like the astronauts, entertained us by showing us the places we never hope to go. War photography, slum photography, "subculture" or cult photography, photography of the foreign poor, photography of "deviance," photography from the past— W. Eugene Smith, David Douglas Duncan, Larry Burrows, Diane Arbus, Larry Clark, Danny Lyon, Bruce Davidson, Dorothea Lange, Russell Lee, Walker Evans, Robert Capa, Don McCullin, . . . these are merely the most currently luminous of documentarian stars.

W. Eugene Smith and his wife, Aileen Mioko Smith, spent the early 1970s on a photo-and-text exposé of the human devastation in Minamata, a small Japanese fishing and farming town, caused by the heedless prosperity of the Chisso chemical firm, which dumped its mercury-laden effluent into their waters. They included an account of the ultimately successful but violence-

ridden attempt of victims to gain redress. When the major court fight was won, the Smiths published a text and many photos in the American magazine *Camera 35*.[7] Smith had sent in a cover photo with a carefully done layout. The editor, Jim Hughes, knowing what sells and what doesn't, ran *a picture of Smith* on the cover and named him "Our Man of the Year" ("*Camera 35*'s first and probably only" one). Inside, Hughes wrote: "The nice thing about Gene Smith is that you know he will keep chasing the truth and trying to nail it down for us in words and pictures; and you know that even if the truth doesn't get better, Gene will. Imagine it!"[8] The Smiths' unequivocal text argues for strong-minded activism. The magazine's framing articles *handle* that directness; they convert the Smiths into Smith; and they congratulate him warmly, smothering his message with appreciation.

Help preserve the "cultural heritage" of the mudmen in New Guinea, urges the travel editor of the Vancouver *Province*. Why should you care? he asks; and he answers, to safeguard the value received for your tourist dollar (Canadians also love Disneyland and Disney World). He is asking for donations to a cultural center. The "mudmen" formerly made large, grimacing pull-on masks to frighten their opponents in war and now wear them in adventure ads for Canadian Club ("We thought we were in a peaceful village until . . ."). The mudmen also appear in the "small room" of Irving Penn's *Worlds in a Small Room*,[9] an effete mimicry of anthropological documentary, not to mention in photos with the Queen. Edward S. Curtis was also interested in preserving someone's cultural heritage and, like other itinerant photographers operating among native North American peoples, he carried a stock of more or less authentic, more or less appropriate (often less, on both counts) clothing and accoutrements with which to deck out his sitters.[10] Here, as with Robert Flaherty a bit later,[11] the heritage was considered sufficiently preserved when captured within the edges of the photographic record and in the ethnographic costume shops being established in museums of "natural" history. In Curtis's case, the photographic record was often retouched, gold-toned, and bound in gold-decorated volumes selling for astonishing sums and financed by J. P. Morgan. We needn't quibble over the status of such historical romances, for the degree of truth in them may (again) be more or less

———

181

equivalent to that in any well-made ethnographic or travel photo or film. An early—1940s, perhaps—Kodak movie book[12] tells North American travelers, such as the Rodman C. Pells of San Francisco, pictured in the act of photographing a Tahitian, how to film natives so that they seem unconscious of the camera. Making such photos heightened patriotic sentiments in the States but precluded any understanding of contemporary native peoples as *experiencing subjects* in impoverished or at least modern circumstances; it even assisted the collective projection of Caucasian guilt and its rationalizations onto the "Indians" for having sunk so and having *betrayed their own heritage.* To be fair, some respect was surely also gained for these people who had formerly been allowed few images other than those of abject defeat; no imagination, no transcendence, no history, no morals, no social institutions, only vice. Yet, on balance, the sentimental pictorialism of Curtis seems repulsively contorted, like the cariogenic creations of Julia Margaret Cameron or the saccharine poems of Longfellow. Personally, I prefer the cooler, more "anthropological" work of Adam Clark Vroman.[13] We can, nevertheless, freely exempt all the photographers, all the filmmakers, as well as all the ethnographers, ancillas to imperialism, from charges of willful complicity with the dispossession of the American native peoples. We can even thank them, as many of the present-day descendants of the photographed people do, for considering their ancestors worthy of photographic attention and thus creating a historical record (the only visual one). We can thank them further for not picturing the destitution of the native peoples, for it is difficult to imagine what good it would have done. If this reminds you of Riis and Hine, who first pictured the North American immigrant and native-born poor, the connection is appropriate as far as it goes but diverges just where it is revealed that Curtis's romanticism furthered the required sentimental mythification of the Indian peoples, by then physically absent from most of the towns and cities of white America. Tradition (traditional racism), which decreed that the Indian was the genius of the continent, had nothing of the kind to say about the immigrant poor, who were fodder for the industrial Moloch and a hotbed of infection and corruption.

Or consider a photo book on the teeming masses of India—how different is looking through it from going to an Indian restaurant or wearing an Indian shirt or sari? We consume the world through images, through shopping, through eating

> Your world is waiting and Visa is there.
> 120 countries
> 2.6 million shops, hotels, restaurants and airlines
> 70,000 banking offices
> For traveling, shopping and cash advances . . .
> Visa is the most widely recognized name in the world.
> We're keeping up with you.

This current ad campaign includes photographs taken here and there in the world, some "authentic," some staged. One photo shows a man and a boy in dark berets on a bicycle on a tree-lined road, with long baguettes of bread tied across the rear of the bike: rural France. But wait—I've seen this photo before, years ago. It turns out that it was done by Elliott Erwitt for the Doyle Dane Bernbach ad agency on a job for the French office of tourism in the fifties. Erwitt received fifteen hundred dollars for the photo, which he staged using his driver and the man's nephew: "The man pedaled back and forth nearly 30 times till Erwitt achieved the ideal composition. . . . Even in such a carefully produced image, Erwitt's gift for documentary photography is evident," startlingly avers Erla Zwingle[14] in the column "Inside Advertising" in the December 1979 issue of *American Photographer*—which also has articles, among others, on Bill Owens's at best ambivalent photos of mid-American suburbs, leisure activities, and work ("sympathetic and honest, revealing the contentment of the American middle class," according to Amy M. Schiffman); on a show of photos from the Magnum news-photo agency held in a Tokyo department store ("soon after the opening [Magnum president Burk] Uzzle flew off to hunt down refugees in Thailand while Glinn remained in Japan, garnering much yen from assignments for the likes of IBM, Seagram,

and Goldman Sachs," says E. F.); on Geoff Winningham's photos of Texas high school football ("Inevitably one can compare him with the legendary Robert Frank, but the difference . . . is that . . . Winningham clearly loves the craziness [more on craziness later] he dwells upon," writes Schiffman); on Larry Clark's photos of Tulsa speed freaks ("A beautiful, secret world, much of it sordid" and "although there is plenty of sex, death, violence, anxiety, boredom . . . there is no polemic apparent . . . so it doesn't really matter whether or not we can trust these photos as documents; to see them as photographs, no more and no less, is enough," remarks Owen Edwards). There is a Washington column by James Cassell complaining that "the administration frowns upon inspired photojournalism" and a page on Gamma photographer David Burnett, who arrived in Santiago de Chile a few days after the brutal putsch in 1973. On a government tour of the infamous stadium where people were detained and shot, he and other photographers "noticed a fresh batch of prisoners." Burnett says, "The Chileans had heard many stories about people being shot or disappearing [in a war does one learn of death from hearing stories?] and they were terribly frightened. The haunting gaze of one man in particular, whose figure was framed by two armed soldiers . . . caught my eye. The picture has always stayed with me." We see a contact sheet and that image enlarged. The article, by Yvette E. Benedek, continues: "Like most agency photographers, Burnett must shoot both color and black and white to satisfy many publications in different countries, so he often works with three Nikons and a Leica. His coverage of the coup . . . won the Overseas Press Club's Robert Capa Award . . . 'for exceptional courage and enterprise.'"

What happened to the man (actually men) in the photo? The question is inappropriate when the subject is photographs. And photographers. The subject of the article is the photographer. The name of the magazine is *American Photographer.* In 1978 there was a small news story on a historical curiosity: the real-live person who was photographed by Dorothea Lange in 1936 in what became *the world's most reproduced photograph.* Florence Thompson, seventy-five in 1978, a Cherokee living in a trailer in Modesto, California, was quoted by the Associated Press as saying, "That's my picture hanging all

over the world, and I can't get a penny out of it." She said that she is proud to be its subject but asked, "What good's it doing me?" She has tried unsuccessfully to get the photo suppressed. About it, Roy Stryker, genius of the photo section of the Farm Security Administration, for which Lange was working, said in 1972: "When Dorothea took that picture, that was the ultimate. She never surpassed it. To me, it was *the* picture of Farm Security. . . . So many times I've asked myself what is she thinking? She has all of the suffering of mankind in her but all of the perseverance too. . . . You can see anything you want to in her. She is immortal."[15] In 1979, a United Press International story about Mrs. Thompson said she gets $331.60 a month from Social Security and $44.40 for medical expenses. She is of interest solely because she is an incongruity, a photograph that has aged; of interest solely because she is a postscript to an acknowledged work of art. Mr. Burnett's Chilean photograph will probably not reach such prominence (I've never seen it before, myself), and we will not discover what happened to the people in it, not even forty-two years later.[16]

A good, principled photographer I know, who works for an occupational health and safety group and cares about how his images are understood, was annoyed by the articles about Florence Thompson. He thought they were cheap, that the photo *Migrant Mother,* with its obvious symbolic dimension, stands over and apart from her, is *not-her,* has an independent life history. (Are photographic images, then, like civilization, made on the backs of the exploited?) I mentioned to him that in the book *In This Proud Land,*[17] Lange's field notes are quoted as saying, "She thought that my pictures might help her, and so she helped me." My friend the labor photographer responded that the photo's publication caused local officials to fix up the migrant camp, so that although Mrs. Thompson didn't benefit directly, others like her did. I think she had a different idea of their bargain.

I think I recognize in his response the well-entrenched paradigm in which a documentary image has two moments: (1) the "immediate," instrumental one, in which an image is caught or created out of the stream of the present and held up as testimony, as evidence in the most legalistic of senses,

arguing for or against a social practice and its ideological-theoretical supports, and (2) the conventional "aesthetic-historical" moment, less definable in its boundaries, in which the viewer's argumentativeness cedes to the organismic pleasure afforded by the aesthetic "rightness" or well-formedness (not necessarily formal) of the image. The second moment is ahistorical in its refusal of *specific* historical meaning yet "history minded" in its very awareness of the pastness of the time in which the image was made. This covert *appreciation* of images is dangerous insofar as it accepts *not* a dialectical relation between political and formal meaning, not their interpenetration, but a hazier, more reified relation, one in which topicality drops away as epochs fade, and the aesthetic aspect is, if anything, enhanced by the loss of specific reference (although there remains, perhaps, a cushioning backdrop of vague social sentiments limiting the "mysteriousness" of the image). I would argue against the possibility of a nonideological aesthetic; any response to an image is inevitably rooted in social knowledge—specifically, in social understanding of cultural products. (And from her published remarks one must suppose that when Lange took her pictures she was after just such an understanding of them, although by now the cultural appropriation of the work has long since removed it from this perspective.)

A problem with trying to make such a notion workable within actual photographic practice is that it seems to ignore the mutability of ideas of aesthetic rightness. That is, it seems to ignore the fact that historical interests, not transcendental verities, govern whether any particular form is seen as adequately revealing its meaning—and that you cannot second-guess history. This mutability accounts for the incorporation into legitimate photo history of the work of Jacob Riis alongside that of the incomparably more careful Lewis Hine, of Weegee (Arthur Fellig) alongside Danny Lyon. It seems clear that those who, like Lange and the labor photographer, identify a powerfully conveyed meaning with a primary sensuousness are pushing against the gigantic ideological weight of classical beauty, which presses on us the understanding that in the search for transcendental form, the world is merely the stepping-off point into aesthetic eternity.

The present cultural reflex of wrenching all art works out of their contexts makes it difficult to come to terms with this issue, especially without seeming to devalue such people as Lange and the labor photographer, and their work. I think I understand, from the inside, photographers' involvement with *the work itself,* with its supposed autonomy, which really signifies its belongingness to their own body of work and to the world of photographs.[18] But I also become impatient with this perhaps-enforced protectiveness, which draws even the best intentioned of us nearer and nearer to exploitiveness.

The Sunday *New York Times Magazine,* bellwether of fashionable ideological conceits, in 1980 excoriated the American documentary milestone *Let Us Now Praise Famous Men* (written by James Agee and photographed by Walker Evans in July and August of 1936, in Hale County, Alabama, on assignment from *Fortune* magazine, rejected by the magazine and only published in book form in 1941).[19] The critique[20] is the same as that suggested in germ by the Florence Thompson news item. We should savor the irony of arguing before the ascendant class fractions represented by the readership of the Sunday *New York Times* for the protection of the sensibilities of those marginalized sharecroppers and children of sharecroppers of forty years ago. The irony is greatly heightened by the fact that (as with the Thompson story) the "protection" takes the form of a new documentary, a "rephotographic project," a reconsignment of the marginal and pathetic to marginality and pathos, accompanied by a stripping away of the false names given them by Agee and Evans—Gudger, Woods, Ricketts—to reveal their real names and "life stories." This new work manages to institute a new genre of victimhood—the victimization by *someone else's* camera of helpless persons, who then hold still long enough for the indignation of the new writer to capture them, in words and images both, in their current state of decrepitude. The new photos appear alongside the old, which provide a historical dimension, representing the moment in past time in which these people were first dragged into history. As readers of the Sunday *Times,* what do we discover? That the poor are ashamed of having been exposed as poor, that the photos have been the source

of festering shame. That the poor remain poorer than we are, for although *they* see their own rise in fortunes, their escape from desperate poverty, we *Times* readers understand that our relative distance has not been abridged; we are still doing much better than they. Is it then difficult to imagine these vicarious protectors of the privacy of the "Gudgers" and "Ricketts" and "Woods" turning comfortably to the photographic work of Diane Arbus?[21]

The credibility of the image as the explicit trace of the comprehensible in the living world has been whittled away for both "left" and "right" reasons. An analysis that reveals social institutions as serving one class by legitimating and enforcing its domination while hiding behind the false mantle of even-handed universality necessitates an attack on the monolithic cultural myth of objectivity (transparency, unmediatedness), which implicates not only photography but all journalistic and reportorial objectivity used by mainstream media to claim ownership of all truth. But the Right, in contradistinction, has found the attack on credibility or "truth value" useful to its own ends. Seeing people as fundamentally unequal and regarding elites as natural occurrences, composed of those best fitted to understand truth and to experience pleasure and beauty in "elevated" rather than "debased" objects (and regarding it as social suicide to monkey with this natural order), the Right wishes to seize a segment of photographic practice, securing the primacy of authorship, and to isolate it within the gallery–museum–art-market nexus, effectively differentiating elite understanding and its objects from common understanding. The result (which stands on the bedrock of financial gain) has been a general movement of legitimated photography discourse to the right—a trajectory that involves the aestheticization (consequently, formalization) of meaning and the denial of content, the denial of the existence of the political dimension. Thus, instead of the dialectical understanding of the relation between images and the living world that I referred to earlier—in particular, of the relation between images and ideology—the relation has simply been severed in thought.

The line that documentary has taken under the tutelage of John Szarkowski at New York's Museum of Modern Art—a powerful man in a pow-

erful position—is exemplified by the career of Garry Winogrand, who aggressively rejects any responsibility (or shall we say culpability?) for his images and denies any relation between them and shared or public human meaning. Just as Walker Evans is the appropriate person within the history of street photography to compare with Lee Friedlander, the appropriate comparison for Winogrand is Robert Frank (who is compared with almost everyone), whose purloined images of American life in the 1950s suggest, however, all the passionate judgments that Winogrand disclaims.[22] Images can yield any narrative, Winogrand says, and all meaning in photography applies only to what resides within the "four walls" of the framing edges. What can, in Frank's work, be identified as a personally mediated presentation has become, in Szarkowski's three "new documentarians," Winogrand, Arbus, and Friedlander, a privatized will o' the wisp:

> Most of those who were called documentary photographers a generation ago . . . made their pictures in the service of a social cause. . . . to show what was wrong with the world, and to persuade their fellows to take action and make it right. . . . [A] new generation of photographers has directed the documentary approach toward more personal ends. Their aim has not been to reform life, but to know it. Their work betrays a sympathy—almost an affection—for the imperfections and the frailties of society. They like the real world, in spite of its terrors, as the source of all wonder and fascination and value—no less precious for being irrational. . . . What they hold in common is the belief that the commonplace is really worth looking at, and the courage to look at it with a minimum of theorizing.[23]

Szarkowski wrote that introduction to the *New Documents* show in 1967, in an America already several years into the "terrors" and disruptions of the Vietnam War. He makes a poor argument for the value of disengagement from a "social cause" and in favor of a connoisseurship of the tawdry.

How, for example, do we define the boundaries and extent of "the world" from looking at these photographers' images, and how we can be said to "know it"? The global claim he makes for their work serves to point out the limits of its actual scope. At what elevated vantage point must we stand to regard society as having "frailties" and "imperfections"? High enough to see it as a circus before our eyes, a commodity to be "experienced" the way a recent vodka ad entices us to "experience the nineteenth century" by having a drink. In comparison with nightmarish photos from Vietnam and the United States' Dominican adventure, the work of Friedlander, Winogrand, and Arbus might be taken as evidencing a "sympathy" for the "real world." Arbus had not yet killed herself, though even that act proved to be recuperable by Szarkowki's ideological position. In fact, the forebears of Szarkowski are not those "who made their pictures in the service of a social cause" but bohemian photographers like Brassaï and the early Kertész and Cartier-Bresson. But rather than the sympathy and almost-affection that Szarkowski claimed to find in the work, I see impotent rage masquerading as varyingly invested snoop sociology—fascination and affection are far from identical. A dozen years later, aloofness has given way to a more generalized nihilism.

In the San Francisco Sunday paper for November 11, 1979, one finds Jerry Nachman, news director of the local headline-and-ad station, saying:

> In the sixties and seventies all-news radio had its place in people's lives: What was happening in Vietnam? Did the world blow up last night? Who's demonstrating where? . . . Now we're on the cusp of the eighties and things are different. To meet these changes KCBS must deliver what's critical in life in a way that's packaged even perversely. . . . There's a certain craziness that goes on in the world and we want people to understand that we can chronicle it for them.

Nachman also remarks, "Our broadcasters tell people what they saw out there in the wilderness today." The wilderness is the world, and it inspires in us, ac-

cording to this view, both anxiety and perverse fascination, two varieties of response to a spectacle.

IV

Imperialism breeds an imperialist sensibility in all phases of cultural life. A safari of images. Drunken bums[24] retain a look of threat to the person. (Not, perhaps, as well as foreign prisoners . . .)[25] They are a drastic instance of a male society, the lumberjacks or prospectors of the cities, the men who (seem to) choose not to stay within the polite bourgeois world of (does "of" mean "made up of" or "run by" or "shaped by" or "fit for"?) *women and children*. They are each and every one an unmistakably identifiable instance of a physically coded social reality. The cynicism they may provoke in observers is far different from the cynicism evoked by images of the glitter world, which may end in a politically directed anger. *Directed toward change.* Bums are an "end game" in a "personal tragedy" sort of chance. They may be a surreptitious metaphor for the "lower class" but they are not to be confused with a social understanding of the "working class." Bums are, perhaps, to be finally judged as *vile,* people who deserve a kick for their miserable *choice.* The buried text of photographs of drunks is not a treatise on political economy, on the manipulation of the unemployment rate to control inflation and keep profits up and labor's demands down, on the contradictory pressures on the institution of the family under capitalism, on the appeal of consciousness-eradicating drugs for people who have little reason to believe in themselves.

V

The Bowery in two inadequate descriptive systems is a work of refusal. It is not defiant antihumanism. It is meant as an act of criticism; the text you are reading now runs on the parallel track of another descriptive system. There are no stolen images in this book; what could you learn from them that you didn't already know? If impoverishment is a subject here, it is more centrally the

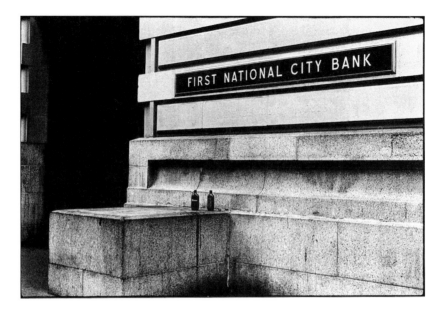

Martha Rosler, from *The Bowery in two inadequate descriptive systems,* photo–text work (1974–75). Forty-five black-and-white gelatin silver prints mounted on 22 black mountboards.

plastered stuccoed

rosined shellacked

vulcanized

inebriated

polluted

impoverishment of representational strategies tottering about alone than that of a mode of surviving. The photographs are powerless to *deal with* the reality that is yet totally comprehended-in-advance by ideology, and they are as diversionary as the word formations—which at least are closer to being located within the culture of drunkenness rather than being framed on it from without.

There is a poetics of drunkenness here, a poetry-out-of-prison. Adjectives and nouns built into metaphoric systems—food imagery, nautical imagery, the imagery of industrial processes, of militarism, derisive comparisons with animal life, foreignisms, archaisms, and references to still other universes of discourse—applied to a particular state of being, a subculture of sorts, and to the people in it.

The words begin outside the world of skid row and slide into it, as people are thought to slide into alcoholism and skid to the bottom of the row. The text ends twice, comprising two series. First the adjectives, beginning with playful metaphor to describe the early, widely acceptable stages of intoxication and moving toward the baldness of stupor and death. A second series begins, of nouns belonging firmly to the Bowery and not shared with the world outside. Occasionally the texts address the photographs directly; more often, if there is a connection, it is the simultaneous darkening of mood as the two systems run along concurrently.

The photos represent a walk down the Bowery seen as arena and living space, as a commercial district in which, after business hours, the derelict residents inhabit the small portal spaces between shop and street. The shops range from decrepitude to splendor, from the shabbiest of ancient restaurant-supply houses or even mere storage spaces to astonishing crystal grottoes whose rapt cherubim entwined in incandescent fixtures and whose translucent swans in fountains of fiber-optic tubes relentlessly dripping oil blobs into dishes radiate into the street. Above the street, the now-infrequent flophouses and their successors the occasional, unseen living lofts, vary from mean raw space to constructed tropical paradises, indoor boweries whose residents must still step over the sleeping bums in the doorway and so are not usually the type

who think of having kids. None of this matters to the street, none of it changes the quality of the pavement, the shelter or lack of it offered by the doorways, many of which are spanned by inhospitable but visually discreet rows of iron teeth—meant to discourage sleep but generally serving only as peas under the mattress of a rolled-up jacket. While the new professional-managerial urban gentry devour discarded manufactories and vomit up architectural suburbiana in their place, the Bowery is (so far) still what it has been for a hundred years and more. Bottles, and occasionally shoes, never flowers, are strewn on the Bowery, despite a name that still describes its country past.

The photos here are radical metonymy, with a setting implying the condition itself. I will not yield the material setting, though certainly it explains nothing. The photographs confront the shops squarely, and they supply familiar urban reports. *They are not reality newly viewed.* They are not reports from a frontier, messages from a voyage of discovery or self-discovery. There is nothing new attempted in a photographic style that was constructed in the 1930s when the message itself was newly understood, differently embedded. I am quoting words and images both.

VI

Sure, images that are meant to make an argument about social relations can "work." But the documentary that has so far been granted cultural legitimacy has no such argument to make. Its arguments have been twisted into generalizations about the condition of "man," which is by definition not susceptible to change through struggle. And the higher the price that photography can command as a commodity in dealerships, the higher the status accorded to it in museums and galleries, the greater will be the gap between that kind of documentary and another kind, a documentary incorporated into an explicit analysis of society and at least the beginning of a program for changing it. The liberal documentary, in which members of the ascendant classes are implored to have pity on and to rescue members of the oppressed, now belongs to the past. The documentary of the present, a shiver-provoking appreciation

of alien vitality or a fragmented vision of psychological alienation in city and town, coexists with the germ of another documentary—a financially unloved but growing body of documentary works committed to the exposure of specific abuses caused by people's jobs, by the financier's growing hegemony over the cities, by racism, sexism, and class oppression; works about militancy or about self-organization, or works meant to support them. Perhaps a radical documentary can be brought into existence. But the common acceptance of the idea that documentary precedes, supplants, transcends, or cures full, substantive social activism is an indicator that we do not yet have a real documentary.

NOTES

Permission to reproduce Irving Penn's photograph *Asaro Mudmen, New Guinea, 1970* was refused by Condé Nast Publications, Inc., in a one-sentence rejection stating: "Unfortunately, the material requested by you is unavailable for republication." By phone their representative suggested that it was Penn who had refused the request.

Permission to reproduce a photograph of Ida Ruth Tingle Tidmore, one of Walker Evans's Hale County subjects, taken in 1980 by Susan Woodley Raines and reproduced in conjunction with Howell Raines's article "Let Us Now Revisit Famous Folk" in the Sunday *New York Times Magazine* of May 25, 1980, was refused by Ms. Raines because Ms. Tidmore was suing Mr. Raines over the content of the article (see note 20). The photo requested was captioned "Ida Ruth Tingle Tidmore and her husband, Alvin, outside their mobile home, which is adjacent to Alvin's collection of junked automobiles." A small corner inset showed one of Evans's photos from *Let Us Now Praise Famous Men* and was captioned "Young Ida Ruth struck this pensive pose for Walker Evans' camera." However, the inset photo is identified in *Walker Evans: Photographs for the Farm Security Administration 1935–1938* (New York: Da Capo Press, 1973, photo number 298) as being of Ida Ruth's younger sister Laura Minnie Lee Tengle (*sic*) (LC-USZ62-17931).

1. In England, where documentary practice (in both film and photography) has had a strong public presence (and where documentary was named, by John Grierson), with well-articulated theoretical ties to social-democratic politics, it is customary to distinguish social documentary from documentary per se (photos of ballerinas, an English student remarked contemptuously). The more general term denotes photographic practice having

a variety of aesthetic claims but without involvement in exposé. (What is covered over by this blanket definition, such as the inherently racial type of travelogue, with its underpinnings of essentialist rather than materialist theories of cultural development, will have to remain under wraps for now.) Of course, such distinctions exist in documentary practice everywhere, but in the United States, where positions on the political spectrum are usually not named and where photographers and other artists have only rarely and sporadically declared their alignment within social practice, the blurring amounts to a tactic. A sort of popular-front wartime Americanism blended into Cold War withdrawal, and it became socially mandatory for artists to disaffiliate themselves from Society (meaning social negativity) in favor of Art; in the postwar era, one finds documentarians locating themselves, actively or passively, as privatists (Dorothea Lange), aestheticians (Walker Evans, Helen Levitt), scientists (Berenice Abbott), surrealists (Henri Cartier-Bresson), social historians (just about everyone, but especially photojournalists like Alfred Eisenstaedt), and just plain "lovers of life" (Arthur Rothstein). The designation "concerned photography" latterly appears, signifying the weakest possible idea of (or substitute for) social engagement, namely, compassion, of whom perhaps the war photographers David Douglas Duncan, Donald McCullin, and W. Eugene Smith have been offered as the signal examples. If this were a historical essay, I would have to begin with ideas of truth and their relation to the developments of photography, would have to spell out the origins of photographic instrumentalism, would have to tease apart the strands of "naturalistic," muckraking, news, socialist, communist, and "objective" photographic practice, would have to distinguish social documentary from less defined ideas of documentary unqualified. . . .

2. Jacob A. Riis, *The Making of an American* (1901; reprint ed., New York: Harper Torchbooks, 1966), p. 267.

3. In quoting Jacob Riis, I am not intending to elevate him above other documentarians—particularly not above Lewis Hine, whose straightforward involvement with the struggles for decent working hours, pay, and protections, as well as for decent housing, schooling, and social dignity, for the people whom he photographed and the social service agencies intending to represent them, and whose dedication to photography as the medium with which he could best serve those interests, was incomparably greater that Riis's, to whom photography, and probably those whom he photographed, were at best an adjunct to, and a moment in, a journalistic career.

———

197

Margaret Sanger, a nurse in turn-of-the-century New York, became a crusader for women's control over reproduction. She founded the American Birth Control League in the 1920s (and much later became the first president of the International Planned Parenthood Federation) and similar leagues in China and Japan. Like many women reformers, she was arrested and prosecuted for her efforts, which ranged from disseminating birth control literature to maintaining a clinic in the Lower East Side. Many other people, including Jane Addams, founder of Hull House in Chicago, and Lillian Wald, founder of New York's Visiting Nurse Association, might be cited as dedicated reformers in this tradition of middle-class championship of the oppressed, with varying relations to the several strategies of self-help, charity, and the publication of wrongs to awaken a healing empathic response.

4. The buried tradition of "socialist photography," a defined—though no doubt restricted—practice in some parts of Europe and North America in the late nineteenth and early twentieth centuries, is being excavated by Terry Dennett (of Photography Workshop) in England. His research so far suggests that the showing of lantern slides depicting living and working conditions and militant actions were a regular part of the working-class political organizing, and references to "socialist photography" or photographers appeared in the leftist press in that period. Furthermore, the world's first news-photo agency, World's Graphic Press, seems to have had a leftish orientation. In the collection *Photography/Politics: One* (London: Photography Workshop, 1979), a start was made toward a worldwide history of the photo leagues. In relation to Left photography, one must mention the illustrated magazines, the most popular of which was the German *Arbeiter-Illustrierte Zeitung,* or *AIZ* (Worker-Illustrated Newspaper, 1924–38).

5. For a discussion of the work of Richard Herrnstein, chairman of the psychology department at Harvard University, see Karl W. Deutsch and Thomas B. Edsall, "The Meritocracy Scare," *Society* (September-October 1972), and Richard Herrnstein, Karl W. Deutsch, and Thomas B. Edsall, "I.Q.: Measurement of Race and Class" (in which Herrnstein debates Deutsch and Edsall on some of their objections to his work), *Society* (May-June 1973); both are reprinted in Bertram Silverman and Murray Yanowitz, eds., *The Worker in "Post-Industrial" Capitalism: Liberal and Radical Responses* (New York: Free Press, 1974). See also Richard Herrnstein's original article, "I.Q.," in *Atlantic Monthly,* September 1971, 43–64; and Arthur Jensen, "How Much Can We Boost IQ and Scholastic Achievement?" *Harvard Educational Review,* reprint series no. 2 (1969): 126–34. See, e.g., Samuel Bowles

and Herbert Gintis, "IQ in the U.S. Class Structure," *Social Policy* (November-December 1972 and January-February 1973), also reprinted in Silverman and Yanowitz, *The Worker*, for a critique of the theorizing behind intelligence testing. There have been many critiques of I.Q.—a very readable one is Jeffrey Blum's *Pseudoscience and Mental Ability* (New York: Monthly Review Press, 1977)—and of sociobiology, exposing their ideological foundations and poor scientific grounding—critiques that haven't inhibited either enterprise.

Milton Friedman, best known of the extremely conservative "Chicago school" (University of Chicago) anti-Keynesian, "monetarist" economists, has strongly influenced the policies of the Conservative Thatcher government in England and the rightist Begin government in Israel and has advised many reactionary politicians around the world (and "los Chicago boys" laid the foundations for the brutally spartan policies of the Pinochet military regime toward all but the richest Chileans). Implicit in the pivotal conception of economic "freedom" (competition) is that the best will surely rise and the worst will sink to their proper level. That is the only standard of justice. In remarks made while accepting an award from the Heritage Foundation, Friedman, referring to the success of his public (i.e., government- and corporate-sponsored) television series *Free to Choose*, commented that conservatives had managed to alter the climate of opinion such that the series could succeed and proclaimed the next task to be the promulgation of "our point of view" in philosophy, music, poetry, drama, and so on. He has also recommended the dismantling of the National Endowments for the arts and the humanities (government funding agencies). We can expect the currency of such policies and their ideological corollaries to grow as they increasingly inform the policies and practices of rightist U.S. governments.

6. A remarkable instance of one form that such fascination may take, in this case one that presented itself as militantly chaste (and whose relation to identification I won't take on now), is provided by the lifelong obsession of an English Victorian barrister, Arthur J. Munby, which was the *observation* of female manual laborers and servants. (The souvenir *cartes de visite* of young female mine workers, at the pit head and in studio poses, suggest that some version of Munby's interest was widely shared by members of his class.) Simply seeing them dressed for work rather than watching them work generally sufficed for him, though he often "interviewed" them. Munby was no reformer or ally of feminists, but in opposing protective legislation he considered himself a champion of working-class women, particularly the "robust" ones whose company he much preferred to that of the genteel women of his class, sufferers from the cult of enforced feebleness. After a secret

liaison of nineteen years with a maid-of-all-work (a low servant rank), Hannah Cullwick, Munby married her but kept the marriage secret, and although he dressed her as a lady for their journeys, they lived separately and she remained a servant—often waiting on him. He also insisted she keep a diary. Munby's great interest in the new field of photography was frustrated by the fact that as in painting most aspirants had no interest in images of labor; he bought whatever images of working women he could find and arranged for others, often escorting women in work dress to the photo studio and sometimes using Hannah as a stand-in. He would dress her in various work costumes for photo sessions, and his diary describes how, pretending no relationship, he savored the sight of the photographer bodily arranging her poses and the degradation it imposed on her. In 1867 he took her to be photographed by O. J. Rejlander, the famous painter-turned-photographer of (simulated) "genre" scenes.

The huge Munby collection at Cambridge, consisting of six hundred surviving photos as well as his sketches and private papers running to millions of words, provided the material for Derek Hudson's *A. J. Munby, Man of Two Worlds: The Life and Diaries of Arthur J. Munby, 1828–1910* (London: J. Murray, 1972), and Michael Hiley's lavishly illustrated *Victorian Working Women: Portraits from Life* (London: Gordon Fraser, 1979). (I am profoundly grateful to Stephen Heath not only for calling Munby and his preoccupations to my attention but also for generously sharing his own research with me.)

Not in relation to photographic imagery but to the sexualization of class itself that lies behind Munby's scopophilic obsession, we note that in Victorian England, where only working-class women were supposed to have retained any interest in sexuality, gentlemen might cruise working-class neighborhoods to accost and rape young women.

7. April 1974. (I thank Allan Sekula for calling this issue to my attention.) The Smiths subsequently published a book whose title page reads *Minamata, Words and Photographs by Eugene Smith and Aileen M. Smith* (New York: Holt, Rinehart and Winston, 1975). I am not arguing for or against Smith's art-history-quoting, bravura photographic style. Nevertheless, and in spite of the ideological uses to which Smith's (and in this case the Smiths') work has been put in the photo world, the Smiths' work at Minamata was important in rallying support for the struggle throughout Japan.

8. *Camera 35* (April 1974): 3.

9. Irving Penn, *Worlds in a Small Room, by Irving Penn as an Ambulant Studio Photographer* (New York: Grossman, 1974).

10. The work of Edward S. Curtis, incorporating photographs from his monumental work *The North American Indian,* is now widely available in recent editions, including Ralph Andrews, *Curtis' Western Indians* (Sparks, Nev.: Bonanza Books, 1962), and the far more elevated editions of the 1970s: the very-large-format *Portraits from North American Indian Life* (New York: Outerbridge & Lazard, 1972; small-format paperback edition, New York: A & W Publishers, 1975); an exhibition catalogue for the Philadelphia Museum, *The North American Indians* (Millerton, N.Y.: Aperture, 1972); and *In a Sacred Manner We Live* (Barre, Mass.: Barr Publishing, 1972; New York: Weathervane, 1972). One can speculate that it was the interest of the "counterculture" in tribalism in the late 1960s and early 1970s coupled with Native American militancy of the same period that ultimately called forth these classy new editions; posters of some of Curtis's (and others') portraits served as emblems of resistance for radicals, office workers, college students, and dope smokers.

Curtis, who lived in Seattle, photographed Native Americans for several years before J. Pierpont Morgan—to whom Curtis had been sent by Teddy Roosevelt—agreed to back his enterprise. (Curtis's "first contact with men of letters and millionaires," in his phrase, had come about accidentally: on a mountaineering expedition Curtis aided a stranded party of rich and important men, including the chiefs of the U.S. Biological Survey and the Forestry Department and the editor of *Forest and Stream* magazine, and the encounter led to a series of involvements in governmental and private projects of exploration and the shaping of attitudes about the West.) The Morgan Foundation advanced him fifteen thousand dollars per year for the next five years and then published (between 1907 and 1930) Curtis's resulting texts and photographs in a limited edition of 500 twenty-volume sets, selling for three thousand dollars (now worth over eighty thousand dollars and rising). The title page read:

> The North American Indian, Being a Series of Volumes Picturing and Describing the Indians of the United States and Alaska, written, illustrated and published by Edward S. Curtis, edited by Frederick Webb Hodge [of the United States Bureau of American Ethnology], foreword by Theodore Roosevelt, field research under the patronage of J. Pierpont Morgan, in twenty volumes.

Fabulously wealthy society people, including Andrew Carnegie, Solomon R. Guggenheim, Alexander Graham Bell, Mrs. Frederick W. Vanderbilt, and the kings of England and Belgium, were among the sets' early subscribers. But according to Curtis, over half the cost of a million and a half dollars was borne by Morgan and his estate.

Curtis dedicated himself completely to his task, and in addition to his photography and notes (and the writing of popular books, two of which became best-sellers), he recorded thousands of songs on wax rolls, many of which, along with oral histories, were transcribed and published in his *magnum opus.* Curtis's fictionalized film about the Kwakiutl of Vancouver Island, British Columbia, originally titled *In the Land of the Head Hunters* (1914), has recently been released under the title *In the Land of the War Canoes.*

On the subject of costuming, see, for example, Joanna Cohan Scherer, "You Can't Believe Your Eyes: Inaccuracies in Photographs of North American Indians," *Studies in the Anthropology of Visual Communication* 2:2 (Fall 1975), reprinted in *Exposure* (Journal of the Society for Photographic Education) 16:4 (Winter 1978).

Curtis's brother, Asahel Curtis, was a commercial photographer and city booster in Seattle and an enthusiast of development. A book of the distinctly nonpictorialist photographs of life and especially commerce in the Puget Sound area has been assembled and published by David Sucher as *An Asahel Curtis Sampler* (Seattle: Puget Sound Access, 1973). The one brother was integrated into the system of big capital and national government, the other into that of small business and regionalism.

11. Robert Flaherty is well known for his fictionalized ethnographic films, especially the first, *Nanook of the North* (made in 1919–20, released in 1922). A catalogue of his photographs (formerly ignored) of the Inuit, with several essays and many reproductions, has recently been published by the Vancouver Art Gallery: Joanne Birnie Danzker, ed., *Robert Flaherty, Photographer-Filmmaker: The Inuit 1910–1922* (Vancouver: Vancouver Art Gallery, 1980).

12. Eastman Kodak Company, *How to Make Good Movies* (Rochester, N.Y.: Kodak, n.d.).

13. Cameron's work can be found in Graham Ovenden, ed., *Victorian Album: Julia Margaret Cameron and Her Circle* (New York: Da Capo Press, 1975), and elsewhere. For Vroman's work, see Ruth Mahood, ed., *Photographer of the Southwest: Adam Clark Vroman, 1856–1916* (Los Angeles: Ward Ritchie Press, 1961; reprinted, Sparks, Nev.: Bonanza

Books, n.d.); or William Webb and Robert A. Weinstein, eds., *Dwellers at the Source: Southwestern Indian Photographs of Adam Clark Vroman, 1895–1904* (New York: Grossman, n.d.). It might be noted that Vroman was occasionally quite capable (as were Hine and Smith) of thrusting his work into the mold of the "traditional" Western sentimental iconographic coding of piety, humbleness, simplicity, and the dignity of labor: a photo of a mother and child is titled *Hopi Madonna;* one of a man working is called *Man with a Hoe.*

14. Zwingle's story seems to derive almost verbatim from the book *Private Experience, Elliott Erwitt: Personal Insights of a Professional Photographer,* with text by Sean Callahan and the editors of Alskog, Inc. (Los Angeles: Alskog/Petersen, 1974). The strange assertion about Erwitt's gift for documentary follows an interestingly candid quotation from ad agency president Bill Bernbach (as does most of the anecdote): "Elliott was able to grasp the idea quickly and *turn it into a documentary photograph.* This was tremendously important to us because the whole success of the campaign rested on the *believability* of the photographs. We were telling people that there was a France outside of Paris, and Elliott *made it look authentic*" (p. 60, emphasis added). In repeating the book's remark that Erwitt had achieved "the ideal composition"—called in the book "the precise composition"—the focus point marked with a stone, Zwingle has ignored the fact that the two photos—the one shown in *Private Experience* and the one used by Visa—are not quite identical (and the one in the ad is flopped). Questions one might well ask include what does "documentary" mean? (This question, for example, lay at the heart of an often-cited political furor precipitated when photographer Arthur Rothstein placed a locally obtained cow skull in various spots in drought-stricken South Dakota to obtain "the best" documentary photograph. When FDR was traveling through the area months later, the anti-New Deal editor of the *N. D. Fargo & Forum* featured one of the resulting photos [as sent out by the Associated Press, with its own caption] as "an obvious fake," implying that trickery lay at the heart of the New Deal.) And how precise is a "precise" or "ideal" composition? As to the relationship between documentary and truth: The bulk of Zwingle's article is about another photo used by Visa, this one of two (Bolivian) Indian women that the photographer (not Erwitt) describes as having been taken during a one-day sojourn in Bolivia, without the women's knowledge, and in which "some graffiti, . . . *a gun and the initials ELN, were retouched out to emphasize the picture's clean, graphic style*" (p. 94, emphasis added). The same photographer shot a Polynesia ad for Visa in San Francisco's Golden Gate Park using "a Filipino model from San Jose" who "looks more colorful in the picture than she

did in real life. She was freezing" (pp. 94–95). The question of documentary in the wholly fabricated universe of advertising is a question that can have no answer.

15. Roy Emerson Stryker and Nancy Wood, *In This Proud Land: America, 1935–1943, as Seen in the FSA Photographs* (Greenwich, Conn.: New York Graphic Society, 1973; New York: Galahad Books, 1973), p. 19.

16. [Sometime at the end of the twentieth century, it seems, this man, a survivor of the terror, was identified and located.]

17. Stryker and Wood, *In This Proud Land,* p. 19.

18. I am not speculating about the "meaning" of photography to Lange but rather speaking quite generally here.

19. Agee and Evans went to Hale County to do an article or a series on a white share-cropper family for Henry Luce's *Fortune* magazine; because Evans was employed by the Historical Section of the Farm Security Administration, it was agreed that his negatives would belong to it. When Agee and Evans completed their work (dealing with three families), *Fortune* declined to publish it; it finally achieved publication in book form in 1941. Its many editions have included, with the text, anywhere from sixteen to sixty-two of the many photographs that Evans made. A new, larger, and more expensive paperback edition has recently been published; during Agee's lifetime the book sold about six hundred copies.

 It hardly needs to be said that in the game of waiting out the moment of critique of some cultural work it is the capitalist system itself (and its financial investors) that is the victor, for in cultural matters the pickings of the historical garbage heap are worth far more than the critical moves of the present. By being chosen and commodified, by being *affirmed,* even the most directly critical works in turn may be taken to affirm the system they had formerly indicted, which in its most liberal epochs parades them through the streets as proof of its open-mindedness. In this case, of course, the work did not even see publication until its moment had ended.

20. Howell Raines, "Let Us Now Praise Famous Folk," *New York Times Magazine,* May 25, 1980, pp. 31–46. (I thank Jim Pomeroy for calling this article to my attention and giv-

ing me a copy of this issue.) Raines is the chief of the *Times*'s Atlanta bureau. The article seems to take for granted the uselessness of Agee's and Evans's efforts and in effect convicts them of the ultimately tactless sin of prying. To appreciate the shaping effects of one's anticipated audience, compare the simple "human interest" treatment of Allie Mae Fields ("Woods") Burroughs ("Gudger") Moore in Scott Osborne, "A Walker Evans Heroine Remembers," *American Photographer* (September 1979): 70–73, which stands between the two negative treatments: the *Times*'s and the sensationalist newswire stories about Florence Thompson, including ones with such headlines as "'Migrant Mother' doubtful, she doesn't think today's women match her" (*Toronto Star,* November 12, 1979). Mrs. Moore (she married a man named Moore after Floyd Burroughs's death), too, lived in a trailer, on Social Security (the article says $131 a month—surely it is $331.60, as Mrs. Thompson received), plus Medicare. But unlike Thompson and Mrs. Moore's relatives as described by Raines, she "is not bitter." Osborne ends his article thus: "Allie Mae Burroughs Moore has endured She has survived Evans [she died, however, before the article appeared], whose perception produced a portrait of Allie Mae Burroughs Moore that now hangs on permanent display in the Museum of Modern Art. Now the eyes that had revealed so much in that picture stare fixedly at the violet rim along the horizon. 'No, I wouldn't change my life none,' she says." According to Raines, *that picture* is the most sought-after of all Evans's Alabama photos, and one printed by Evans would sell for about four thousand dollars. Predictably, in Osborne's story, Mrs. Moore, contemplating the photo, accepts its justice, while Raines has Mrs. Moore's daughter, after her mother's death, bitterly saying how much her mother had hated it and how much unlike her it looked.

21. In the same vein, but in miniature, and without the ramified outrage but with the same joke on the photographed persons—that they allowed themselves to be twice burned—*Modern Photography* (July 1980) ran a small item on its "What's What" pages entitled "Arbus Twins Revisited." A New Jersey photographer found the twins, New Jersey residents, and convinced the now-reluctant young women to pose for him, thirteen years after Arbus's photo of 1967. There is presently a mild craze for "rephotographing" sites and people previously seen in widely published photos; photographers have, I suppose, discovered as a profession that time indeed flows rather than just vanishing. *Mod Photo* probably had to take unusual steps to show us Arbus's photo. It is very difficult to obtain permission to reproduce her work—articles must, for example, ordinarily be *read* before permission is granted—her estate is very tightly controlled by her family (and perhaps

Szarkowski) and Harry Lunn, a photo dealer with a notorious policy of "enforced scarcity" with respect to the work of "his" photographers (including Arbus and Evans). *Mod Photo*'s staff photographed the cover of the Arbus monograph (published by Aperture in 1972), thus quoting a book cover, complete with the words "diane arbus," rather than the original Arbus print. Putting dotted lines around the book-cover image, they set it athwart rather than *in* a black border, while they did put such a border around the twins' photo of 1979. The story itself seems to "rescue" Arbus at the expense of the twins, who supposedly without direction, "assumed poses . . . remarkably like those in the earlier picture." (I thank Fred Lonidier for sending me a copy of this item.)

22. Although both Frank's and Winogrand's work is "anarchic" in tendency, their anarchism diverges considerably; whereas Frank's work seems to suggest a Left anarchism, Winogrand is certainly a Right anarchist. Frank's mid-1950s photo book *The Americans* (initially published in Paris in 1958, by Robert Delpire, but republished by Grove Press in New York in 1959 with an introduction by Jack Kerouac) seems to imply that one might travel through America and simply *see* its social-psychological meaning, which is apparent everywhere to those alive to looking; Winogrand's work suggests only the apparent inaccessibility of meaning, for the viewer cannot help seeing himself, point of view shifts from person to person within and outside the image, and even the *thought* of social understanding, as opposed to the leering face of the spectacle, is dissipated.

23. John Szarkowski, introduction (wall text) to the *New Documents* exhibition, Museum of Modern Art, New York, February 28–May 7, 1967. In other words, the photographer is either *faux naïf* or natural man, with the power to point but not to name.

24. Among the many works that have offered images of drunks and bums and down-and-outers, I will cite only Michael Zettler's *The Bowery* (New York: Drake Publishers, 1975), which I first saw only after I completed *The Bowery in two inadequate descriptive systems* but which, with its photographs and blocks of text—supposed quotations from the pictured bums and from observers—can nevertheless be seen as its perfect foil.

25. Such as the photographs of Chilean detainees taken by David Burnett, to which I referred earlier. See also note 16.

POST-DOCUMENTARY, POST-PHOTOGRAPHY?

"The penalty of realism is that it is about reality and has to bother for ever not about being 'beautiful' but about being right." So wrote John Grierson, the man considered the "father of documentary film," the person who named the genre and helped establish documentary film in the English-speaking world.[1] Grierson is pointing here to the dichotomies of accuracy and aesthetics, the criteria by which we have come to judge the worth of documentary imagery. But documentary—a practice that began and flourished with the twentieth century and may indeed die with it—is undergoing profound challenges from multiple sources, on social, political, and ethical grounds. These challenges, which radically undermine photography's fundamental claim to a unique capacity to offer a direct insight into the real, have

This essay was originally published in *Samuel P. Harn Eminent Scholars Lecture Series in the Visual Arts, 1996–1997* (Gainesville: College of Fine Arts and Harn Museum, University of Florida, [1999]), with other essays by Michael Brenson, Elizabeth Brou, and Douglas Crimp. It was republished in *Photo.doc: Dokumentteja dokumentarmista / Documents of Documentary Photography* (Helsinki: Musta Taide, 2000). The version published here was revised in 2001.

produced something of a crisis among artists and intellectuals and troubled some in journalism and the legal professions, if not others in the wider audience. My aim here is to explore some of the attributes and functions of social documentary photography in the postmodern world.

Recently an artist friend and I had a conversation about the effects of exhibiting lush photos of transvestites and transsexual prostitutes of color. My friend (herself a woman of color) quickly made what amounted to a common argument underlying documentary—namely, that it humanizes the so-called Other and promotes identification between the viewer and people so regarded. My concern about this particular line of argument was that the barriers to identification, particularly in this era of scapegoating, are too high to be vaulted over, and not easily with spectacular color images of people having such highly marked appearances and ascribed identities.

But, my friend asked, what if the photographer saw herself as part of the subjects' milieu? This is an argument that had been made about, say, Diane Arbus's work in the 1960s. I responded that a photographer's intentions are unrecoverable from most images. Well, then, would including quotations from the people pictured lessen the distance between them and other viewers? Similar projects in the populist 1970s, such as Bill Owens's *Suburbia*, didn't appear to decrease that symbolic distance very much. In that instance, the recorded (or approximated) remarks may increase the psychological distance from those who on the surface might seem to be "just like me." The inclusion of purported quotations, clearly, changes the nature of the transaction between image and viewer; the subject speaks, whereas in a caption what is pictured is spoken about. But the subject's enunciation alone will not overcome the power of framing elements, which include the preexisting attitudes of viewers rooted in dominant discourses. The muteness of a photograph of someone different from the viewer may paradoxically be more effective in inviting projection, empathy, or pity than even the same photo representing a speaking subject, because the icon is universalized and depoliticized. Still,

there is always a text somewhere—even when it starts with and departs from physical appearance as an index of character.

In the particular project my friend and I were discussing, the subjects were pleased by their photos and their public reception. This appears to be a powerful argument, but whether even well-received photographic projects do much to lessen social stigma needs to be confirmed rather than assumed. Ultimately, my friend reaffirmed her belief in the power of identification. She argued that the aesthetic power of the photographs significantly increased the likelihood of the social acceptance of the people portrayed. On my part, I wondered what role images can really play in promoting acceptance of Others by familiarizing viewers with physical appearances (and identities) with which they have had little real-life experience. The fixity and iconicity of still images, particularly portraits, continue to worry me; I suspect that moving images—film and television—as opposed to still photos of entertainers are potentially far more powerful in reducing social stereotyping, although even they also may ultimately be ineffectual. We have gotten well used to images of Others without necessarily seeing them as "Us." But perhaps identitarian times breed identitarian projects. "Ethnographic" images of people "performing identities" may confirm difference as distance. But there are questions of representation that go beyond the social reevaluation of foreigners or local subcultures. Documentary, journalistic, and news photography, rather than seeking to promote understanding, may aim to provoke, to horrify, or to mobilize sentiment against a generalized danger or a specific enemy or condition. In any case, our discussion brought to mind all the questions surrounding the social power and epistemological understandings (as opposed to the aesthetic qualities alone) of certain forms of photography.

It is true, of course, that *all* forms of representation call forth questions of responsibility and perhaps of descriptive accuracy, but those evoked by photographic representation are unique. The apparent truth value of photography and film has made them powerfully effective vehicles for reportage and commentary. Of all photographic practices, social documentary—the

self-professed truth-teller, implicated in modernity and part of its "life world"—is the one in which the underlying issues of social power are accessible to contestation. Until recently there has been little reason to question photographic accuracy (and then only in specific instances, not globally in respect to the practice itself), and many reasons—notably the immense commercial and bureaucratic usefulness of photography to the mass media, advertising, police, and the family—to accept it. But over the past few decades, photography and photographic practices have been subjected to attacks on all fronts. Striking to the heart of the matter, the Sunday *New York Times Magazine,* addressing the great suburban middle class, in March 1997 proclaimed right on the cover, "Documentary film makers have to manipulate reality in order to make their art, even if that means exploiting their subjects." This implies that filmmakers are also manipulating—and exploiting—their audience; "reality" is sold out in favor of "art." What is said here about documentary filmmaking can be said as well of documentary still photography, despite the imperative toward narrativity of the time-based medium. But documentary, whether still or moving, precisely as an "art-ful" practice, can hardly escape the inclination toward some form of dramatization.

In the advanced industrial world, the questioning of who is speaking, and from where, has occurred in the context of a wider cultural suspicion—or delegitimation—of political authority as well as of the truth and objectivity of journalism. Narrative theory and discourse analysis, analyzing the structure and situatedness of communication, have further enlivened the distinction between truth and accuracy in representation. And the status of the photographic image as a faithful representation of sheer "visuality" is radically impeached by the wide availablity of computer programs that easily manipulate and alter the image. As digital imaging technologies are being developed at a gallop, they bring the ability to capture and manipulate both still and moving imagery to every consumer with a home computer and the entry price to the right gadgetry. This domestication blurs the line between still and moving imagery and its sources, further threatening the epistemological status of both. The "photograph" itself, a fixed physical outcome of a mentality

and a mode of production, is receding from common exchange (leading premier photo schools and departments to shut down their "wet" darkrooms). The tide of change poses its own particular threat to documentary, since "post-photographic" practice at a minimum can be said to have abandoned any interest in indexicality and, perhaps just as importantly, in the privileged viewpoint of "witness"—and therefore any embeddedness in a particular moment in time and space. The photograph seems poised to mutate into just another, relatively ephemeral, aesthetic form and its maker into an artist. What will determine the outcome of this unstable condition is not clear.

Thus, post-structural and postcolonial discourses, along with digital technologies, have undermined the subject position of the photographer (and the cultural milieu into which the images are inserted) and the epistemological status of the image—its relationship to a phenomenologically present visual reality—denigrating its (metonymic) adequacy in relation to the situation it depicts and problematizing the ability of *any* image of a visual field to convey lived experience, custom, tradition, or history.

Through much of its working history, documentary's burden of truth has shouldered aside aesthetic matters in favor of a variety of other issues, leaving aesthetics to surface seemingly as an afterthought—as Grierson's remarks, quoted above, suggest. Nevertheless, documentarians have explicitly called upon the aesthetic dimension of their work as a kind of necessary surplus that protects them from charges of propagandizing, so that the language of aesthetic appreciation is always available to "rescue" documentary from itself—that is, from its own truth claims. This trope, far from being born of postmodern doubt, was already typical of modernism, an insertion of unstated commentary between "the sheer sensation" of the image and its reception by the viewer or, in contrast, a heightening of meaning in the face of flat reality. The poetics of form can lead to a reception of images as poetic, a form of personalized address that escapes either responsibility or reportorial accuracy, though it may of course increase the force of truth, but as subjectivized witness rather than objective reportage.

———

Documentary is currently experiencing another sort of crisis in that it is losing access to a mass public via print journalism as well as losing a fair chunk of that public's interest, which is more and more attuned to television and to accounts of the real refracted through the distorting prisms of sensationalism, voyeurism, and what might be called a neo-gothic sensibility (and the apparently rank naturalism of "reality television"). Perhaps, then, documentary really is a dying practice; but there is much to consider before consigning it to the ash can of history. Photography (now over 150 years old) and film (about 100) have never been stable practices and are continually changing.[2] Both the production and the interpretation of photographic imagery are made according to prevailing social and historical trends.

Photographers who work outside the studio are sometimes accused of having a ghoulish addiction to misery and, worse, of profiting financially from the desperation of others. The accusation, often leveled at war photographers, is also increasingly directed at documentarians. A number of years ago, the well-known and widely respected (white) American documentarian Eugene Richards was at the center of an editorial controversy over his book on the social effects of crack cocaine in an urban ghetto. The charge was racism—that his work was part of the media's unflagging stream of images of drug-taking blacks, which (even apart from contextualization) leads to a greatly exaggerated idea of the percentage of African Americans engaged in crime. The photographer was infuriated and hurt by such a response. In a letter to a newspaper he ascribed it to the handy bugaboo of "political correctness." The argument here revolves not around sympathy or understanding for the poor but over the interpretation of the motivation for socially and personally destructive behavior and whether those pictured are worthy of blame for their own depicted actions. Richards's long-established interest in representing the life of America's poor people, especially the urban poor, may make his motives and methods in obtaining his images unassailable, but the wider African American community has no obligation to ignore the context of reception of his, and related, work—which includes not only the nightly

television news and the tabloid press but also a political climate of racial de-monization, downsizing, and disentitlement.

Similar difficulties have arisen with respect to images from abroad. The end of European empires, the social movements of the 1960s and beyond, and the political needs of the West, have amplified the demands of the world's unrepresented and oppressed for both political autonomy and—more promi-nently than ever before—cultural self-representation. The mission of docu-mentary photographers, often self-assumed, of speaking for the oppressed or disregarded is no longer casually ceded to those from privileged countries or groups. The wherewithal to produce some forms of self-representation, or to intervene in representation produced by and for the (former) First World, or by and for a social majority at home, is much closer to hand than ever before. Entertainment and information media are undergoing consolidation and globalization, and cultural hegemony is exercised around the world by West-ern (not to say U.S.) media. But one result is that reports from elsewhere meant for Western consumption are likely to be viewed as well by those who inhabit what used to be the barely imagined peripheries of empire, residents of the self-same "elsewhere." Clearly, some disruption to documentary and photojournalistic practices has been caused by the blurring boundary be-tween citizenship and spectatorship.

A case in point: An English "alternative" political magazine, the *New Internationalist,* decides to produce an issue on coffee, tracing it back to the growers from the dining rooms of the developed world. A reporter and a photographer visit a coffee-growing area in the southern Peruvian Andes. A local official of the coffee cooperative serves as guide and translator. The group drops in on the man's elderly parents at their farm; the photographer obtains a posed portrait. Later, the son, in London to help complete the issue, worries that showing his parents in their work clothes is disrespectful. He is persuaded, however, that the image is *accurate* and therefore important. His misgivings are published in the magazine along with the photo (a print of which goes home to the parents). If the son weren't working with the mag-azine, the ethical question might not have been articulated, but how often

Darran Rees, *Luis and Celestina*, 1995, Peruvian coffee farmers; below, Luis and Celestina's son Gregorio Cortéz inspecting photos at the London offices of the *New Internationalist* magazine. Courtesy *New Internationalist*.

have subjects had second thoughts about appearing in published photos taken in circumstances more uncontrolled than these? Folkloric portraits and photos of peasants at work are routine for such a story, the stock in trade of *National Geographic;* yet this magazine was attempting to demystify the relation between Third World producers and First World consumers. In other, more pointed situations, reactions to "outside" photographers can be explosive.

In time-honored fashion, the images of people engaged in the production of consumer goods at the heart of viewers' lives are intended to awaken conscience over the disparity between the two sets of life circumstances. Since advertising photography sometimes supplies images of colorful natives for this purpose (Juan Valdez, the long-established figure concocted to represent the Colombian coffee-growers' association's advertising campaign, comes to mind), photographers wish to supply counterimages. (Even Lewis Hine, in his *Making Human Junk,* consciously produced counteradvertising to the popular "making healthy children" advertising of the early-twentieth-century food industry.)

Although socially disempowered people may object to being photographed or filmed, in some cases they seek news coverage; the (right) camera is now even more pointedly recognizable as an instrument of power, and the desire for a large megaphone may conflict with a palpable desire to thwart the bearer of bad news.

Some see in all this the end to the legitimate role of the documentarian from "outside." Unfortunately, such a position, while understandable and to some degree even necessary, is problematic, presupposing that the identities—or roles or experiences—in question are straightforwardly recognizable (Indian peasants, transvestites, or African Americans, say) and uncomplicatedly singular (Peruvian, American, poor) or that they assume a hierarchy within the individual (being a peasant, being black, or being poor is more determining than being a woman or being an Indian, and so forth).[3] The doctrine of no exogenous narration may, in addition, rely on an essentialist interpretation of identity and have a positivist and empiricist bias that tends to privilege appearance over interpretation. For those with a psychoanalytic—or indeed another analytic—proclivity, it can be less than satisfying.

215

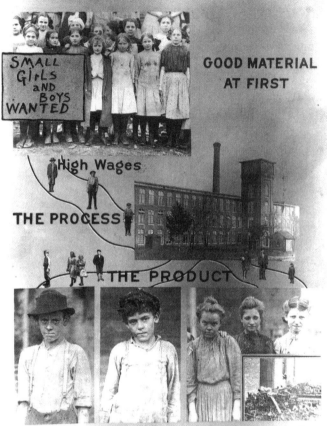

Lewis Hine, *Making Human Junk*. One of the posters that Hine produced while working for the National Child Labor Committee and published in his pamphlet *The High Cost of Child Labor*, 1915.

On an entirely different plane, it rejects the notion of alliances, assuming that social movements are necessarily autonomous as well as constituted and led from within. But social documentary has tended to assume a humanist and generally universal ethical basis in the society to which it has been directed, or to see itself as directly attuned, often militantly, to the interests of the photographic subjects.[4] I say more about the assumptions behind documentary further on, after a brief telling of elements of its history.

Arthur Rothstein wrote about his widely reproduced photograph *The Dust Storm* (1936), of a farmer and his sons trudging through a dust-beclouded landscape:

> In the beginning it was a record, after which it became a news picture, then it became a feature photograph, eventually an historical photograph, and now it's considered a work of art in most museums. It has a life of its own.[5]

A defining element of a documentary image is its particularity, that it represents a specific spatiotemporal "what-is." But the ability to evoke identification, when there is no clear-cut context of group membership, means a loss of specificity in favor of a more universal appeal, or perhaps a certain mythic element. (The precise identity, as opposed to group identity, of the individual before the lens is not generally of interest—these are not, after all, celebrities.) With the passage of time, specificity fades and projection more easily does its work. Furthermore, the criteria employed by aesthetic judgment evolve, partly under pressure of photographic practices. There is no use in trying to pin down photographic, or cultural, meaning outside a context of reception.

SOME AMERICAN DOCUMENTARY PRACTICES

Alongside context is history, including the foundational history of the photographic practices in question. Photography played a notable role in campaigns

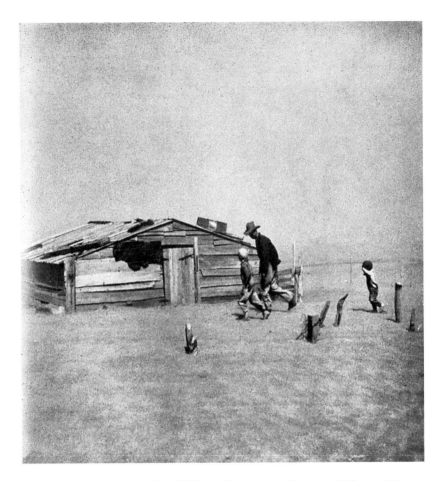

Arthur Rothstein, *Father and Sons Walking in Dust Storm, Cimarron, Oklahoma*, 1936.

for social betterment in turn-of-the-twentieth-century United States.[6] The Danish-born New York newspaperman Jacob Riis enlisted photography for a brief time in his housing crusade. Riis had little concern for the aesthetic element of his photos, for he saw them as evidentiary; the images were initially taken by someone else hired to accompany him on midnight police raids, and convenience alone led him to begin taking them himself. Riis hardly considered the transaction between himself and his photographic subjects; he saw them as symptomatic—representatives of the ill-housed urban poor, many of them newly arrived immigrants, and his interest did not extend far beyond that role. Riis was countering the idea of poverty as synonymous with moral decay and was portraying his poverty-stricken subjects as victims of an impossible situation unprotected by law. His appeal was to law, routed through the consciences and judgments of the new modernizing elites, on the assumption (not unjustified) that poor immigrants, and native-born blacks, could not themselves effectively mount such appeals.

A more sophisticated photographic practice was developed soon after by Lewis Hine, often in the pursuit of legislative changes relating to work—such as regulating or ending child labor. Hine, a young teacher who came to documentary already concerned with photographic aesthetics, was hired by crusading social-work organizations and magazines. For Riis, ethics (moralism, actually) drove his use of photography, but matters relating to individual subjects lay outside his ethical compass; for Hine, aesthetics were married to ethical concerns. The persuasive power of the photograph, he believed, greatly depended on its formal elements, yet he never treated his subjects merely as representative ciphers. Even under difficult circumstances (he frequently lied his way into factory situations, from which he was otherwise excluded by the owners and managers), in researching child labor he took the time to learn the names of those he photographed and to ascertain their occupations, their ages, and other pertinent information, information that often figured in the essays and articles employing his photos. Unlike Riis, Hine also attempted to engage in a transaction with the subjects that resulted in a dignified yet responsive pose.[7]

Hine's concern for his subjects' dignity, evidenced in his images of labor as well as in his portraits of tenement families, led to a strategy opposite to Riis's raw naturalism. Hine's entire concept of the political sphere and the participation of poor people, especially in their role as workers, differed from that of Riis. Both attempted to link the moral order to the political order. Despite Hine's constancy, he no more than Riis could promise the direct utility of his project to the person before the lens; that is not the nature of the documentary transaction, which is an argument about the experience of a class or category of people, as I have suggested above. The stark, often adversarial quality of Riis's photos is a powerful signal of their "truth value," whereas Hine's formal control in many of his images suggests a photographer's advocacy. The people in Riis's photos were caught in the act of being victims (oft-times complicit ones) of their terrible surroundings and existential conditions, whereas Hine's were often shown poised between moments of activity, often at work in poor and exploitative circumstances but within the stream of life and time so different from the airless stasis of Riis's subjects, who seem almost outside the possibility of any dynamic movement forward. And despite the vastly different approaches of the two—the naturalistic artlessness of Riis, the careful realism of Hine—and their disparate relationship to photography and its uses, time and the workings of the art world have transmuted both these outsiders into notable figures. Their work is accepted into the roster of important historical photographic practices because of its foundational role, bringing their formal properties into the register of the aesthetic.

One of Hine's young students, the New Yorker Paul Strand, was inspired by a visit to Alfred Stieglitz's art galleries to become "an artist in photography"—but without the European-influenced pictorialism promoted by Stieglitz. Strand built on English debates about photographic aesthetics, which hinged on how best to arrive at aesthetic value without excessive artifice or concern with surface detail. Strand's work was revolutionary in its embrace of modernist ideas, all but abandoning romantic pastoralism in favor of an eager look at the life of now—yet a significant portion of his work was concerned with natural form and with rural and peasant life. In the teens,

Strand produced a series of candid portraits of New Yorkers—poor, elderly men and women (generally taken with a trick camera whose lens appeared to point elsewhere). Unlike Hine, Strand appears to have been concerned with them as exemplars, but his moral concerns were also very different from those of Riis. His appeal seems not to have been to the polity as a body of laws (or to the aesthetic faculties via the document) but to the moral order as an ideal implicit in the life of a modern urban democratic nation; unlike Riis and Hine, Strand (at that moment, at least) was not involved in specific reform campaigns. Strand's interest appeared to be not only in reforming photographic aesthetics but in establishing an iconography of the marginal that afforded them respect through full incorporation into the physiognomy of the human. What Strand was after depended on the shock of confronting the viewing public with those considered unworthy of attention. These early works show his subjects in the everyday world, their subjectivities hinted at but coiled up, driven inward by isolating circumstance or personal reserve.

SOME ASSUMPTIONS

As this early history suggests, documentary engages with structural injustices, often to provoke active responses. Much of its appeal stems from what might be called the physiognomic fallacy: the identification of the image of a face with character, a body-centered essentialism. An alternative to American psychologism is suggested by the approach developed in the 1920s through the 1940s by the German photographer August Sander, who was loosely associated with the Neue Sachlichkeit (New Objectivity) movement. Sander's taxonomy of German society through a large number of portraits of people occupying every possible social location was far more concerned with a representation of a person as an ensemble of self, setting, and social role than with challenging the viewer to concoct a psychology of the individuals or a reading of their character. These people, whether beggar, gypsy, thief, artist, circus performer, soldier, capitalist, wife, or manager, are unquestionably embedded in a complex yet knowable, decipherable structured society.

Paul Strand, *Photograph—New York,* 1917.

The concepts of "citizenship" that I have suggested here in germ suggest powerful motives for documentary production. The logic of capital, with its division of society into expropriators and expropriated, has functioned as a powerful underlying assumption for documentary through much of this century, providing images of "society's losers"—its victims—and occasionally of its winners, who are less often directly identified as its victimizers. But this division of the world may not have the force it did just yesterday. Political scientist Robert Meister argues, for example, that post-structuralism—on the basis of readings of Nietzsche, as well as of Hegel by Alexandre Kojève and his students, among them Michel Foucault—radically questions the rhetoric of victims and victimizers. Post-structuralism, in Meister's view, rejects the "demonization" of any member of an oppressive system; thus, calling people victimizers, whether for their behavior or their class characteristics, is considered an unacceptable error, both analytically and ethically. Even the class of capitalism's beneficiaries cannot be named as oppressors, since as in Foucault's analysis, power resides everywhere in society. In Nietzschean terms, the "will to power" means that those who are oppressed also oppress and would do so in greater measure if given the opportunity to turn the tables.[8]

In postmodern times—in which it cannot be assumed that for the good of the collective whole, groups or individuals will willingly take less in order for others to have more—explanations of oppressive social practices, of classes of beneficiaries, and appropriate structural reforms are all contested, along with the hypostatization of the notion of "victimhood" as an abstract category of explanations of differential social power. If there are no victims—or if, what amounts to the same thing, we are all equally victims—then there are no oppressors. Social inequality appears to be produced by a system without active human agents or collective remedies. At the end point of such logics, naming "the system"—capitalism, say—as the oppressor leads to no change, since there are no steps that can be taken that do not tread on someone's toes. Patently, no practice of social documentary that sees itself as providing evidence of structural injustice can flourish where there is no model of social progress, of implied routes to get to a better place.

I have already suggested alternative explanations of documentary imagery that might present themselves: psychologistic stasis, dehistoricized universal "truth," a depoliticized visual typology of social "losers"—the homeless, single mothers, battered women, inner-city residents, crack users, happy-go-lucky bums—or even of "winners," all without any presumed idea of wrongs or remedies, all iconographies of myth. But before any of these explanations take hold, there is a more basic axiom, that of credibility, the fundamental issue in the reception of documentary imagery.

Documentary Practices and Credibility

At one time, reconstructions and restaging were acceptable as documentary, but now photographic believability requires a discreet distancing from (inescapable) formal visual and dramatic tropes. More important, it requires a balance of trust in the photographer and the medium of distribution of the resultant imagery. Despite the radical questioning of the truth value of documentary, every day, countless times a day, images that document events, in the form of news photos and documentation, are produced and received in a great variety of forms and at a growing host of sites of reception. Although a judicial body may, because of the possibility of digital manipulation, now be prodded to disbelieve photographic evidence, the public by and large still trusts images it sees in the daily newspaper and on the evening news. Aside from the privileging of the apparatus itself, it is on the specific codes of production of news imagery that the acceptance of this infinitude of images rests.[9] The durability of the reputation of objectivity of the apparatus, buttressed by the (apparent) reliability of the medium, overwhelms all but the most inescapable doubts about the image. But the audience certainly recognizes the stylistic markers of "actuality" photography and, more pertinently, moving footage, which have been imported into advertising and music television and purposefully distorted in the burgeoning genre of docudrama and real-crime shows. The artless quality of "snapshots" that art photographers once sought so energetically to avoid has become a reigning style in photog-

raphy and advertising, having first been routed through the hand-held camera style of "cinéma vérité" and pop.

Over the past couple of decades, color has expanded into news photography from personal and commercial photography and produced powerful dislocations, since serious news had been so long identified with black-and-white photography. Yet color is now sufficiently normalized that black-and-white imagery may seem mannered and artificial (as it has been presented in music television and advertising). Highly saturated color film enhances the aestheticization of the image, producing eye-catchingly beautiful images of crime scenes, battlefields, slums, and mean streets—rendering them the visual equal of green acres and luxury residences. (The paradoxical aestheticism of black-and-white imagery has produced a still-evolving situation with no place for truth value to rest easy.) The use of color in documentary is still uncommon, and its aestheticism problematic, for it is hard to hang onto the literalness of the image without the direct headline-related news value.

Photographic credibility is strongly conditioned by codes of professionalization. Photojournalism was well-established in the decades after the First World War, aided by the new European mass-circulation picture magazines.[10] Later decades produced a highly professionalized corps of photojournalists. The codified ethics of news reportage entailed maintaining a wall of separation between photographer and subject (rules suspended, by popular demand, during wartime, when news reportage is meant to support far more than to inform; under pressure of nationalism, partisanship easily aces objectivity). Documentary and photojournalistic practices overlap but are still distinguishable from one another. Photojournalists are primarily employed to work on specific journalistic "stories," supplying images while others provide copy, and their feelings and sympathies about what they are photographing remain unsolicited. In contrast, documentarians choose their subjects and treat them as they will, but with no guarantee of publication. In reality, however, many photographers engage in both practices, and the same images may function in both frames as well.[11] Journalistic ethics may prescribe honesty, objectivity, and responsibility to the subject, but they privilege the document,

which supersedes all but the most urgent interests of the individuals involved.[12] Responsibility is to society—that is, to readers and viewers.[13] In another sense, however, for journalists, whether photographers or reporters, the most crucial thing is to protect the professional status of the practitioners and the practice itself through the establishment of "objectivity" (but the unstated rules of war photography expose the relativity of this standard).

Especially for those being photographed, the photographer is sometimes seen as an interloper, "selling papers" through sensationalism or furthering the editor's or publisher's ideological and political agenda. But we all pay a price for summarily dismissing journalistic claims of objectivity—namely, the end to the demands for representational responsibility to the subject, whether in terms of a true and faithful account of appearances and behaviors or in terms of satisfying the subject's desires.

There is a long-standing documentary subgenre, namely "street photography," filling this niche of "nonresponsibility" to the subject. (I note in passing that, historically, "proto-documentary" practices were anthropologically descriptive and took for granted that the photographer-audience group and those depicted were essentially different and inhabited different social locations, but street photography has evolved away from this model.) The loss of specificity or scrupulousness, as it empties information from the image, aids the aestheticization and universalization favored in the art world, whether such loss represents a view of photography as a form of self-portraiture through projection—an important argument, applied in varying degrees to a host of photographers—or some less definable release from social goals. Despite its often acute revelations of social power differentials in what it observes, street photography does not incline toward a calculus of rectification.

The photographer, rather than the subjects, becomes a kind of psychological or characterological type, and it is with the photographer that one identifies, reforging links between this form of photography and old-fashioned travelogues ("Our correspondent in the land of . . ."). The photographer is weeping, despairing, astonished, amused, disgusted, spiritually transformed, and so on, mediating through her or his sensibilities and (to use Robert Frank's word) "vision" the raw social facts at hand. In war, the viewer

———

is a partisan observer and the photographer one's surrogate more than a representative of one's inquiring mind; we cheer the wins and decry (and perhaps analyze) the losses.

METHODOLOGIES OF PRODUCTION: DEGREES OF DISTANCE

In the face of the challenges to social documentary—not the least of which is the distinct possibility that projects will find no sponsors and no distribution—production methods have come under scrutiny by interested observers. Many documentarians were trained in sociology or anthropology, and many of documentary's frames of reference are drawn from these disciplines. Documentary photographers often think, for example, that they must become "participant observers"—part of the group or subculture whose members they are photographing—or maintain intense relationships with group members. This is in contrast to the street photographer or that stereotypical figure of irresponsibility to the subjects, the "parachuting photojournalist."

Some supporters of documentary—such as anthropologist Jay Ruby, a central figure in the study of "visual anthropology"—believe that only self-representations can solve the problem of unequal power in the photographic transaction. A form of equalization theory underlies the work of photographers following the trail blazed by anthropologist Sol Worth, who gave movie cameras to Native Americans.[14] As Brazilian educator Paulo Freire has shown, providing narrative tools—most basically, "alphabetization," or literacy—to the socially and politically excluded is in itself empowering. This approach of giving the tools of production to the ostensible subjects has most often been adopted by naturalist and realist documentary filmmakers, who have tried to re-create the experience of presentness with a minimum of intervention and interpretation and little hint of political agency. Those who use this method with still photography must add verbal texts of witness, testimony, and confession.

Photographers following this method include Wendy Ewald, working with poor North and South American children, and Deborah Barndt, working primarily with immigrant women in Toronto, as well as a number of

photographers in many countries working with homeless children. Their projects are indispensable. My great admiration for such projects, however, is tempered by some concerns about their possible limitations. Freire's methodology was pedagogical, meant for use within a learning group, where his technique has repeatedly been shown to be powerfully effective. With work that circulates publicly, however, relying on giving the camera to the subjects underestimates the shaping effect of institutions and the context of reception, which are likely to reimpose the unequal power relationship banished from the photographic transaction. The project gains credibility for external observers from the subjects' sharp investedness, possibly from photographic naiveté (many such projects employ children), and from imagery that is aesthetically appealing, perhaps unexpectedly. As the sole form of representation, this work seems vulnerable to those with no desire to change political realities. In the words of a municipal bureaucrat, it represents a tool for "managing diversity"; thus, it has come to be seen as therapeutic or cathartic. Depoliticized and dehistoricized, the hack version of this work offers a preferred picture of the social victim, who might not earn sympathy if portrayed as analytic or militant: activists among the poor consistently claim that journalists, at least, focus on the abjection of individuals and ignore group activism, which implies a demand against the privileges of the viewers. The best of these undertakings (which are, of course, not organized by journalists with their professional credentials and codes at stake, as described above) project a powerful idea of the subjects' desired self-image, but in routine applications the skills of the facilitating photographer are not put to full use. This approach, if it displaces other documentary methodology, smacks of positivism—one obtains testimony but provides only limited analysis.[15]

If documentary appears to be under pressure—from distributors, sponsors, and subjects, as well as from leery practitioners and postmodern critics of traditional social, particularly class, analysis—and if the radical contraction of the public sphere means that there is no place to insert documentary arguments, why continue to talk about documentary practices? It is enough, perhaps, to claim that documentary still represents a lively impulse, but there

are more important reasons to continue to distinguish documentary from street photography, which appears to be in no danger of withering away. In the world of just-yesterday, documentary could convey a sense of a "social scene"—and the mediating observer of that scene—to you. But in the present map of the world, the self-same photo might simply be readable as an image of the random Brownian motion of individuals present in the same unit of space-time, and adding up only to numbers, not to "society." Without a sense of the social, only the personal remains, and a look at the merely personal is an invitation to voyeurism. Documentary—more properly, "social documentary"—provides a frame of unity, even if a fractured and fractious one.

Voyeurism as a naked motive for photography is increasingly expressed and rewarded, in art and mass culture, even in polite society. The art world is not immune from the rhetoric of demonization of immigrants and the poor, and galleries and museums are revoking their former discreet avoidance of sensationalistic and tendentious images of poor people. Finding favor as well are colorful images reminiscent of club-world journalism, which displaces the kind of color work that was first allowed through art world gates—namely, melancholy images of urban and small-town landscapes, often of the American South or postindustrial New England, blank empty places of special cachet. What has also captured attention—particularly in Europe—is a de-skilled "slacker" aesthetic of blurry, informal photos, often of conglomerations of people doing nothing much. This flashy casualness, patently influenced by and feeding back into fashion photography, suggests the way in which photography is seen to describe the postmodern social dimension.

I will use as my example the work of the English artist Richard Billingham, discovered as a student of painting in an art school not many years ago. In exhibiting, textless, in commercial galleries and museums his greatly enlarged instant-camera color photos of his drunken father and brother and his rot-toothed mother in their sorry council-house flat, Billingham—who won instant fame and the patronage of Charles Saatchi and a hungering pack of international collectors—may be taken as illustrating the collapse of the

tattered but still widely upheld art world stance of generalized humanism and noblesse oblige. Promoters praise his freak show as a form of poetry—thus, self-expression, following the argument referred to earlier, meant to rescue street photography from seeming simply predatory. Billingham's book of these photos—whose only text is a short descriptive blurb on the dust jacket—is called, appropriately enough, *Ray's a Laugh*.[16] Ray is Dad, and, yes, Oedipal rage is on view. If the identities sketched out here are those of working-class people in postindustrial Britain, they are not being described by admirers; drunks always appear as self-produced permanent losers, not as victims of *someone* or *something*.[17]

Despite this further step along the road of artists' pantomimes of social disengagement, it is important to reiterate that documentary is not primarily an art world practice—although, as I have noted, art world practices have the ability to capture center stage, displacing an interest in documentary among potential future documentarians as well as viewers and critics. But plenty of people are still producing documentary images, despite the loss of stable avenues of dissemination, and it is up to us in the audience to prevent them from being submerged by those on the other side of an ethical and political divide. A tiny number of projects are represented on accompanying pages.

Let me recapitulate some of the arguments of the present essay. First, documentary, a polarizing practice that must inevitably provoke opposition, is perpetually teetering on the brink of its demise. Those hostile to the demands of "crusading" documentary may find it easiest to call for its end, ironically enough, in the name of ethics and "responsibility." Second, as postmodernists claim, demands for "straight information" without interpretation are unrealistic, for there is no voice from outside particular human communities. Strict objectivity, a standard derived from journalistic ethics, may prove an inappropriate ideal for documentary—as documentarians and photojournalists already know—but so is the alibi of personalization, sentiment, or disengagement. Third, the partial melding of the photographic audience and its subjects has put great pressure on the institutionalized methodologies

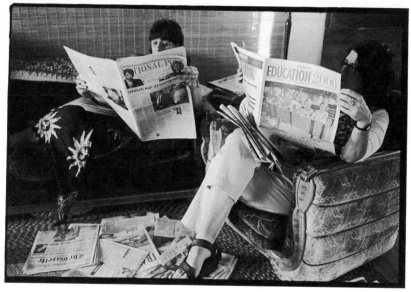

Judith Lermer Crawley, from the series *The Poker Group*, 2000. Gelatin silver print. *The Poker Group* is one of Crawley's many series documenting the lives of women and their families, especially those around her in Montréal, Québec.

Mel Rosenthal, *Palestinian Wedding at Widdi's Caterers, Bay Ridge, Brooklyn*, 2000. Gelatin silver print.

Fred Lonidier, *Egg Packer's Arm,* from the series *The Health and Safety Game,* 1976.
Photo-text work. "I told the foreman, 'It's too dangerous, I can't hurry.' So sure enough,
I got real busy and was having to hurry and was running. The next thing I knew, I was
on the floor. And from that minute on I have had those real dizzy spells. Just any little
thing, I get dizzy. I can't walk straight. If I try to go upstairs or especially downstairs, I
don't know, I just wobble around. And I was in a cast for over two years off and on.
Then they put me in this brace."

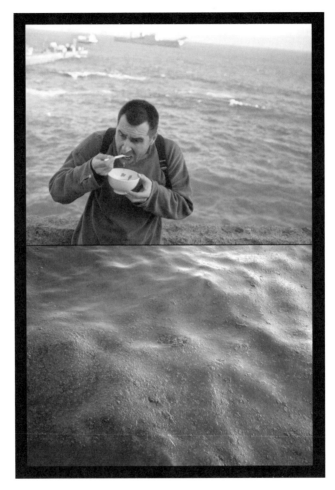

Allan Sekula, volunteer's soup, Isla de Ons, Galicia, Spain, December 19, 2002, from *Black Tide / Marea Negra (fragments for an opera)*, 2002–03.

The Chorus is dressed in white: hooded in waterproof, / sweat-retaining Tyvek suits, taped at the cuffs with transparent / package tape. They seal each other into their suits, / stooping to bite at the tape with their teeth. This preparation / is performed with ritual solemnity, in silence. A fisherman enters, / stage right, and gestures toward the chorus: / "These are the astronauts."

Jason Francisco, man driving a tractor to the landlord's godown, delivering his share of a day's work, Magallu village, near Nandigama, Krishna District, Andhra Pradesh, 1995, from *A Place in the Periphery: Rural India at the End of the Twentieth Century* (1990–97). Looking at globalization from the perspective of the "developing" world, this project follows the circulation of economic, political, and cultural power in a hierarchical rural society in the Telugu-speaking countryside of southeastern India and traces its responses to changing conditions.

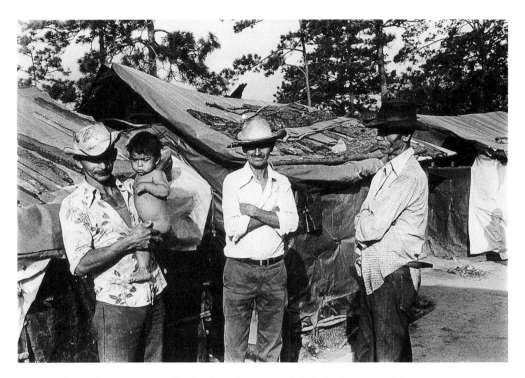

Steve Cagan, *Mesa Grande, Honduras, Summer 1981.* Gelatin silver print. Salvadoran peasants, fleeing attacks and repression, wait in Mesa Grande, the largest refugee camp in Honduras. Residence there was no guarantee of safety from Salvadoran death squads making cross-border raids.

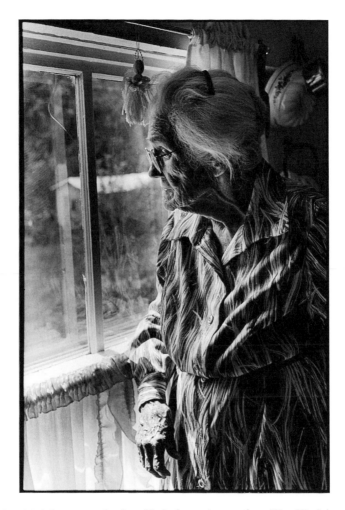

Dona Ann McAdams, portrait of an elderly farmer in a southern West Virginia mountain community, from the series *The Last Country,* 1997–present. Gelatin silver print. Williamsburg, West Virginia, is a small community (population 230) many of whose residents are elderly farmers living alone in remote homes. McAdams set up a darkroom there and taught photography to children and adults.

Loraine Leeson, *West Meets East,* 1992. Textile and photographic montage displayed as a 16 x 12 foot photomural. Produced in collaboration with pupils and teachers from Central Foundation School in East London, England. A class of Bangladeshi girls represented their experiences of living in two cultures through the image of a sewing machine joining eastern and western materials. Original image is in color.

Martha Rosler, Richard Billingham exhibition at a commercial gallery, New York, 1997. Original photographs are in color.

of documentary, for interpretation has become a field of perpetual contestation. Finally, the art world embrace of photography can squeeze documentary to death—or maybe I've got cause and effect reversed, for it could be that all of photography is already a nostalgic craft, given the explosion of computer-based manipulations that drive our stepping off into the post-photographic moment, leaving behind both photograph and photographer.

So why continue to defend documentary? The short answer is, because we need it, and because it likely will continue, with or without art world theorizing. As the division widens between rich and poor in the United States and elsewhere (and as art practices are institutionalized and academicized), there is less and less serious analysis of the lives of those on the wrong side of that great divide. My understanding of postmodernism does not extend to the idea of a world with no coherent explanation of differential social power or advocacy of ways to right the imbalance. Explanation and advocacy are still viable in relation to photography, as in purely word-based journalism. Documentary's best course, it seems to me, is to provide a balance between observing the situation of others and expressing one's own point of view[18]—which ought to include some form of analytic framework identifying social causes and proposing remedies. In pursuit of this, documentary will continue to negotiate between sensationalism on the one hand and instrumentalism on the other.

As I began with a quotation from Grierson—that old-style utopian social democratic optimist—it seems appropriate to end with one:

> A mirror held up to nature is not so important in a dynamic and fast-changing society as the hammer which shapes it—it is as a hammer, not a mirror, that I have sought to use the medium that came to my somewhat restive hand.[19]

NOTES

1. John Grierson, in *Documentary News Letter,* quoted in James Beveridge, *John Grierson, Film Master* (New York and London: Macmillan and Collier, 1978), p. 178; and in Forsyth

Hardy, ed., *Grierson on Documentary* (London: Faber & Faber, 1966), p. 249. Grierson was no revolutionary but a proponent of democratic participation who believed that imagination was needed to help citizens make sense of events and of the news. I cite him here because his influence has been so pervasive.

2. Most histories of photography (and some histories of documentary film and video) tend to take a position of technological determinism in which the development of new and ever lighter, more portable, more automatic apparatuses of reproduction determine what kinds of things can be photographed or filmed and thus what *will be* photographed or filmed. Technological change does not, in my estimation, drive social events; rather, technological developments are accomplished within a framework of social and economic imperatives, although in practice this is a complex relationship in which technology also organizes experience and functions as a means of social control. See also "Image Simulations, Computer Manipulations: Some Considerations," reprinted in this volume.

3. Not all such conflicts, by any means, hinge on what we have come to call identity, whether essentialist (biology, race, ethnicity), cultural, national, or sex- and gender-related. Shared experience, such as being involved in a strike, having a certain kind of job, or living in a certain neighborhood, are also the sorts of things documentary might address but which are not, in the present understanding, primary identities. Furthermore, postcolonial discourse has highlighted the very instability of identities—and not only ethnic or national ones—pointing out that they are constructed by the universes of discourse that we inhabit, and we assuredly inhabit more than one.

4. As an aside, I note that it is an oversimplification to treat the appeal of documentary as always from one group or class to another. Nevertheless, most documentary practices presuppose a mass-market model, in which elites with the power to produce and disseminate messages will, through a gate-keeping process, direct them to nonelites.

5. Arthur Rothstein, *Words and Pictures* (New York: Amphoto, 1979).

6. A small motion toward its use in this manner, in the case of the London charity for street children run by Dr. Barnardo, came to a litigious end. See "In, around, and afterthoughts (on documentary photography)," reprinted in this volume.

———

7. Riis, like all photographers of the day (and many photojournalists today), also obtained set-up and posed images.

8. There is a further problem, according to Meister's analysis (in *Political Identity: Thinking through Marx* [London: Basil Blackwell, 1990] and "Logics of Space and Time in the Demystification of Capitalism," unpublished paper), in identifying the perpetrators of social oppression with its beneficiaries. Using the recent conflict in Rwanda as an example, one can argue that the perpetrators of the genocide were not its beneficiaries. In South Africa, where the beneficiaries (most whites) were not the perpetrators (those who operated the police state), meaningful structural reform may be thwarted when the beneficiaries of oppression are asked to shoulder the collective guilt implied by redistribution of wealth and power—a viewpoint echoed in the United States in arguments attacking affirmative-action policies.

9. What I mean by "the privileging of the apparatus" is simply this: In the absence of hints of unreliability, people believe what the image shows. In the so-called amateur videotapes picked up by news media for use in high-profile court cases, such as the touchstone Rodney King case, the apparatus is seen as the primary actor and witness, and its operator is forgotten.

10. A fuller account would detail the origins of "street photography" as an outgrowth of documentary and allied with war photography. Further, there were professional photojournalists before the turn of the century, including the American Frances Benjamin Johnston, most of whose work was imbued with the Progressive ideals of the era. Friendly with ruling Republican elites, she produced sympathetic portrayals of Native Americans, southern blacks, and women workers intended to promote their incorporation into the mainstream of the American working class; that this practice occludes difference and supports the now-discredited practice of radical separation of native peoples and "minorities" from traditional languages and practices hardly needs to be said. This was the America of great industrial and demographic transformation, an era of social work reformers, primarily women, whose advocacy for the poor was useful to nervous elites whose politics of social incorporation, dubbed Americanization, could range from charitable undertakings to rank brutality. Among Johnston's most arresting images is one of a classroom at the Hampton Institute in Virginia, with neatly attired African American young people around the turn of the twentieth century (December 1899), standing in solemn contemplation of

a Native American classmate in full traditional Plains war regalia, standing on a box in front of a display case containing a stuffed bald eagle. This rich field of signs marks the compost of national identity.

11. As suggested earlier, as time passes the news value of images loses currency, and news images, documentary photos, and photographs taken on story assignments are all judged by similar aesthetic criteria. Further, very few people can make a living from self-chosen projects. Photojournalists and documentarians are, in addition, constantly seeking greater control over dissemination of their work. And many documentary photographers make their living from commercial work and are likely to employ their signature styles, muddying the waters.

12. See, for example, Robert Aibel, "Ethics and Professionalism in Documentary Film-Making," in Larry Gross, John Stuart Katz, and Jay Ruby, eds., *Image Ethics: The Moral Rights of Subjects in Photographs, Film, and Television* (New York: Oxford University Press, 1988), on a film of a rural U.S. auction, in which the subject was unrelated to politicized issues of class, race, gender, wealth, or social or political power.

13. In the United States, though not elsewhere, the "rules of engagement" are such that most photographers in public situations don't stop to obtain permission from those they photograph, and a person's failure to object immediately is taken as acquiescence. Those making news photographs are not legally obligated to seek permission.

14. In *Through Navaho Eyes: An Exploration in Film Communication and Anthropology* (Bloomington: Indiana University Press, 1972). The 1970s Australian film *Two Laws,* made with aboriginal collaboration, was produced on this model, with clear political intent.

15. This is not meant to suggest that people are unequipped to describe or understand their own situations, but only as a reminder that there is a dimension of one's own situation and behavior that is not available to consciousness, not to mention the comparative knowledge that others may bring to a situation.

16. Richard Billingham, *Ray's a Laugh* (Milan: Scalo, 1996).

17. A more nuanced argument has been offered for the acceptance of Billingham's work by some English critics of good will and admirable political sentiments. Billingham's work, and some of Gillian Wearing's recent portraits, in video and photography, of drunks in desperate condition, these observers argue, bring to public view images of the working class (and lumpen?) not only left behind by the demise of British "socialist goals" but no longer even championed by New Labor, and thus no longer represented in the public conversation. These two YBAs (young British artists), situated outside the documentary tradition, claim a "familial" or affiliational connection with those pictured: Billingham offers his family, Wearing the drunks she interacted with daily outside her studio. On balance, however, I still think that images of drunks, rather than being indicative of the bottomless pit into which the marginalized postindustrial working class is falling, continue to call to up a raw mythology of timeless depersonalization. Thus I find this rationale for their work less persuasive than that dealers, critics, and observers are interested in the return of the frisson—or the *affreux,* the frightful.

18. This trope is increasingly evident in documentary film and video, in modern reflexive documentaries and diaristic films, and in web-based works that appear more and more like glossily produced magazine articles with live interviews and spoken commentary.

19. Quoted in Beveridge, *John Grierson, Film Master,* n.p.

This article was originally published in a small "alternative" newspaper, and it func-tioned as a book review of Susan Meiselas's book Nicaragua. *The publication of Meiselas's book was significant: a high-budget, high-profile photo book, put out by the important publisher Pantheon Books, about a leftist revolution in the Third World—just the area of the world that we in the United States considered our fiefdom—at the start of the "Reagan revolution" and the historic swing to the right in the United States. The present version of my short article substantially restores the original text, which reflects my concern with the appearance and context of war images and their effects on the reception of those images by various viewing publics. It restores my criti-cism of publishers that the newspaper was reluctant to print, which led to editing that appeared to lay too much responsibility for the book's format, and my estimate of its likely reception, at Meiselas's feet. In the intervening years I have gotten to know Su-san Meiselas, and my admiration for her commitment, skill, and resourcefulness, which I had already felt at the time of this consideration of her work, has grown. It is inter-esting to consider whether the shock caused by seeing war photos in color is no longer*

This essay was originally published under the title "A Revolution in Living Color: The Photojournalism of Susan Meiselas," *In These Times* (Chicago), June 17–30, 1981.

quite such an important issue, since color images of all photojournalistic subjects are now the norm. These remarks are not, however, meant to defuse the questions that I put forward about aspects of war photography, questions to which I have returned several times in my thinking and writing.

Once there was a brutal dictator in a small banana republic in steamy Central America who so abused his people, grabbing most of the wealth, stifling initiative, and causing misery, that waves of discontent spread throughout the entire population until finally peasants, lawyers, housewives, businessmen, and even priests and nuns rose up in outrage. Despite incredible atrocities, they eventually succeeded in driving out the beast and his minions, and they looked forward to living in peace forever after.

It would be easy to garner this fairy-tale impression of the Nicaraguan revolution from photojournalist Susan Meiselas's book *Nicaragua*. Meiselas's book is one of the very few journalistic works that are sympathetic to a popular struggle. But the book bears evidence of contradictory aims and approaches to the laying out of meaning, contradictions whose collision damages the book's ability to inform and to mobilize opinion. The claims to truth of documentary photography, at least for the general public, rely on the principles of realism to convince us of their accuracy. Meiselas, a member of the important news-photo agency Magnum, provides many images that are affecting and convincing. Unfortunately, the design, organization, and possibly the overall conception of the book, which were presumably intended to deepen their appeal to the photo-book audience—essentially an art audience—mar the book's reportorial work.

The movement from photojournalism to art photography travels a well-worn path, but it is a difficult one to negotiate if specific information is not to fall by the wayside. It is especially difficult when the situation is not only recent but still at issue, for as "art" takes center stage, "news" is pushed to the margins. Furthermore, there are disturbing qualities in Meiselas's photographic style that, while grounded in historical trends within photography, nevertheless have an antirealist effect.

Susan Meiselas, *A funeral procession for assassinated student leaders,* 1978. Chromogenic print. Original photograph is in color.

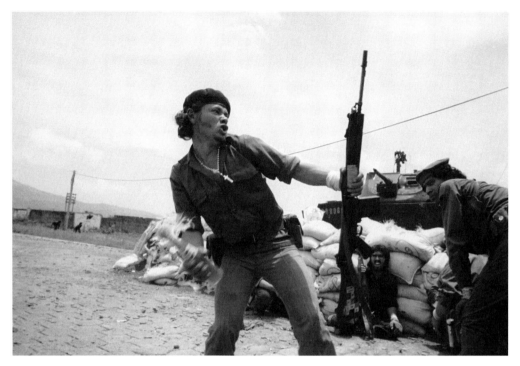

Susan Meiselas, *Sandinistas at the walls of the Estelí National Guard headquarters,* 1979. Chromogenic print. Original photograph is in color.

MYSTERY AND ROMANCE

Pick up the book . . . at first sight it looks like a catalogue for an art show. On the cover, young men in bandanas crouch or stand against a pink and brown, graffiti-marked wall. The words "Nicaragua" and, smaller, "Susan Meiselas" appear above and below, white letters in mock-crude stenciling on a black ground. Open the book; just the word "Nicaragua" . . . but how can one book, a photo book, represent Nicaragua? Turn the page, and you are being looked at by a close-up face in an expressionless, gauzy mask, seemingly young and male, with a hand on a strand of barbed wire. Mystery.

Central to the book is that the photos are in color. Although color photography is becoming the standard in such magazines as *Time* and *Newsweek,* cut loose from their overwhelmingly text-dominated format a photojournalist work in color is still unexpected, especially when the subject is war.

The color, of course, functions in several ways at once, some of them contradictory, some of which have resonance only for specialized audiences. Color photography is most widely used in advertising, signifying commodification, a certain culinary appeal. In advertising and in other fields, it is often used to portray the exotic, the desirable Other or fantasy identification, with implications of primitiveness, mysteriousness, romance. This is *National Geographic* photography, a genre modernized by *Geo* magazine, in whose pages Meiselas originally published some of her Nicaraguan photos. In Meiselas's book, the color, while emphasizing the tropical surroundings, the pastel buildings, the intensely blue sky, also calls our attention to the ordinariness of the people shown. This impression is largely conveyed through clothing, which is like our clothing. These aren't scarified "primitives" or shanty-town dwellers in a jungly fantasy vision of Latin America. A boy on the cover wears a hat saying "New Orleans"; men and women in summer dress line up, hands raised, facing their bus for a weapons search. With whatever irony we may approach the fashion dominance exercised by the United States over Latin America, we can't help apprehending the arbitrariness of war in seeing these eminently "civilian" people. But, oddly, by appearing in the same lushly

colorful mode as do the representations of tourism of the colonized, Meise-las's photos also evoke the question of whether these people are really like us—are they, or are they impostors? Some images take on the hint of a fash-ion show masquerade.

After the first mysterious images, a single page of quotations sets the scene: an intransigent remark by Somoza followed by statements from a San-dinista commander, a lawyer, and a rich but despairing economist. The im-ages begin: They include Somoza, the National Guard in its training school, a sweating sack-carrier under a glorious sky, a grimacing dark-skinned woman in a pink uniform tending rich, light-skinned toddlers.

Then the book, in horror-movie fashion, establishes its legitimacy as a book of war photography in a war with very few battles, slamming the viewer with a terrible photo, a lush lake-and-mountain vista on whose hillside lies a body clad from the waist down in intact dungarees and consisting from the waist up of nothing but a thick spinal cord studded with a few rib stumps, with severed hands and naked bones nearby. This grisliest image, partly de-pendent for its effect on clothing again, becomes the context for the rest of the photos.

There are many other strong images in the book, but few are images of atrocities, though there are a number of photos of fires and burning bodies. War photographers complain that magazine editors demand photos of ex-treme violence, counterpart to TV's gore-squad coverage of local accidents for the nightly news, and particularly favor photos of fire now that color is the norm in magazine coverage. In this, Meiselas, or her editor, showed re-straint, and most of the photos are of the people, civilian and guerrilla.

GORE AND COMPASSION

Although the increasing nihilism and sensationalism of photojournalism and war photography leave Meiselas far behind, her photos are marked by a no-ticeable streak of alienation—including the fashion bizarrerie and color fan-tasia—that places her well within the traditions of modern photography. War

photography oscillates between the ideological poles of gore for gore's sake and exaggerated compassion, in which the anguish and heroism of the photographer command most attention. We should acknowledge Meiselas's bravery, especially since she has recently been wounded in El Salvador, but this is, after all, her chosen work; unfortunately, war zones are dangerous, and the injury and even the death of photojournalists and war correspondents occur far too frequently.

I recently attended a panel of war photographers held at New York's New School that began with a memorial showing of photos taken by Olivier Rebbott in San Salvador before his death in Miami from a wound sustained in El Salvador. The panelists expressed confusion about their own usefulness. Many said they were pacifists, but they were shaky about their relation to the struggles they photographed—and even shakier about whether they ought to believe in the struggles they photographed. One suggested that, as in Method acting, one should adopt a cause and force oneself to take on its values in order to obtain powerful and passionate images. They wanted to make an end run around the "photo opportunities" of captured arms caches that anxious governments arrange for photographers who parachute in, so to speak, for a short stay. But other photographers expressed frustration that images of war didn't end war. Cornell Capa—photographer and founder of New York's International Center of Photography, as well as brother of the great leftist war photographer Robert Capa, founder of Magnum, Meiselas's agency, who died stepping on a land mine in Indochina in 1954—complained that war used to be blamed on "lack of communication." Yet since the 1930s there has been an inundating amount of information about the horror of war and there are now more wars than ever.

The term "documentary" itself did not appear until the 1930s, a time of social combat over the control of meaning. After that era, in which documentary in the United States was anchored above all by the gigantic Photographic Section of Roosevelt's Farm Security Administration, documentary as an expression of ideological commitment declined. By the 1960s, documentary was regarded as a bore. Photojournalism, not only in the service of

reportage but also for "human interest" stories—and, of course, war—kept the photo magazines such as *Life* and *Look* healthy until TV killed them off. (The new *Life* consciously addresses a different audience.) At the same time, the more ambiguous, noncommercial tradition of "street photography" produced the Swiss photographer Robert Frank's book *The Americans*. His photos, taken on a Guggenheim-financed American odyssey, could find no U.S. publisher and appeared first in France, in 1958.[1] By the mid-sixties the book's underground influence was undeniable. *The Americans* portrayed the fifties' alienated "lonely crowd" with unstrung imagery, championing the socially marginalized. With its beat preference for peripatetic individualism, Frank's work ushered in the overwhelming subjectivization of street photography that still covers its spectrum of tendencies and that marks most other types of art photography as well.

IMAGES WITHOUT WORDS

In Meiselas's book we do not often see "people united." Many of the photos, as in Frank's book, show individuals isolated in the frame, looking off, moving in diverse directions, or joined in an unfathomable project. The impression of posturing, the hint of sexualization of the young male fighters, that originates in this antiheroic style, is intensified by the design of the book in the collision of the aims of journalism and art photography, as I've indicated. The most damaging element of the design is the placement of the photos all together in a single section, without captions or text. The captions, some markedly inadequate, appear at the back of the book, accompanying small black-and-white reproductions—just as in an art catalogue—that run alongside the text.

The text consists almost solely of quotations from participants, moving testimony about atrocities, battles, victories. There is a wonderfully ironic telegram lampooning Somoza's self-puffery in his captive press, there are poems and documents and a final chronology. But the list of encyclopedia-style statistics fails to mention anything about the country's economic base (except

the people's impoverishment), which is symptomatic of the book. Just as the photos, in avoiding "revolutionary" poses, do not stress collectivity and united purpose, the text omits all mention of political convictions and their possibility. Even the naming of political organizations is minimal, hit-and-miss. What, for instance is the G.P.P., whose initials appear on the front cover and elsewhere? (This fuzziness about details underlies the fairy-tale impression I suggested at the outset.) This is the liberal pipe dream of revolution, occurring on a moral plane and anointed by the blood of the innocent. In this context, particularizing the struggle into a set of images and a set of testimonies, the revolutionary process itself is depicted as fragmented, and the politics that inflect the Nicaraguan revolution are paradoxically lost. We do not gain a sense of the *systematic* relation between U.S. policies and exploitation of the Third World. Further, by inadequately describing the currents within the united front, particularly the mixture of leftist, business, and religious interests, by ending the chronology at the moment of entry of the victorious provisional government into the central plaza of Managua, the book fails to build a bridge to the Nicaraguan present. Thus, the sympathy the book intends to incite falls short of the political complexities of reconstruction.

Despite the "humanization" of Nicaragua, the provision of concrete imagery and human voices, the stereotypes of Latin American underdevelopment and carnivalism can remain unchallenged. Images without the verbal anchoring of what they show cannot rightly be termed journalism. They can nudge the viewer away from reading out of images toward reading into them. With the kind of projection that accompanies art photography, they can convert reality into metaphor and generalize the particular. The conversion from reportage to art attempts to hurry a historical process, abridging the decent interval that is supposed to elapse before war photos are taken as universalized testaments to a set of ideological themes with a powerful hold on the collective imaginary: War Is Hell, Admire the Little People, Everything Important Occurs within the Individual, and finally, The Photographer Is Brave. One of the important messages of most photojournalism is the

assumption by the photojournalist of the burden of pain, compassion, and bravery that inspires but simultaneously absolves the rest of us.

A focus on war photographers' heroism is a permanent feature of their reputations, yet *Nicaragua* provides no biographical information, no hype and puffery, about Meiselas; a silence I assume to be her own. Her refusal to be lionized, her modesty, is particularly admirable for a woman, for the adulation of women war photographers, including Margaret Bourke-White, is so glibly available. I see it as counterpoint to her refusal in her photographs to probe the psyches of the victims of misery, avoiding the conversion of grief into spectacle, a standard trick of most war photography and much human-interest reportage. Nor does she suggest, as these approaches often do, that war is like a natural calamity.

Just how spare Meiselas's book is in relation to the orgies of blood, fire, pain, and photographic heroism that form the backbone of war-photo books can be gauged by comparison with another just-published book, Don Mc-Cullin's *Hearts of Darkness*.[2] The book of black-and-white, gritty, grainy photos, mostly classically composed images of war combatants and casualties, is indeed a catalogue, of an exhibition at the Victoria and Albert Museum late in 1980. This book, too, has its captions collected at the back, and it is explicitly claimed in the introduction by spy-novel writer John Le Carré to be about the photographer: "His work is an externalization of his own fragmented identity." On the cover of this book, the order of titling on Meiselas's is reversed: McCullin's name is at the top and larger than the book title below the photo. That fits publishers' logic, for Nicaragua is better known than Susan Meiselas, but Don McCullin is better known than the dark hearts he photographs.

CHILDHOOD TRAUMA

After amply establishing, through sexual anecdotes, McCullin's moral superiority to the scruffy crew of war photographers, Le Carré writes of a photo of a dead Vietnamese boy with whose body McCullin had shared a foxhole:

Don T. McCullin, *Waiting for Food,* Biafra, 1970. Gelatin silver print.

"If it were a painting, I would call it sentimental; but it isn't, it's life, and it's love outraged, it's a cry of fury from deep in McCullin's feeling heart, but I think he wants me to understand that it's also a cry of fury about his own truncated childhood."

Most of the photos, from England, Cyprus, Vietnam, Cambodia, the Congo, Biafra, India, Palestine, Lebanon, and Ireland, were taken during the 1960s and early 1970s. A few landscapes near the end are of his property in the English countryside, shrouded in mist, and a dead sparrow in the snow.

A dead sparrow in the snow? At the New School panel of war photographers, I asked McCullin whether what war photographers do, given their own expressed frustration over editors' demands and their evident inability to "end war," is not somewhat pornographic. I asked him whether, in his own case, it was not deplorable to publish his photos captionless and with an introduction anointing him as artist. McCullin, a soft-spoken person, showed a strange incoherence about his reasons for taking photos and his feelings about war. But he agreed with me: War photos are far more pornographic than any sexual image, he said. Now a staff photographer for the London *Sunday Times,* he said he'd rather photograph slums but that the market was slight. As he spoke I forgave him a bit for the book, with its blind construction of a photographer-artist-hero, its flattening of all the photos to War is Hell and Man's Inhumanity, its title bearing the racist weight suggested by Conrad's story.

In the 1980s, cynicism and the cult of decadence are far more acceptable in the art world than the image of compulsive empathizing on which McCullin's reputation has been built. Le Carré injects a suggestion of a modish chasing after violence in lieu of meaning, more Sid Vicious than Cornell Capa: "I expect that McCullin has committed suicide through his camera many times, only to lower the viewfinder and discover himself once again, sane and intact, and obliged to continue 'a normal life' . . . perhaps it is . . . possible to feel nostalgia for physical suffering as a form of human nobility from which our good luck frequently withholds us." How does one read such an introduction in conjunction with photos of the dying and the dead, the

starving and the destitute, most of whom, dead or alive, are looking right at you from the frame? Le Carré exults over the suggestive surrender of the photographed person to McCullin's camera, the "yes" the literate might associate with Molly Bloom: "Yes, take me. . . . Yes, show the world my pain. And I remember reading . . . that an ailing buck has been seen . . . to turn and face his predator with acceptance: 'yes.'" Le Carré strikes just the right note for the eighties: The photographer stalks the creature given into the final embrace of death.

Don McCullin meditatively told the audience that he sought out the worst atrocities, for who ever said that a dead body had no use? Its use was to be photographed. His point was not the framing of a spectacle, it was the obsessive need to create and to re-create the one telling image, the one that would finally do the work. He expressed, in answer to my question, embarrassment at Le Carré's introduction; he had been, he said, captive to his editor, who had sat on the book for a year until he found a big name to write. In comparison, Meiselas seems lucky to have escaped with no introduction, even though the book cries out for an analysis of Nicaraguan reality.

What the war correspondents at that conference could not face squarely, but could only worriedly circle around, was the possibility of the meaninglessness of their work, or worse, its translation into sentimentality or sports photography. One panelist suggested that photojournalists had to write more of the copy themselves. But most of the panelists rejected this idea, as they had others. They backed away from personal commitment, in part because, if nothing else, that might damage their saleability and head them toward despair. And was it really even an option for most of them?

Meiselas, in *American Photographer,* provided a modern rationale for photojournalism: that her photos, appearing almost immediately in American magazines, were quickly seen in Nicaragua and—presumably—served to reinvigorate the rebel cause. Excellent. But if internal circulation were the only aim, one could bypass *Geo, Der Spiegel,* and *Time-Newsweek* in favor of direct distribution (though, to be fair, these publications pay the bills and provide access and legitimacy). It is when one sends one's photos outside the

circle of the convinced that the problems begin—problems compounded by publication in book form. Science fiction has pictured a time in which "bush" wars will serve as gladiatorial entertainment for stay-at-home TV viewers. (Until the U.S. Civil War dragged war into the modern age with its change in technology and scale, spectators in fact often gathered at battle sites at a safe viewing distance from engaged combatants, watching a battle as an extension of sport.) Is it unreasonable to conceive of an image-consuming public responding with a similar detached aesthetic appreciation to a photo-journalistic style deriving not only from the "anomic" street-photo tradition but also from the feral exoticism of fashion photography? Even the most committed photographer, such as Meiselas, is so far hostage to the interests of editors and publishers and their products, which in the main have little to do with "truth" but which willingly merchandise a nihilistic fascination with death, death, and more death, to help us steer a course between intolerable personal anxiety and its alternative numbness.

NOTES

1. Robert Frank, *Les Américains,* ed. Alain Bousquet (Paris: Robert Delpire, 1958).

2. Don McCullin, *Hearts of Darkness* (New York: Alfred A. Knopf, 1981).

IMAGE SIMULATIONS, COMPUTER MANIPULATIONS:
SOME CONSIDERATIONS

Pick a picture, any picture. The question at hand is the danger posed to "truth" by computer-manipulated photographic imagery.[1] How do we approach this question in a period in which the veracity of even the "straight,"

This article, in all its permutations, is gratefully and lovingly dedicated to the memory of Jim Pomeroy, who gently but persistently insisted I address this subject. Versions were published in *Afterimage* (December 1989), in *Ten-8* (Autumn 1991), and in Jeremy Gardiner, ed., *Digital Photography* (New York: Van Nostrand Reinhold, 1994). A still earlier version, titled "Image Simulations, Computer Manipulations: Some Ethical Considerations," appeared in the exhibition catalogue *Digital Photography: Captured Images, Volatile Memory, New Montage,* ed. Marnie Gillette and Jim Pomeroy (San Francisco: San Francisco Camerawork, 1988), and was republished in the *Women Artists' Slide Library Journal* (Summer 1989). The mid-1990s version was republished in Hubertus v. Amelunxen et al., eds., *Photography after Photography: Memory and Representation in the Digital Age* (Munich: G & B Arts, 1996), and was translated as "Bildsimulationen, Computermanipulationen: einige Überlegungen" in Amelunxen et al., *Fotografie nach der Fotografie* (Munich: Siemens, 1996), and (slightly abridged) in Amelunxen, ed., *Theorie der Fotografie: 1980–1995* (Munich: Schirmer/Mosel, 2000). It has also been translated (earlier version) and adapted as "Kuka pommittaa tajuntaasi?" *Image* (Helsinki), no. 4 (December 1992), and (later version) in Jorge Luis Marzo, ed., *La fotografía y los tiempos sociales* (Madrid: Editorial Gustavo Gili, 2004).

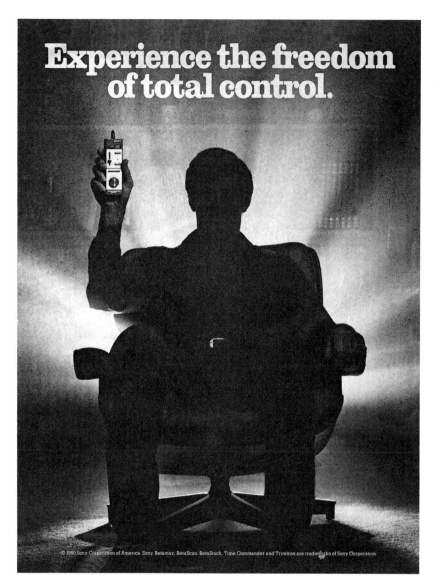

Sony Corporation advertisement, 1980.

unmanipulated photograph has been under attack for a couple of decades?[2] Think of how much time has been spent in that period on the relation between the photographic "map" and an instant of past time. Think about Sergei Eisenstein and his development of filmic montage, to extend and multiply the power of an instant. Now consider (an image of) the pyramids. If a photograph represents mutability, then surely the pyramids are the very image of immutability—the immutability of objects. Necropolitan skyscrapers, they symbolize a death culture; they represent the staying power of something that yet decays, that will not last as long as the earth. Unlike the blasted ruins of the Acropolis, they are, moreover, brute geometry, enduring monuments to a long-eclipsed power of command over labor in a land now reduced to dry dust. Like Uluru (Ayers Rock) in the middle of Australia, the pyramids represent another people's relation to the earth itself, about which we are nervously aware that we are largely unaware. Now think about moving the pyramids—as a whim, casually. What, if anything, would such an impulse tell us about ourselves? . . . More on this later.

We tell ourselves that ever-mutating experiences of space and time are the commonplaces of "postindustrial" civilization. If travel and telephone meant the abridgment of space and time, then sound recording, film, and video meant the collapse of their continuity. Fredric Jameson and others[3] relate the experience of postmodernism to the loss of maps—we depart from and arrive nowhere in the movement through time and space, which have in any case been collapsed into one another. In recounting the multiple echoing self-referentiality of the forms of representation we have uncertainly called postmodern, one finds it hard not to sound overawed—the dizzying displacement has a certain primitive appeal; some people have taken Jameson's criticism of the Los Angeles Bonaventure Hotel's dislocating plan as praise. There is, after all, pleasure to be had in the giddiness of dislocating oneself in a culture that has been experienced for a couple of centuries as dislocating us. This, however, is old talk.

Early in the marketing of VCRs, in 1980, a Sony advertisement (showing a photo of a man in an armchair, holding aloft a remote TV-VCR

controller and emanating both bourgeois complacency and patriarchal god-head majesty) promised you and me the ability to "master time, memory, and circumstance" and suggested, "Experience the freedom of total control"—through time shifting of TV programs, of course. We keep hoping that (this kind of) control over time and space does offer both freedom and totality, on a personal level.

If a consumer culture centers on the manipulation of desire, then controlling time and space is a small matter, for desire knows only the present—so we need control only the fantasies of the moment. Technological fetishism underlies our preference for vast, or vastly convincing, technological apparatuses, like VCRs, to channel those momentary desires. Machinery is the answer, as even most hippies thought. (In their fantasies of stripping away the taints of civilization, virtually everything seemed expendable except some source of electricity to run the sound system—which, we should note, produces not music in the traditional sense but the representation of music.)

PHOTOGRAPHY AND MANIPULATION

And photography? Its abilities are so modest that in a heady discussion of time-warping they can be overlooked. Still, let's say you want to move that pyramid. "Technology" makes it possible to move it *photographically* with hardly any trouble. Now, before we proceed with moving the pyramids, be fore-warned that critical considerations of the possibilities of photographic manipulation tend to end with a tolling of the death knell for "truth." This discussion will not end that way.[4] It's possible that certain modes of address are near exhaustion as ways of communicating "facticity," but that doesn't amount to asserting either that "truth is dead" or that "photography is used up." Any familiarity with photographic history shows that manipulation is integral to photography. Over and above the cultural bias toward "Renaissance space" that provides the conceptual grounding of photography itself, there are the constraints of in-camera framing, lenses, lighting, and filtration. In printing an image, the selection of paper and other materials affects color or tonality,

texture, and so forth. Furthermore, elements of the pictorial image can be suppressed or emphasized, and elements from other "frames" can be reproduced on or alongside them. And context, finally, is determining. (For linguistic context, there is the ubiquitous caption; for visual context, the multiplicative effect of images placed together; recall also the early Soviet filmmaker Lev Kuleshov's experiments in the influence of sequence on meaning in film.)

In the mid-nineteenth century, Oscar Rejlander concocted photographic montages that intrigued Queen Victoria. (If street urchins could be seen in interior doorways, and painters could represent them, why not photographers, despite the technical inability of photography to do so? If the representation of a dreamer and his dream can be thought, why not presented photographically?) Charles Darwin, impressed by Rejlander's simulations, engaged him to prepare photographic representations of facial expressions of emotion from terror to loathing[5]—the distinction between representation and falsification was not of interest here, and Rejlander's photos, in contrast to less staged or unstaged images in the same book, look Victorian, theatrical, Rejlanderesque.

Nineteenth-century rural Americans apparently had some trouble distinguishing between photographs of dead people as records of their bodies and as repositories of some portion of their souls; by the twentieth century this distinction had become a litmus test of civilization. In a less mystical, more practical vein, any nineteenth-century photographer of landscapes was likely to make good exposures of cloud-bearing skies to marry to appropriate images of the terrain below (or to retouch or double-expose the negatives), simply because orthochromatic film couldn't do justice to both at once.[6] The great attention paid to skies in landscape painting had prepared the way for photographic skies to appear as presence, not as absence. So any outdoor photo was likely to be a montage, posing no problems of veracity for maker or viewer. All these manipulations were in the service of a truer truth, one closer to conceptual adequacy, not to mention experience.

The identification of photography with objectivity is a modern idea, and the fascination with the precision of its rendering has only partly characterized its reception. Certainly the *artistic* practice of photography incorporated markers of the effort to evade the mechanicity of "straight" photography. The *deceptive* manipulation of images is another matter. The use of faked photographs is a long-standing political trick, in the form both of photographs misappropriated or changed after they were produced and of ones set up for the camera. Before lithography enabled newspapers to use photographs directly around 1880, photographs were at the mercy of the engravers who prepared the printing plates for reproduction. Even now, cropping and airbrushing are decisive methods of manipulating existing imagery, and set-up or staged ("restaged") images are always a possibility.

Restaging[7] or faking is always an issue in war photography. Even "the most famous war photograph," Robert Capa's image of a soldier falling in battle in the Spanish Civil War, has been called a fake (partly because there is another Capa image that is strikingly similar), although its veracity was subsequently reaffirmed.[8] In America, the emblematic photograph of World War II, Associated Press photographer Joe Rosenthal's Pulitzer Prize–winning image of Marines raising a huge flag at Iwo Jima, is something of a fudge (on the press's part) or a fraud (perpetrated by Marine brass). Despite the existence of photos of the original event by Marine photographer Louis Lowery, the statue at the Marine Corps War Memorial at Arlington is based on Rosenthal's image. The use of the Rosenthal image—a postbattle replacement by a different set of Marines of the original, smaller flag planted earlier under fire—was in the interest of Marine Corps public relations. Both groups of men—those who had raised the original flag during combat and those who had taken part in the second raising—were repeatedly made to lie about the event. It was the second group, not those who had initially raised the flag, and Rosenthal, not Lowery, who were honored.[9] Earlier, and with less consequence, in the American Civil War, photographer Alexander Gardner, in Mathew Brady's employ, is believed to have moved at least one body.[10] By the Spanish-American War of 1898, when news images had routinely (if recently)

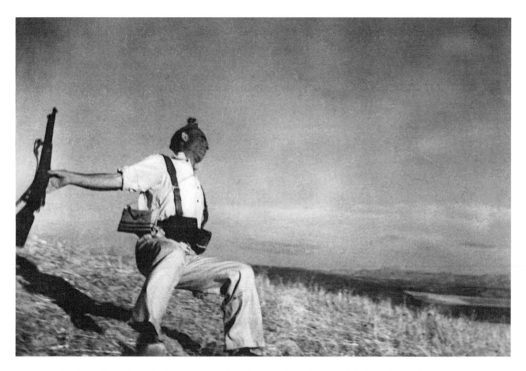

Robert Capa, *Loyalist Militiaman at the Moment of Death, Cerro Muriano, September 5, 1936* ("Falling Soldier"). The soldier has been definitively identified as Federico Borrell García. Gelatin silver print.

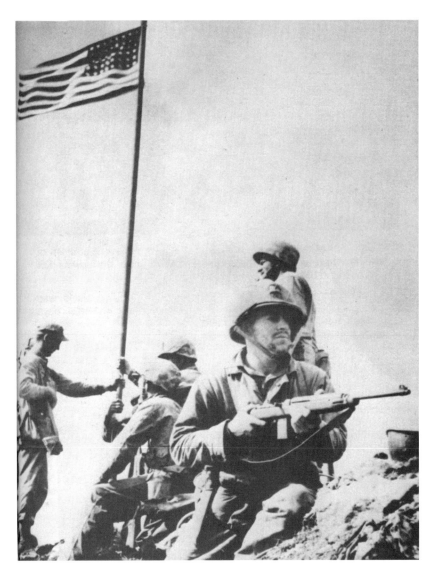

Louis Lowery, *Flag raising on Iwo Jima,* February 23, 1945. Gelatin silver print. One of several images from Lowery's sequence. Marine Staff Sergeant Lowery was assigned to *Leatherneck* magazine.

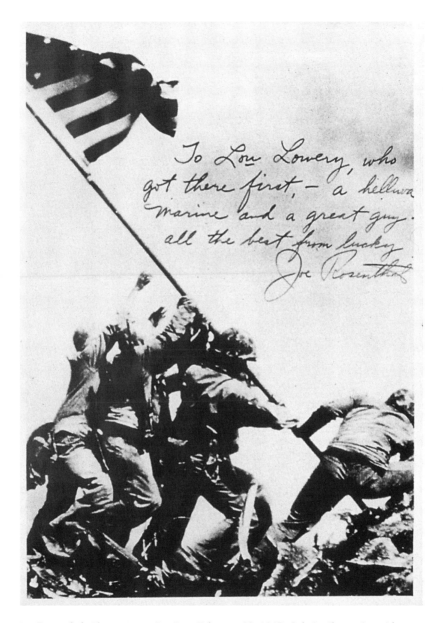

Joe Rosenthal, *Flag raising on Iwo Jima,* February 23, 1945. Gelatin silver print with inscription to Louis Lowery. Rosenthal was working for the Associated Press.

Alexander Gardner, *Home of a Rebel Sharpshooter, Gettysburg, July 1863*. Gardner's *Sketchbook* provides lurid speculations on the manner of the soldier's suffering and death and observations on the subsequent decomposition of the body.

become photographic, American newsreel photographers were re-creating important scenes such as the taking of San Juan Hill in Cuba or the battle in the harbor below, famously restaged in a bathtub. Audiences were not yet schooled to ask whether the image was a product of the precise event and the precise moment it claimed to represent. Journalistic veracity and, more sophisticatedly, objectivity—the absence of an invested point of view—are concepts born of the early twentieth century, vexed responses of the newspaper industry to the crises of jingoistic political journalism—particularly war reportage, and particularly in the Spanish-American War.

In early newsreels, meant as entertainment, events such as important prize fights might be restaged for the camera, with painted spectators as backdrop. In the infancy of corporate photography, which has burgeoned into brochure production, images of manufacturing plants were routinely adjusted to get rid of dirt, damp, decay, and any other form of intrusive ugliness detracting from the nascent image of the manufactory as one grand machine. The resulting films and photos look to our eyes nothing like the external world as we know it. And midcentury *Playboy,* airbrushing its painstakingly posed nudes in the interest of a more perfect vision of an ideal bedroom appliance, was simply following custom. Commerce and entertainment still provide the most widely accepted rationales for manipulation.

In producing images of proposed buildings, architects not willing to forgo the superior veracity suggested by the photograph might go to Hedrich-Blessing,[11] a photographic firm that pioneered the stripping together of negatives. The company blended images of the architect's model of the proposed building with others of the site so skillfully that clients couldn't tell they were looking at something Walt Disney's "Imagineers" might have conjured up. Were the clients fooled? Less than visitors to Disneyland. Not fooling people but selling them was the idea, as in the rest of advertising, where reality is adjusted. Magic-show illusionism done with the proverbial smoke and mirrors helped spur the invention of filmic projection and movies.[12] Daguerre himself was a showman whose business depended on the two-dimensional re-creation of architectonic space (though most likely a space already known, but only

through pictorial representation or verbal description) and its "placement" in time through the manipulation of light.[13] It can, finally, be argued, as does the critic Janet Abrams, that all architectural photography fictionalizes because it "prepares one only for the optimum conditions, not just the building new-born, . . . but the building severed neatly from its surroundings, the building always sunbathing . . . smiling for the camera."[14]

In the late 1980s, while digitizing technology was being developed, there was still a lucrative market niche for spectacularly manipulated images produced in the old-fashioned, in-camera way; photo magazines tended to feature their makers one a month. For example, in 1988, the first issue of Kodak's high-gloss promotional magazine *Studio Light,* aimed at commercial photographers, led with the "special effects" photography of Kansas City photographer Michael Radencich.[15] Radencich specialized in *Star Wars*-like corporate images, each produced through the use of handmade tabletop (often paper) models and multiple exposures, on a single sheet of Ektachrome 64 Professional Film. Radencich stresses the need for "believability."[16] So much has changed since 1988, not only for image production but also for Kodak, which no longer even uses the word "photography" in describing itself. But in the interim, although most such trick photos have become likely to be made without being physically staged, the point to note is that the technology is following a cultural imperative rather than vice versa.

IMAGE INTERVENTION VIA COMPUTER

When the *National Geographic* abridged the space between one pyramid and another on its cover for February 1982, was it betraying its (believing) public? Earlier, I harped on the reading of the pyramids as a symbol of immutability and control. If we move them photographically, are we betraying history? Are we asserting the easy dominion of our civilization over all times and all places, as *signs* that we casually absorb as a form of loot? For their April 1982 cover, the *Geographic* adjusted the emblem on a Polish soldier's hat, importing it from another frame in the photographer's roll of film. These perhaps inconsequential changes have provoked a small but persistent fuss. The *Geographic*

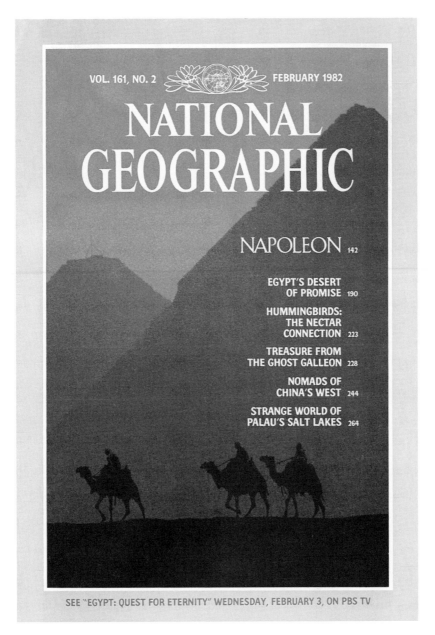

Cover of *National Geographic*, February 1982.

was using computerized digitizing technology, which converts an image into minuscule "pixels" (a neologism for "picture elements") that can be adjusted at will. To move a pyramid with the use of a computer seems to some more innocent than moving it, say, by stripping negatives or making photomontages, where the brute act of combination requires the handling of materials and their physical separation by cutting, not just the rearrangement of "information." To others it seems, for that very reason, more suspect and dangerous. The *Geographic* apparently isn't above using staged photos, though presumably the staging is done at the initiative of the photographers, not by editorial directive, for the imperative is to get that picture, no excuses. The fact that this occasions small comment underlines the point.[17]

When I described the basics of computer manipulation of photographs to a California law officer in 1988, his immediate response was, "That would mean the end of photographs as evidence." The consequences of undermining the credibility of photographic legal evidence shouldn't be underestimated, but the issue is more complex than it might appear and is beyond the compass of this article.[18] I consider the matter briefly further on. In journalism—where standards of evidence are more nebulous but of great interest nonetheless—observers are worried that digitizing technology will be used to "fix up" news photos. Once again, the journalistic profession is attempting to close ranks against overt manipulation in order to protect its reputation and the basis of its license to practice. The fears about digitization center on the ease and availability of digitizing equipment. Such machinery, pioneered by Scitex,[19] Hell, and Crosfield, is part of the equipment used to produce many newspapers and magazines. The controversy centers on news images, since magazines (and feature sections of newspapers, such as food, fashion, and other "life-style" or "business" sections) have often made use of set-up images as well as manipulated and retouched photographs. The rationale is that visual appeal and cleanliness (so to speak) of images, not photographic accuracy, are the criteria in these uses. But "interpretive" representations in which elements are literally manipulated—either before or after the photograph is made—are anathema to photojournalists, publicly, at any rate.

IMAGE CONTROL OR INFORMATION CONTROL?

When a U.S. art critic gave a talk at a photographic "congress" in the late 1980s on a well-known artist whose practice was built solely upon appropriated mass-media (in fact, advertising) photos, the response was volcanic.[20] The audience's worst nightmares, it seemed, had never thrown up a practice such as the critic described. The proprietary relation of the professional photographers present to their images was made very clear when they threatened physical doom to any artist found appropriating *their* work. No surprise, then, that they expressed general support for the then-pending congressional amendment, sponsored by the aggressively right-wing Senator Jesse Helms of North Carolina, to withhold public funding from artwork deemed obscene or otherwise offensive—an initiative that expressed in extreme form the collective Imaginary's fear and loathing of artists and, in fact, of photographers. Of *art* photographers, that is—the same people whom professional ("working") photographers fear and loathe (or at least loathe) for their lack of respect for the unmediated image.

I remarked earlier that art photography perpetually defines itself by stressing its distance from the recording apparatus; it often does so by relying on arcane theories of vision and on manipulation of the print, more recently on conceptual or critical-theoretical grounding. In the eyes of professional photographers, this no doubt makes them skill-less charlatans, loose cannons who get rich by fleecing the public. Such professional photographers, fixing their horizon at the level of copyright, are in no position to see that artists' motivations for appropriating photojournalistic and other workaday photographic images are not so far from their own fears of manipulation; the difference, of course, is that the artists see commercial photography and photojournalism as deeply implicated in the processes of social manipulation[21] while the producers of the images are more likely to see themselves as at the mercy of those who control the process. Autonomy for each is the underlying theme.

While professional photographers stop at the level of ownership of the image, the future lies with the conversion of the image to "information," making photographers, no matter how souped up, chip-laden, automated, and expensive their still cameras are, look like little ol' craftsmen or cowboys, cranky remnants of the old petite bourgeoisie. There's more to say about photographers, cameras, and the nature of their output in the digital age, but that will have to wait until later on in this article. In 1986, *American Photographer* magazine reported on an effort by a bunch of business-school whiz kids in their newly formed National Digital Corporation (NDC) to create a stock-image bank in digital form. The writer, Anne Russell, treated the effort with suspicion, remarking that (a) NDC, while acknowledging that the low-profit stock-image trade would represent only a third of their business, declined to specify what the other two-thirds would be, citing only unstated government archives; and (b) several similar but less ambitious efforts in the early 1980s had already foundered. Russell concluded: "The toughest test of the system will not be the technical one, however; it will be whether [it] can win converts in an industry that so far has demonstrated little love for technology beyond the camera."[22] I'll say. But digitized stock-image banks were inevitable, and again there is more about this later. In her 1986 article Russell makes no mention of the hazards of the loss of control of the image's visual appearance—that is, of its conversion into information. And, as information (which every hacker—unlike every photographer or every computer and software executive—believes should, by definition, be free, although what "free" means is itself a matter of serious wrangling), both sellers and buyers will have to pay for access.

Although NDC's dream of workstations in offices across the country may not yet have been realized, the conversion of stock-photo resources to digitized form is happening very rapidly and frightening many professional photographers.[23] As to the production of print media, every newspaper of any size now has the Scitex-type digitizing technology (despite its considerable cost) in its make-up room.[24] This increases the likelihood that decisions to alter photos will be made casually, by those liable to slight the niceties of

photojournalistic ethics. Presently the primary newspaper use of this technology in respect to images is in adjusting color and "burning and dodging" as in traditional black-and-white darkroom procedures. (The newspaper *USA Today* tells its photographers what kind of film to use for given situations, regardless of the lighting source, and removes the hues produced by fluorescent lighting by recoloring, which other newspapers do as well.)[25] At present, there is increasing use of digitization techniques outside the news section, as in feature stories, especially food and fashion, in which cosmetic techniques of image manipulation, including adjusting the product or the resulting image, have long been accepted.[26] The nightmare of photojournalists, who remember that W. Eugene Smith quit *Life* magazine (twice) over its editors' intention to use some of his photos in ways he didn't appreciate, is that some editor somewhere will start by adjusting the color or diminishing the clutter in some news image and go on to a career of photographic alteration. Tom Hubbard, in *News Photographer* magazine, recounts the routine "dialing in" by an engraver of the color blue for a swimming pool photo in the *Orange County Register* illustrating a story about vandals dyeing the water red(!).[27] Here the change was not editorial but technical and "inadvertent," but it's just the kind of egregious error that makes photographers and ethicists wince.

Newspaper photo editors, when asked, uniformly reject the retouching or other forms of manipulating photos, claiming that even flopping photos is not allowed, so why would they acquiesce in more pernicious changes? In contrast, U.S. television network executives have been more positive about the possibilities of photo retouching of all sorts (there seem to be no "picture editors" on TV). They describe the removal of elements in photos and footage, such as microphones in front of speakers, or the straightening of presidential candidates' shoulders (but supposedly *not* their faces).[28] Nevertheless, as time has passed, supposedly reputable (print-) journalistic outlets have run photomontages (e.g., the *New York Times*) and even digitally retouched images (e.g., *Newsweek* and *Time*).[29] Formerly less reputable—that is, "tabloid," or sensationalist—publications rely on this technique; they are noted for pasting, say, piglets' heads on babies' bodies. Interestingly, in this

same period, the distance between tabloid and so-called legitimate media has drastically diminished.

Photojournalists and even newspaper picture editors are still interested in obtaining assurances from management that they won't do what the editors of the *Geographic* (and of *Newsweek*'s puff series on various countries called "A Day in the Life of . . .")[30] have seen fit to do, which is to "improve" their pictures for the sake of conceptual accuracy, aesthetic pleasure, formatting, hucksterism, and so forth. Yet they are well aware that photographs have been subject to change, distortion, and misuse since the beginning of photographic time. The simplest misrepresentation of a photograph is its use out of context. The most remarked-on examples of this pertain, of course, to political instances and prominently feature examples related to war. War photographers Susan Meiselas and Harry Mattison have exhibited photos of theirs (of atrocities in El Salvador and events in Nicaragua) that they claim were clearly labeled but that have been intentionally misused by journalistic outlets, with lies about what is being shown, when, who did it, and what it "means."

HARD EVIDENCE

Photographic exhibits of documentary evidence provide another arena of exploitation. Senator Joseph McCarthy made liberal use of damning photographs and charts in his anticommunist crusade, and in one celebrated instance—captured in Emile De Antonio and Daniel Talbot's wonderful film *Point of Order!* (1963)—the exposure of McCarthy's use of a cropped photo provided a vehicle for his discrediting during the 1953 Army-McCarthy hearings. My favorite variety of lying through the presentation of a photographic exhibit is the photo of mysterious cargo—as used, for example, by President Ronald Reagan in exposing to the public via television a blurry photo of "Nicaraguan Sandinista official Tomás Borge loading drugs" (cocaine) onto or unloading them from a small plane on an obscure airstrip in "Nicaragua." This line of evidence is one of the CIA disinformation mill's favorites. Blurry aerial photos, virtually incomprehensible without decoding,[31]

Unattributed photograph of Secretary of the Army Robert Stevens and Private G. David Schine, 1954, as cropped by Senator Joseph McCarthy.

were used to very powerful effect in the Cuban missile crisis. It seems that no matter how much we don't believe the media, such exhibits always give doubters pause. Maybe.

Years ago, writer Susan Sontag expressed righteous anger over the political manipulation of photographs by Chinese authorities. Her cases in point included the removal of the suddenly hated Chiang Ching from a venerated image of Mao on the Long March. Such maneuvers point to the authoritarian manipulativeness of the regime, but they appear most of all to be a neatening up of historical representations having a largely ceremonial function, in a society unlikely to base its conceptions of social meaning on photography quite the ways ours does. In a widely noted example—one more recent and closer to home—of the misuse of an apparently straightforward documentary photograph, early in the Reagan administration, Secretary of State Alexander Haig waved a photo of a body on fire, calling it an image of a Miskito Indian being burned after a Sandinista massacre and citing it as evidence of Sandinista brutality. In fact, this photo, which he obtained from a right-wing French magazine, was of a body being burned by Red Cross workers—who were cropped out of the photo—during the uprising against the dictator Anastasio Somoza.[32] Haig meant the image to be decisive in rallying support for our still-secret war in Nicaragua. In this instance the original photo could be located, and perhaps its negative.

In digitization, there may be no original, no negative—only copies, only "information." Certainly, as the image emerges from digitization, it is not via a "negative"; the final image has no negative. Perhaps even more troublesome is the fact that electronic still cameras (produced by several Japanese manufacturers such as Canon, Sony, and Fuji,[33] with others promised from other manufacturers) can bypass the production of film, negatives, and prints and feed their information directly into a computer. Once in the computer, it is more likely that technicians rather than photographers or editors will monitor the fate of those images.

If we want to call up hopeful or positive uses of manipulated images, we must choose images in which manipulation is itself apparent, and not just

as a form of artistic reflexivity but as a way to make a larger point about the truth value of photographs and the illusionistic elements in the surface of (and even the definition of) "reality." I don't mean a generalized or universal point alone, but ones about particular, concrete situations and events . . . Here we must make the requisite bow to Brecht's remark about the photo of the exterior of the Krupp works not attesting to the conditions of slavery within. The origins of photomontage as an aesthetic-political technique are not certain, but the dadaists used it to disrupt the smooth, seamless surface of quotidian urban existence. Before them, Soviet constructivists used them to suggest the nearness of the just society and the complexity of social relations. Drawing in some respects upon their example, the German photomontagist John Heartfield still provides an unsurpassed example of political photomontage. In the 1930s, Heartfield, employing painstaking techniques and a sizeable staff, produced photomontages with integral texts for the left-wing mass-circulation magazine *Arbeiter-Illustrierte Zeitung* (Worker-Illustrated Journal), or *AIZ*. In every photomontage was the implicit message that photography alone cannot "tell the truth" and also the reminder that fact itself is a social construction. This is not meant to deny that photographs provide some sort of evidence, only to suggest that the truth value of photography is often overrated or mislocated.

The Digitization Market

Digitization techniques, based on previously developed, more direct forms of image manipulation, are pervasive in commercial fields of visual illustration. They are used in the production of television commercials, music videos, and still-image advertisements (which may or may not be based on traditionally produced photographs) and are the backbone of desktop publishing.[34] Digitization and still-video imaging are finding new corporate uses in financial, training, sales, and marketing presentations.[35] In medicine, digitized imaging, particularly in conjunction with CAT scans and ultrasound, has produced a new type of representation of bodily innards.[36] Ultrasound

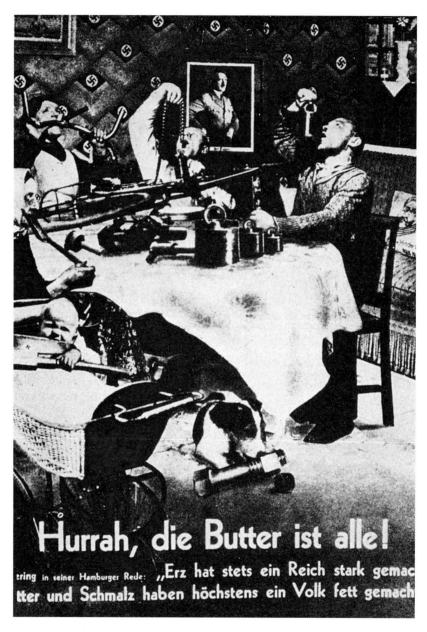

John Heartfield, *Hurrah, die Butter ist alle!*, 1935. Photomontage.

imaging, particularly of developing fetuses, is now widely recognizable, and this potent representation has been of use to anti-abortion forces.[37] For the home market—interested not in strict accuracy but in prestige-enhancing aesthetic values, in landscape, tourism, and above all in portraiture—ordinary color labs now may purchase an Agfa CRT printer (still in limited production) that offers image enhancement in making prints from slides, from the increase of sharpness and reduction of grain to the removal of "unwanted features, such as shadows."[38]

Most of these applications are bound up with the capacity to produce still images in printable form from a computerized image. Digitization is also used to produce computerized simulations of the movement of vehicles and people through landscapes, real and imaginary. The TV networks make increasing use of elaborate simulations, such as animated footage of the truck bombing of the U.S. Marine Corps barracks in Beirut in 1982 or projections of "Star Wars" battle engagements or crashes of commercial airliners—for anything relating to death and danger, whether immediately grisly or simply military. The increasing acceptance of the image field as composed of fragments or overlays means that the public has no trouble understanding cockpit images with data overlays, as in footage from the Persian Gulf War of 1991.[39] The temptation to reproduce the video-arcade experience is apparently as high in the network newsroom as in the military planning suite (where video games are already used not only in military simulations but in recruitment).

MOTION SIMULATION, MOVING SIMULATIONS

Likely to upset the apple cart of earlier forms of representation is the complex digitized simulation that goes under the name "virtual reality" (coined by Jaron Lanier, deposed head of VPL Research Inc. of California, a prime promoter and developer of the technique). In 1990 former psychotropic-drug promoter Timothy Leary appeared on CBS's *60 Minutes* television program to tout virtual reality's potentials. Like many amusement park experiences, virtual reality has caught the public's imagination before it is particularly

well-developed or widely available. While some computer software makers are working on "rendering" programs that will allow nonexistent objects to be represented from all angles, virtual-reality developers are attempting to create the illusion of a physically present environment, through which one may feel oneself moving, touching, seeing, and otherwise sensing things. Virtual reality is meant to allow people to feel as if they are actually immersed in another time or place or even personality (a husband or a frog, writes Trish Hall in the *New York Times*, or Ronald Reagan, or Elvis Presley, or a bag lady, to quote a promoter cited in the same article).[40] This promise of voyeuristic identification is not a startling discontinuity with previous fantasy vehicles that embody a desire to be or to see and feel as others might. (Calling this empathy might be going too far. Instead, it seems more appropriate to call upon the cultural critiques, such as those that build upon the work of the Frankfurt School or even that of Marshall McLuhan, which emphasize the numbness engendered by modern life and the desperate search to return meaning to individual existence through the consumption of simulations.)

Such simulations can have other uses than learning to play at war or to "forget yourself." *Times Square,* a fifteen-minute computer animation made in 1985 by Peter Bosselmann, the director of the Environmental Simulation Laboratory at the University of California at Berkeley, was intended to demonstrate that the essential experience of New York City's Times Square—an area that is an emblematic draw for tourism, one of the city's most vital "industries"—would be lost if plans for its redevelopment proceeded unmodified. His technique, which used still photos and harks back to the stripping of photos of architects' models into photos of real locales, was similarly intended to project a future space or experience, but with differing intent: It has its eye on public policy, not ecstasy or sales. A discussion of Bosselmann's film in the *New Yorker* mentions that the environmental-impact statement for the proposed Times Square redevelopment cost close to a million dollars to prepare whereas Bosselmann's simulation cost (only) twenty-five thousand dollars.[41] Bosselmann was reportedly following a trail blazed by Hollywood special-effects developers.

Movement through a landscape is just the sort of thing that military strategists want to develop intensively—and will be quite pleased to have artists, urban planners, Hollywood, independent studios, and anyone else do the advance work for them.[42] One of the most popular and relatively inexpensive recreation programs, and one of the most important, albeit expensive, work-training programs, has been the flight simulator. The military has helped develop 3D virtual-reality-type helmets that enable pilots to experience some form of alternate space conjured up on the basis of their more complete sensory immersion, and such devices likely played a role in the Persian Gulf War.[43]

Computer animation techniques have been used to combine photographic and drawn imagery in films, such as Disney's *Tron* (1982). After the popular apocalypto-shoot-'em-up *Terminator II* (1991) used an advanced computer-animated image-metamorphosis ("morphing") program, the technique was featured so heavily in television commercials that its novelty value was quickly exhausted. The TV news directors who were enthusiastic about light retouching of nonfacial stills also claimed to have produced simulated moving footage of political personalities but never to have put such simulations on the air. In an instance of non-news simulation of dead personalities—or, one should say, of "icons"—in the six-minute videotape *Rendez-vous à Montréal* (1987), Humphrey Bogart and Marilyn Monroe were computer-animated.[44] Although the characters, based on small sculptural models, are blatant caricatures and their movements and voices bizarrely unlifelike, lawyers for the Bogart estate have reportedly threatened to sue the videotape's makers, Nadia Magnenat-Thalmann and Daniel Thalmann. The Thalmanns, who operate under the *nom de computation* The Human Factory, were computer instructors at the Université de Montréal business school at the time they produced this and similar animations. Their ventures have been funded by the Québec provincial government and a number of institutions and corporations from Kodak to Bell Canada and Northern Telecom. Daniel Thalmann, according to the Dallas *Morning News,* has said, "I think that within five years, one won't be able to tell the difference between a real person on film

and one created by the Human Factory," and, "Soon, a film may no longer be accepted as proof that something happened." The first question we might ask is, under what circumstances is a film acceptable *now* as proof that something happened? The *Morning News* also quotes Daniel Thalmann as claiming that "you won't need real people any more. . . . Actors could be out of a job."[45] The second question to ask is, when can a film be taken as displaying "real people"? These are not empty questions.

As Thalmann's remarks suggest, the discussion of the effects of computerization on modern society tends to bifurcate: Either the concern is with the reception of computerized images and the effects on society as a whole, or it is with the impact of computerization on production and the experience of labor—the classic split between production and consumption, in which the latter is universalized and the former demoted, at best to a technicality and at worst to an inconvenience. Jean Baudrillard dismisses George Orwell's vision of the video screen as Big Brother surveillance monitor because, following Hans Magnus Enzensberger (with whom he agrees about nothing else), he notes that television has already prevented people from talking to one another—so there is no possibility of significant subversion to monitor. "There is no need to imagine it as a state periscope spying on everyone's private life—the situation as it stands is more efficient than that: it is the *certainty that people are no longer speaking to each other,* that they are definitively isolated in the fact of a speech without response."[46] As usual, this leaves out the question of the relation of the screen to productive labor.

COMPUTERIZATION AND THE PROCESSES OF LABOR

The development of digital image-processing techniques will most immediately affect the status of those who work with still images—particularly photographers. As I suggested earlier, it opens the way for a further loss of relative autonomy for the professional photographer, who may become, like the TV news-camera operator, merely a link in the electronic chain of command. Kodak is marketing a sensor capable of high-resolution digital imaging that

couples with a conventional Nikon F3 camera body. This device, selling for about twenty thousand dollars, captures images easily transmissible by satellite or wire, making the still photographer part of the "electronic newsroom." According to *Fortune,* in 1989 a CNN photographer using a similar device bypassed Chinese censors by surreptitiously sending an image of a Tiananmen Square demonstrator via telephone. But there is a wider application for computerization than image conversion, and the computer's effects on work apply far beyond the bounds of photography.

Consider some of the effects of computerization on work in general—both the changed nature of the work itself and new hazards associated with it, both physical and personal, such as loss of autonomy in the work process and loss of privacy because of monitoring. Computerization is well entrenched in productive-labor (nonoffice) processes, in the form of machine-shop computer-control applications and sophisticated three-dimensional drafting and modeling.[47] Computer-enhanced imaging has also altered the face of the graphics industry, turning graphic artists into computer operators. This has wrought changes not only in the types and level of skills (and capitalization) such artists require but also in the nature and locale of their work. Virtually all computer jobs (despite Baudrillard's assertion about the television set, which he considers as the site of reception, not production) also contain the possibility of absolute and effortless surveillance, as well as ever-expanding forms of Taylorism—time-and-motion "study" or efficiency-expert management. Since computers have the inherent ability to monitor all work done on them, the *number of keystrokes per hour* of computer operators can be monitored, or surveilled, effortlessly. And it is, as all observers have reported.[48]

A large proportion of workers affected by computerization—and monitoring—are women, so-called pink-collar workers.[49] The women's clerical workers' union 9 to 5 began reporting on health problems associated with video display terminals, or VDTs, in the 1970s and has more recently considered the issues associated with monitoring.[50] By the 1980s, concern about

hazards associated with computer use among workers (now including white-collar workers, including those in the newsroom—i.e., reporters)[51] was so widespread that the U.S. Congress looked into it.

The hazards of the machinery are in some ways like and in other ways quite unlike those posed by earlier types of machinery developed since the industrial revolution. Reporters, for example, are most worried about carpal tunnel syndrome or repetitive strain injury (keyboard-related injuries resulting from repetitive motion) and other health effects more than about surveillance, since the story, not the keystroke, is their measure of productivity. The Newspaper Guild has been studying VDTs since the early 1970s, but the repetitive strain injuries, which are more characteristic of industrial labor (and even of such activities as hand knitting), were an unlooked-for effect and result from keyboard use, not from the video display terminals, or VDTs.[52]

Meanwhile, new fears among computer users have arisen over the potential hazards of electromagnetic emissions from the terminals. This is consequent on the more general reawakening of concern over extremely low frequency (ELF) magnetic fields generated by all electrical sources, including high-voltage power lines but also all household appliances, from toasters to TVs. The computer magazine *MacWorld* broached the subject of physical hazards,[53] including the dangers of ELF and the more widely attended-to VLF, or very low frequency, range (forty-five to sixty kilohertz). The magazine, which featured a discussion by *New Yorker* staff writer Paul Brodeur, a tireless writer on the subject, also editorialized forcefully for accountability from the computer industry that provides journalism's route to its own bread and butter. Consideration of the validity of widely reported negative effects of VLF and ELF radiation on eyesight, reproduction, and other bodily functions is beyond the scope of this article. While most public attention to computer hazards has centered on such physical effects, especially those on female reproductive processes, the monitoring function of computerized workplaces has been lost on no one. In 1987, in "'Big Brother' in the Office," *Newsweek* wrote:

Warning: your computer may be watching you. For many American workers that's not just a paranoid fantasy. Last week the congressional Office of Technology Assessment (OTA) reported that computers are being used to keep tabs on as many as 6 million workers, from government employees to bank tellers. . . . "It's Big Brother at its worst," says Democratic Rep. Don Edwards of California. . . . "Just because you get a job," says Edwards, "doesn't mean you lose your constitutional rights."[54]

Barbara Garson demonstrates in her book *The Electronic Sweatshop*[55] that "word processing" has brought about new forms of de-skilling (to use Harry Braverman's word).[56] Workers—in her study, secretaries—are reduced to performers of single, repetitive tasks. Garson claims that IBM sold employers on the idea that word processing was not just a way to get more work out of secretaries—it offered management the possibility of redefining the jobs of both secretaries and all-but-top-level bosses so that more work could be gotten out of both of them. Secretaries, IBM pointed out, need not be "freed to do more important things" than typing; instead, a new job category of *word processor* would allow people, primarily women, to be removed from their offices and put in "pools," where they would do nothing but operate word processors all day, and their relationship (of who knows what complex and antiproductivist character) with individual bosses would be severed. Garson notes that this also enables the productivity of the bosses to be monitored, since they are the ones providing the words to be processed.

In fact, as I have suggested, most jobs performed using VDTs are subject to such surveillance, and everyone who works with a VDT quickly finds that out, whether it is actually applied to them or not; the chilling effects are obvious. For example, a Rutgers University memo of July 1985 to "deans, directors, department heads, and others" *re* VDTs responded to requests for information on the health effects of VDTs. Sixth and last on the list was stress: Studies showed "workers experienced stress over their concerns about the possibility of almost constant surveillance." Although guidelines were offered

"to reduce or eliminate pain, strain and stress," surveillance had vanished from consideration.

To consider for a moment the effects of computer surveillance of a different sort on a younger, unpaid set, I heard a radio reporter quote an education specialist enthusiastically describing primary education in the twenty-first century, when the home computer would be hooked up to the school's, and each pupil's progress could be charted at every moment; utopia or hell?

To return to the graphics industry, which may soon be barely distinguishable from the photographic industry: Computerization reduces the number of technologies involved in production and allows the workforce to be dispersed, with the work often done in the artists' own homes—which might be in Asia. This reversion to "home work" (not in the school sense but as the term has been used in sweated industries like garment production) fragments the labor force, making not only conversation but solidarity close to impossible, producing a more docile group of pieceworkers, who as independent contractors also generally lose all their nonwage benefits, such as health insurance, paid vacations, sick leave, and pensions. The ability to work at home is often treated as a social advance, but in most discussions the people affected are executive or managerial in rank; the effects on lower-level or shop-floor employees are slighted, if not celebrated for producing labor peace. In arguing for the repeal of labor laws that prohibit piecework, the defense of these new forms of home work for production workers has been disingenuously couched in terms of rural or small-town craftswomen sewing for a living while tending the homestead.

The Culture of Simulation

The decline of industrial labor and its system of valuation and work-force organization (and self-organization), and the development of a culture whose common currency is the production of images and signs, constitutes the burden of Baudrillard's arguments about simulation, which have provided so much grist for contemporary critical mills. Yet, as with Baudrillard's precursor and

intellectual mentor Marshall McLuhan, recognition of the media's power to flatten both experience and difference has led to capitulation or (more in the case of Baudrillard than McLuhan) to cynicism. Baudrillard, with many followers, believes that truth is no longer an issue, since all signs are interchangeable. He writes that, for example, the subject of every single thing that appears on television is "you": "'YOU are news, you are the social, the event is you, you are involved, you can use your voice, etc.' . . . No more violence or surveillance; only 'information,' secret virulence, chain reaction, slow implosion, and simulacra of spaces where the real-effect again comes into play."[57] The problem with such totalizing pessimism is that it provides an adequate description of neither causes nor real-life experiences. It remains a fantasy of power of those implicated in the system of production of signification. Yet we cannot dismiss the tendencies toward "implosion" of meaning and the difficulty of distinguishing the real from the artificial that Baudrillard describes, following a line of thinkers that includes not just McLuhan but Frankfurt School cultural critics Adorno and Horkheimer and Walter Benjamin, as well as Gunther Anders and the French situationists, notably Guy Debord. In 1967 Debord opened Part I, "Separation Perfected," of his immensely influential book *La Société du spectacle*[58] with the following quotation:

> But certainly for the present age, which prefers the sign to the thing signified, the copy to the original, fancy to reality, the appearance to the essence, *illusion* only *is sacred, truth profane.* Nay, sacredness is held to be enhanced in proportion as truth decreases and illusion increases, so that the highest degree of illusion comes to be the highest degree of sacredness.

This quotation is from Ludwig Feuerbach's preface to the second edition of *The Essence of Christianity,* published in German in 1841.[59] Feuerbach's remark is taken as an early diagnosis of a trend that has since become all-pervasive. For the writers I have named, the "spectacle" represents not a panoply of images but a symptom or nexus of the relations of production and

therefore lies at the heart of social relations. Well, then, what shall we think about computer-processed imagery, which may indeed produce copies with no "original," and about its relation to photographic documentation?

Earlier I invoked the pyramids and the cultural transactions involved in photographing them and electronically adjusting their placement on the land. In Jean-Luc Godard's anti-imperialist, antiwar movie *Les Carabinières* (1963), the main characters, tattered simpletons named something like Michelangelo and Raphael, return home to their wives after a grotesque national military adventure. "We bring you all the treasures of the world," they proclaim, opening a suitcase and pulling out card after card picturing monuments and wonders. In 1992, the United Nations Educational, Scientific and Cultural Organization (UNESCO) announced a plan to photograph two hundred "cultural and natural wonders" of the world and to make the images "instantly available worldwide through digital transmission," according to the *New York Times.*[60] This UNESCO adventure, called Projet Patrimoine 2001, is backed financially by the immensely rich La Caixa Foundation (supported by Barcelona's municipal pension funds), which donated $140 million for the first year.[61] Technical services will be provided by Kodak, France Telecom, and the Gamma photo agency. Selected sites, to be recorded with "scientific comprehensiveness and artistic beauty" in mind, will come from a UNESCO list of so-called world heritage sites. The idea is to make images of such treasures as Angkor-Wat or the Seychelles Islands turtles, before, according to the *Times,* "they are further damaged by war or the environment." On a lesser scale, there are moves afoot in various cities, such as New York, to require that buildings slated for demolition be photographed beforehand (by an unspecified process). One wonders whether proponents of such measures know that such cataloguing was one of the earliest governmentally mandated uses of photography, as in Thomas Annan's documentation of slum sections of old Glasgow in the 1860s and 1870s before demolition, the photographing of old Paris by Charles Marville in the 1860s before the implementation of Baron Haussmann's monumental (and historically destructive) boulevard plan—or the self-appointed documenter of "old Paris" at the turn

of the twentieth century, Eugène Atget.[62] The relation to Godard's carabineers needs no further explication—but what of the idea of "capturing" something photographically and transmitting it in a medium that implies mutation and change? Of what value, precisely, will be the record assembled?

Perhaps it is time to return to the questions I raised about computer animator Daniel Thalmann's remarks—namely, when can we ever take film or photos to represent real events or real people? Earlier I referred to the endangerment by digitization of one of photography's quotidian uses, that of the provision of courtroom evidence. Granted, with respect to publishing, all publishers of whatever size should be assumed to be in possession of image-processing equipment and all publications to be produced by one computerized process or another. But these elements of the labor process are not prominent in the public consciousness. What will affect public attitudes, however, are imaging products soon to be available for the mass market. Companies are devoting a great deal of attention to developing such products at acceptable cost. These will likely provide customers with multiple possibilities for viewing, from "hard copies" to television-screen images, and the information will be stored in a variety of ways—on video disks, tape, or most likely compact disks. Images will be manipulable with varying degrees of ease. As the public becomes used to the idea of the image as data in flux, the believability of photographic images—the common assumption that a photo is true unless shown to be otherwise—will likely wane. (But we have also to acknowledge the perverse tenacity of the will to fantasy outside the judicial process [one hopes], the fantasy that sells the *National Enquirer,* the *Weekly World News,* and *People* magazine images we have discussed, fantasy which requires the suspension of disbelief about the provenance of photos that marked the beginning of the era of published photographic imagery.)

It is in any case simplistic to assume that processes of fact-finding and adjudication through evidence are what drive the judicial process. In fact, as most people realize, the judicial system might better be viewed as a theater in which the adversaries deploy props and variously encoded arguments.[63] At present, lawyers, particularly in accident and negligence cases, like using

videotapes showing accident scenes and sufferers; such videotapes frequently short-circuit the judicial procedure by leading to pretrial settlements with insurance companies. However, computerized simulations (such as the movements through a landscape that I described earlier as in use for the military) are gaining favor with lawyers as the technology for producing such "forensic animations" improves and the cost of producing them drops. Here, perhaps, it is easier to see that the "document" is in reality a text or an argument.[64]

Still, there are social costs associated with the radical delegitimation of photography. Although such delegitimation would make it more difficult for State officials to wave photos around as evidence of this or that, clearly it also diminishes the public circulation of communications of factuality. The development of a politically active citizenry depends on the ability to receive and communicate information about events and situations not directly experienced, including the experiences of Others. Even without the collapse of photographic legitimacy, merely reproducing documentary images can rarely mobilize or even, perhaps, inform. Without an *adequate* discussion of the context and meaning of the social relations represented, such images cannot *work,* unless the audience already shares certain presumptions about "what things mean."[65] Like the photo of the Krupp works, such documents are accurate but insufficient. The question, then, is not whether to manipulate images but how—and also how to use them straight to "tell the truth."

The confusion of style with substance is fostered by any situation that allows advertising to be integrated into its fabric and format. The increasing commercialization of everyday life continues to blur the boundaries between objective evidence, informed knowledge, prejudicial opinion, and sheer fiction. The syndrome represented by a huckster claiming "I'm not a doctor, but I play one on TV" does not end there. Just as "public relations" was invented early in the twentieth century to mimic and exploit the printed news release, and, more recently, U.S. children's cartoon shows have been developed as marketing vehicles for new toys, television now can boast ads that appear to be programs. Such "infomercials" or "program-length commercials" (PLCs), copy television formats closely. They represent an interesting but

ominous crossing of genre boundaries. The simulation at issue is not computerized but based on old-fashioned mimicry.[66] Jeffrey Chester and Kathryn Montgomery, in "Counterfeiting the News,"[67] describe a newslike show on violent crime that was actually an ad for a stun gun,[68] a "consumer-advocacy show" that hawked sunglasses, a "legal-action hotline" that featured lawyers who paid to be listed. "A growing number of these commercials," they continue, "are disguising themselves as news." (They also provide revenue for stations that would otherwise have to pay to fill the slots they occupy with more traditional programming.)

Such programs were banned by the Federal Communications Commission (FCC) in the early 1970s because of viewer complaints, but the ban was lifted under the Reagan FCC's deregulation. The possibility exists that vigilant viewers and groups can push back this particular form of simulation once again, just as it seems likely that advocates for children's programming might curb toy-based cartoons in the United States. Such activism is not only necessary but also often effective.

Although John Kamp, director of public affairs for the FCC, says that "under existing rules, there's no such thing as excess commercialization," Jeffrey Marks, chair of the Ethics Committee of the Radio-Television News Directors Association, remarks: "We've made the news interesting to a lot of people [by showing 'soft news' to increase ratings] and raised the production values, so in a sense news became as glitzy as commercials. Now the reverse is happening."[69] The news profession, of course, is fearful that actors who appear to be news personnel will destroy the credibility of the news, a process that is already under way, for somewhat different—and more fundamental—reasons than the use of actors as news readers. Yet, like the use of the political press release by newspapers and television, short "segments" on health produced by—surprise!—manufacturers of health products are regularly and seamlessly inserted into local news programs without either newsroom distress or acknowledgment.

The pressure of cable television, which has developed in the climate of deregulation, and of Rupert Murdoch's Fox television network has resulted

in "tabloid television," featuring sensationalist exploitation as well as simulations of news events, on the one hand, and the theatricalization of actual events, such as police raids, on the other. (The opener of Fox's program *Cops* shows real police on real raids taking real captives, cut to a rap song called "Bad Boys.") But the presentation of grisly "actualities," harking back to the beginning of cinema (and to the sensationalist newspaper tabloids flourishing by then), is also represented by the mid-1970s network broadcasts of open-heart surgery. In a related matter, few have bothered to question the long-standing involvement of television stations in law enforcement through their Crime Stoppers campaigns, which have spawned the burgeoning audience-participation shows on the order of Fox's *America's Most Wanted*. In 1991 a reporter for the Los Angeles *Daily News* discovered that the Federal Bureau of Investigation had made an unpublicized deal to release the additions to its list of the "most wanted" directly to *America's Most Wanted* and to *Unsolved Mysteries* (NBC) before alerting any other outlet.[70]

The intertwining of law enforcement and reportage puts journalism in an untenable relation to the State—a fact that apparently bothers almost no one. Indeed, such shows have become the model for much of the rest of television programming and have markedly affected even the more legitimate varieties of television journalism.[71]

The difference between the presentation of open-heart surgery and police raids, then, is the difference between a certain prurience expressed as scientific curiosity and an implicit identification with the police powers of the State. This is dangerous to any polity and points yet again to the decline of a public sphere standing resolutely apart from the interests of the State. The traditional adversarial relation of press and State, let alone standards of fairness or objectivity, attenuates under these circumstances. It does so as well when the press positions itself as an unabashed conduit of government pronouncements and positions, as it always does in wartime—as in the Gulf War, where the government's control of images and language were paramount. Although in photos of Saddam Hussein his mustache was cropped to resemble Hitler's, and the usual stories and images depicting him as a baby killer were circulated,

this was penny-ante stuff compared with the totality of the government on-
slaught on the autonomy of the press. Control over information in this war,
represented as being the one most intensively "visualized" to date by press
images, was as great as it was in the days when the English Lord Kitchener
threatened to shoot any reporter found on the battlefront. The principle of
using a flood of controlled information to bombard the sense out of the pop-
ulace was well applied.

In the CNN war, instant replay of cockpit video images forestalled
analysis; the simulation environment overlaid and obscured reality—the brute
facts of bombs falling on and killing people that constituted "collateral dam-
age." (But this too was simply the latest step in the technological vision of war
as a hardware—and now software—contest.) On a more mundane level,
"infotainment" is whizzing along like a bullet train, blurring the landscape
outside. Although comments on cultural and technological developments,
such as those in this article, are soon outdated by the pace of change, it is
worth noting the current rage for "multimedia." Multimedia, one may sur-
mise, is envisioned as an educational answer to the video game, but it is an-
other heavily commodified simulation in which the continuity of a historical
text or narrative is fragmented by vicarious excursuses into other simulated
or recorded byways. Post-structuralists take note.

Rapid advances in digitization and other computer technologies will
continue to alter modes of information delivery in specialized and general
uses and will certainly transform not only photography but also the televi-
sion, telephone, and personal computer industries. The present article is a
palimpsest of arguments configured to conform to questions posed by the
state of computerization of photography and other images. When I began
writing in 1988, Kodak was still a "photo" company, making and marketing
film, and the professional photography establishment was worrying about
digitization of photos. As I write in 1995, digitization is taken for granted,
and interest centers on the use of new, miniaturized digitization devices for
photographers such as were used at the recent Olympics; on data compression
that enables the transmission of digital video images by telephone (presently,

fiber optic) lines or other modes of transmission, and on the tremendously important contest of corporations as this field becomes increasingly monopolistic and internationalized; and on encryption.[72] In the first instance, tiny portable monitors and scanners return some measure of control in the field to the photographer. In the second, digitization and, importantly, compression of video images may well make broadcast television obsolete; the Supreme Court has granted the myriad phone companies the right to transmit video, in a service called "video dial tone," and as I revise this in 1995, the U.S. Congress is in the process of handing industry a new omnibus telecommunications bill that gives them all their hearts' desires and allows industries formerly barred from various types of transmission activities to enter into them. In the third instance, the transmission of images, and indeed of other data, has opened the possibility of tampering, so that corporate senders have urgently developed highly complex, virtually unbreakable forms of encryption. But the government is opposing such encryption, because it does not wish to allow any entity to transmit data it cannot intercept and monitor at will. Meanwhile, the computer industry seeks resuscitation, searching desperately for a new industry-transformative device, whether it be keyboardless, cable-free, or even wearable computers.

THE LARGER PICTURE

These are the contexts for the manipulation of still photographs (now perhaps better termed "photographic information"). In sum, concerns about manipulation center on political, ethical, judicial, and other legal issues (such as copyright),[73] as well as the broader ideological ramifications of how a culture deploys "evidence" it has invested with the ability to bear ("objective") witness irrespective of the vicissitudes of history and personality. Complications posed by questions of reception, such as those raised by poststructuralist critics and philosophers, have themselves fueled a pessimism about the ability to communicate meaning (let alone "truth"). Nevertheless, as I've already indicated, it seems unreasonable to conclude that meaning cannot be communicated, let alone that "the photograph as evidence of any-

thing is dead," to quote the *Whole Earth Review*'s slightly hysterical discussion of digitized photography.[74] To be sure, newspapers, photographers, and governments should be enjoined, formally or informally, from changing elements of photographs that are presented as evidence of anything at all; but the idea of the photograph as raw evidence is one with a rather short history, and the erection of Potemkin villages for politics or entertainment neither began nor will end with the electronic manipulation of photographic imagery.

That is not to say that an era characterized by certain beliefs and cultural practices is not passing in the West. A more general cultural delegitimization than the questioning of photographic truth is at work in the industrial societies. This delegitimization is as much a product of political failure as of image societies, and it entails the declining faith in the project of modernity and its religion of "progress." In describing its material basis (though not, one must hope, in his totalized conclusions), Debord was surely correct to locate the genesis of "the society of the spectacle" in the process of capitalist industrial production and the dominance of the commodity form—despite Baudrillard's attempted correction of Debord's theory[75] to the interchangeability not of commodities but of signs.

There are productive aspects to the adoption of a skeptical relation to information provided by authorities. The real danger—as evidenced by the mass willingness of Americans to take refuge from uncertainty in the utterances of their leaders, regardless of the plethora of evidence contradicting them—is political; it is the danger that people will choose fantasy,[76] and fantasy identification with power, over a threatening or intolerably dislocating social reality.

The highly consequential Rodney King beating case of 1991–92 provides an instructive reminder of the way that evidence is received. In that instance, the evidence videotape appeared to afford a "candid," irrefutable peep at unwarrantedly brutal police behavior—and was so judged by the court of media opinion. The ability of such evidence to persuade those left unconvinced by generations of firsthand verbal reports of police violence is a reminder that there is still a cultural inclination to treat photographic evidence as objective. But to the surprise of many, in the courtroom—in *that*

courtroom—it was adjudged simply to show the legitimate exercise of po-
lice power, to use the common phrase. Although the cultural reception of
nonprofessional video (labeled "amateur video" when broadcast) has privi-
leged the apparatus over the operator and thus generally taken its testimony
as unimpeachable (home videotapers are assumed not to be invested with the
skill, the interest, or the wherewithal to alter the material), the meaning of
what we see is not in what we see but in what we/it "means." Truth isn't nec-
essarily taken to be empirically demonstrable; when those who are asked to
judge must pass judgment on the police or the State, many will choose alle-
giance to the police and the State over specific evidence of misconduct. Put
more simply, we seem likely to forgive those in power for abusing it—as long
as we don't identify personally with the abused.[77]

As always, social meanings and their perception are not fully deter-
mined by the technologies used in their production but rather are circum-
scribed both by wider hegemonic ideological practices and by the practices
and traditions of those who oppose them. If material conditions need to be
redescribed, more painstakingly and in novel forms, in order to be reinvested
with "believability," then we can surely develop the forms—and the means
of dissemination—to do so. A cautionary note, however, is that it is only
those committed to rationality who make political—or any—decisions on
the basis of rational criteria. Unfortunately, in the United States, and surely
elsewhere, the corporatization of what has come to be known as the infor-
mation superhighway means that just as the gulf between those rich and those
poor in monetary resources is yawning wider, the gulf between those infor-
mation-rich and information-poor is also widening, threatening to convert
democracy into demagogic rule. These developments, not the structure of
the photographic image, remain the main challenge to civilization.

NOTES

1. Image digitization and manipulation go by a variety of names—including computer,
digital, or electronic imaging or retouching; computer enhancement; and electronic color

imaging (ECI). Associated processes are sometimes referred to as the electronic darkroom. This laser-based technology may employ scanners to convert already existing still images into digital information, or information may be garnered in digital form from electronic cameras or camera elements.

2. In 1966, *Life* magazine opened its thirtieth anniversary issue, a special double issue entitled "Photography," with a rumination on photographic truth, including this quoted remark by James Agee: "it is doubtful whether most people realize how extraordinarily slippery a liar the camera is. The camera is just a machine, which records with impressive and as a rule very cruel faithfulness precisely what is in the eye, mind, spirit and skill of its operators to make it record." *Life* comments, recuperatively: "it is entirely possible for a skilled photographer to twist the truth to his liking. . . . To use this power well requires a strong conscience, and the best photographers suffer its burden [But] who would say that a photograph should just mirror life And which man among us holds the one, true mirror?" *Life* 61, no. 23 (December 1966): 7.

3. See, for instance, Jameson's "Postmodernism: The Cultural Logic of Late Capitalism," *New Left Review,* no. 146 (July–August 1984), and "Postmodernism and Consumer Society" in E. Ann Kaplan, ed., *Postmodernism and Its Discontents: Theories, Practices* (London: Verso, 1988); and what is in effect Mike Davis's rebuttal, "Urban Renaissance," *New Left Review,* no. 151 (May–June 1985), also reprinted in Kaplan, ed., *Postmodernism.* See also Kevin Lynch, *The Image of the City* (Cambridge, Mass.: MIT Press, 1960), which seems to have precipitated Jameson's line of thought. Many other references could be offered; I'll mention only the works of Henri Lefebvre.

4. See "In, around, and afterthoughts (on documentary photography)" and "Post-Documentary, Post-Photography?," both reprinted in this volume.

5. They appear, among other images, in Charles Darwin, *The Expression of Emotion in Man and Animals.* (See the 1965 reprint by the University of Chicago Press. No date is offered for the original, but other sources suggest 1872.)

6. Modern film is termed panchromatic, sensitive to the entire visible spectrum of colors, including the red end. Most image manipulation was done for simple expediency, not outright fakery—it was "business as usual."

7. The term "restaging" is meant to suggest that an event that actually occurred is being re-created for the camera, not simply invented.

8. See Jorge Lewinski, *The Camera at War* (New York: Simon and Schuster, 1978), pp. 83–92; and Phillip Knightley, *The First Casualty* (New York: Harcourt, 1975), pp. 209–12. Restaging was widespread in coverage of the Spanish Civil War, but the precise identity of the fallen trooper in Capa's photo seems to have been decisively established and his death in battle confirmed, effectively clearing Capa of the charge of fakery.

9. Substitution, not restaging, was the issue here. See Karal Ann Marling and John Wetenhall, *Monuments, Memories and the American Hero* (Cambridge, Mass.: Harvard University Press, 1991), and its review by Richard Severo, "Birth of a National Icon, but an Illegitimate One," *New York Times,* October 1, 1991. As the fiftieth anniversary of the Iwo Jima battle of February 1945 approached, several publications offered clarifications to correct the historical record. See also Bill D. Ross, *Iwo Jima: Legacy of Valor* (New York: Vanguard, 1985), which has several photos of the events and of both photographers and Marine cameraman William Genaust, who filmed the first raising.

10. The resulting image, made after the Battle of Gettysburg, is generally known as *Dead Confederate Soldier at Sharpshooter's Position in Devil's Den, 1863* but is also sometimes identified as *Home of Rebel Sharpshooter.* It appeared as part of *Gardner's Photographic Sketchbook of the War* (Washington, 1866), the first book on the Civil War, consisting of 100 tipped-in photo prints and accompanying text. For a brief discussion, see Howard Bossen, "Zone V: Photojournalism, Ethics, and the Electronic Age," *Studies in Visual Communication* 7, no. 3 (Summer 1985): 22 ff.

11. See Robert E. Sobieszek, *The Architectural Photography of Hedrich-Blessing* (New York: Henry Holt, 1984).

12. See Eric Barnouw, *The Magician and the Cinema* (New York: Oxford, 1981), for an account of the relation between the two.

13. Nicéphore Niépce, the other inventor, was interested in reproducing images of already existing art prints, to facilitate their production and improve profitability.

14. Quoted in the *New York Times,* August 15, 1991, in a brief discussion of the exhibition *Site Work: Architecture in Photography since Early Modernism,* at the Photographers' Gallery in London, and of Janet Abrams's catalogue essay for that show.

15. "Michael Radencich," *Studio Light,* no. 1 (1988): 2–10. See next note.

16. It isn't clear why someone wouldn't just as soon do most of the work on a computer—perhaps the far greater resolution of film still tells, though the computer is getting better and better. But a fascination with the microcosm, with real tabletop models and miniatures, has pervaded photography, film, and video—particularly, though not only, that made by men.

 Kodak, of course, to avoid extinction, began aggressively pursuing the image-processing market; it offers a case-in-point of corporate retooling—if you can't beat 'em, join 'em. In fact, it now refers to its industry not as "photography" but as "imaging," and it calls digital manipulation "image enhancement." Kodak married one of its systems (Premier) to the graphics-friendly Macintosh computer, and its various professionally oriented publications promote electronic imaging, including "virtual reality" (see further on in the text). Kodak has a number of products designed to keep film in the equation while allowing for digital operations between input and "hard copy" output. In 1991 it established the Center for Creative Imaging ("where art and technology meet") under the sway of Raymond DeMoulin, general manager of Kodak's professional division. DeMoulin wrote, in the summer 1992 course catalogue: "In the fifteenth century Gutenberg democratized—and universalized—publishing. Early in this century George Eastman enabled every man and woman to capture images photographically. Today, we face the millennium and a world of new media and technologies that are interactive and highly accessible. Kodak continues to embrace the challenge." In the same catalogue, John Sculley, CEO of Apple, Inc., writes: "Camden, Maine [where the center is located], feels a bit like Florence in the Renaissance."

17. "Even in the so-called photojournalist's magazine, in the much revered *National Geographic,* I have been witness to many, many contrived pictures. Of course, they say that those pictures reflect what actually happened, but wasn't happening at that moment. And so they had to fake it, right? Well, that's really beside the point. We have to question their integrity." Richard Steedman, stock-photo supplier, in edited transcript of panel remarks

at the Maine Photographic Workshops, "What's Selling in the Stock Photography Market," *Photo/Design* (January–February 1989), published by the Workshops in support of its yearly photo conference.

In this regard, Rich Clarkson, director of photography at *National Geographic* and past president of the National Press Photographers Association, commented in another context: "Sometimes we pose pictures. I think it's very important that the reader understand what the situation is. . . . Sometimes in a caption we can explain that we organized these people to have this picture taken in a certain way. Or in the style of the photograph, it is so obviously posed that no reader is fooled into thinking that this was a real event." In "Discussion Group: Impromptu Panel Questions Integrity of News Photography, Worries about Electronic Retouching," *News Photographer* (January 1987): 41. Clarkson's remarks don't really address Steedman's concerns, however.

Instances of crude manipulation—a time-honored tradition in the tabloids—are easy to find in publications of the *Weekly World News* variety; we probably aren't really supposed to believe that the two warring stars in the photo (or, in another scenario, the two unexpectedly romancing stars) were actually photographed together—everything is *as if.* And sometimes their heads don't even fit their bodies. But the *reputable* press isn't supposed to indulge in these things, so eyebrows were raised when (for example) Raisa Gorbachev and Nancy Reagan (fulfilling either scenario outlined above) were pasted together in Time-Life's *Picture Week* for November 25, 1985, as were Tom Cruise and Dustin Hoffman in *Newsweek* in 1988. When an illustrator doing talk-show host Oprah Winfrey for the cover of *TV Guide* for August 25–September 1, 1989, married Oprah's head to actress Ann-Margret's body, his faithfulness to the photograph from which he cribbed the body was so extreme that the man who had, six years earlier, designed Ann-Margret's gown recognized it and called her husband, who recognized Ann-Margret's ring on "Oprah's" finger. The *TV Guide*'s editor assured everyone that the illustrator had been spoken to and that such a thing would never happen again—so recognizably, that is. My only glimpse of this cover—prior to a report about it on National Public Radio's evening news program *All Things Considered* on August 30, 1989—was at a supermarket checkout counter, and I thought it was a photo.

18. For example, it is not clear even without questions of digital manipulation, or indeed any kind of manipulation, how definitive—or even admissible—photographic evidence can be. Is it substantive and can it stand alone, or can it be accepted as only

corroborative of the testimony of a human observer? A brief discussion of the fatal problem this posed for street-corner traffic-surveillance cameras in Canada is presented in "Plainclothes Cameras" (unsigned), in *Photo Communiqué* 8, no. 4 (Winter 1986–87): 3.

19. Scitex, an Israeli-based company founded by engineer Efraim Arazi, saw the bulk of its early business in producing patterns for automated knitting and weaving machines; its attempt to enter—and dominate—the "printing-publishing-packaging" field did not begin until 1979 or 1980. Its major boost came from *USA Today*'s heavy reliance on its system. "Pre-press" production had been labor-intensive, time-consuming, and very expensive; Scitex put in the hands of a single operator (not necessarily one trained in earlier cut-paste-and-airbrush methods of image production) the ability to take an image from its "raw" state to its desired final form, and in very short order indeed. Although Scitex led the way, it was quickly followed by Dr-Ing Rudolph Hell, a subsidiary of the West German conglomerate Siemens, which produces the Chromacom system, and by the Crosfield electronics subsidiary of the English De La Rue Group. (There are now other manufacturers as well.) Since the explosive development of this industry, many of these companies have been bought, sold, or merged. For example, the press manufacturer Linotype merged with Hell in 1991, and according to *Fortune*'s cover story "The New Look of Photography" (July 1, 1991), Du Pont and Fuji jointly bought Crosfield for $370 million in 1989.

Arazi's story is interesting. Having learned electronics in the Israeli military, Arazi went on to study at the Massachusetts Institute of Technology in the early 1960s and then worked on Boston's high-tech Route 128 for Itek, an image-technology company. Itek helped sponsor Scitex's start-up in Israel. One of the company's early projects, before entering the textile field, was the use of satellite technology during the Vietnam War to detect the Viet Cong on the basis of their "pajamas." (See the *New York Times,* December 28, 1980, business section, p. 7.) In 1992, Arazi was mentioned as president and CEO of a firm called Electronics for Imaging in San Bruno, California, and was quoted as saying "Photo CD [a Kodak imaging system based on compact disks] is God's gift to man" (*Business Publishing* [formerly *Personal Publishing*], April 1992).

20. Personal communication.

21. I'll mention in passing the issue of envy here that, interestingly, operates in both directions. (The issue is who has what kind of power—if the professional photographer

envies the creative autonomy and perhaps the fame and fortune of the art photographer, the artist, of course, envies the professional photographer's wide audience.)

The matter of copyright is not trivial with respect to electronic imaging, however—by and large, the client, not the photographer, holds the copyright on images produced for hire and can manipulate the Hell (or the Scitex—or the Mac) out of the image without obtaining the photographer's consent. More photojournalists than (other sorts of) commercial photographers are likely to retain the rights to their images. Some photographers are leading a movement toward having the photographer retain those rights. A similar issue of control has surfaced in relation to art, where the concept of the artistic integrity of a work is used to challenge a buyer's right to dispose of it as she or he sees fit. In 1992 Kodak, through its new Center for Creative (that is, digital) Imaging, published *Ethics, Copyright, and the Bottom Line,* based on a one-day symposium. It is likely that a new standard of control over the image (that is, of property rights) will have to be developed in the courts, not only because of digital imaging but because of widespread cultural practices of incorporating previously produced material, such as "sampling" in rap music and hip hop, the dissemination of entertainment and other materials on the Internet, and the desire of the infotainment complexes to continue milking their products for profits. The standards established in the nineteenth century in relation to photographic production, for example, may give way to a twenty-first-century conception of property and personhood. See Bernard Edelman, *Ownership of the Image* (London: Routledge and Kegan Paul, 1979), translated from *Le Droit saisi par la photographie* (Paris: Maspero, 1973).

22. Anne M. Russell, "Digital Watch," *American Photographer* 16, no. 6 (June 1986): 20. While it may be true that the industry has "so far demonstrated little love for technology," love isn't what motivates technological change. Stock-image libraries may not yet (1995) be fully converted to digitization, but the technology continues to make significant inroads, and by 1988, according to the *Photo District News* (September), NDC's "Photo Management Workstation" was in use at *U.S. News & World Report, Newsweek,* Houghton Mifflin, and several important stock agencies. At that time, NDC was also gearing up to use its scanning technology and a new portable workstation at the Olympics, to produce digitized images from stationary or video sources in three to twenty seconds and transmit them over phone lines in fifteen to ninety seconds.

23. See, for example, May Yee Chen, "For Professional Photographers, a Digital-Age Debate," *New York Times,* July 24, 1994, business section, p. 8. This article centers on

copyright infringement and on the driving down of fees for image use occasioned by their easy availability as "clip art."

24. Including, say, *Time* magazine, which began in 1991 to do its pre-press on a Mac-Scitex combination, or *Fortune,* which was poised to do so later in the year. And every small publisher has a Macintosh.

25. According to an interview with Jackie Greene, director of photography at *USA Today,* reported in Shiela (*sic*) Reaves's careful inside-the-industry article "Digital Retouching," *News Photographer* (January 1987): 27. (*News Photographer* is published by the National Press Photographers Association, which accounts for the apparent care with which this issue, which contains a number of considerations of digitization, was researched and assembled.) Reaves's article, based on her studies and interviews, reports that *USA Today* tells all its 584 freelance photographers exactly what to use for each assignment and how, from the ASA to fill flash. It also reports that *USA Today* helped with the research and development of portable Scitex transmitters, of which it now has exclusive use, which use either telephone wires (taking three-and-a-half minutes) or satellites (thirty seconds) to transmit color photos to headquarters. All the newspaper personnel Reaves interviewed eschewed the use of their digitizing equipment for anything other than color correction and the enhancement of printability (whatever that means) in news photos. Interestingly, although the *Chicago Tribune* now uses digitizing procedures, Jack Corn, its director of photography, is quoted as saying that before his tenure in the job, all photos were routinely retouched but that that no longer happens.

26. But every technological advance leads to increased fears of magnified effect. See, for example, Mary Tannen, "That Scitex Glow," in the Sunday *New York Times Magazine* (which itself does not hesitate to use digitally retouched images), July 10, 1994, pp. 44–45. The article is critical of the retouching of female models as indicative of cultural rejection (and self-rejection) of women's bodily realities—fueling the cosmetic surgery boom?

27. Tom Hubbard, "AP Photo Chief, AEJMC Professors Discuss Ethics, Electronic Pictures at Convention," *News Photographer,* "Higher Education" column (January 1987): 34. "AEJMC" stands for Association for Education in Journalism and Mass Communication.
 Invoking Smith in this context is not without its perils: In *American Photographer* (July 1989), John Loengard, former *Life* staffer, recalls his discovery after Smith's death

that the famous portrait of Albert Schweitzer as Great White Father in fact was something of a composite. Smith had introduced a couple of somewhat extraneous elements into the lower right-hand corner. Smith had kept this a carefully hidden secret, even making up a cover story about the negative. Loengard, calling his story "Necessary Cheating," writes "I understand and approve of what he did . . . even a photographer of his legendary sincerity felt driven to cheat a bit when he found his subject wasn't up to snuff." In contrast, U.S. Farm Security Administration photo head Roy Stryker emphatically disapproved of Dorothea Lange's removal of a minor element (a thumb) from that troublesome lower right-hand corner of her even more famous photograph, *Migrant Mother, Nipomo, California, 1936,* occasioning a bitter exchange of letters between Stryker and Lange. See Jack F. Hurley, *Portrait of a Decade: Roy Stryker and the Development of Documentary Photography in the Thirties* (Baton Rouge: Louisiana State University Press, 1972; reprinted, New York: Da Capo, 1977). These examples can be variously interpreted, but Smith and Lange were intending to keep control of the images themselves, while Stryker, who apparently had no second thoughts about sending photographers into the field with shooting scripts (though not, presumably, wanting to have them create situations outright) could not accept the photographer's quasi-aesthetic decision to modify an image after the negative was produced.

28. Roger Armbrust, "Computer Manipulation of the News," *Computer Pictures* (January–February 1985): 6–14. The author spoke with representatives of the three "major television networks."

29. A watershed media event, the trial of O. J. Simpson for murder—which is still running as I write this—has changed many of the rules of media coverage. Right at the beginning, long before the trial itself, *Time* got into trouble for digitally altering a photo of the celebrity suspect, making his skin darker.

30. The editor of this series, which began with *A Day in the Life of Australia,* is Rick Smolan, a photographer who conjured up the Australia project as a freelance package in 1980–81. Its cover showed some minor manipulation about equivalent to the other examples I've raised. Subsequently, according to a note in a 1992 Kodak publication, Smolan went on to train on its digital-imaging equipment and is now associated with the Kodak imaging center.

31. However, the photos evidently were not disinformation. As to readability, the initial photos, taken through the belly of a U-2 reconnaissance plane, required the deciphering abilities of highly trained photo interpreters. The photos finally exhibited were taken from very-low-flying airplanes. The account in *Life* (Richard V. Stolley, "The Indispensable Camera," *Life* 61, no. 26 [December 23, 1966]: 98–100) offers no hint that military computer-assisted "enhancement" or interpretation systems were being developed, but the information presented in note 19 (above) about Arazi's work for the U.S. military suggests otherwise.

32. This story was documented by Susan Meiselas.

33. The list of corporations, Japanese or not, that have produced or expressed the desire to produce electronic still-imaging apparatuses—which actually includes Konica, Copal, Fuji, Hitachi, Nikon, Matsushita, and Mitsubishi, and the European companies Rollei Fototechnic and Arca Swiss, as well as Kodak and Polaroid—pits photographic firms against video and electronics manufacturers. Early versions of these apparatuses, such as Sony's Mavica, Canon's Xapshot, and Fuji's Fujix, while of use for small publications, haven't so far been particularly successful in the consumer market because their prices are high, the image resolution is poor, and the outcome less interesting to the consumer than video. This will change. The various manufacturers are at work on higher resolution, more flexible devices—and among the major photo manufacturers, Polaroid had to run to catch up. To that end, it hired as director of research the former head of "innovative science and technology" for the government's "Star Wars" program, or Strategic Defense Initiative. The stand-alone photography firm—like the stand-alone newspaper company or telephone company—not also involved in something electronic will shortly be a thing of the past. See John Holusha, "American Snapshot, the Next Generation," *New York Times,* June 7, 1992, business section, p. 1: "Kodak and friends are betting that film is the key. Sony and Canon think otherwise," and "Photo CD is critical to the future of Kodak."

34. Digitization techniques are also used to enhance the readability of existing (usually still) images, most often by reducing blur. Compare the Agfa slide printer described a bit further on in the same paragraph. (Agfa too is working on digitization applications.)
 A stumbling block in the mass-marketing of image-processing programs has been the tremendous size of the computer files generated by images, but advances in image-

compression programs and the tumbling cost of high-memory microprocessors (home computers) greatly alleviated this problem. Such programs are now available for the IBM system as well as the Macintosh, and the cost is not much more than for a word-processing program. By 1991, estimates of graphics software sales lay between $160 million and $275 million (*New York Times,* May 17, 1992). The home availability of such programs will literally domesticate image manipulation.

Quantel Corporation's Paint Box was the first widely used image manipulation program for video (commercial television). By the mid-1980s, IBM's Targa board was marketed, a highly versatile, not terribly expensive "frame grabber" and digitizer that could be locked into or mixed with a video signal. Fairly sophisticated programs for the Macintosh computer include Image Studio, Digital Darkroom, and Studio 8 [and later Final Cut]. The Amiga's more recently introduced Toaster put complex animation within the reach of the masses of computer-imaging lovers, or at least those with the patience to learn the program. Video-production programs can now operate through low-end computers. But the future of "multimedia," to judge by its promoters, is infinite—and close at hand.

35. See "The Rapidly Moving World of Still Imaging," *MPCS Video Times* (New York; Summer 1988), pp. 28–33. Curiously, this unsigned article, in running through the various applications of still-video imaging, describes its uses in law enforcement to survey scenes "so that the videotape or stills pulled from it can be used as demonstrative evidence which can hold up as proof in a court of law" (30). Of course, the equipment is also used for surveillance by police and by employers seeking evidence of employee theft. There is no suggestion in the article that these images can be manipulated and falsified, making them, one would think, essentially useless as courtroom evidence. Recall the instinctive response of the California state trooper described above; see also the discussion of the Rodney King beating case, below.

36. Ibid., p. 30, and Carol G. Carlson, "Medical Imaging," in Rutgers University's *Matrix* (Spring 1986): 10–12.

37. Many people, regardless of their opinions about abortion, accept and display ultrasound images of their developing fetuses as photos of their unborn children.

38. Hans Kuhlmann, general manager of marketing and sales, consumer and professional division, Agfa Corporation, speaking on the topic "Productivity—Preparing for the Future," at the Association of Professional Color Labs twenty-first annual convention in Hawai'i in 1988. Quoted in the convention report in *Photographic Processing* (March 1989): 36.

39. The concept here is the transmission of technical data, which also applies to, say, the scrolling of sports scores or financial-exchange data over running footage of something else entirely. The most memorable example for me was the running of sports scores below footage of grieving relatives at the site of the Oklahoma City terror bombing in 1995. More mundane examples of the acceptability of data intrusion: Many consumer cameras can put time-date imprints on images, and the network identification graphic logo often appears in the lower right-hand corner of the television screen throughout a news broadcast.

40. Trish Hall, "Virtual Reality Takes Its Place in the Real World," *New York Times,* July 8, 1990.

41. In Tony Hiss, "Reflections: Experiencing Places, Part II," *New Yorker,* June 29, 1987, 73 ff. Hiss has subsequently incorporated this discussion into his mild-mannered, semi-utopian book *The Experience of Place* (New York: Knopf, 1990).

42. Making use of the cockpit voice recorder and other sources of information, the National Transportation Safety Board produced a fifteen-minute computer animation film of Northwest flight 255, which crashed on takeoff in Detroit in August of 1987. Portions were shown on the nightly news on May 10, 1988. The Air Line Pilots' Association took exception to the simulation, claiming that its aim was to blame the pilot. (See *Post* magazine, June, 1988, 78.) The pilots' association apparently reasoned that, despite the lack of visual detail, the fact of computer production added credence to the conclusions.

43. The social fact that adolescent boys are informally trained for the military by playing video games has often been remarked on. *The Last Starfighter* is an eighties movie that centers on this phenomenon.

44. W. Richard Reynolds, "Computers Take Animation Beyond Cartoons: Lifelike Images May Rival Actors," *Dallas Morning News,* March 28, 1988, sec. C, pp. 1–2. Reynolds

———

could not have actually seen the efforts. For the sake of accuracy, despite the *Morning News* (which misspells the Thalmanns' name), *Rendez-vous à Montréal* is generally credited primarily to Nadia Magnenat-Thalmann, who is currently professor of communication and computer science at the University of Geneva in Switzerland, and to her—or their—computer lab, Miralab. *Rendez-vous*—in English—combines Sleeping Beauty with Pygmalion; the male prince calls up and animates the lovely but reluctant woman. In 1994 the *New York Times* was still chasing this primitive animation. See Bruce Weber, "Why Marilyn and Bogie Still Need a Lawyer," in the law section of the *Times,* March 11, 1994, with the ubiquitous illustration of Marilyn. The article focused on copyright.

45. All quotations from Reynolds, "Computers Take Animation," p. 2.

46. Jean Baudrillard, "Requiem for the Media," in *For a Critique of the Political Economy of the Sign* (New York: Telos Press, 1981), p. 172. Italics in original.

47. Collectively known as CAD, for computer-aided design, and CAD/CAM, computer-aided design [and] computer-aided manufacturing. Although the present article focuses on graphics and office work using video terminals, computer technology and its ability to monitor and control workers applies to industrial workers just as well. The reorganization of work for the purposes of increased managerial control has been a major focus of labor studies. See, for example, Richard Edwards, *Contested Terrain: The Transformation of the Workplace in the Twentieth Century* (New York: Basic Books, 1979), for a broad discussion of the changed nature of work. Some unions, such as the Newspaper Guild and the Communication Workers of America, have gotten some restrictions on computer monitoring written into their contracts, and some industrial unions have gained some say in automated processes. See Andrew Zimbalist, "Worker Control over Technology," *The Nation,* November 17, 1979, 488–489; and a trio of articles—David Moberg, "The Computer Factory and the Robot Worker"; Harley Shaiken, "The Brave New World of Work in Auto"; and "The Great Computer Heist of Jobs, Skill and Power," an interview with representatives of U.S. auto unions—all in *In These Times* (Chicago), September 19–25, 1979, 11–14. See also notes 50 and 51.

 In an art-related field, computers and lasers are used to produce sophisticated copies of very expensive period furniture. These copies—warps, fades, and all—revive the market for up-market simulations, but now it seems unnecessary to pretend that the copies are

authentic antiques in order to command very high prices. Of greater moment is that CAD is now at the heart of the architecture curriculum and of many architects' practice.

48. See, for example, "Keystroke Cops," *Dollars & Sense,* July-August 1986, 15. The paranoiac term "surveillance," as opposed to the more neutral "monitoring," accurately conveys the perception of those so monitored that they are in a situation not unlike covert war.

49. According to the *Village Voice* (Katherine Silberger, "The Electronic Snitch," September 18, 1990, p. 83), about 85 percent of monitored workers are women. The article quotes a 1989 ad for Close-up LAN, a networking program tying computer "workstations" together: "Look in on Sue's computer screen. You monitor her for a while . . . in fact, Sue doesn't even know you're there!"

50. The union's full name is 9to5, the National Association of Working Women. In 1986, 9to5 issued a report entitled *Computer Monitoring and Other Dirty Tricks* (Cleveland, Ohio). It reported, among other findings, that monitored workers lost much more work time to illness than unmonitored workers did.

 The National Institute of Occupational Safety and Health (NIOSH) in 1980 reported a study of computer-monitored clerical workers at Blue Cross/Blue Shield (the nation's largest private medical insurer) showing that they suffered increased rates of "depression, anxiety, instability, fatigue, and anger" ("Keystroke Cops").

 In 1985 Québec filmmaker Sophie Bissonnette produced a four-part film entitled *Quel Numéro—What Number?* about women working as telephone operators, grocery check-out clerks, secretaries, and mail sorters. Also in 1985, the British Granada Television produced *Terminal: VDTs and Women's Health,* and Judy Jackson produced *Hired Hands,* about female secretaries, for Britain's Channel 4. Questions about VDT use for women inevitably come around to the effects of electromagnetic radiation on reproductive health; see also notes 52 and 53.

51. See Diana Hembree and Sarah Henry, "A Newsroom Hazard Called RSI," *Columbia Journalism Review* 25, no. 5 (January–February 1987): 19–24, which also mentions the stressful role of computer surveillance.

52. Concern over RSI has spread, despite its initial underplaying in the news. Enough research has now gone into ergonomic keyboards and the like that the *New York Times* wrote of the Communications Workers union, half of whose 450,000 VDT-worker members show some signs of the disorder, that it "has found no evidence of a decrease in the number or severity . . . when ergonomic programs addressed the equipment, furniture and design of workplaces without also changing operating practices that workers find stressful, like having supervisors monitor the number of keystrokes each worker makes. . . ." In Barnaby J. Feder, "A Spreading Pain and Cries for Justice," *New York Times,* June 5, 1994, sec. 3, p. 1. In 1995 the newly elected rightist and pro-corporate U.S. Congress attacked newly proposed ergonomic regulations drafted by the Occupational Safety and Health Administration, leading the president to reject them. See Steve Lohr, "Administration Balks at New Job Standard on Repetitive Strain," *New York Times,* June 12, 1995. [They were subsequently made law during the Clinton Administration and canceled by the second President Bush.]

53. Diana Hembree, "Warning: Computing Can Be Hazardous to Your Health," *MacWorld* (January 1990), discusses RSI and eyestrain as well as radiation hazards—everything except monitoring and the stress it causes.

54. "'Big Brother' in the Office," *Newsweek,* October 5, 1987.

55. Barbara Garson, *The Electronic Sweatshop: How Computers Are Transforming the Office of the Future into the Factory of the Past* (New York: Simon and Schuster, 1988). See also Barbara Garson, "The Electronic Sweatshop: Scanning the Office of the Future," *Mother Jones* 6, no. 6 (July 1981): 32–42; also in that issue, publisher Adam Hochschild, in "The Press Punches Printers," discusses a "news blackout" on VDTs, which he attributes to the wholesale adoption of computerization technologies by newspapers.

56. Braverman introduced the term in his path-breaking work *Labor and Monopoly Capital* (New York: Monthly Review Press, 1973). In his discussion of the effects of technological change, Braverman related how control over workers was increasingly structured into the work process and its technology, precisely to decrease workers' control and get more work out of them. New sorts of machines at first require increased skills on the part of the worker, but past a certain degree of complexity the level of skill required of the "op-

erator" diminishes. Braverman was also well aware of the in-built possibilities of surveillance involved in highly regularized and mechanized, and latterly computerized, work processes. Even the most primitive version of the assembly line results in monitoring, for it is all too obvious when a worker fails to keep up with the movement of the line. Garson stresses the desire for control even at the expense of productivity. When word processing was first introduced, the people supplying the text were called "dictators."

Business and science publications have explored office automation for decades (see, for example, the *Scientific American* collection *Automatic Control,* incorporating articles from 1948 through 1954 [New York: Simon and Schuster, 1955]), and some few may even have considered possible negative effects on workers—in the abstract. An exception, which considers the negative effects on women's work opportunities and skills, is by University of Maryland professor of economics Barbara Bergmann: "A Threat Ahead from Word Processors," *New York Times,* May 30, 1982, business section, p. 2. Reports authentically grounded in experience are represented by "Legal Secretaries Organize," *Downtown Women's News* 1, no. 4 (August 1975): 3, published by Women Organized for Employment, San Francisco; and "Automation Nips Office Workers," *Guardian* (U.S.), November 5, 1975, p. 7, both of which criticize the industrialization of office work. From the latter: "'People will adapt nicely to office systems—if their arms are broken,' says IBM vice president William Laughlin in a *Business Week* article this spring. 'And we're in the twisting stage now.'"

57. Jean Baudrillard, "The Precession of Simulacra," in *Simulations* (New York: Semiotext(e), 1983), pp. 53–54.

58. Guy Debord, *La Société du spectacle* (Paris: Buchet/Chastel, 1976); translated as *The Society of the Spectacle* (Detroit: Black & Red, 1970; revised, 1977). The book, which presents a numbered series of propositions (221 of them), is not paginated. (Newly translated by Donald Nicholson-Smith [New York: Zone Books, 1995]; this version is paginated.)

59. Ludwig Feuerbach, *The Essence of Christianity* (1841), English translation by George Eliot (London: John Chapman, 1854). Italics in original. I will not here attempt any discussion of Debord or the reason for his invocation of Feuerbach.

60. John Rockwell, "Photo File of World's Wonders," *New York Times,* March 5, 1992.

61. UNESCO's Director-General, Federico Mayor Zaragoza, and La Caixa bank, are Catalonian. Photography, digitization, preservation—this is the new agenda of an agency that, under its previous, African, director, had attempted to address issues of information control by the developed West, particularly the United States. Its efforts to work toward what it called a New World Information and Communication Order led to a bitter campaign and boycott against it in the West, which labeled its efforts "press censorship," not completely without cause. Under Mayor, who is actively seeking U.S. funding and involvement to help rescue the agency, UNESCO has turned toward preservation. See "UNESCO Comes Knocking, Seeking U.S. Help," *New York Times,* March 1, 1992.

62. Annan, a sort of recordist-photographer, of whom there were many, was working for the Glasgow improvement trust. Marville, who had previously photographed medieval buildings for the committee on historical monuments, published numerous views of pre-Haussmann Paris. Atget worked for the city of Paris and also compiled archives of views on his own. The Society for Photographing Old London operated in the 1870s and 1880s. The municipal efforts coincided to some degree with tourist-oriented photographic collections. Helmut Gernsheim, in *The Rise of Photography, 1850–1880* (London: Thames and Hudson, 1988), writes that societies for architectural photography began in Britain as early as 1854 (Antiquarian Photographic Club) and 1857 (Architectural Photographic Association).

63. Since the O. J. Simpson trial, this message has been widely received by Americans and much of the rest of the Western television audience. Whereas all kinds of physical evidence was challenged by the defense in this case, there was no image evidence of the commission of the crime, and photographic evidence, such as autopsy photos, was not questioned.

64. See Jane B. Baird, "New from the Computer: 'Cartoons' for the Courtroom," *New York Times,* September 6, 1992, business section, p. 5. Again, see also Edelman, *Ownership of the Image.*

65. See the discussion of the home videotape of the Rodney King beating, below.

66. The introduction of in-school, teen-oriented imitation TV news shows that carry ads into the classroom—the latest plot to cash in on this lucrative, none-too-independent-

minded, and in this case captive audience—hatched by the sinister U.S. entrepreneur Chris Whittle in league with Time-Life, shows that there is much more at stake than selling Strawberry Shortcake dolls and Pound Puppies.

67. Chester and Montgomery claim that "new cable networks, such as TWA's *The Travel Channel* and Teleworld's *World Access Television,* are being created that will rely almost entirely on PLC's." Jeffrey Chester and Kathryn Montgomery, "Counterfeiting the News," *Columbia Journalism Review* (May-June 1988): 38–41.

68. I happen to have seen this half-hour program (in Philadelphia); the opportunity it offered even the most eagle-eyed viewer to ascertain its true nature was absurdly brief. See the *New York Times's* Style (*sic*) section's lead article for October 4, 1992, "The Stepford Channel," section 9, p. 1, in which Rick Marin complains that "infomercials have lulled, soothed and mesmerized Americans into forgetting the difference between advertising and entertainment." Forget the difference between advertising and entertainment, on the one hand, and information, on the other!

69. All quotations in Chester and Montgomery, "Counterfeiting the News."

70. "F.B.I. Gives Television Programs Exclusive on New Fugitives," *New York Times,* September 15, 1991. The "managing editor" of *America's Most Wanted* claimed that the size of his audience (which the FBI estimated to be sixty million households) meant that the wanted person would have "nowhere to run." The bureau would not release the names of the persons most recently added to the list until after the shows' broadcasts, to preserve this element of "surprise." Aside from broadcasting NBC's *Unsolved Mysteries,* South Africa's state-run television has long had a regular program featuring a police official describing wanted persons and their alleged crimes.

71. The TV "re-enactment" in the late 1980s of the passage of a suspicious briefcase between U.S. attaché Felix Bloch and a presumed Soviet spy was apparently worthy of criticism only because it was done on NBC, one of the "responsible" networks, since police shows do it all the time (but, it's true, generally using the label "re-enactment").

72. On transmission devices, see John Durniak's untitled *New York Times* "Camera" column for March 15, 1992, subtitled "A photographer develops a fast transmitting device

that makes editors smile." On digitized, compressed video images, see Rachel Powell, "Digitizing TV into Obsolescence," *New York Times,* October 20, 1991. On encryption, see John Markoff, "Experimenting with an Unbreachable Electronic Cipher," *New York Times,* January 12, 1992, which refers to government efforts to impose an encryption standard that industry finds inadequate but does not take up the question of why the government objects to the other, more reliably secure, standards.

73. As suggested by a letter by Joseph Allen, the president of the Copyright Clearance Center, an arm of the publishing industry (*New York Times,* February 13, 1994, business section), even scanning technologies of published articles threaten copyright—not to mention the conversion of stock imagery to CD-ROM, as discussed above.

74. See Stewart Brand, Kevin Kelly, and Jay Kinney, "Digital Retouching: The End of Photography as Evidence of Anything," *Whole Earth Review,* July 1985, 42–49.

75. And perhaps despite even Debord's own recent revisions.

76. Needless to say, this does not characterize Americans alone; only consider, for another example, the Germans' tumultuous support for the absurd promises of Helmut Kohl's CDU as unification neared in late 1990. During the Gulf War, the responses of the public in both the U.S. and Great Britain to stage-managed news provided another case in point. Although in the latter instance electronic imaging on television and in the newspapers was integral to the war "story," these approaches were different only in kind, not in strategy or effects, from the propaganda efforts in earlier wars.

77. In the violence in Los Angeles following the acquittal of the police officers, newsmen in a helicopter shot footage of a white truck driver, Reginald Denny, being dragged from his truck and viciously beaten by young African Americans. This video footage was used as the countertext to the amateur tape of King being beaten, despite the lack of symmetry occasioned by comparing the actions of agents of the State with those of rioters. The fact that it was contextualized as being on-the-spot evidence not mediated through an "anchoring" newsroom helped it gain the same "candid" status. But the black community was reluctant to condemn the young men identified just on the basis of the tape— just like the white community that exonerated the police officers in the first King case.

The 1995 O. J. Simpson case is regarded as a sort of sequel to the King case; in this as in other post-King cases, black jurors (in what is termed jury nullification) seemed unwilling to accept the credibility of evidence, such as DNA blood evidence, that might be considered unimpeachable in other contexts.

In 1871 the painter Gustave Courbet was identified and convicted of revolutionary activity—pulling down a statue of the emperor—primarily on the basis of a widely circulated photograph.

IV

CENSORSHIP AND POWER

Theses on Defunding

1. The presence of monetary support for art cannot be viewed as neutral.

2. The source of monetary support cannot be viewed as neutral.

3. The presence and the source of funding have a systematic influence that is both economic and ideological.

3a. For the sake of the argument, the aesthetic is a subset of the ideological.

4. Government support, foundation support, and corporate support differ in their effects on the art system. The government, by ideological necessity, has had to adopt standards that seem disinterested and depoliticized—that is, that

This essay was a contribution to a panel discussion at the Mid-America Art Association (Houston, 1980). It was published in *Afterimage* (Summer 1982). It was republished in Brian Wallis, Marianne Weems, and Philip Yenawine, eds., *Art Matters: How the Culture Wars Changed America* (New York: New York University Press, 1999).

appear firmly aesthetic—and has supported work that satisfies criteria of newness and experiment. Nevertheless, those who do not share the associated assumptions about the meaning and direction of life—assumptions, say, of egalitarianism, cultural and personal pluralism, social progressivism or liberalism, and scientism—perceive the ideological character of art and reject the claim of sheer aesthetic worth.

4a. State granting agencies are idiosyncratic. They are likely to change quickly as they take up more of the burden of funding, under the rubric of "the new federalism." State agencies are probably more prone than federal ones to bow to conservative tastes and right-wing pressure.

5. Foundations, and, even more so, corporations, are not expected to be even-handed or even impartial in the way that government must seem to be. Rather, they are expected to stand on the bedrock of self-interest.

5a. Foundations vary in their policies, but many must now choose between supporting services to the poor that have been cut and supporting art. Several giant foundations have already announced policy shifts toward services to the poor, at the expense of a variety of other activities.

5b. Corporations are expected to maintain a monolithic public image that is anthropological to the extent that personality traits can be attributed to it. Thus, by lending an air of philanthropy and generosity, corporate benevolence can be used to defuse charges of wholesale theft, as in the case of Mobil or Exxon. One required trait is good taste, which is assured only in aesthetic territory that is already known and ideologically encompassed, territory necessarily barren of present-day "cutting-edge" art, politically engaged art, or anything other than the safe. Most corporate money for art goes to the old, the safe, the arch, items that are above all redolent of status and spiritual transcendence, work that is more likely to be embalmed than alive.

5c. Many large and influential corporate funders are quite willing to congratulate themselves (before business audiences) for the public-relations value of their contributions to culture.

6. In high times, when the economy has been strong, and large numbers of people have felt relatively secure about the future, the interest in personal well-being has risen beyond a survival level to an interest in personal happiness and cultural pursuits. Art is then accepted as important to society as a whole and therefore to its individual members.

6a. The latter part of the 1970s saw corporations competing with each other to attract executives and other employees not only with economic lures but also with "quality of life" incentives, most of which involved the reclaiming of urban areas and especially the refurbishing of urban culture: that is, centrally, cultural outlets and activities.

7. In high times, art has been treated as the symbol and the vehicle of the spiritual treasure trove that "is" civilization and history. It is paradoxically both "priceless," meaning irrespective of mere monetary valuation, and "priceless," meaning terribly expensive. People think that art is a good thing even if they don't like, know, or care about what goes by that name—and nonbelievers are not given much of a hearing.

8. As the economy has skidded and recessions have come more and more frequently, the economic has taken precedence over most other aspects of collective and personal life.

8a. In the second meaning of "priceless," that is, expensive, art is a speculative good, a store of monetary value. This side of art, art as investment, becomes more prominent in speculative times, when the social values that underlie a confident economy are in question, and the future is uncertain. But art, as being above price, transcendent, bears social values. In speculative

times, the opponents of current, unlegitimated art begin to gain a following because of that art's social uselessness in reinforcing traditional values. For those outside the closed-in system of consumption and investment, art has appeared as a monetary drain as well as ideologically—morally and politically, as well as aesthetically—suspect.

8b. The current [Reagan] administration's radical restructuring of American institutions includes an aggressive repoliticization of many aspects of culture. The shifting of constituencies to include a sector of the radical right-wing and Christian fundamentalist elements in working-class and middle-class strata has given powerful encouragement and an official platform to the nonbelievers in the reigning paradigms of art and in the nonpolitical nature of art. In the placement of right-wing ideologues in policy positions, the National Endowment for the Arts has not been spared. Thus, even within the administration, the nature of art is under attack, though in a muted way.

9. Corporations follow the lead of federal programs. During the 1970s, as government contributions to art increased, the contributions made by business increased dramatically. The withdrawal of government money is a signal to corporations to cut back their contributions as well, or to restrict them more closely to the most public-relations-laden kind of art.[1]

9a. The government follows the lead of corporations. Much of the government's giving, except to individuals, is done through "matching grants": Each government dollar must be matched by one from a private giver. The government will pay only as much as the private sector will match, no matter how far short of the original award that might fall.

9b. Many corporations will give only on a match basis as well: Without government funding, they will not give money. Such corporations as Exxon, ITT, and Aetna Life have declared themselves reluctant to replace the government in funding cultural activities.

10. Policy shifts with ideology. As ruling elites restore the legitimacy of big business as well as its economic preeminence, corporate givers gain more credibility as policy sources and are able to influence the policy of grant-giving agencies. These agencies are now likely to be headed and staffed by pro-business people. Further, corporations gain more influence as givers as they take on an increasingly significant role in the funding of culture. By unofficially signaling their wish to give to certain individuals and projects, corporations reportedly have already managed to influence the government to match their contributions.

11. The government's policies aggressively favoring corporations and the rich affect funding. The 1982 tax act is projected to cause a drop in private giving to nonprofit institutions conservatively estimated to be above $18 billion in the next four years. According to the Urban Institute, an independent research and educational organization in Washington, D.C., such groups would lose at least $45 billion in combined funds from the government and private donors. Educational institutions, hospitals, and cultural activities were considered likely to be the most adversely affected.[2]

11a. The pattern of giving will likely be shifted by the new tax law from the rich (who are inclined to support educational and cultural institutions) to those earning under $25,000 (who are more likely to give to religious organizations).[3]

12. Many small, community-based, and community-oriented cultural organizations must have a steady income to stay in existence. A gap of even a couple of months would force many to fold. Yet the next few years are considered a transition period in which adequate money must be successfully solicited from the private sector to replace withdrawn federal money. Therefore, many small organizations, especially those serving ethnic communities, will shut down.[4]

12a. Fewer ethnic- and community-oriented artists (including dancers, theater people, musicians, and so on) will be encouraged to continue their work. Consequently, we can expect their numbers to decline proportionally more than those of more mainstream-oriented artists. "Cultural pluralism" will fade as a reality as well as an ideal.

12b. Ideologically, cultural pluralism has already been tacitly discarded. We should be clear that ethnic arts have been targeted for defunding as being "divisive" and perhaps un-American, as well as (predictably) aesthetically inferior. (The Visual Arts section of the NEA advertised itself a few years ago with a mass mailing of a poster in which "Visual Arts" was written on a wall as a graffito in Mexican American barrio-style *placa* writing. We shall see nothing of the sort for at least the next few years.)[5]

12c. The "populist" orientation of the Carter Endowment/NEA has been discarded by the pseudo-populist Reagan administration, which is in this as in other policies intent on reestablishing the material signs and benefits of great wealth—in this case, an elite, restricted cultural practice.

13. Artists are as sensitive as anyone to changes in wind direction and as likely to adjust to them. The production of artists depends on conditions "in the field" of art as a sector of the economy as well as a sector of the ideological. There are more chances to enter and pursue a life of art making when there is more money devoted to art. There are more places in school and more jobs in education, more general attention to a broader range of art activities. As the climate favoring government support of art and art education darkens, and the amount of money available for things perceived as nonessential to personal and societal survival declines, fewer people are attracted to a life of art making. Fewer parents are likely to encourage nascent artists.

13a. Severe cuts in student aid will affect art and the humanities far more than business and engineering, and nonwhite and working-class students far

more adversely than middle-class whites. Minority recruitment has also been de-emphasized under the new administration, as have affirmative-action hiring policies. Thus, the conspicuous lack of nonwhite staff and staff of working-class backgrounds in museums and most other cultural services will probably become even more egregious.[6]

14. Artists have been quick to bend to the replacement of the humane and generous social ideal of liberal administrations with an ideal of aggressive and cynical me-firstism. (The several reasons for this lie beyond my scope here.) Although the image of the artist as predator or bohemian has gone in and out of favor, a questionnaire by a West Coast artist suggested that by the late 1970s a surprising number of artists, some quite well-known, were calling themselves politically conservative and expressing the wish to make a lot of money. Artist-landlords are now common. (Of course, the impulse to make money rather than reject a life of financial comfort can be traced to the market success of art starting around 1960.)

15. Artists still vacillate between doing just what they want and developing a saleable product. That is, their integration into the commercial system is not complete. The institutionalization of art and the replacement of the paradigm of self-oriented expression with that of art as a communicative act helped bring to art a uniformity of approach and a levelheaded interest in "success"—as well as the expectation of its accessibility.

15a. The current generation of artists sees art as a system and knows how to operate by its rules.

15b. Thus, it is not a surprise that after the announcement of drastic funding cuts, especially in the National Endowment for the Arts, there was a disproportionate drop in the number of applications for fellowships. Next year will presumably bring a disproportionate rise, when word of the excessive timidity gets out. Equilibrium will eventually be reached, assuming that the

Endowment survives, but meanwhile artists will adapt to the requirements of other kinds of financial support (which is still likely to be a job outside art).

15c. The blurring of the line between commercial and fine-art production is farthest advanced in photography, which therefore may be the visual art most easily swayed by corporate backing—and most likely to attract it.

16. The "lower" end of the art system will continue to strangle, and the "upper" will swell and stretch as more of the money available from all sources will be concentrated in it. SoHo will become more elite and exclusive. Artists who are serious about pursuing money will continue to seek it, and the rewards will, perhaps, be greater than they have been in the past. Superstars will be heavily promoted and highly rewarded, while the absolute number of people calling themselves artists will shrink drastically.[7]

16a. The restratification or perhaps bifurcation of the art system will continue, mirroring the labor-market segmentation in the economy as a whole.

16b. As artists' incomes shrink, except for the relative few, and as urban real estate in most cities continues to escalate in value, artists, who have functioned as pioneers in "reclaiming" decayed urban areas, will find themselves displaced, and the stability of artists' communities, so essential to the creation of art, will be seriously threatened. This is already happening in New York.[8]

16c. The policies of the present administration—such as the rewriting of tax law to greatly increase the "safety" of tax shelters, especially in real estate—as well as the moderation of inflation, and perhaps other factors as well, have made the "tangibles" and "collectibles" market, a product of the rampant inflation of the 1970s, soften and fade, while the top of the art market is doing better than ever.[9] Sotheby Parke Bernet, the largest auction house in the world, which rode to the top of the collectibles wave, refused to announce

their losses for 1981.[10] At least one dealer felt it necessary to advertise his continuing solvency and reliability.[11]

17. The nature of the alternative system will change. The smaller spaces will close, perhaps; the politically dissident centers will come and go, relying as they must on member artists' funds; the most favored ones, such as P.S. 1 in New York and the Los Angeles Institute of Contemporary Art, which basically were products of the Endowment system, will become more and more indistinguishable from the junior museums they in fact are.

17a. New "alternative" spaces, perhaps most easily those for photography, will be financially supported by corporations and private dealers.

17b. Private dealers and perhaps corporate galleries will continue to tighten their grip on the exhibition system.

17c. The Museum Purchase Grant category has been eradicated. Private funds must now be sought for acquisition. Typically, foundations and fund-raising committees are inclined toward "historical" rather than current purchases, and toward physically large work—painting or sculpture, say—rather than photography. Once again, the dealer's or collector's loan or gift of art will regain its former influence in determining what is shown in museums.

18. The number of institutional art jobs, from grade school through college teaching, to administrative, curatorial, and other art-bureaucratic jobs, will drop steeply, so that artists will once again have to become petit-bourgeois entrepreneurs, attempting to make money through selling their work. They may seek financial support directly from corporations, perhaps photographic ones, so that their work will risk becoming, in effect, advertisements, like Marie Cosindas's work for Polaroid.

18a. Grant-getting agencies and agents, like the swollen few no-longer-alternative spaces, will see great expansion. Art promoters employed by art organizations are now being turned out by business schools, in programs that have existed for only the past few years. According to Valerie Putney's "More than Talent," in *Pace,* Piedmont Airlines's magazine, the first such program was at Yale's drama school in 1965.[12] At the State University of New York at Binghamton, the program aims to produce students able to "influence future policy regarding the appropriate role of the arts in a diverse technological free-enterprise society." These unashamed bottom-liners spout the language of fiscal accountability while like-minded artists may also need to learn it to gain grants from cost-conscious corporations (and other sources, including the government). Or they may simply buy the services of agents themselves. (A long-standing example of grant-getting moxie is Christo, whose career has depended on it.)

19. The parts of the system adjust to one another: Artists learn the language of the accountants, and their thinking becomes more like accountants' (or salespersons') thinking. Art institutions and art-makers adapt their offerings to the tastes of grant-givers (that is, to the current ideological demands of the system). The new head of the Humanities Endowment has already disclaimed certain projects of the preceding one,[13] and the current head of the Arts Endowment has held up certain project grants. Will these kinds of grants now be curtailed?

20. Through the past decade, art organizations of all sorts had already begun adapting their offerings to the ideal of entertainment for a broad audience (partly as a funding ploy). The reduction in funding has also spurred more and more of them to advertise for money and attendance in print media, on the radio, and on television. "Arts management seminars" teach ways to "target" audiences and to get good returns for advertising dollars, as well as "how to identify and solicit the most receptive customers—through marketing surveys, direct mail, or whatever means has [*sic*] proven best. . . ."[14]

20a. In using the techniques of advertising, art organizations adapt their thinking and their offerings to the form of advertising. Increasingly, these appeals have been to pretentiousness, cultural ignorance, and money worship.

21. Because the pauperization of artists and others is connected to the reactionary policies of the current administration, while the absolute number of artists shrinks, proportionately more artists are likely to become social dissidents.

21a. The model of activism for artists and other cultural workers was slowly rebuilt during the Vietnam era, and that process will not have to be repeated today. Our society as a whole is much more given to public display and political activism of every variety than it has been for most of the period after the Second World War.

22. The conservative or reactionary artistic tastes of the corporate donors and private buyers will be prepotent, perhaps decisive, in their influence. But the content of their tastes cannot be assumed in advance: The ideologically reactionary work is not necessarily the most formally conservative, and we may find work that appears "advanced" formally backed by some political reactionaries. We may return to a kind of formalist modernism; artists, dealers, and their coteries will speak again of "quality" and mean "formal values," while other artists will expect to make their living only outside the high-art system and will refuse its values.

22a. If modernism is not restored, its formalist "investigations" may yet continue as part of a fragmented art scene, in which the present imagery expressing antirationalism, alienation, and uncertainty provides the theme.

22b. The next generation of artists, if there is one, will be part of a "post-institutionalized" art system with a solidly restored hierarchy of glamour, wealth, and status. But the probably metaphysical high style it draws in its

train may well be shot through with the cynicism of a delegitimating vision—one that questions the authority of art and its forms as well as that of social institutions.

22c. The inevitable corollary will be that this smug display of wealth and ostentation, particularly if combined with flashy nihilism, will be a spur to the resurgence of a well-developed, socially engaged, and egalitarian art, such as has recurred in the industrialized world for over a century. Networks of artists who are interested in making such art have proliferated in the past few years.

> *Unlike many corporate donors who finance performances of established works such as Swan Lake and Carmen, Philip Morris seeks out the experimental and avant-garde. In addition to Hopper and German Expressionism, there has been a Jasper Johns retrospective, shown at the Whitney and subsequently in Cologne, Paris, London and Tokyo. And there has been a photography show at the Museum of Modern Art. The company has also underwritten Michelangelo at the Morgan Library, North American Indian art at the Whitney and a traveling show of American folk art. . . .*
>
> *Philip Morris executives express a fundamental interest in helping to develop the arts and shape public taste.*
> —from Sandra Salmans, "Philip Morris and the Arts," New York Times, business section, November 11, 1981.

> *"We believe that supporting the arts is one of the best investments NCR can make," says William S. Anderson, chairman and chief executive officer of the Dayton-based NCR Corporation and chairman of the Dayton Performing Arts Fund. "There is a high level of competition throughout the industry to hire the caliber of people we need. Dayton is*

> *not in the Sun Belt. It is neither on the East Coast nor on the West*
> *Coast. In fact, whether we like it or not, many people consider this part*
> *of the country just a step or two removed from the boondocks. When we*
> *recruit new employees, they want to know what they are getting into.*
> *This inevitably leads them to ask what the Dayton area has to offer in*
> *the arts and cultural activities."*
>
> *A concentrated effort has been made to upgrade the cultural climate*
> *in the Dayton area in the past half-dozen years. The availability of new*
> *resources and some good artistic choices have made the job credible.*
> —Paul Lane Jr., "Who Covers the Cost of Culture in Middle
> America?" *New York Times,* arts and leisure section, March 28,
> 1982.

NOTES

1. *SVA* [School of Visual Arts, New York] *Alumni Chronicle,* Winter 1982.

2. *New York Times,* August 28, 1981.

3. Ibid.

4. See Harold C. Schonberg, "Cuts in Federal Arts Budgets to Hit Small Groups Hardest," *New York Times,* February 19, 1982.

5. In hindsight, one can observe that "ethnic arts" were refurbished as community expression and the notorious diversity management strategies of various levels of government planners.

6. The remarks in the previous note apply here, with the additional observation that some of the children of the "new" middle classes of color have entered cultural institutions as both professional staff and as artist-exhibitors.

7. The number of self-described artists seems to have grown rather than shrunk, and SoHo became so "elite and exclusive" that it became a bedroom community for the very rich at night and a moderate- to high-end shopping district by day, driving the galleries to lay claim to new turf, in far-West Chelsea.

8. In New York, artists have continued to establish colonies in Brooklyn and a few areas of Queens, though none of these are particularly stable, as the cycles of gentrification and displacement continue to revolve rather rapidly.

9. See, e.g., Rita Reid, "Auction: Art Records Set in May," *New York Times,* June 7, 1981; and "Auctions: A Low Volume but a High Yield," *New York Times,* November 8, 1981; "The Collectibles Market in Decline," *New York Times,* January 3, 1982; under the heading "Investing" (business section), H. J. Maidenberg, "Slack Days in the Tangibles Market," *New York Times,* March 21, 1982; and, under the heading "Personal Finance," Deborah Rankin, "There's More Shelter Now in Real Estate," *New York Times,* August 23, 1981.

10. R. W. Apple Jr., "Sotheby Tries to Overcome Business Problems," *New York Times,* March 18, 1982; and "Sotheby Troubles Shake Art World," *New York Times,* March 21, 1982.

11. Howard Beilin, Inc., according to the *New York Times,* March 28, 1982; Sotheby's also ran a series of color ads in British magazines.

12. Valerie Putney, "More than Talent," *Pace,* March-April 1982.

13. See Irvin Molotsky, "Humanities Chief Calls PBS Film Propaganda," *New York Times,* April 9, 1982.

14. Putney, "More than Talent," p. 30.

THE SUPPRESSION AGENDA FOR ART

We've entered a period of witch-hunting. Whether this one will rival earlier ones in ferocity and waste remains to be seen. The country is in a strange mood—the Cold War has faded, but few ordinary Americans are exhibiting the "We-won-you-lost, stick-it-in-your-ear" attitude toward the Soviets attributed to Secretary of State James Baker by Thomas Friedman of the *New York Times.* In fact, according to the *Times,* Americans feel that the Soviets may have lost, but we sure didn't win. After the jumped-up patriotism of the Reagan days, we're experiencing the nightmare of the dream come true. As a man in Dallas told the *Times,* "Now that the communists have been put to sleep, we are going to have to invent another terrible threat." Perhaps we've already put our Evil Empire, our Great Satan, together out of bits and pieces, the shifting target flickering on the political screen.

This essay was originally presented as a paper at the conference "Forms of Censorship" held at the Harvard Center for Literary and Cultural Studies, Harvard University. It was published under the title "On the Suppression Agenda for Art" in Susan Suleiman, Alice Jardine, Ruth Perry, and Carla Mazzio, eds., *Social Control and the Arts: An International Perspective* (Boston: Agni and Boston University, 1990). It was also published in *Agni* 31–32 (1990).

Reaganism, while accomplishing a tremendous upward shift of wealth, posited a national unity based on pride and on targeting enemies within and without. It called up the organizing power of fear and demonization of Others. Censoriousness as a politico-social tool requires multiple targets and means because the material bases of the conflict can never be fully articulated but are always covered over and often displaced. In political image politics this approach—named by its victims and critics as "negative campaigning"—defines the opponent while leaving the attacker, usually the incumbent, relatively undefined. Although the various JUST SAY NO campaigns of the decade play out the scenario of affirmation through negation—of authoritarian populism—in various ways and on various targets, my primary focus here is the attack on "high art" and artists in full swing right now.

In 1981, Ronald Reagan attempted bureaucratically to shrivel the National Endowment for the Arts by halving its budget—in a likely first step toward shutting it down—and it was partly through the efforts of patrician Washington wives, seeing their leisure activities such as the opera and ballet jeopardized, that the Endowment was preserved, though with a 10 percent smaller budget; a political appointee at its head with a new, self-granted veto power; and a new burden of ideologically active right-wingers on its policy-making council. The new attempt to destroy the Endowment and what it represents has taken the form of moral panic.

Moral-purification campaigns, generally justified by recourse to children and family values, have remained important to the Right, particularly the religious Right, whereas rational child-centered policies addressing the very real crisis of children, if they appear to transfer parental authority to experts and the State, are unacceptable. Instead, the Right has demanded State intervention in the interest of patriarchy, through blanket prohibitions of cultural elements that might promote personal autonomy, including sexuality as a complex arena of open-ended choice.

While the religious Right calls for censorship and banning of certain cultural products primarily for teenagers, especially school library books and music albums, their mainstream allies, such as Tipper Gore, call for a more

sophisticated solution of music-album rating systems and warning labels, preserving a semblance of rationality and choice and avoiding the book-burning stigma attaching to the right-wing efforts to remove accepted classics from library shelves. Similar solutions have been proposed for funded art.

In 1988, religious groups, including Donald Wildmon's obscure American Family Association, based in Tupelo, Mississippi, mounted a highly visible but unsuccessful boycott against Martin Scorsese's mass-market film *The Last Temptation of Christ,* bringing to the headlines the rhetoric of Christian orthodoxy deployed by the early Reagan presidency and prefiguring the more terrifying Islamic campaign against Salman Rushdie's novel *The Satanic Verses* early in the following year. Boycott campaigns aimed at television also have been mostly unsuccessful economically. Throughout the decade the religious Right's cultural attacks continued to aim largely at children's books and mass-cultural elements; scrutiny of the art and humanities endowments, begun by some minor congressmen from Texas, mostly continued out of the public eye. Senator Jesse Helms expanded his antigay efforts from AIDS education to an attack on the National Endowment for the Humanities for funding lesbian poets. But attacks on literature failed to generate much public fire. The battle over literary obscenity had already been lost by the Right, and poetry, with its highly restricted audience, was hardly likely to ignite popular indignation. And lesbianism did not compute.

When censorious attention shifted last summer from mass culture, popular porn, and poetry to visual art, the art community was taken by surprise. Far-Right ideologues like Patrick Buchanan may fulminate that while the nation slept the Left captured the cultural agenda, but naming the enemy as "the Left" meant little until it was defined as flag burners, homosexuals, child pornographers, and Christ bashers. The Right has long campaigned by masking political onslaughts as cultural crusades. The attack on the posthumous traveling retrospective of photographer Robert Mapplethorpe was couched as a defense against polluting images of sexual libertinism and depravity, and the attack on photo artist Andres Serrano as a defense against a photo insult to Christianity.

These attacks appeal to popular presuppositions about the slippery slope of moral degradation and the efficacy of visual imagery. Despite arguably postmodern blurring of notions of photographic truth, photography still popularly represents a window on the world, and it isn't accidental that both targets were photographic. The beauty of Serrano's photo crucifix was all the more inflammatory given its title, *Piss Christ,* since irony is hardly acknowledged in popular culture, and never with such material. In Mapplethorpe's case, the ponderously complete but highly aestheticized rendering of a gay bohemian sensibility provided large-format evidence of utter degradation. Much has been made of the fact that the offending images aren't suitable for reproduction in "family" publications.

Attacks take different forms for different constituencies. For those outside the farthest reaches of art's audience, any reference to the things in Mapplethorpe's photos, such as golden showers or a little girl's genitalia, is strictly proscribed as itself a moral offense and as immediately polluting to others. Such images cannot be allowed into the public mind, even if cordoned off in the museum by signs restricting entry much like the movie industry's self-imposed Xs and Rs.

For a second, somewhat more art-savvy audience—though not the aficionados—the argument pertains to funding. Why should the government support questionable representations? This argument is generally made in relation to sensibilities other than one's own—namely, of those Others in the heartland—especially if one is a legislator or public official, even if it is really a projection and denial.

Both the moral and the fiscal arguments rely on a suspicion of experts and of "nonessential" expenditures. Hostility and resentment toward experts is a feature of the old petite bourgeoisie—the "grassroots," typified by small business owners and farmers—a declining class whose position is usurped by yuppies who constitute the professional-managerial class, the *new* petite bourgeoisie. The Endowment can hardly be defended before the grassroots opposition on the basis of the specialized knowledge and measured judgments of experts in the field. And yuppies aren't likely to be impressed by arguments

that other people should get their tax dollars rather than earning their money in the marketplace, which is where they believe any scam, no matter how outrageous, ought to be located.

Debate on these issues is affected by the efforts of a number of groups, particularly students of color and women students, to envision colleges as special protective communities in which offensive and damaging speech is proscribed. Debates about free expression in music have been affected by protests over anti-Semitic, antigay, misogynist, anti-immigrant, and other offensive pop music lyrics, while on the other side of the political aisle, there have been efforts to censure black rap groups. The use of public-access cable television by Nazis and other hate groups has caused protests, as has its use by pornographers. Calls by socially disempowered groups for curtailment of free speech make it more difficult to argue for untrammeled artistic expression, even though in the one case we are dealing with arguments centered on power inequities and in the other on moral purification.

Since the summer of 1989, when the ferocious attack on art was mounted, strategy sessions in defense of art routinely have broken down over whether lobbying should focus on preserving the Endowment and its peer-panel structure or on defending freedom of expression, with arts professionals preferring the former and artists the latter. When a dozen people—including artists but no arts professionals—sat around glumly trying to develop some public arguments, we stalled not only on that issue but on the public defense of art in general. Each time someone proposed an argument for a relatively enlightened public—that art is essential to society and that art experts have the best chance of divining *which* art is good and thus deserves funding, that art adds to the quality of life and is fun, that all the other advanced industrial democracies support more art and artists than we do—someone else asked, "But what do we say in defense of what looks like pornography in the heartland?"

The suppression agenda depends on the impossibility of appealing to the public good, to a common search for social and human meaning. Political governance through talk shows and opinion polling helps reconstitute the

public sphere as an audience which has the right to a thumbs-up, thumbs-down vote, but not as an arena in which ideas are presented for enlightened debate. Instead, preconceived ideas, generated elsewhere—by folklore, religion, self-help, astrology, the panoply of *acceptable* experts—are brought fully formed to the public arena, in which leadership consists of theatrical deployment of powerful, reductive cultural icons: the flag and the cross.

In this model, the home and the marketplace are the only stable non-State entities, and art must be understood only in relation to each. Art as therapeutic, ennobling, decorative, lucrative, and commemorative is understood and accepted; art as the articulation of a despised or devalued social location, as a search for a deeper truth, or as the expression of political dissidence is not—except if it is art by Eastern Europeans.

But even before the virulent attacks of the past season, the art world had been strongly reshaped by the events of the past decade, particularly the unprecedented market ebullience. The art world as a social institution obeys prevailing social logic. Art has turned in a stellar performance compared to other investments, including real estate, creating hyperinflation in this commodity. Corporate participation in the art world, especially in relation to exhibitions, has also greatly modified the art world. And modern structures of celebrity have modified art world behavior. Finally, the patrician class relations within the art world have been reaffirmed by the decade's changes.

Since the sixties, artists have attempted to come to terms with the domination of the image landscape by mass-cultural artifacts and advertising and television images. Pop mannerism jettisoned the Kantian paradigm of transcendence; and many artists stepped outside the gallery system, producing low-cost, low-cachet multiples and books, using noncommodity forms such as performance, or adopting vernacular forms like photography and video. The political delegitimations of the era allowed for strong oppositional strains. But by the early eighties, art world interest in a mass audience was more likely to be couched as an attempt to crack the pop-commodity market than to reject commodity production. By now this has been largely abandoned, since most artists have reentered the elite gallery system, and the democratizing,

anticommodity rhetoric of the sixties has given way to a search for means to insert art-as-information into the spaces of mass culture itself, such as on billboards and in TV spots. The rhetoric of control over conditions of production and distribution has shifted to the rhetoric of finding a voice, particularly for women and gay artists and artists of color. Traditional theories of utopian social change, which artists adapted as a set of countering beliefs to those of bourgeois patrons and market, are virtually gone from artists' rhetoric, as scarce as they are in any arena at the present moment.

Corporate support for art, spearheaded in the seventies by Nelson Rockefeller, quickly became written into federal and state policy in the form of matching grants. The increasing corporate presence in the museum led to the invention of the crowd-pleasing blockbuster show and a watering down of the kinds of art that funded institutions will show. Safety and familiarity are what corporations seek, and corporate support for art is routed through public relations departments. Even Endowment-supported public art projects have a matching-funds requirement, and production must therefore be adjusted to what suits the corporate image—as I discovered to my chagrin.

Reaganist gutting of social services forced socially inclined foundations to shift funding from culture to more immediate social needs. The hyperinflation in the art market has meant that museum exhibitions are vastly more expensive, if only because of insurance costs. Cuts in purchase grants forced museum administrators to go to their notoriously conservative boards for funding. Museum "de-acquisitioning"—selling art to raise money to buy more—is currently causing an art world controversy over a lost heritage. Finally, new tax-law changes have made the donation of art far less attractive.

In the market, scads of new dealers have swept up new art school grads, occasioning great cynicism and fostering an enfeebled doctrine of subversion as a vestigial encoding and encapsulation of the greatly eroded oppositional stance. The sixties' system of artist-run exhibition venues, whose funding was gutted, virtually dried up over the decade, and artists have few options outside the gallery system.

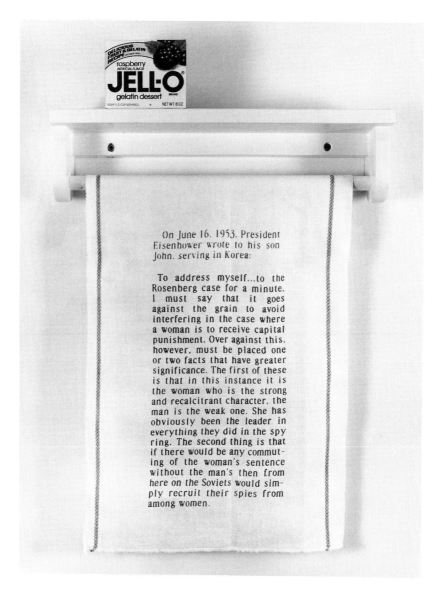

On June 16, 1953, President Eisenhower wrote to his son John, serving in Korea:

To address myself...to the Rosenberg case for a minute, I must say that it goes against the grain to avoid interfering in the case where a woman is to receive capital punishment. Over against this, however, must be placed one or two facts that have greater significance. The first of these is that in this instance it is the woman who is the strong and recalcitrant character, the man is the weak one. She has obviously been the leader in everything they did in the spy ring. The second thing is that if there would be any commuting of the woman's sentence without the man's then from here on the Soviets would simply recruit their spies from among women.

Martha Rosler, *Unknown Secrets (The Secret of the Rosenbergs)*, 1987–88. Detail of mixed-media installation showing cloth towel with red lettering and Jell-o box on painted wooden rack.

Martha Rosler, *Unknown Secrets (The Secret of the Rosenbergs)*, 1987–88. Detail of mixed-media installation showing life-size photograph of Ethel Rosenberg, framed by silkscreened magazine images.

Martha Rosler, *Untitled (Chicago O'Hare),* from the series *In the Place of the Public: Airport Series,* 1983–. Original photograph is in color. Work comprises photographic, textual, and video elements.

Martha Rosler, *Untitled (Salt Lake City, Utah),* from the series *In the Place of the Public: Airport Series,* 1983–. Original photograph is in color. Work comprises photographic, textual, and video elements.

The effects of the decade on criticism have been similarly profound. Unhappy with criticism's leftward slant, the Reagan Endowment eliminated critic's grants. Artists championed by trendsetting oppositional critics at the decade's start had become rich and celebrated by its end—but not the critics. They'd been bypassed by their oppositional stable, now at the most expensive and retrograde galleries, but these critics were identified with that group and unable or unwilling to move to a new one. Besides, dealer primacy had drastically hobbled critics. A number of the best critics returned to graduate school in their forties to retool as art historians, and few good young critics have emerged. Thus we find the same retreat to the academy affecting most of the Left intelligentsia come of age in the sixties. This has affected art production even in the sector deemed political, which has become anti-activist (with notable exceptions) and heavily theory-driven—though there are wider social reasons for that, of course.

Meanwhile, to add to the self-censorship pressures, in every panel member's packet at both Endowments, and in every grant recipient's envelope, is a blurb to the effect that the Endowment doesn't fund obscene material, including but not limited to sex acts, child exploitation, and homoeroticism. Thus, the Endowment and the panelists are cast in a quasi-judicial role, and obscenity—a category for which it is extremely difficult to obtain a court conviction—is barred without trial. In every public arena, the chilling effects of the attacks on the Endowment have been extreme. Local and state art councils have withdrawn funding from anything that might possibly be questioned and typically have extended the grounds for defunding beyond "obscenity." Significantly, new Endowment head John Frohnmayer removed funding from a New York show, calling it "political"—the dirty word that can never be uttered in relation to art. Challenged, he recanted this term, but at every level "political" expression has been defunded or not shown. In choosing among my works, two excellent curators for a social issues show soon to open in New York hesitated between a work of mine about the Rosenbergs and one about airports. (Guess which one they chose.)

The leadership of Jesse Helms shouldn't be taken to mean that he is alone or even representative in his attacks. *Anti*-populist (elite) neoconservatives in and outside the art world, as represented by the heavily Right-funded *New Criterion,* pose perhaps a longer-term threat. Still, we must draw some hope from the recent refusal of the Bush administration to join or support *public* tampering with the Endowments, as well as from the mobilizing efforts of the art world, and from the continued vitality of oppositional art, even if reduced and adapted to a newer, less congenial climate. Since the attack on art is part of a more generalized repressive agenda, it remains for artists and their supporters to make common cause with those with other stakes in the game.

PLACE, POSITION, POWER, POLITICS

It is an open question what role art might play in a society that has all but ceased recognizing the existence of a public arena in which speech and symbolic behavior address important questions for the sake of the common good. Even introducing these terms shows how outdated they are. Instead, the language of cost accounting anchors the discussion of the role of art in public life. This loss of sense of (united) purpose has provided an opening for the right wing to launch an assault on culture, with various rationales, including the rarely stilled voice of aestheticism, which prefers to see art as a transcendent, or at least an independent and therefore formalist, entity, with no social tasks to accomplish—itself a powerful ideological task after all. On the other side is a critique from the Left, which is often more open about its desire to tie art to its agendas. But neither Left nor Right is unified in what it wants of art, and on both sides there is the assertion of the need for artistic autonomy from the prescriptions of political figures. Nevertheless, there always seem to be people unhappy with the degree of autonomy that artists

This essay was originally published in Carol Becker, ed., *The Subversive Imagination: Artists, Society, and Social Responsibility* (New York: Routledge, 1994), a book seeking artists' direct testimony about oppositional practice.

Martha Rosler, *From Our House to Your House,* 1974–78. Photo postcard (holiday card) #2 from the series.

actually manifest. These are the broad terms of what has been a vital argument in the developed West through most of the century. For me, a child of the sixties, the questions of how engaged, how agitational, how built upon mass culture, how theory-driven (my) art should be have been ever-present, the answers never settled, since the terms of engagement themselves are constantly being renegotiated.[1]

The much-noted crisis of modern society and culture continues to affect the art world, offering me no reason to change my judgment of twenty years ago that artists have difficulty discerning what to make art about. During the "emancipatory" sixties, many artists sought what seemed an attainable grail in their self-liberation from market forces, which had been a recurrent goal of artists throughout the modern era. Such liberation, it was believed, would free artists to interpret—or perhaps to interpret for—the wider society. A number of strategies were directed toward this goal, including the circulation of art by mail and the development of happenings, performances, and other Fluxus-type interstitial maneuvers. Soon after, the rhetoric of democratization helped artists gain State support for the establishment of "artists' spaces," outside the market system, to pursue "experimental" forms. It would probably be a mistake to see this as elitism or separatism, as some have done, for artists were likely to identify with a rather vague notion of the common person, over and against art dealers and their clientele.

These "artists' spaces" were therefore thought of as more democratic, more related to the grassroots, than museums and market galleries. The concept of the art world as a system was just then being developed, and thinking about such matters as communicative acts or messages in art, about audiences, or about government aims in giving grants was often not clearly articulated. The conceptualization of the new set of practices as a space was consistent with the notion of space as created by the practices of social institutions and the State. The alternative-space movement took place in the context of a wide acceptance of the idea of alternative cultural spheres, or countercultures, which was richly inflected through the late 1960s and early 1970s, largely as a result of the antiwar/youth movement and its alienation

from modern technological/institutional power. Many young artists wanted to evade dominant cultural institutions: museums and their ancillary small shops the commercial galleries, on the one hand, and broadcast television, on the other. High-culture institutions were criticized for fostering individualism, signature, and careerism, and for choosing expression over communication. Television was castigated for empty commercialism (that part was easy). The institutional critique was also embraced by people who, with populist and collectivist impulses, made videotapes outside their studios in the late 1960s and early 1970s.

The anti-institutional revolt was unsuccessful, and the art world has now completed something of a paradigm shift. The mass-culture machine and its engines of celebrity have long overtaken the other structures of cultural meaning, so that patterns of behavior and estimations of worth in the art world are more and more similar to those in the entertainment industry, particularly as represented by television and the music industry. Most artists no longer seek to make works that evade representation and commodification or that will not, in the case of video and film, be shown on television. In fact, the art world has been called a branch of the entertainment industry, and its dizzying bowing to trends, its need for splashy new talent and forms of presentation (acts), supports this view. The end of high modernism has led to the fulfillment of demands for the new in art on grounds other than formal innovation. As the art world moves closer to an entertainment model of cultural production, it is moving toward a closer accord with mass culture in its identification of narratives of social significance.

In contrast to the entertainment industry, however, which, as personified by Oprah, promises that everything—even mass murder—will go down easy, art sometimes produces social lectures uncomfortably resistant to interpretation, containing complex significations and seeming to embody ugliness and threat. Art is not going to be a successful player if made to compete on the same court. It may be more apt to think of the art world as a branch of the fashion industry because of its characteristic ability to turn substance into style, a maneuver accompanied by timidity and groupthink masquerad-

ing as bold new moves. As with clothing fashions, high-end products are custom made, unique, or scarce, and chosen and displayed (worn) by rich people.

When I began working, the two-worlds model of culture was dying along with abstract expressionism and high modernism, but the wrecking ball swung into motion by pop art hadn't yet brought down the whole edifice—on which, it seems, stood the artist as teacher (I don't say visionary, although "even" McLuhan imagined there would still be such a role for artists in the global village). My politicized practice began when I saw that things were left out of explanations of the world that were crucial to its understanding, that there are always things to be told that are obscured by the prevailing stories.[2] The 1960s brought the delegitimation of all sorts of institutional fictions, one after another. When I understood what it meant to say that the war in Vietnam was not "an accident," I virtually stopped painting and started doing agitational works. A further blow to my painterly life was dealt by the women's movement. But my ambivalence about the matter of the *telos* of art persists; the question was to what degree art was required to pose another space of understanding as opposed to exposing another, truer narrative of social-political reality.

When in the late 1960s Michael Fried argued against the abandonment of modernist presuppositions of transcendence because they could be supplanted only by presence (and temporality)—by what he called "theatricality"—it seemed to me he was right, but on the wrong side of the question.[3] I had begun making sculpture; I soon realized that what I wanted wasn't *physical* presence but an imaginary space in which different tales collided. Now I understood why I had been making photomontages: It was the symbolic collision that had attracted me. But I adapted my sculptural efforts to installation works. I want to discuss the photomontages at greater length here because their trajectory indicates something about changes in the art world, in which I have participated, though from the margins. I initially began making large, complex collages of magazine photos of political figures and ones of significant institutional and social sites, including hospital operating rooms and cities viewed from the air. Then I began making agitational works "about"

Martha Rosler, *Cleaning the Drapes,* from the series *Bringing the War Home: House Beautiful,* 1967–72. Photomontage. Original is in color and black and white.

the Vietnam War, collaging magazine images of the casualties and combatants of the war—usually by noted war photographers in mass market magazines—with magazine images that defined an idealized middle-class life at home. I was trying to show that the "here" and the "there" of our world picture, defined by our naturalized accounts as separate or even opposite, were one. Although some of these works contrasted women's domestic labor with the "work" of soldiers, others simply dealt with women's reality and their representation: women with household appliances, or *Playboy* nudes in lush interiors. In all these works, it was important that the space itself appear rational and possible; this was my version of this world picture as a coherent space—"a place."

At the time it seemed imperative not to show these works—particularly the antiwar montages—in an art context. To show antiwar agitation in such a setting verged on the obscene, for its site seemed more properly "the street" or the underground press, where such material could help marshal the troops, and that is where they appeared. During the 1970s I worked more intensively with photographic media, including video and photography, as well as installation and performance, and did some critical writing. In lecturing, however, particularly to art students, I often included slides of these photomontages; talking to artists in the process of defining a practice is critically important.

In the late 1980s, almost twenty years after their making, an art dealer surprised me by suggesting we produce a portfolio of some of the antiwar images. What would determine my answer, aside from an allegiance to my own long-standing refusal to take part in the financial dealings of the art world? The reasonable man making the suggestion had established a practice of showing politicized, sometimes agitational, works on diverse subjects in his small gallery. It had begun to seem important to preserve my antiwar work, for the following reasons. I wanted a record, because it was my own work, but also because it was a kind of work that represented a political response to political circumstances. The art world had changed a great deal since the

works had been made; by the late 1980s there was little possibility of defining a practice outside the gallery-defined art world that still could be acknowledged within it.[4] Market discipline of the 1980s, enforced in part through the conscious action of the Reagan administration, had stripped away the monetary and ideological cushion for such practices. No matter what the cause, the discourse of the art world in the late 1980s flowed most directly from the gallery-museum-magazine system, but no magazine would devote serious attention to any artist not firmly anchored in the gallery world.

U.S. dealers, it turns out, don't concern themselves much with a wider view of art or with art's recent history, so it wasn't surprising that the man who wanted to publish my portfolio knew little of my work or my writings. In other words, in the 1980s the commodification of the art object—against which a good portion of artists' energies had been devoted to fighting in the late 1960s and through the 1970s—was complete. As the dealer said bluntly, I wasn't on the art world map. I realized that if I wished to have these works written into history, they would have to be somehow normalized. The works' entry to the present was highly "economical" with respect to time and effort. Soon after their first appearance in a published art world source in the early 1980s in a survey article by a noted critic, the works appeared sporadically in other critics' writings. One of these had attracted the dealer's notice. After he published the portfolio and showed the works in his small, slightly out-of-the-way gallery, *Art in America* published a feature article on them during the Gulf War of 1991. The whole portfolio was promptly included in a show on war images held at the Museum of Contemporary Art in Mexico City. Now they are mentioned and shown regularly, at home and abroad. They have become art, and in becoming art they no longer "are" the works I made but rather representations of them.

I have dwelled on these works because they so smoothly illustrate the operations of the art world and suggest the difficulty of establishing a strategy that one can maintain comfortably over a long period. The work migrated from the street to the gallery because that seemed to be the only way it might influence present practice.[5] It could be written about only after en-

tering the art world as a commodity. The initial audience had disappeared with the times, and it needed a new one, which might take the work as a historical lesson. In order to have any existence, it had to become part of a much more restricted universe of discourse than I had aimed for earlier.

In a contrary movement, quite a few politicized artists who find their primary home within the gallery-museum-magazine system use their fame to reach beyond it by employing the tools of mass culture: the mass-circulation magazine, the billboard, the train station or airport wall, broadcast television. This useful strategy is not without dangers, because rhetorical turns common in the art world may seem cryptic, incomprehensible, or insulting to the general audience, or their wider import may simply be inaccessible. The invisibility of the message can be ignored by art world institutional types, but when members of the wider community misread the work and take umbrage, the art world must take notice. (A number of well-known instances could be cited.) The right-wing ability to attack artists so convincingly grows out of the incommensurability of general culture and art world discourse. Thus, despite my remarks about the closer identification of real-world issues with art world issues, the art world, or art scene, is still a distinct though internally disjunctive community with specialized understandings and patterns of behavior.

Furthermore, the art world may support what I have come to call "critique in general" but draws back from particular critiques about specific places or events—as I learned to my unhappiness when invited to mount a billboard in Minneapolis in the mid 1980s. The billboard I submitted, which was about Minneapolis, was refused by the funders, who thereby abrogated their self-generated contract that no censorship would be imposed. (Of the eight or ten invited artists, the two local submissions and mine were censored. No other out-of-town artists were curbed.) My substitute proposal, a surreal photomontage with a somewhat vaguely worded critique of television, was accepted without demur.

The several roles art serves in society often seem to conflict. People (the daytime television audience, say) who have no difficulty absorbing fantastic

amounts of social information and innuendo relating to sexual conduct from the flirtatious through the highly unusual to the criminal, as long as it is transmitted through entertainment media, discover in themselves a streak of self-righteous puritanism when the material in question is produced by people called artists and when government money is involved. How the issue of taxpayer funding figures in the actual reasons for people's negative reactions is hard to ascertain. It cannot seriously be argued that entertainers with risky acts, like Eddie Murphy, are successful because people pay to see them and that that should be the model for art as well. The support for television "personalities," especially comics, is not so straightforwardly measured, and even the television industry cannot develop a "popularity index" for individual figures that has any degree of accuracy, except for those at the extremes. It is plausible that people want to punish artists, whom they can easily scapegoat, since they are perfect social outsiders. Perhaps people simply long for those who have representational magic to use it to create visions of beauty and wonder, not real-world engagement—a long-standing problem for those who wish their work to critique present events. Risqué acts have an unofficial license to be bad, while art (but not artists) is idealized as an uplifting, and universalizing, social force.

The increasing walling-off of intellectual activity in institutions and the marginalization of elements of high culture are undeniable, as are their continued disparagement.[6] The preservation of art world subculture activities that were the main impetus for the formation of the artists' space movement are furthered, as I've indicated, in small undercapitalized institutions, in boutiques (art galleries), in journals and magazines, in classrooms, and sites of social intercourse, and also to an extent in high-profile, highly capitalized elite institutions, making high art largely invisible to all but a fairly small proportion of Americans. Unlike many other fields of specialized knowledge in advanced industrial societies, art's institutional base is not stable, and art is not consistently useful to the aims of the State. Moral panics may target social groups (leading to repression of people of color, lesbians and gay men, Jews or Muslims, or even artists, for example) or may center on the symbolic realm

(sparking campaigns or witch-hunts against pornographers, blasphemers, flag burners, and so on). Subcultures with their own supporting publics are mostly insulated from the criticisms and financial disinvestments of the larger culture or the State. Artists care because the attacks may affect their ability to make art or make a living, and mainstream art institutions are compelled to protest as well when the Right engineers a withdrawal of funding not only for production but for exhibition as well.

On the Left, hostility to artistic autonomy also stems from the idea that art turns its back on the common folk. The Left used to harbor a certain hostility to "vanguard" art because artists weren't sufficiently allied with the working class, presumed to be the motor of social change. That class *as such* is no longer united, and its power in public life in the United States is not great (a prime indicator of its power as a class, the union movement, once an important political and social force, now covers less than 13 percent of the labor force, and its focus is almost exclusively on economics). The more contemporary critique from the Left often takes the form of a complaint that artists don't address "the people" or "the grassroots" or "the community," with those terms left more or less undefined. (The terms, and sometimes the understandings, are about the same as those of the Right populists.) Left anti-art (and anti-artist) sentiment, traceable to Marxian economism, perhaps, now stems as much from a critique or rejection of the restricted discourse— that is, the *community* understandings—that artists share. It is a criticism of language and audience, a criticism behind which lie charges of elitism and careerism. Hostility to artists' failure to occupy the social and moral high ground remains after theories of the proletariat have died.[7] If you are for us, why does your work seem either propagandistic or willfully incomprehensible?

Although artists have often allied themselves with the so-called laboring classes since the early nineteenth century, artist subculture has constituted an enduring bohemianism, characterized by a rejection of certain defining working-class characteristics—most prominently, wage labor itself (not to mention disregard for whatever passes for respectability). Yet the shared vision of autonomy helps divide the two groups. The story of the Western

tradition in art history has been a narrative of the valorization of personal and aesthetic autonomy, despite the fact that this dream of autonomy generally remained no more than that for the great majority of people; the same dream thrives among workers, where its elusiveness seems to cause hostility to artists because of their relative freedom and mobility. The relationship to authority and power, then, and not simply to financial success, is at issue. Artistic autonomy has also led to the suspicion of artists and rejection of "advanced art" by political elites of both West and East. "Bourgeois" values have long been hegemonic in the United States, and the working class, in rejecting exponents of sexual license or marital casualness, hedonism, atheism, or iconoclasm, is rightly or wrongly ascribed to artists, often spurning not the practices but their public espousal. People may engage in sexual practices that violate social norms and conflict with religious teaching, such as sex outside marriage, the use of birth control, or the resort to abortion, as long as a certain element of duality—some might say hypocrisy—is maintained. It is a consistent finding that some people engaging in same-sex practices reject the associated label and thus the stigmatizing identity; naming something, writing it into public discourse, is too powerful. To accept the right of "everyone" to live their lives as they see fit or to claim that so-and-so is all right, but that race or gender or sexual orientation do not deserve "special rights" is to accept a policy of informal exceptionalism.[8] Artists and activists offend the sensibilities of the rule-bound when they interfere with people's ability tacitly to accept or ignore things in the private realm as long as they are not made part of the structure of law.

Artists, in turn, are often repelled by working-class social conservatism or political jingoism, while, ironically, the high-profile allegiances that prewar artists on several continents proclaimed with working-class political movements has led to suspicions that vanguard artists were Bolsheviks. Nativist movements, xenophobic and racist, are constantly re-creating themselves among working-class adherents. But such policies of exclusion not only are socially institutionalized (as suggested by the inability of people of color to get jobs or mortgages and other loans compared with similarly quali-

fied white applicants, and a host of other institutionalized discriminatory practices) but also are held by the middle class and enforced by social power elites. The latter, however, don't need to agitate for the maintenance of privilege, since they can resort to increasing behind-the-scenes pressure on institutions such as banks and courts and to manipulating public discourse—and thereby encouraging reactionary-populist attitudes—by deploying coded language for distraction and divisiveness. The visible result, however, is that hatred, violence, and exclusion appear to emanate from below. Politicized artists are vulnerable to charges from the Right that they violate community norms in the practices they countenance or the groups whom they champion and from the Left that they don't situate their works in those communities or use language that can be readily understood by them. Stung by the tendency of conflictual capitalist society toward social divisiveness, many artists have lost interest in instituting a broadly inclusive social discourse; the impetus to do so supplied by black liberation, feminist, and antiwar militancy in the 1960s has dissipated. A new form of politics, called "identity politics," has entered the art world, as I consider later.

As symbolic activity condensing social discourse, art does play an important social role, though not one accepted with equanimity by those with reactionary agendas. Furthermore, as I suggested at the outset, artists have uncertain epistemological bases for their art. Transcendence is gone, along with ties to religion and the State, leaving an ever-changing rendition of philosophical, scientific, social-scientific, and cultural theory, including iconoclastic readings of identity and religion (Andres Serrano and Robert Mapplethorpe were both lapsed working-class Catholics).[9] Authorship, authenticity, and subjectivism seemed no longer supportable by the mid-1960s and remain questionable despite the heroizing tendencies and aspirations of the regressive painting movements of the 1980s. Culture itself—"society"—continues to be a problem, as it has for artists for centuries. The problem tends to manifest as a series of questions: with whom to identify, for whom to make work, and how to seek patronage. The immediacy of AIDS activism and its evident relevance to all levels of the art world, including museum staff, brought

politicized art far more deeply into the art world than, for example, earlier feminist activism had. It led to the inclusion of directly agitational works, including graphics and posters. But the museum/gallery door is open wider for this issue than for most others; it is seen as a sort of family issue in the art-and-entertainment sphere, and public acknowledgment and rituals of mourning first appeared within mass entertainment industries, such as the movies, and in decorative arts, not in the high-art world.

It can hardly be easy for artists to discern any responsibility to a society that demands they simply be entertainers or decorators. Those who demand racier material from art tend to be more privileged and educated, and it is those about whom artists are most ambivalent. At the same time, art objects are highly valorized (often unique) commodities. Although real estate and other holdings have served to fill out the investment portfolios of the rich and superrich, including corporations, art in the boom 1980s had a number of relative advantages as a safe haven for investment: Its value was rapidly multiplying; it was generally portable and easily stored; and it provided a kind of cultural capital no other entity could offer. Nothing else quite suggests both the present and the transcendent, both the individual (touch) and the collective (ethos). Nothing else reflects quite so directly on the social status and personal qualities of the purchaser. Elites, defining this as art's raison d'être, recognize that art—and therefore artists—have a certain social necessity:

> Alas, poor artists! They pour their lifeblood into the furrows that others may reap the harvest.
> —Louisine Havemeyer, wife of the Sugar King H. O. Havemeyer, patron of the arts, grand benefactor of New York's Metropolitan Museum of Art, crusader for women's suffrage; from the address she delivered at the (women's suffrage) Loan Exhibition [Tuesday,] April 6, 1915

Mrs. Havemeyer was not intentionally referring to financial rewards. She meant that society was the recipient, for she believed in the uplifting power

of art, as did all the progressive elites at the turn of the twentieth century. Art and culture were part of the Americanization (civilizing) program for the immigrant hordes, a program whose financial support was part of the noblesse oblige of the rich. Such elites have also understood that if society is to have any degree of coherence and continuity, this sort of cultural production must be preserved. The establishment of the National Endowments for the Arts and for the Humanities marked a recognition that in order for art to be preserved, it must be cushioned to some degree from market forces. In the 1980s, when market forces had again become paramount, this recognition was not so apparent.

The viewpoint of social elites toward art is neither reliable nor consistent. In the early 1980s, the Reagan regime's plan to shut down the arts endowment was stopped partly because Republican elites recognized the importance of saving the subsidies directed to orchestras, opera companies, and museums.[10] But eventually, Republican strategists like point man Leonard Garment tried to engineer a mission for the Endowment of preserving the work of the dead—the "cultural legacy" or "masterpiece preservation" argument—allowing the Republican Party to placate its reactionary-populist elements (and perhaps gladdening some less ideologically invested but penny-pinching taxpayers) by dropping support for living artists. Property before people is an enduring principle.

In contradistinction, critique from the Left has been complicated by changes in dominant political discourses, particularly the fragmentation and rejection of "international Marxism"—of the master narratives (*grands récits*) of politico-philosophical theorizing. The articulation of (the positionality of) those who have been excluded from public discourse—the voices of the previously marginalized or unheard—means that multiple discourses of difference must be voiced (and be heard) simultaneously. At the moment, they cannot comfortably be harmonized except through a "pluralism of Others," but numerous contradictions erupt. Although identity appears to be a stable characteristic, a person's very essence, people in fact maintain multiple, even conflicting, identities and positionalities, whose importance shifts, advancing

and receding in response to other factors.[11] Art world "multiculturalism" is a reading of identity politics and the so-called new social movements whose rise attended the fragmentation of Marxism. Having been implicated in this "discourse of Others," I find myself, not too unexpectedly, on both sides of the question.

On the one hand, who could possibly quarrel with the need for the articulation of Others, for and of themselves? On the other hand, it is far too simplistic to end there. All articulation occurs in a specific time and a place, in the context of a preexisting discourse and a real politics. How do you put a patent on a point of view when every identity, and every identity discourse, can be subdivided? How fine do you dice an identity? And what are the exclusions that result from your definition? Feminism in the 1960s and early 1970s was most visibly formulated by straight, white, middle-class women and then by white, middle-class, professional women. Questions of race and class haven't been answered within the women's movement, despite years of struggling, and positions on sexual orientation are sometimes precarious. Political positions and movements are constantly being renegotiated from within by the pressures of groups which feel themselves to be excluded, unrepresented, or underrepresented. These mutating categories are not well represented by the simple formulas often applied, generally informally, within art institutions. Including the previously excluded in the art world, however, doesn't solve the problem of attracting audiences. An African American artist I know remarked in a public talk that there is as yet no measurable black audience, only a white one, and that black artists must accept this—for now. But if she is even partly correct, yet another deformation, another self-Othering, is imposed on artists simply by entering the vital institutions of fame and fortune. (On a smaller scale, and despite the ease of "passing," this argument applies as well to class.)

"Identity" in the art world has so far coalesced around race, sexuality, and gender. As I've indicated, class identity is not a powerful mobilizer, tending to be despised (by non-working-class people), dismissed (because self-evidently powerless), or denied (by many working-class people themselves).

A further problem with the obscuring of class membership is that people benefiting from middle-class and "upper-class" privileges can claim perhaps more visible identities suggested by skin color or ethnicity without acknowledging the access to knowledge and power that superior class status provides. But even were this not so, social schisms that shear along class lines are recast as something else.

I recently ran into heavy criticism from a media theorist for a videotape I made on representation and the Baby M "surrogate motherhood" case.[12] Apparently it isn't fashionable among some feminists to criticize the real-world practices of substitute childbearing in case we foreclose an important option for women. I first codified my thoughts about the court case in a lecture on photography, in which I had rudely asked, *which* women, and of what social class? The videotape I subsequently made with the populist media-activist collective Paper Tiger Television, *Born to Be Sold: Martha Rosler Reads the Strange Case of Baby $M,* has been broadcast and circulated not only in the art world and in classrooms but among medical and nursing groups, since it raises the ethical questions that must attend the formulation of social and legal doctrine in relation to newly capitalized forms of reproduction. I think this is one of the things art should do, but I suspect some of the academic border police dislike the fact that the work has the possibility of instrumental use—although its didacticism has nothing to do with its presentational form, which involves some very broad burlesque. My sympathy for the birth mother, painfully arrived at, has opened me to some silly charges of essentialism (birthmotherhood is sacred) and even, perhaps, Luddism. Many viewers appreciate the defense of "poor women" and women of color; relatively few applaud the work for its class analyses in respect to norms, moves, access to resources, identification, and legal and journalistic bias. At the heart of the Baby M controversy was the question of whose identity was going to win out by being formally recognized: Even the name given the child by the working-class birth mother, who kept her for six months, was expunged by the court.

Martha Rosler and Paper Tiger Television, *Born to Be Sold: Martha Rosler Reads the Strange Case of Baby $M,* 1988. Still from color videotape.

Looked at from the perspective of a trend-driven industry, the advent of art-world identity politics—the embrace of multiculturalism as an officially sanctioned category—represents the incorporation of marginal producers, who bring fresh new "looks" to revivify public interest. The usual scenario is that a few handfuls of young artists of color and gay and lesbian artists are drawn into the system for an indeterminate amount of time and have international gallery and museum shows. Some are offered grants and highly capitalized fellowships. A smaller number of somewhat older ones are conscripted to tenured professorships.[13] This is still a form of marginalization though worlds better than the exclusions of the past; the number of "places" is kept low. What differentiates the multiculturalism vogue from the art world's mid-1970s vogue for "Marxism" or "political art" is the scope of those rewards. Powerful cultural institutions like the Rockefeller Foundation and many universities, which didn't care for the older version of political art, have been quick to sponsor multiculturalism, which is, after all, a demand for inclusion rather than for economic restructuring. Multiculturalism accepts that artists are actually representative of non-art-world communities, whereas whom did the artist of political critique represent? It is still possible that, despite the shifts in rhetoric, what the two moments share is that they represent passing fashions. Prominent people of color and women greatly celebrated in one generation are often expunged from cultural memory by neglect in the next. But it is surely true that sweeping in the margins has so far left the white power structure of museums—curatorial staffs and those above them—relatively untouched.

The politics informing my work are those of power/knowledge/representation, to call on a familiar formulation, which include class and inclusion. In the obvious instance where my works address feminist issues in the broadest sense, the art world may accept them. But when they are about the politics of localisms or labor that are closer to class politics, the art world remains largely uninterested. I recently exhibited an installation about the flows of toxics, wastes, traffic, and population in the largely white, working-class north Brooklyn community of Greenpoint in which I live. I had often

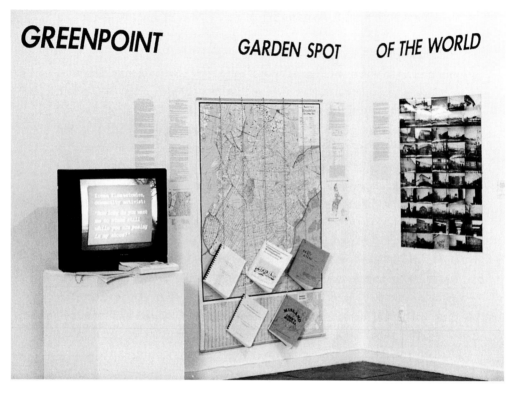

Martha Rosler, *Greenpoint, Garden Spot of the World,* 1992. Mixed-media installation (detail). Maps, photographs, and a computer animation trace toxic sites and flows in this old Brooklyn neighborhood, while the books on chains present detailed information and outline ways to combat pollution.

considered making a work about this community, a postindustrial wasteland populated by a working-class remnant, by those who have fallen through the bottom of that class, and by new immigrants. Although it is highly polluted and used as a convenient site for unappreciated city services, such as garbage transfer and waste treatment, a number of factors, including its large transitional population of immigrants from diverse places (but overwhelmingly from Poland), have prevented it from organizing effectively against this. Because class politics are taboo in America, social problems traceable to class demographics have a chance of becoming visible only when they impinge upon the lives of people of color; some communities of color have recently defended themselves against toxic sitings by suing on the basis of denial of civil rights ("environmental racism"). Greenpoint cannot effectively employ this civil-rights strategy, since this very old community was historically white. An invitation from a Manhattan museum to participate in a show on involuntary urban population flows gave me a framework and an impetus to look at Greenpoint. I began working on the theme of "flow": the flow not only of immigrants but of traffic and toxics. The more I researched the polluting city services and private industries, the more that became the central focus of the work.[14]

After the work was installed, I was stung by a friend's questioning of the work's exhibition at a Manhattan museum. An environmental activist, with whom I'd worked locally for a few years, suggested I send out a press release, whose local publication brought in some Greenpoint residents. A local NPR producer saw the work and invited me to speak on the radio; I brought the activist along to provide a wider perspective. The only visible art world response to the installation came from artists living in the adjacent community of Williamsburg and a pair of documentary filmmakers in Greenpoint. I've informally advised local artist activist groups and student researchers.

Were it not for the museum invitation, the work would not have been made. The invitation apparently stemmed from the cycle of shows and forums I'd organized at a high-art venue in SoHo. *If You Lived Here . . . ,* as the project was called, centered on homelessness and urban issues. I had been

If You Lived Here . . . , 1989. Shown is a corner of *Homeless: The Street and Other Venues,* the second of three exhibitions in this multipart curatorial project at the Dia Art Foundation, New York. Visible, left to right, are works by Kristin Reed (corner of billboard); Andrew Byard, Michael Thompson, Krzysztof Wodiczko, Cenén (below, on left wall); MadHousers (wooden hut); Gerald Pagane, Men of the Third Street (New York) Men's Shelter, with Rachael Romero (back wall, collage); students at Otis/Parsons with Robbie Conal, *Los Angeles' Official Housing Project for the Homeless* (bus bench posters).

invited to do a solo exhibition, and my theme of homelessness was acceptable primarily, I think, because it invoked newly visible issues of "the city" and fit with the institution's wish to manifest some degree of social engagement in the face of criticism. The American art world virtually ignored it, and the sponsoring institution rather marginalized it, but the project's visibility, nationally and internationally, has steadily grown, and it is routinely referred to in the literature, proving the rule of thumb about which political and social issues the art world likes: those long ago or far away.

This project spawned the show in 1993 to which I was invited to contribute (or so its curator told me) in the company of a number of artists whose work had appeared in that earlier project of mine. Unlike most shows, *If You Lived Here* . . . had brought together art world and non-art-world artists, community activists, homeless people, photographers, videomakers, filmmakers, architecture professionals, urban designers, and teachers. A book published in conjunction with it, incorporating work from the shows and forums and related material, has given it a new, longer life.[15]

In 1990, rather than excerpting the show cycle for exhibition at Washington University in St. Louis, I put together a consideration of housing and homelessness in that city instead. Could a university setting be effective in communicating the material? St. Louis was a much harder community to work with than New York; the sizable homeless community was invisible, swept into shelters, facilities, and homes administered by various religious communities (most governmental aid was funneled through churches). Local newspapers were generous to the project, but the only mention in the art press was in a minor national magazine whose reviewer vituperatively produced the old chestnut on this sort of work: Show it in a bus shelter or somewhere where such people congregate. In other words, get it out of my face. This criticism oddly mirrors the left-wing populist complaint that artists like me who put their work in art world (or university?) settings are playing to an imaginary audience. I find startling the static conception of audience this implies and the lazy thinking that produced it. Audiences for art are carefully constructed by lifetimes of parental and scholastic preparation, expectation, and guidance.

Although this training can't be duplicated in untutored viewers, audiences can be constructed on the basis of a community of interest. This process clearly can work, and even my limited efforts in relation to *If You Lived Here . . .* and *Greenpoint: Garden Spot of the World* succeeded in bringing out diverse communities, which also occurred in St. Louis.

The overlay of "place" and "the body" (often woman's body) and their relationship to discourses of power and knowledge have often been driving issues in my work. That conjuncture clearly lay behind *If You Lived Here . . .* and the photomontages I described earlier. It was also the impetus behind, say, *The Bowery in two inadequate descriptive systems* of 1975, which sited a work about socially transient (and déclassé) people, their street locale, and their photographic representation within the art world discourse in which such representations had come to find a "home." But it also motivated the mail-work "novels" on women and food, and my work on anorexia and bulimia (done in the mid-70s, before the words had even entered popular language).

An oft-cited critical response to *The Bowery* and its accompanying essay "In, around, and afterthoughts (on documentary photography)" articulated the degree to which the work engaged with the question of the presentation of (socially victimized) Others, and, by extension, women and different Others.[16] But as usual, I am located on both sides of this question as well. Last year I found myself working with Native Americans. Invited—along with a number of other artists—by the art commission of Seattle, Washington, to do a public art work, I proposed a series of short radio and television "spots" on the theme "hidden histories." Although Seattle's residents are of many different ethnic origins, with a strong gay community and a venerable, sometimes explosive, labor history, the feel of the place is white and polite. I proposed working with a wide range of ethnic and racial communities and with women's, gay and lesbian, and labor histories. Time and funding limitations led to my scaling back the project to a single element, and in consultation with an academic project adviser (whose own work was on the recovery of women's histories), I chose the Native American community—feeling a bit hesitant.[17]

———

Martha Rosler, Cecile Maxwell in *Seattle: Hidden Histories,* 1991–95. Still from one-minute color videotape.

During the interview process, a number of participants asked that the works not be aired on "educational" television but on local commercial stations. This imposed a powerful new stricture on the work; those stations said they would be happy to review the completed work, as long as it fit their PSA, or public-service announcement, formats: sixty seconds, thirty seconds, twenty seconds, ten seconds! I chose sixty seconds (nothing I'd made before had been shorter than six minutes). I have recently completed a handful of these one-minute bites, and they are being reviewed by the people in them. There will certainly be those who believe that I cannot legitimately work with Native Americans, but the success of this project cannot be judged until it has been aired and exhibited.[18]

The basis of the anticipated criticism is that people must speak for themselves, but—a friend murmured when I mentioned that the participants had chosen to talk about having been robbed of their cultures, their languages, and their spirituality—aren't you worried about pandering to essentialism, to imaginary identities?[19] Worried? The entire cast of *criticisms* of "people like me" making work with, or about, say, Native Americans is often essentialist, though suspicion, I might add, is not unjustified. Formerly, people used to question the propriety of making works about working-class people, especially since the majority of such works were malicious efforts that involved negative stereotyping. But solidarity is not an empty concept, especially when collaborative.

I have been cited often enough as opposed to documentary photography for the way it has portrayed those without power to those in power, although in fact my critique was of the particular way in which particular sorts of images are used, institutionally and by the photographers (or filmmakers). But some have taken this criticism as reason or excuse to turn away from documentary-style representations, no matter how "extended" a definition of documentary might be in question. Anthropologist Jay Ruby has suggested that only self-reflexive documentary—"giving the camera" to those represented—evades authoritarian distortion. Others consider all representations

to be fictive, and some would therefore reject them. I cannot accept these wholesale dismissals.

The enforcement of regimes of thought may always entail excessively strict application of rules, policing the borders of meaning. Racism and sexism, for example, produce polarities in which a vital step toward liberation is the self-articulation of meaning, and the self-naming, of colonized subjects.[20] This long, often convoluted process may make it imperative to suspend alliances, whether substantive ones or matters of representation.

As I saw on a recent visit to Russia, the search for authentic expressions of identity can be highly regressive, even delusional, and as the war in the Balkans amply shows, dreams of ethnic autonomy can lead to bestiality and murder. What grounds for exclusion are spurious, criminally so? This question, still animating liberation struggles, also pervades cultural policies and social attitudes, albeit far less convulsively in the United States.

A critique of excessive particularism is more easily articulated when it applies to issues other than identity or language. For example, Alexander Kluge described a situation in which he and his crew wanted to film an eviction of squatters in Frankfurt.[21] The squatters protest that their eviction cannot be filmed from without, by someone not living and struggling alongside them. Kluge and his crew reply that this point of view copies "the other side" by producing a "nonpublic sphere," a relationship of property and exclusion, whereas what is needed is the ability to disseminate information outside that sphere: "A public sphere can be produced professionally only when you accept the degree of abstraction that is involved in carrying one piece of information to another place in society, when you establish lines of communication."[22] Kluge and his crew were unsuccessful in persuading the squatters, who apparently saw authenticity of experience as a prerequisite to its representation.

I, in contrast, don't seem to be able to learn this lesson. I feel strongly that it is my responsibility to try to puzzle out these involvements or obsessions in the best way I can, and as I get older I trust this impulse more. I have to, for otherwise I might do nothing at all.

NOTES

1. I have spent quite a bit of time considering questions of inclusion and exclusion of artists and audience members, censorship and communities of meaning, and related issues. Some of these thoughts are included in "Lookers, Buyers, Dealers, and Makers: Thoughts on Audience," reprinted in this volume; "In, around, and afterthoughts (on documentary photography)," also reprinted in this volume; "Matters of Ownership and Control," *Artist Trust* ([Seattle], Autumn 1990), 8, 13, reprinted as "The Repression This Time: On Censorship and the Suppression of the Public Sphere," in *Release Print* (Film Arts Foundation) 13, no. 10 (December-January 1990–91); "The Suppression Agenda for Art," reprinted in this volume; and most recently, *If You Lived Here: The City in Art, Activism, and Social Theory, a Project by Martha Rosler,* ed. Brian Wallis (Seattle: Bay Press, 1991), and a few short articles and interviews.

2. I certainly said this differently at different times of my life, but I think an earlier self would recognize this particular formulation.

3. See his essay "Art and Objecthood," in George Battcock, ed., *Minimal Art, a Critical Anthology* (New York: E. P. Dutton, 1968), pp. 116–47. Originally published in *Artforum* (June 1967).

4. Many artists, of course, have nothing to do with the art world. This includes people whose work is situated in various communities outside the dominant culture, often artist-activists. Certainly, few media activists place themselves in art world settings.

5. I benefit financially from work that was made with no thought of permanence, let alone sales; oddly, that remains for me the most peculiar element.

6. Imagine Picasso, Pollock, de Kooning, Hesse, Warhol as tenured professors. The incommensurability of such artists with the role of ivory-tower denizen began fading only thirty years ago.

7. Furthermore, the argument is likely to be put forward by those who are too young ever to have had an interest in the "working class" or the masses.

8. As I write [1994], Massachusetts congressman Barney Frank, who is out of the closet, is suggesting, as a loyal Democrat, that gays in the military ought to remain in the closet, since that was the position President Bill Clinton was forced to adopt ("Don't ask, don't tell").

9. The photographic work of both these men provided the soapbox on which the congressional and religious Right have tried to destroy social acceptance of critical art and end the funding of all art.

10. See my "Theses on Defunding," reprinted in this volume.

11. See Felicity Barringer, "Ethnic Pride Confounds the Census," *New York Times,* May 9, 1993, sec. 4, p. 3, and on the next page (by way of obvious example), Roger Cohen, "The Tearing Apart of Yugoslavia: Place by Place and Family by Family," sec. 4, p. 4. See also Abdul R. JanMohamed and David Lloyd, eds., *The Nature and Context of Minority Discourse* (New York and Oxford: Oxford University Press, 1990).
 A number of factors help determine what people identify themselves to be. A despised identity can become a powerful organizer. The process of liberation and self-nomination of oppressed people—sometimes creates bogus or imaginary identities for members of the oppressing society, which itself may contain other competing group. "Identity" is a shifting signifier invoking culture, class, ethnicity, and race. See also my remarks in "Post-Documentary, Post-Photography?" reprinted in this volume.

12. See Maureen Turim, "Viewing/Reading *Born to Be Sold: Martha Rosler Reads the Strange Case of Baby $M,* or Motherhood in the Age of Technological Reproduction," *Discourse* 13, no. 2 (Spring-Summer, 1991): 21–38; and my response, "Of Soaps, Sperm, and Surrogacy," *Discourse* 15, no. 2 (Winter 1992–93): 148–65.

13. The grounds for granting such professorships seem as good as any, I hasten to say, having witnessed firsthand the hiring policies at various colleges and universities.

14. For me there is a primary irony in that until recently I still vowed I would never make a work about housing, health care, pollution, environmentalism, or anything related of social work or urban planning.

15. *If You Lived Here* (see note 1).

16. Craig Owens, "The Discourse of Others: Feminists and Postmodernism," in Hal Foster, ed., *The Anti-Aesthetic* (Seattle: Bay Press, 1983), pp. 65–90. (Reprinted in Owens, *Beyond Recognition: Representation, Power, and Culture* [Berkeley, Calif.: University of California, 1992].)

17. My hesitancy was mitigated by my lifelong interest in Northwest Coast Indian art and culture, spurred by my early exposure to them through museum collections at the Brooklyn Museum, the Heye Foundation, and the Museum of Natural History in New York; and it was dissipated by the very generous response of the Indians whom I approached to work with me.

18. An English friend recently reminded me that I had been taken to task in 1980, at a symposium at London's Institute of Contemporary Arts accompanying a political-feminist art exhibition. The objections—that I should not be representing Others—were directed at a "postcard novel" I had produced about a fictive undocumented Mexican maid (a composite based on interviews) in San Diego, where I lived the work was part of a trilogy on women and food production and for me flowed logically from my interest in labor.

 Although this was a fictionalized effort, the Indians are, of course, speaking on camera. I decided to leave my name off these mini-discourses by Native Americans, but the city is balking at my unmediated use of the Indian head that is the city's logo. They want an attribution line and a logo tying the work firmly to the Arts Commission and offering its phone number, all within sixty seconds; we shall see. The State of Washington has also contracted to distribute the tapes to schools throughout the state.

19. I become uncomfortable when I begin to see these "good" lost identities as not so different in kind from the East Bloc ones currently being pursued.

20. See note 11.

21. In an interview with Klaus Eder published as "On Film and the Public Sphere" in *New German Critique,* nos. 24/25 (Winter 1981–82): 206–20, an excerpt of which was published in *If You Lived Here,* pp. 67–70.

22. *If You Lived Here,* p. 68.

——

Photo Credits

Page 4 Photograph by Oren Slor.

Page 56 Courtesy Electronic Arts Intermix, New York.

Page 77 Courtesy Electronic Arts Intermix, New York.

Page 80 Courtesy Electronic Arts Intermix, New York.

Page 104 Photograph by Lloyd Hamrol.

Page 105 Photograph by David Daniel.

Page 107 Installation photograph Collection of the International Center of Photography.

Page 120 Photo courtesy of the artist and Frankel Gallery, San Francisco.

Page 122 Photo courtesy of the artist and Frankel Gallery, San Francisco.

Page 124 Photo courtesy of the artist and Frankel Gallery, San Francisco.

Page 153 Courtesy of the artist.

Page 159 From Jo-Anne Birnie Danzker, ed., *Robert Flaherty, Photographer/Filmmaker: The Inuit, 1910–1922* (Vancouver Art Gallery, 1980).

Page 162 © Elliot Erwitt/Magnum.

Page 247 © Susan Meiselas/Magnum.

Page 248 © Susan Meiselas/Magnum.

Page 255 Courtesy Contact Press Images.

Page 265 Collection of the International Center of Photography, Gift of Cornell and Edith Capa. © Cornell Capa.

INDEX